Studies in Post-Impressionism

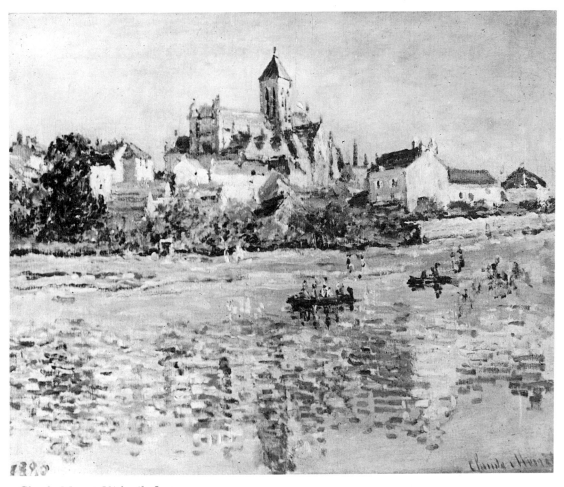

1 Claude Monet *Vétheuil* 1879

for the first time, I felt mostly its sad aspects . . . and that has remained with me for a long time, although I eventually did understand that Paris is above all a hothouse for ideas and that the people there try to obtain from life everything it is possible to obtain.'[9] If his sojourn in Paris while he was still employed by Goupil had truly been dominated by sadness, such was not the case during his second stay, when he had come there to complete his education as a painter and he, too, was trying 'to obtain from life everything it is possible to obtain.' He very quickly acquired a circle of friends, though his associations with some were occasionally quite agitated, as were also his relations with Theo from time to time. Among Vincent's acquaintances were Emile Bernard, Toulouse-Lautrec, Louis Anquetin, Charles Angrand, Paul Signac, Georges Seurat, Lucien and Camille Pissarro, Armand Guillaumin, and Paul Gauguin. Only the last three belonged to the old group of Impressionists and had participated in their previous exhibitions (although Signac and Seurat took part in the final show of 1886). But Guillaumin had

11

always remained in the background; Pissarro had just adopted Seurat's scientific divisionism; and Gauguin, a latecomer among the Impressionists, was detaching himself from his mentor, Pissarro—whom he accused as sharply as did Durand-Ruel of having succumbed to the 'little dot'—and was pursuing in Brittany a more cerebral expression of his perceptions.

Vincent introduced his new friends to Theo (who may already have met Pissarro) and doubtless also took him to *père* Tanguy's, whose shop on the rue Clauzel was located halfway between their home on the rue Lepic and the gallery on boulevard Montmartre. Tanguy was handling the works of some of Vincent's colleagues, but especially those of Cézanne, for whom Theo does not seem to have cared particularly. It is certain that Vincent should have liked to see his brother follow Tanguy's example and devote himself to young and still-unknown artists, those whom he called 'les peintres du petit boulevard,' in contrast to those of 'le grand boulevard,' who had already achieved a certain renown. Yet Theo was not his own master; he was grateful to his brother for having been put in touch with so many new painters and admired some of them, but he was forced to continue selling the products that assured the fortunes of Messrs Boussod and Valadon. For the entire year of 1886 a single transaction in the bulky account books of Goupil's concerns an Impressionist work, a seascape by Manet, who had died in 1883, which Theo acquired for 100 francs in October and sold for twice that much to a painter named Boggs.[10]

Unfortunately the ledgers of the firm record simultaneously and only in vaguely chronological order (pp. 38–43) the transactions of the establishment of the place de l'Opéra, of the boulevard Montmartre (usually with the citation 'Boulevard'), and of the various foreign branches.[11] They do not all indicate deposits on consignment. These were listed only when the work was sold, so that it is impossible to ascertain how long a painting may have been with the gallery before it found a buyer. Consequently, the sale of a work may even seem to precede its acquisition, but this merely means that the consignor received his remittance *after* the purchaser had paid. At a time when settlements were made in cash, several days could elapse until the consignor, informed through the mails, appeared at the gallery to obtain his share. Thus, whenever the date of acquisition is identical with or follows the date of sale, this is a clear indication that the work in question was consigned to the gallery by its owner, an intermediary, or the artist himself.

When a consignor left a work with the gallery which, after a certain time, was returned to him unsold, this fact is not registered, since the account books only record actual sales. This is illustrated by a letter Vincent van Gogh sent to Charles Angrand on October 25, 1886, in which he mentions the painter Boggs—who had just bought the seascape by Manet—with whom he had discussed the possibility of an exchange such as he was then advocating

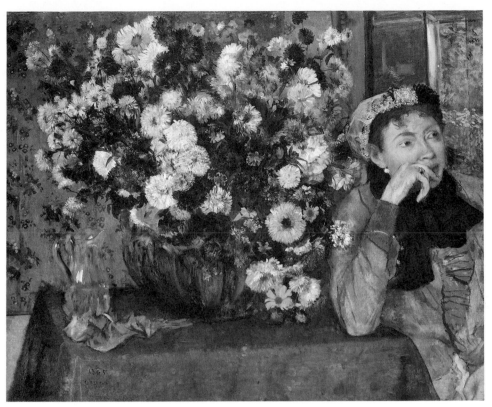

2 Edgar Degas *A Woman with Chrysanthemums* 1865

among artists as a means of forming a small collection for himself and his brother:[12]

> Dear Sir,
> I spoke to M. Boggs concerning our discussion and if you would like to make an exchange with him go ahead without fear, because you will see beautiful things at his place and he will be very happy to meet you. I also recommend myself for an exchange. I happen to have two views of the Moulin de la Galette that I could exchange.
> Hoping to see you soon, I extend my best wishes.
> Vincent
> Also go up to see my brother (at Goupil et Cie., 19 boulevard Montmartre). He has at this moment a very fine de Gas. I have again seen your *Jeune fille aux poules* at Tanguy's. It is that study that I would like to exchange with you.[13] Enclosed is my brother's card, if you do not find him there, you could in any case go up to see the painting.[14]

The ledgers of Goupil's do not list a single work by Degas sold at the end of 1886 or the beginning of 1887, so the painting must have been returned to the consignor. The first work by Degas recorded in the register was purchased

outright from the artist in July 1887, for 4,000 francs, but was sold only in February 1889. It was doubtless in order to inveigle the painter to do business with him that Theo was obliged to buy it—and at such a high price—since Degas may not have agreed to leave anything with him on consignment. It is true that the picture was an important early work *(2)*.

In his letter Vincent advised Angrand to *go up* to see the pictures at his brother's place. Indeed, Theo had finally obtained permission to use the mezzanine of the boulevard Montmartre gallery for modern works more to his liking. The premises were not very spacious, so that he was unable to organize large exhibitions, but at least there he could devote himself to the things in which he believed. Thus, in the course of 1887 he managed to secure not only from Degas, but also from Monet, Sisley, Pissarro, Gauguin, and Guillaumin one or more paintings for which—with patience and conviction—he tried to find buyers. Little by little Theo thus turned the two small, low-ceilinged rooms on the mezzanine into a showroom for avant-garde pictures. The location was excellent; businessmen on their way to the stock exchange could drop in to see what was new, people strolling on the large boulevard might stop by, and anybody interested in art could combine a visit to the gallery with a tour at the nearby Hôtel Drouot where all the public sales took place. Also near was the rue Laffitte, studded with art galleries and shops for antiques or curios; it was there that Durand-Ruel was established. Soon, every evening artists, collectors, writers, and their friends gathered at Theo's place between five and eight for animated discussions. Though the hours may have been late, the mezzanine now became alive.[15]

1887

Already threatened by Georges Petit, Durand-Ruel discovered another rival in the person of the calm and modest Dutchman of the Goupil gallery. Meanwhile he himself was endeavoring to find new outlets and, with an energy steeled by dire need, increased his activities on all fronts. In 1885 he had organized, without noticeable results, a series of exhibitions in London, Rotterdam, and Berlin. In 1886, invited to come to America by James F. Sutton, a powerful wheeler-dealer in art, he had traveled to the United States with an important collection of works by his artists. His mission turned out to be relatively successful, in any case more so than he had dared expect. Yet, in view of the enormous expenses, the profits were by no means spectacular, but the harassed Durand-Ruel saw a ray of hope and returned to New York the following year with another load of pictures. During his repeated absences, however, his painters began to feel 'abandoned,' the more so as their monthly remittances often went amiss. Thus, in 1887, Berthe Morisot, Monet, Pissarro, Renoir, and Sisley accepted an invitation from Georges Petit to participate in his sixth Exposition Internationale.

Theo van Gogh as art dealer

In memory of Jean Diéterle, 1881–1972

Logo of Boussod,
Valadon, & Cie

It would seem that both Vincent and Theo van Gogh were fated to become art dealers. Three brothers of their father, the pastor Theodorus van Gogh, followed this profession and one of them, called Vincent, had particularly distinguished himself, acquiring wealth and renown. This uncle, married to a sister of their mother, had no children and evinced a benevolent interest in his two nephews, especially after failing health had forced him to retire. But years before he did so he had been invited by Adolphe Goupil of Paris to join his art business and had gone to live in the French capital, leaving his own gallery in The Hague to be managed by a trusted employee named Tersteeg (who is frequently mentioned in the painter's letters).

According to the van Gogh family, the importance of the Goupil establishment had grown particularly after uncle Vincent had become associated with it, yet that may have been an exaggeration. The firm had been founded in 1827 in a small shop on the boulevard Montmartre by Goupil, who was twenty-one years old at the time, and an associate. Goupil had wanted to be an artist but found it more rewarding to publish carefully executed engravings after paintings, then the only way to produce multiple reproductions of works of art. These were executed in his own printing shop where eventually he had some ten presses for line engravings, aquatints, mezzotints, and lithographs. His prints were of exceptionally high quality and found a ready market.

In addition to works by old masters such as Veronese, Titian, Murillo, Correggio, and Raphael, Goupil also reproduced pictures by contemporaries. For this purpose he would sometimes buy their paintings and later sell them. Thus, little by little, he began to deal in works of art. In 1848, when the demand for his engravings slackened in Europe, he opened a branch in New York. Until then, according to his biographer, 'the exportation of prints to the

First published as 'Theo van Gogh, Goupil, and the Impressionists' in the *Gazette des Beaux-Arts*, January and February 1973

United States had been nil and the exportation of pictures did not even exist.'[1]

By 1864 the house of Goupil had expanded extraordinarily; not only did it have two galleries and the printing shop in Paris, as well as a correspondent in New York and uncle Vincent's place in The Hague, it also had branches in London, Brussels, and Berlin. It had become the leading firm in its specialty in Europe and that—in those days—meant the leading firm in the world. Although the American establishment, founded for Goupil by a Frenchman, Michel Knoedler, was subsequently bought out by the latter who then conducted it under his own name, the Knoedler gallery of New York continued to work closely with Goupil in Paris. It, too, did extremely well and periodically moved to larger quarters; in 1869 it was installed 'uptown,' at 170 Fifth Avenue, on the corner of Twenty-second Street.[2]

No doubt Goupil's business in contemporary art was bolstered by the fact that his daughter married Léon Gérome, one of the most famous Salon painters. Goupil also had four sons; one died in 1855 at the age of twenty-five, supposedly for having overexerted himself while helping run the New York branch; another, Albert, apparently showed no inclination for the commerce of art or of anything else, but he did have a passion for North Africa where he sometimes traveled in the company of Gérome who found there— particularly in Egypt—many of his favorite subjects.[3]

Through his son-in-law, Adolphe Goupil must have gained access to the studios of all the artistic luminaries of the time. Indeed, the Goupil galleries specialized in the works not only of Gérome, but also of such other academic celebrities as Meissonier, Cabanel, de Neuville, Ary Scheffer, Delaroche, and countless more, without, however, neglecting the Barbizon masters as soon as their canvases began to sell. Being an exceedingly astute merchant, Goupil— while insisting on the highest craftsmanship in his reproductive prints— followed rather than guided popular taste. On the occasion of the second Impressionist exhibition in 1877, Renoir's friend Georges Rivière spoke contemptuously of 'these small pictures from the Goupil enterprise that the inhabitants of the New World love as much as rum and glass trinkets.'[4]

It was obviously thanks to Goupil's partner from The Hague that the business in Dutch landscape and animal paintings prospered; they were greatly in demand both in England and the United States. One of the most successful Dutch artists, Anton Mauve, was married to a niece of the pastor Theodorus van Gogh and his brother Vincent. When, in 1869, at the age of seventeen, the pastor's eldest son, named Vincent like his uncle, had to choose a profession, he followed his namesake's advice and became an apprentice in The Hague gallery where Tersteeg soon was delighted with his eagerness. In 1873 he was sent to the London branch which handled what was called 'high class continental pictures by modern artists,' such modern artists being neither Manet nor Monet nor Renoir nor Cézanne, but Bouguereau,

8

Cormon, Detaille, Fortuny, Madrazo, Meissonier, de Nittis, Ziem, and of course Gérome, Dutchmen like Maris and Mauve, as well as Corot, Daubigny, and Théodore Rousseau.[5]

During the fall of 1874 young Vincent van Gogh accomplished a short tour at Goupil's in Paris; in May 1875 he was definitely transferred to France. By that time, however, he had grown disenchanted with his work. His lack of zeal soon became so obvious that, on April 1, 1876, he was dismissed, his career as an art dealer permanently over. From then on his uncle lost all interest in him.

Van Gogh had been notified of his discharge by Etienne Boussod who, the year before, together with a man named Valadon, had succeeded Goupil, to whose granddaughter (née Gérome) he was married. The firm, now called Goupil–Boussod & Valadon Successeurs (though most people kept referring to it as 'Goupil'), continued to be extremely prosperous with a main gallery at 2, place de l'Opéra, a prestigious location in the heart of modern Paris, its printing shop at 9, rue Chaptal, and a second, more modest gallery at 19, boulevard Montmartre—probably the place of the original establishment— only a short walk from the Opera.

Notwithstanding the disappointment his nephew had caused him, the helpful uncle soon arranged for Vincent's younger brother, Theo, to work for Goupil's. Theo apparently went to Paris in 1878, having just turned twenty-one, and immediately was put to work at the stand representing the firm during that year's World's Fair. He managed to sell one painting and also exchanged a few words with the French president, Mac-Mahon, during the latter's official tour of the grounds. These auspicious happenings filled Theo's mother with great pride.[6] A little later her son was put in charge of the small gallery on the boulevard Montmartre.

Once settled in Paris, Theo van Gogh, a modest, quiet, cultured, and—in his silent way—ardent young man, must have attended *all* the artistic events of the bustling city instead of concentrating exclusively on the annual Salons whose most prominent artists supplied Boussod & Valadon with an unending flow of merchandise. There can be no doubt that Theo visited the various exhibitions of the Impressionists and that he knew the gallery of Paul Durand-Ruel, who so courageously defended these painters. At the same time he was certainly also familiar with the somewhat pompous Expositions Internationales organized by Georges Petit, Durand-Ruel's most active rival, who was staking his phenomenal success on such favorites of the haut monde as Boldini, Besnard, and, later, Jacques-Emile Blanche, as well as on such 'anecdotal Impressionists' as Raffaëlli and de Nittis. Petit was even willing to take some chances with the Impressionists themselves if this could hasten the ruin of Durand-Ruel. Observing the art scene, Theo soon formed an independent taste only rarely in agreement with that of his employers. When his brother finally decided to become a painter, Theo sometimes wrote him

about the Impressionists and especially Monet, although the budding artist could not even imagine what their works might be like.

While Theo cannot have been very happy selling things he did not really like, he could hardly do otherwise, the more so as the well-known financial difficulties Durand-Ruel constantly faced were in sharp contrast to the lucrative and brisk commerce of Messrs Boussod and Valadon. But occasionally Theo did try to deal in Impressionist paintings. He seems to have begun with a landscape by Pissarro which he accepted on consignment for 125 francs and sold at the end of March 1884 to a collector-dealer, Guyotin,[7] with a profit of 25 francs. It is true that this took place in the context of a severe economic crisis that was felt even in the United States. Like all calamities of this kind, it first affected the 'speculative values' the Impressionists then represented rather than the 'safe investments' enjoyed by works of officially acclaimed and internationally admired artists.

It took another year before Theo could conclude his second Impressionist transaction; this time it concerned a work by Sisley which was obtained on consignment from the artist himself for 300 francs and sold on March 20, 1885, to a collector, Desfossés, for 400. It is not known whether Sisley had come to Theo possibly because Durand-Ruel, perennially short of cash, had been forced temporarily to suspend all payments, or whether Theo had approached the artist directly, conceivably because his client was interested in Impressionists. The only thing certain here is that Theo was not to deal again with Sisley until May 1887, two years later. On the other hand, within a few weeks Desfossés bought two more pictures from Theo: first a landscape by Monet, on consignment from the dealer Bernheim-Jeune for 680 francs, which Desfossés purchased on April 7, 1885, for an undisclosed amount *(1)*; and one week later a *Jardin* by Renoir, which an art broker, Portier, had left with him, asking 450 francs for it, and for which the price paid by Desfossés is also unknown.[8]

These four sales, involving one painting each by Pissarro, Sisley, Monet, and Renoir, represented Theo's entire activity regarding the Impressionists at the time his older brother arrived in Paris in February 1886. If this did not constitute a fabulous debut, at least it is an indication that Theo was interested in independent forms of art *before* Vincent joined him and encouraged him to pursue this path. Indeed, Theo's commercial dealings were soon to change radically on account of two factors: the presence of his brother and the personal friendships he formed with a number of artists of the new generation (actually the one that followed on the heels of the Impressionists, though to Vincent anything opposed to academic concepts was 'impressionist'); and the turn taken by the affairs of Durand-Ruel, especially the circumstances that brought about a great tension in his relationship with Monet and Pissarro.

Later, Vincent was to write to his sister, speaking of Paris, 'When I saw it

Contents

Works by the following artists © 1986 by
S.P.A.D.E.M., Paris
Maurice Denis, Raoul Dufy, Henri Matisse,
Kees van Dongen, Maurice de Vlaminck

Works by the following artists © 1986 by
A.D.A.G.P., Paris
Georges Braque, André Derain, Albert Marquet,
Jean Puy

Library of Congress Catalog Card Number 85-71382
ISBN 0-8109-1632-0

Published in 1986 by Harry N. Abrams, Incorporated, New York.

Printed and bound in Japan

John Rewald

Studies
in Post-Impressionism

Edited by Irene Gordon
and Frances Weitzenhoffer

Harry N. Abrams, Inc., Publishers, New York

In May 1887 Monet informed Durand-Ruel, then in America, that the success obtained at this exhibition had had repercussions since 'we are getting a better welcome from the purchasing public. The best proof that I can offer is that the Boussod Gallery now has some Degas and Monet paintings and will also have some Sisleys and Renoirs. I am in favor of this since the first pictures the gallery bought were quickly resold. Briefly, things are going quite well, which is what makes me regret your absence, especially if you are not achieving what you hoped for in America.'[16] Monet added that he had also sold almost all the paintings shown at Petit's. Though the artist had every reason to be pleased with this turn of events, his letter to Durand-Ruel—who then experienced new and unexpected difficulties in the United States—was rather cruel. Moreover, Monet exaggerated; only he and Sisley had done business with Theo van Gogh, but no Renoir, nor as yet Degas. As a matter of fact, the only one to derive immediate benefits from the show at Petit's was Monet himself.

The rather important deals that Theo concluded with Monet between the spring and fall of 1887 began on April 7 with the purchase of a single painting, followed by a second on the twenty-third of the same month. In May he bought six more canvases on three different occasions, which would indicate that Theo became a frequent visitor at Giverny (at a time when Vincent was staying with him in Paris and doubtless studied every picture his brother acquired). Monet sold Theo another landscape in July, three on October 10, and two more on October 22, altogether fourteen paintings for a total of over 20,000 francs, an amount that exceeded the profit Durand-Ruel had made in New York. According to the dates of sales recorded in the account books of the gallery, these must have been cash transactions for at least twelve of the fourteen works, and possibly for the other two as well. It is true that Monet was a very shrewd businessman who, moreover, was delighted to show Durand-Ruel that the Impressionists no longer belonged to a small chapel at which only their initial dealer officiated. He made no secret of this and eventually explained to Durand-Ruel that he considered it 'absolutely harmful and wrong for an artist to sell exclusively to one dealer.'[17]

In Monet's opinion the public would gain more confidence in Impressionist works if these were to be found in various galleries. This, he felt, would be a reassuring indication that more than one dealer believed in their commercial value. On the other hand, the fact that Durand-Ruel was actively 'pushing' the Impressionists could be construed as almost meaningless, since he might be doing so primarily to reduce his enormous stock. While this reasoning oversimplified matters, it also overlooked an essential factor, namely that without Durand-Ruel's stubborn advocacy and devoted and selfless support, Impressionism would not have been in a position to attract the business of those who now were eager to cash in on its slow success. Even Theo van Gogh, whose motives were not tainted with

15

mercantilism and who *believed* in art rather than considering it merely a source of income, would have been unable to convince Messrs Boussod and Valadon of the—admittedly meager—advantage of dealing in Impressionists if Durand-Ruel had not already cleared the first hurdles. It is certain, nevertheless, that the interest in Impressionism now evinced by such dealers as Petit, Bernheim-Jeune, and Boussod & Valadon contributed considerably to improving the situation. Monet was thus understandably pleased to watch Theo van Gogh find new outlets for his paintings.

The case of Pissarro, for whom Theo sold two pictures in 1887, obtaining 1,000 francs for them and remitting 740 to the artist, was altogether different. His works did not yet command prices anywhere near those reached by Monet; unable to sell them outright, he had to leave them on consignment with Theo. What prompted him to be 'unfaithful' to Durand-Ruel was the fact that the latter did not like his new, pointillist style and simply refused to buy his recent paintings. Since these did not generate any enthusiasm either among most of the friends and collectors who occasionally had sustained him, Pissarro apparently was not surprised that Theo could do no better than sell two of his works during the entire year. Indeed, he was relieved that Theo was willing to handle them at all and later said with gratitude that in those difficult days Theo had been the only one 'who was able to have collectors here accept' his divisionist canvases.[18]

In May 1887 Theo also went to visit Sisley, the only Impressionist with whom he had previously been in touch. He bought an autumn landscape from him for 700 francs (which was sold only eight years later for 1,000). In June he returned to acquire two more landscapes, which were sold in 1891 with little or no profit. Having obtained three canvases which obviously did not meet with great interest, Theo was unable to pursue his purchasing. When he went back to Monet to see Sisley, it was to take pictures on consignment for prices varying between 125 and 225 francs; four of these were sold toward the end of 1887 for a total of 875 francs, of which the painter received 640. Sisley's prices were inferior even to those—already low enough—obtained by Pissarro, and his poverty was still greater. Since Durand-Ruel could not extend to him the help he desperately needed, Sisley was eager to sell under any conceivable conditions. Thus, for different reasons, each of these artists was ready to deal with Theo van Gogh.[19]

Why Degas agreed to sell him a painting in July of that same year seems not as easy to explain. It could be that Durand-Ruel was away, or that the painter's needs exceeded the dealer's available funds, or simply that Degas—jealous of his privacy—did not wish Durand-Ruel to know that he was pinched for money. Since Theo was very anxious to enter into business relations with him, Degas evidently did not hesitate to call on him from time to time. The short messages he dispatched to the gallery usually announced that he was sending over a picture or was expecting a remittance:

Dear M. van Gogh,
It's still wet, take it out of the frame and let it dry a little. Please come to my studio tomorrow morning and bring me some money—I must pay Monday morning before nine o'clock. Excuse the rush. Many thanks,
Degas

My dear M. van Gogh,
Come tomorrow to see the drawing I have made for you or inform M. Etienne Boussod.

Best regards,
Degas

My dear M. van Gogh,
Cashier—2,000 francs.
There are perhaps some spots that are still not dry—Do you think glass would help it? First let it air in the light.

Regards,
Degas

This last note must have concerned a newly finished gouache or *peinture à la détrempe*, but the Boussod & Valadon ledgers make no mention of medium. Degas's hasty notes are undated, yet one of them, a telegram, bears a postal stamp of Sunday, October 23, 1887, and reads:

Dear M. van Gogh,
Please be kind enough to bring or send *tomorrow morning* the money for the small pastel of the other day.
Greetings,
Degas [20]

Strangely enough, the registers of the gallery do not indicate *any* transaction concerning Degas for that month (or the following one). It is of course possible that Theo purchased the pastel with his own money, conceivably because his bosses were unwilling to increase their stock of Impressionists, yet it appears that Theo refused to do business 'on the side.' Indeed, when the question later arose of a private contract with Gauguin, Vincent suggested to Theo that such an arrangement could be made in his, Vincent's, name, 'with the understanding that you are not in business for yourself.' [21]

In August 1887 Theo sold a painting by Sisley *(3)*, which the framer Dubourg had consigned to him, and in November he disposed for the account of a M. Legrand of a canvas by Renoir of canoers *(4)*, which cost 200 francs and for which he received 350. Among all of Durand-Ruel's painters, Renoir was the only one who never dealt with Theo. It was not until 1892 that Renoir

17

sold a painting to an agent of Boussod & Valadon and only later still—when he was famous—that he would 'give in' to requests from Vollard and others. But throughout the difficult years, which were as hard for him as for Durand-Ruel, he refused to desert his friend and dealer.

The last artist for whom Theo was able to place a picture before the end of the year 1887 was Gauguin, who received 300 francs for a painting sold at 450 francs to a collector named Dupuis. Unlike the others, Gauguin was not linked to any gallery. Upon his recent return from Martinique, he had been happy to see how active Theo had become in the field of modern art and had informed his wife in Copenhagen: 'You know the Goupil Gallery, publishers and art dealers. This firm has now become the center of the Impressionists. Little by little it is going to make its clients accept us; this is something to look forward to and I feel that in a short time I shall be on my way.'[22]

Gauguin not only overestimated the importance of Theo's gallery, which was far from being the 'center of the Impressionists,' but he also completely

3 Alfred Sisley *The Seine at Suresnes* 1879

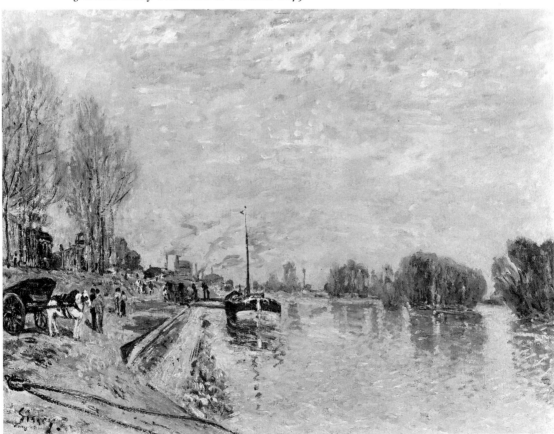

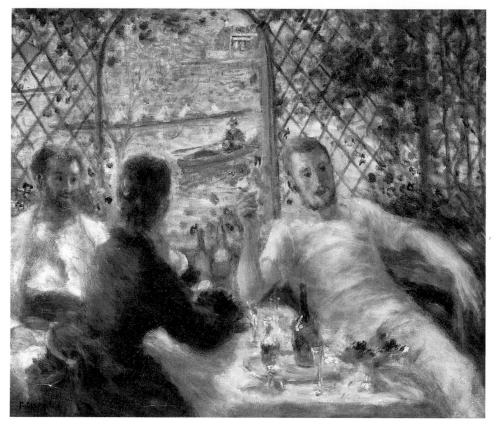

4 Auguste Renoir *The Rowers' Lunch c.*1879

misjudged the situation when he indicated that Goupil's clients could be
persuaded to purchase Impressionist paintings. The loyal customers of the
main gallery at the place de l'Opéra certainly would have considered this
preposterous and there can be no doubt that Theo had to create slowly a new
group of collectors willing to share his beliefs. What is important, however, is
that Theo's interest inspired Gauguin, who had been living in extreme
poverty since his arrival from Martinique, with sorely needed confidence.
Vincent greatly admired this haughty man and the canvases he had brought
back from the Tropics. Of all the painters whose works Theo began to handle,
Gauguin was without question the one whose talent Vincent most ardently
defended in discussions with his brother. It was to Vincent that Gauguin was
indebted for having found a protector in Theo.

But these artists were not the only ones on whose behalf Theo became
active. He also sold works by Guillaumin and sooner or later established
connections with Rodin, Puvis de Chavannes, and Odilon Redon. Monticelli,
who had died in 1886 and for whose work Vincent conceived a real passion,
was another painter in whom Theo took a lively interest. Nobody was more

19

delighted with this evolution of Theo's professional activities than his brother, who actually hoped that Theo would resign from Boussod & Valadon in order to open his own gallery. After Gauguin's return from Martinique, Vincent informed him that during his absence

'the discussions covered a wider field—with Guillaumin, with the Pissarros, father and son, with Seurat. . . . Often these discussions had to do with the problems that are so very near my brother's heart and mine, i.e., the measures to be taken to safeguard the material existence of painters and to safeguard the means of production (paints, canvases) and to safeguard, in their direct interest, their share in the price which, under present circumstances, pictures only bring a long time after they have left the artists' possession.'[23]

This dream of providing a number of avant-garde painters with monthly payments in exchange for their works required funds which Theo did not possess. The two brothers would have liked to see their uncles in Holland subsidize at least part of such a project, yet the latter were no more interested in advanced art than were Goupil or his successors. Moreover, Durand-Ruel's precarious situation after many years of such a policy was by no means encouraging. Theo therefore decided not to embark upon such a risky venture and to keep his job with Boussod & Valadon, although Vincent considered this a sad compromise. But in that way Theo was assured of a steady income (he earned 7,000 francs a year plus commissions) which enabled him to be of occasional help to his friends without heading toward almost certain bankruptcy. After all, the fortune amassed by his bosses had not been made with the type of paintings the two brothers loved; it was based on those Salon artists for whom the rich preferred to spend their money. At the time Theo earned 150 francs for the firm with Renoir's canoers, the main gallery at the place de l'Opéra picked up at Cabanel's studio a life-size portrait of Madame van Loon for 27,000 francs; the very same day her husband, who had commissioned it, paid Boussod & Valadon 30,000. 'Fortunately,' as Vincent later remarked with more irony than bitterness, 'it is extremely easy to sell very proper pictures in a very proper place to a very proper gentleman, now that the great Albert [Goupil] has given us the recipe.'[24]

Indeed, it was much more remunerative to purchase a picture by Jules Dupré for 19,000 francs and sell it the next day to M. Chauchard of the department store La Samaritaine for 24,500; especially as M. Chauchard, that same day, also bought another canvas by Dupré for 27,500 francs which, less than twenty-four hours before, had cost the firm 20,000 (almost twice Theo's yearly salary was thus made in one transaction). In a couple of weeks, 6,000 francs might easily be made on a work by Meissonier; one could also obtain the sensational amount of 150,000 francs for Alfred de Neuville's famous *Les*

dernières cartouches (42×65 inches). Which Impressionist would ever bring such prices? It might even be advantageous to buy from another dealer—Georges Petit—*Une Rue au Caire* by Gérome (M. Boussod's father-in-law, then still alive) for 50,000 francs, since two years later the American magnate George F. Gould would be willing to pay 70,000 francs (or $13,500) for it. In 1889, at the James H. Stebbins sale in New York, a painting by Meissonier measuring $3\frac{1}{2}$×$4\frac{3}{4}$ inches brought $7,100. That same year, Durand-Ruel, forced to liquidate at auction some of his pictures in the United States, could not get more than $675 for a painting by Renoir; a pastel by Degas was knocked down for $400; none of Pissarro's or Sisley's works reached $200; only Monet's canvases commanded more than $1,000. A number of lots had to be bought in.

Sometime before these American sales, Messrs Boussod & Valadon lent their assistance to a three-day auction in Paris, held 'as the result of the renewal of the former firm of Goupil & Cie.,'[25] in the course of which they liquidated some of the residue of their predecessor's stock. They disposed of assorted works by Boulanger, Corot, Couture, Daubigny, Dagnan-Bouveret, Delacroix, Demont-Breton (one of whose paintings Vincent was to 'copy' later), Maris, Mauve, Mesdag, Raffaëlli, Ziem, and even Gérome, only to acquire more of the same for their thriving trade. If Vincent attended the event, he may have witnessed the dispersion of some of the very pictures it had once been his job to try to sell.

Apparently Theo did not suffer so much from the fact that he had to handle merchandise he loathed (though Vincent actually found certain qualities in Dupré, Ziem, and Meissonier[26]), as he was depressed to feel constantly slighted by his employers who refused to provide him with the means to expand his activities in the direction he desired. Indeed, Theo did not enjoy great freedom of action. It seems that all important deals had to be ratified by Messrs Boussod and Valadon and that one or the other often accompanied him when he visited artists to select pictures for his gallery—such as Degas or Monet, whose works were more expensive than those of the other Impressionists. Under these circumstances it is of course impossible to assess fully the scope of Theo's activities, since the purchases he may have wished to make but was not permitted to negotiate did not leave any traces.

Those around him knew that Theo was not really happy in his job and occasionally had bitter differences with his employers. Without giving in to discouragement, however, Theo kept on selling whatever the gallery of the place de l'Opéra provided while continuing his more satisfying though often frustrated efforts on the mezzanine. Whereas during 1887 these efforts had not quite attained the importance at which both Monet and Gauguin had hinted in letters, they had marked considerable progress over the previous year. This trend was to increase in 1888 despite the troubling events in Theo's life.

1888

Theo had wound up the year 1887 with a mixed show in December, comprising three fans by Camille Pissarro,[27] a pre-divisionist landscape by the same, as well as several of his new pointillist pictures. With these he displayed two canvases by Gauguin, painted before his trip to Martinique, together with a scene from that island and a group of the artist's ceramics. There were also several paintings by Guillaumin, one of which was purchased by Dupuis. One of Gauguin's earlier works, *Boys Bathing*, was also sold to the same new client who, in addition, showed great interest in a fan by Pissarro. But on January 30, 1888, Theo was forced to inform Pissarro that he would have to pay for his frames: 'If the collectors were less indifferent I would undertake the framing at our expense; but I am scarcely able to sell any of the works I find beautiful. Even the fan has not yet been sold. When will we get out of this period of indifference?'[28] Dupuis eventually bought Pissarro's fan,[29] though there is no trace of this sale in the gallery's ledger. It could well

5 Paul Gauguin *Fruit Pickers, Martinique* 1887

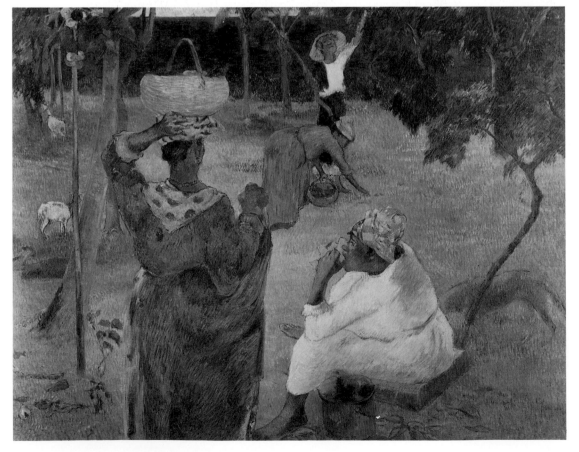

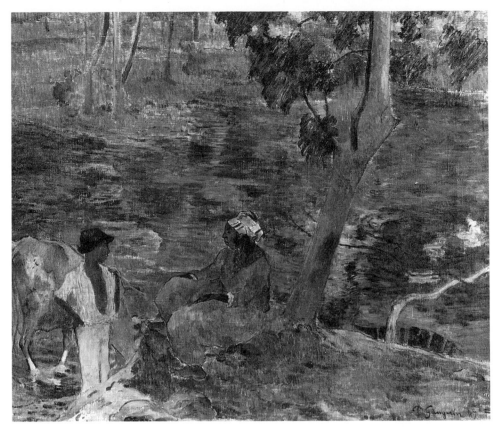

6 Paul Gauguin *By the Pond* 1887

be that Theo accepted it in payment for the frames (which was a less painful solution than to insist on cash).

The critic Fénéon, who was starting a regular column of condensed reviews in the *Revue Indépendante*, discussed Theo's offering under the heading, 'Chez Van Gogh (Boussod & Valadon Gallery, boulevard Montmartre),' but specified that the works by Pissarro, Gauguin—which he evoked at some length—and Guillaumin were to be seen on the mezzanine, 'for the walls of the ground floor are closely covered by vignettes that sell easily.'[30]

Fénéon devoted considerable space to Theo's next exhibition, held in January 1888, made up of a few paintings by Gauguin and several pastels by Degas, mostly of women washing or drying themselves, which Fénéon described in his cryptic though precise style.[31] At the same time Durand-Ruel was showing a number of oils by Degas representing dancers (a more popular subject), which the critic also reviewed. All the works at Theo's gallery must have been consigned to him by the artists or other owners since none can be found in the account books of Boussod & Valadon. This may mean that none

23

was sold and that they were eventually returned to their consignors, at least if these account books can be trusted.

But the records of the gallery seem to conflict with a letter Gauguin sent his wife late in 1887, in which he says, 'Last Sunday someone came from the Goupil Gallery; he was very enthusiastic about my paintings and finally bought three pictures for 900 francs. He will (he says) take some more.'[32] This letter is not dated, yet it would appear plausible that Theo—since he is obviously the man who went to see Gauguin—made this visit before arranging his exhibition. However, except for the painting of the boys bathing sold to Dupuis in December 1887 for 450 francs, the ledgers of the gallery do not indicate a single transaction concerning Gauguin until almost a year later, in October 1888. Like so many other deals, this one remains mysterious, although Gauguin's notes may conceivably shed some light on it. While he does not tell his wife which works were sold on that Sunday, he subsequently filled several pages of a *carnet* with a list of paintings, drawings, and ceramics either given away, exchanged with fellow artists, or sold. There he specified titles or medium and named the recipients or purchasers, neglecting, however, to indicate any dates. On that list appear not only the *Boys Bathing* sold to Dupuis (which shows that Theo identified his clients to the artists), but also a Martinique painting acquired by Theo van Gogh for 400 francs *(5)* together with drawings worth 50 francs.[33] Gauguin, anxious to impress his wife with his financial success as an artist, may well have counted the *Boys Bathing* at 450 francs (the price paid by Dupuis though not received by Gauguin), in which case the total would amount to 900 francs.[34] As a matter of fact, Theo did not *buy* the *Boys Bathing* but took the picture on consignment and sold it on December 26, 1887, the artist being paid two days later.

It appears most likely that Vincent accompanied his brother on that visit to Gauguin—enthusiastic as he was about Gauguin's Martinique paintings—and helped choose the canvas they wished to add to their private collection and which, therefore, is not listed in the account books of Boussod & Valadon.[35] Vincent also saw Theo's exhibitions of works by Pissarro, Guillaumin, and Gauguin—which they may well have selected together—before he left Paris for the South at the end of February 1888. Although his departure must have allowed Theo to find greater peace of mind and to put some order into his daily life, which had been overshadowed by Vincent's sometimes irrational and tempestuous behavior, the responsibility he still felt for his brother, accompanied by constant worries, remained. Once the frequent tensions and frictions were gone, Theo seems actually to have become conscious of a certain isolation, sharply contrasting with the intensity of the painter's presence. He eventually went so far as to tell Vincent in a letter, 'You may do something for me if you like—that is, go on as in the past, and create an entourage of artists and friends for us, something which I am

7 Georges Seurat '*Eden Concert*' 1887–88,
conté crayon drawing

absolutely incapable of doing by my own self, and which *you* have been able to do, more or less, ever since you came to France.'[36]

Shortly after his brother had left, Theo availed himself of such a friendship formed by Vincent when early in March 1888 he asked Emile Bernard to bid for him at a charity auction on a drawing donated by Seurat *(7)*. It went for 17 francs (a drawing by Gérome reached 67 francs and one by Bouguereau was knocked down for 380, more than Pissarro's or Gauguin's average prices for oil paintings).[37] Vincent was delighted with the purchase. 'I congratulate you on purchasing the Seurat,' he wrote, but added that, with the pictures he was shipping from Arles, 'you must try to arrange also an exchange with Seurat.'[38] A little later he repeated, 'It would be a good thing to have a painted study of his,' the accent being clearly on *painted* study.[39]

Vincent also insisted that his brother go to see Paul Signac, particularly after Theo had mentioned that the young artist had made a better impression on him recently than he did at their first meeting.[40] But when Theo did visit Seurat and Signac, in the fall of 1888, he was not very impressed and reported

that Seurat 'had made some good studies showing a laborer taking pride in his work. As for Signac, still as cold. . . .'[41]

Thanks to the steady flow of letters from Theo (few of which, unfortunately, have been preserved), Vincent could from afar participate in his brother's activities. Though he was quite satisfied with these, he also tried to exert some influence upon them, at least as far as his friends Bernard and Gauguin were concerned. But Theo was as yet unable to buy anything outright from either.

In March 1888 Lucien Pissarro informed his father in Eragny that Theo had sold a landscape for him. The artist was enchanted with the news and a few days later wrote his son that he had received 300 francs for it, despite the fact that the picture, *Farm Houses*, actually was owned by Boussod & Valadon; but Theo had bought from him another canvas of the same size and for the same price, *Landscape, full sunlight*.[42] This was a rather common practice to compensate a painter for the sale of a work that didn't belong to him anymore, yet the peculiar thing is that none of this is borne out by the records of the gallery. According to these, Pissarro's *Landscape, full sunlight* was acquired from him on March 17; the following day he was sent 300 francs for *Farm Houses*, purchased a week earlier for 400 francs by the collector Dupuis (exactly as was done when an artist left a picture on consignment). On that same day, March 18, Theo also bought another canvas for 300 francs, *Apple Pickers*. Since *Landscape, full sunlight* and *Apple Pickers* were sold only much later, these must indeed have been cash purchases. The disturbing fact is that where the account books of Boussod & Valadon can be checked against other sources, the information provided by the latter does not necessarily coincide with the records of the gallery.

Later that same month Fénéon noted in Theo's place three new paintings by Pissarro,[43] yet only one of them, *Apple Pickers*, was part of the recent deal; the two others are not listed in the inventory and probably were not sold. In April, Fénéon named a number of fairly unrelated works as being shown 'Chez Van Gogh,' among them three posters by Jules Chéret. Theo did not always arrange regular exhibitions but often merely displayed what he had on the premises, though preferably recent acquisitions or consignments. Fénéon specifically commented on a Martinique painting by Gauguin and suggested that an exhibition of his canvases would reveal what a powerful artist he was.[44] However, the picture in question, *Conversation*, was not to find a buyer before the summer of the following year, at which time Gauguin received the paltry sum of 225 francs for it.

The demand for Monet's works, on the other hand, seems to have risen continually; in February and March 1888 Theo bought several at Hôtel Drouot auctions for more than 1,000 francs each. He had of course to pay cash for them (Durand-Ruel either was unable to sustain the bidding or felt no inclination at this point to help the artist bolster his prices). In April, Theo

acquired three more landscapes by Monet as well as a painting by Pissarro, this time purchasing them directly from Durand-Ruel. Doubtless the latter was in real need of money. Theo paid 1,200 francs for each of the Monets but only 500 for the Pissarro, an early work (none of these pictures were to be sold before 1891). That same month Theo found a buyer for Monet's *Village of Bennecourt*, which the artist had left with him on consignment; he obtained 2,200 francs for it, of which the painter received 1,500, that is, more than any of his canvases had brought at Durand-Ruel's.

Meanwhile Monet's relations with Durand-Ruel had become increasingly worse. The artist reproached the dealer for his irregular and often insufficient remittances; for his long trips abroad, where he concentrated too much of his effort while neglecting the French market; and also for the fact that many of his own works were shipped across the Atlantic without having been seen in Paris. At the end of 1886 Monet had informed Durand-Ruel that he no longer wished to receive monthly payments—with periodic settlements of their accounts—but preferred to deal with him on a cash basis. Thereupon transactions with Durand-Ruel stopped completely, neither one apparently ready to make the first step toward a reconciliation. It was only in April 1888 that the dealer expressed the desire to 'redo business' with the painter, yet the latter, while not opposed to this, now informed him that there were 'other persons' to whom he had promised to show his pictures. During the summer of 1888 Monet suggested that Durand-Ruel contact Boussod & Valadon so that they could 'proceed together.' Indeed, he had wound up by signing a contract with Theo; though he did not promise him any exclusivity, he did reserve him the right of first refusal. This meant that if Durand-Ruel wanted to acquire recent works by the artist whom he had defended and supported since 1871, he would have to address himself to Boussod & Valadon. 'You find it deplorable that I have accepted this contract,' Monet explained in a letter of September 24, 1888,

'but, dear M. Durand, what would have become of me during the last four years without, first, M. Petit, and without the Goupil Gallery? No, sir, what is deplorable is that circumstances have prevented you from continuing to buy. Therefore, please go and see these gentlemen. . . .[45]

The agreement between Monet and Theo, in the name of Boussod & Valadon, appears to have been established on June 4, 1888, since on that day the painter sold the firm ten recent landscapes from Antibes on an entirely new basis: Monet received between 1,000 and 1,300 francs for each canvas, according to size (the total amounted to 11,900 francs), but in addition was promised a 50-50 division of the profits. Thus, the artist did not give anything on consignment, yet did not request an unreasonable outlay of cash either. When seven of the ten paintings were sold that very year and the other three during the following one, the benefits to be shared reached 27,720 francs—

probably minus some expenses—of which the painter's portion must have been about 13,000 francs, or an average of 2,500 per picture.

Theo immediately arranged a small exhibition of these landscapes, about which he apparently sent a detailed report to Vincent. The latter thereupon informed a friend: 'My brother has an exhibition of ten new pictures by Claude Monet—his latest works, for instance a landscape with red sunset and a group of dark fir-trees by the seaside. The red sun casts an orange or blood-red reflection on the blue-green trees and the ground. I wish I could see them.'[46] Writing to Emile Bernard at the end of June, Vincent once more speaks of the show, 'Ten pictures painted at Antibes from February to May; it is very beautiful it seems.'[47]

On June 12 Theo sold the first of this group *(8)* for 3,000 francs (the others were to bring less). Gauguin was pleased with the news because, as he said, 'I am not angry that the Claude Monets are becoming expensive; this will be another example for the speculator who compares the former prices with those of today. And in this context it is not too much to ask 400 francs for a Gauguin compared with 3,000 francs for a Monet.'[48]

Staunch defender of Seurat and Divisionism, Fénéon could not help noticing Monet's obvious disregard for the scientific laws of simultaneous contrasts of color. He did not care for the exhibition. 'Monet responds to a scene immediately; but there is nothing profound or analytic in him. Aided by an extraordinarily skillful execution, a facility for improvisation, and a brilliant vulgarity, his fame grows. . . .'[49]

Theo was not particularly happy with these comments but told Pissarro (who, incidentally, agreed with Fénéon's views) that Monet had warned him to expect that much.[50] There were also more positive reactions, however. A young German painter spending several years of apprenticeship in Paris later remembered how he and a friend 'strolling one day on the large boulevards, suddenly stopped, completely startled. On the other side, in the window of the Goupil gallery, a painting was exhibited that shone across the hustle and bustle of the wide avenue. We went over and saw the first Monet. . . . On the mezzanine, a group of paintings by Monet was on view; we could not see enough of them. They made a tremendous impression on me, one of the strongest of my life. We returned many times; a young and friendly employee with reddish hair, who did not look at all like a Frenchman, soon began to greet us very cordially like old acquaintances. One could see that there was no great interest in the pictures since the place was usually empty.'[51]

Theo's clientele obviously was not made up of people who happened to drift in from the street. But there must have been a few collectors who trusted his judgment and took his advice; he doubtless informed them whenever something worth their while arrived in the gallery. Anything but aggressive, Theo, according to the recollections of the symbolist poet Gustave Kahn, a friend of Fénéon, 'showed his Renoirs, his Pissarros, and, timidly, his

8 Claude Monet *Umbrella Pines, Cap d'Antibes* 1888

Vincents. He was fair, blond, and so melancholy that he seemed to offer the pictures as if asking for alms. He expressed his profound belief in the value of the new painting with sobriety, and thus without great success. He did not have the gift of catch phrases. This art salesman was an excellent critic; his conversation with artists and writers was that of an informed dilettante. . . .'[52] This statement is somewhat faulty because, unable to buy anything, Kahn never dealt with Theo on a dealer-client basis and only knew him as the man who patiently explained his views in the hope of gaining a wider audience for the artists he admired. That Theo's persuasiveness did not fail to impress a number of collectors is shown by the firm's records, where quite a few names reappear frequently, such as that of the young industrialist Dupuis[53] who—between 1887 and 1890—acquired at least seventeen Impressionist paintings.

Theo seems to have been rather reticent concerning his brother's works, though he did show them to those who were interested, such as the two Pissarros and Guillaumin, as well as the German painter who had been so

attracted by Monet's pictures from Antibes. Berthe Morisot, with whom Theo never had any business dealings, also came to the mezzanine with her husband and young daughter to look at some of the paintings Vincent had sent from the South.[54] But these were hardly prospective buyers; at best they might—and some did—agree to an exchange of pictures. Theo may have hesitated to organize an exhibition of Vincent's work, or even to propagandize it more actively, not so much for lack of conviction, but possibly because he did not wish to antagonize Messrs Boussod and Valadon, and conceivably also because Vincent's immediate needs were assured, so that he was better off than Pissarro or Sisley, for instance. From that point of view, Monet evidently required less 'help' than anybody, yet it was precisely the rising demand for his canvases that could—in the eyes of his bosses—justify Theo's handling of unconventional art and provide funds for purchases from less successful artists.

During the summer of 1888 Vincent wrote a peculiar letter to his brother which may have been prompted by a comment from Theo that the firm was considering sending him abroad. Durand-Ruel was opening a branch in New York and Messrs Boussod and Valadon might have felt that they would do better with a direct American representative rather than working with the 'renegade' and independent Knoedler galleries. In any case, Vincent discussed at length the possibility of Theo's leaving Paris but did it in such a strange way that it is difficult to say whether his proposal was a scheme of his own or a counter-project to one conceivably mentioned by his brother.

Vincent began by stating that if he were younger, he would suggest to M. Boussod to send both himself and Theo to London with no other salary but 200 francs a month, to be deducted from Theo's half share in all the profits made on Impressionist pictures. He realized that to go to London in order to sell Impressionist paintings was a quixotic enterprise, yet, according to him, this was still better than going to New York. His own ambition, Vincent added, was not to be a burden to his brother anymore; convinced that his works could not be sold in Paris, he would rather try London where chances might be better. And he concluded:

'When dealing with this Boussod, keep cool and keep your head.

'And if they talk to you about London, *don't* put the thing just as crudely to them as I do here. . . . But you do well not to resist the *powers* that be (such powers!).

'My dear brother, if I were not broke and lost with this blasted painting, what a dealer I'd make just for the Impressionists. But there, I am lost. . . . London is just what we need, but alas I feel I cannot do what I once could. But broken down and none too well myself, I do not see *any* misfortune in your going to London. . . .'[55]

Theo probably replied, as on other occasions, that he felt his brother was doing something much more valuable as a painter and should not even think of reverting to being an art dealer which, after all, was not a very productive occupation. But Vincent immediately retorted:

'Then remember that you are doing exactly the same work as these painters . . . since you provide them with money and sell their canvases for them, which enables them to produce others. . . . Your own work is not only no better paid than his, but costs you exactly what the painter's costs him, this sacrifice of the individuality, half voluntary, half accidental.

'That is to say that if you paint *indirectly,* you are more productive than I am, for instance. The more irrevocably you become a dealer, the more you become an artist. . . .'

And Vincent endeavored to bolster Theo's morale with the unexpected sentence, 'If possible, you ought to make me feel that art is alive, you who love art perhaps more than I do.'[56]

Since Vincent fully realized that there was no market for his paintings, he does not seem to have resented the fact that his own work was not yet being 'pushed' by his brother. During that same summer of 1888 he wrote to their sister Wil from Arles that 'it is already very important that Theo has succeeded in inducing the firm he now manages to have a permanent exhibition of the Impressionists.' He emphasized: 'Theo is doing his best for all the Impressionists; he has done something, or sold something, for every one of them, and he will certainly go on doing so. . . . He is altogether different from the other dealers, who do not care the least bit about [living] painters.'[57]

That was true. After having focused his attention on Monet and also dealt with Gauguin and Pissarro, Theo in 1888 returned to visit Degas. Early in May Vincent replied to one of his brother's letters saying, 'I am glad that you have sold a Degas and to hear what you say of this buyer Meunier.'[58] Yet once again there is no trace of any Meunier in the gallery's records, nor any indication that a work by Degas was sold at that time. It was only toward the middle of July that one of Theo's customers, Boivin, bought a racing scene from him which Degas must have left on consignment. The previous month Theo had paid Degas 2,000 francs for a picture of four racehorses, which was sold only a year later. It may be this transaction to which Degas's hasty note to Theo alludes and in which Degas requests '2,000 francs for that terrible item that I had to do over again. You gave me 500 francs. Send the remainder tomorrow morning so that I can finally leave in the evening for Cauterets. Thanks, Degas.'[59]

Theo obtained another painting by Degas from the dealer Brame, who consigned it for 2,200 francs; it was sold in September 1888 for 3,400 francs to the young collector Dupuis who relied so faithfully on Theo's advice. At the end of the same year Theo also sold Degas's *Ballet Rehearsal,* which he had bought in October from Georges Petit for 5,220 francs; Jacques-Emile Blanche, painter and son of a famous alienist, paid 8,000 for it. The prices for Degas's works were at that time higher than those of any of the Impressionists (yet in cases like these last two transactions, the artist himself did not receive a penny).

31

In August Theo purchased from the American dealer Inglis a view of Naples by Renoir *(9)*, which was sold only several years later to Durand-Ruel in New York where the latter opened a branch in 1888. This was the only picture Durand-Ruel ever seems to have acquired from Boussod & Valadon; it is true that it originally came from him, Durand-Ruel having bought it from the artist in 1882 and sold it to Inglis the following year.[60] In October Theo succeeded in selling a sketch by Toulouse-Lautrec which the painter had entrusted to him and which Dupuis added to his steadily growing collection.

During the summer of 1888 Theo sent a group of Impressionist pictures—including one of Vincent's recent Arles canvases—to Holland, but there was no interest in any of them. Tersteeg even said of a landscape by Sisley (obviously one of the three left over from the 1887 purchase) that he couldn't help thinking the artist must have been slightly drunk when he painted it. Vincent thereupon admitted that, by comparison, his own works looked as though they might have been executed during an attack of delirium tremens.[61]

With a touching twist of 'logic' Theo found this situation almost reassuring and later told his brother, 'When we see that the Pissarros, the Gauguins, the Renoirs, the Guillaumins do not sell, one ought to be almost glad of not having the public's favor, seeing that those who have it now will not have it forever, and it is quite possible that times will change very shortly.'[62] Yet despite such brave attempts at optimism, Theo, according to one of his Dutch acquaintances, was actually quite bitter; whenever he managed to sell a work by Meissonier or Bouguereau for thousands of francs 'but tried in vain to obtain 400 francs for a fine painting by Pissarro, his heart was invaded by hate, an inevitable and ferocious irritation.'[63]

It was to sustain his brother's self-confidence and to make him feel how important his role was that Vincent told Theo once more, 'I wish I could manage to make you really understand that when you give money to artists, you are yourself doing an artist's work, and that I only want my pictures to be of such a quality that you will not be too dissatisfied with *your* work.'[64]

At the end of the summer of 1888 Theo came into the small inheritance left him by his uncle Vincent, the one-time partner of Goupil. Since he did not need the money for himself, he decided to use part of it for his brother and part for the latter's favorite project, that of signing a contract with Gauguin, which guaranteed him a certain amount a month against twelve paintings a year while leaving him free to sell the rest of his production elsewhere. It was to be a rather modest arrangement, but Theo had to finance it on his own as Messrs Boussod and Valadon obviously wanted nothing to do with it.

Bedridden in Brittany and unable to pay his board at a cheap inn, Gauguin had anxiously inquired of Theo in May, 'Do you have a little hope of any kind?' and in June had thanked him for a money order of 50 francs which Theo sent him, ostensibly for a drawing though more likely to ward off the

9 Auguste Renoir *The Bay of Naples* 1881

threat of eviction.[65] Yet at the same time Gauguin informed Vincent of a scheme, on which the latter reported to Theo: 'He speaks of some hopes he has of finding a capital of 600,000 francs to set up as a dealer in Impressionist pictures, and that he will explain his plan, and would like you to head the enterprise. I should not be surprised if this hope is a fata morgana, a mirage of destitution, the more destitute one is—especially if one is ill—the more one thinks of such possibilities.'[66]

As a matter of fact Gauguin was so relieved when Theo offered him 150 francs a month that, with wholly uncharacteristic modesty, he wrote to Vincent (who received the same allowance), 'I fear that your brother, who likes my talent, assesses it too highly—I am a man of sacrifices and I would like him to understand that I will appreciate whatever he will do.'[67] Indeed, Gauguin even accepted Theo's suggestion—prompted by Vincent—to join his brother in Arles where the two could live more cheaply and where Vincent desperately needed company.

Incapable of altruism, Gauguin was unable to conceive of such motives in others; he immediately suspected Theo of speculating on his works. 'Rest assured,' he wrote to his friend Schuffenecker (as though the latter might have worried!), 'as much as [Theo] van Gogh may love me, he would not

33

undertake to support me in the South for my good looks. He has studied the situation as the cool Dutchman he is and intends to pursue the thing as far as possible and exclusively.'[68] Though he knew nothing of these suspicions, Vincent appraised his friend perfectly when he told his brother, 'I feel instinctively that Gauguin is a schemer who, seeing himself at the bottom of the social ladder, wants to regain a position by means which will certainly be honest, but at the same time, very politic. Gauguin little knows that I am able to take all this into account.'[69]

The terms of the agreement between Theo and Gauguin are known only through references in Vincent's correspondence. In a letter to Gauguin, of which only the draft he sent his brother still exists, and which was apparently written in June 1888, Vincent had asked his friend, 'If my brother were to send 250 francs a month for us both, would you come [to Arles]; we would share them. . . . And you would give my brother one picture a month while you could do what you like with the rest of your work.'[70] Yet after Theo had come into his inheritance the amount was raised from 125 to 150 francs a month for each, at least so it appears from a letter Vincent wrote in September, advising his brother, 'I do not think it would be wise to offer Bernard straight off 150 francs for a picture every month, as was done for Gauguin.'[71] But when Gauguin subsequently compiled in his *carnet* a list of all his works sold, given, or exchanged, he did not mention a single painting for which Theo had paid 150 francs, a price actually lower than what he generally charged.

For six paintings sold by Theo between December 1887 and December 1888 Gauguin received an average of around 320 francs per canvas, and Theo's clients paid an average of about 440 francs each (Theo himself had bought a Martinique picture for 400 francs). While discussing the arrangement made with Gauguin, Vincent pointed out to his brother: 'Those pictures, which one day will be salable, may freeze possibly for years the interest on the purchase money invested in them. As a matter of fact, a picture paid 400 francs today, and sold for 1,000 francs after ten years, will still be sold at cost, as all that time nothing could be done with the money.'[72] This was precisely the difference between spending one's own money or taking works on consignment, between helping an artist to live or keeping him waiting for possible sales.

Nevertheless, it appears more likely that Theo did not offer a mere 150 francs per picture to Gauguin but agreed to monthly payments of 150 francs to be credited against works, just as Durand-Ruel had done with the Impressionists. Indeed, Durand-Ruel's name is mentioned by Vincent in the discussions of the contract with Gauguin. Yet the surprising thing is that the list in Gauguin's *carnet* records only very few purchases by Theo, the most important of which are the Martinique painting for 400 francs and drawings for 50 francs.

It is not known exactly when Theo began to make his monthly remittances, except that in a letter of October 8, 1888, Gauguin informed Schuffenecker from Brittany, 'Henceforth [Theo] will provide my small monthly allowance.'[73] Though he was in no hurry to leave for Arles, where Vincent awaited him with growing excitement, Gauguin could not stall any longer when Theo took over 300 francs worth of his potteries (the firm's records show no trace of this transaction). Theo even agreed to pay his fare and to accept drawings and paintings in exchange. On October 22 Theo also sold a painting to Dupuis—for whom this was a second acquisition of a work by Gauguin—for which the collector paid 600 francs. The artist received this amount less 15 percent (510 francs) and Theo wrote to Vincent that he was sending Gauguin 500 francs.[74]

This deal was concluded while Gauguin traveled to Arles, where he arrived on October 23. When Theo received the rolled-up canvases Gauguin had shipped to him before leaving Brittany, he organized an exhibition of them. On November 13 he wrote a long letter to the painter:

Dear Monsieur Gauguin,

It will undoubtedly give you pleasure to know that your paintings are having much success. Before receiving my brother's letter I had put already all the canvases on stretchers, and in order to display those of 92 by 73 centimeters, I chose a handsome white frame of simple wood, which suits them very well. Degas is so enthusiastic about your work that he is talking to a lot of people about it and he is going to buy the canvas representing a spring landscape with a meadow and two figures of women in the foreground, one seated, the other standing. So far two canvases are definitely sold. One is the vertical landscape with two dogs in a meadow, the other a pond at the edge of a road. Since there is an exchange involved, I assess the first *at a clear* 375 francs, the other at 225 francs.—I could also sell the little Breton girls dancing [1], but there is a bit of retouching to do. The little girl's hand, which comes to the edge of the frame, takes on an importance that it doesn't seem to have when there is only the canvas [without a frame]. The buyer would like you to redo the shape of this hand just a little without altering anything whatever in the painting. It shouldn't be difficult I think and I shall send you the canvas for that purpose. He will pay 500 francs—for the painting framed, with a frame coming to about 100 francs.—See if you are able to please him and if you wish to make the deal. For the recently sold painting I deducted 15 percent, which is the minimum commission that the gallery takes. Many painters allow us 25 percent. If we begin to sell your work more or less regularly I must ask you to do the same if you don't mind. In that case, it is easier to make exchanges or sales on credit. Tell me your opinion on this subject.

I was happy to learn that you are getting along well together and that you were able to begin working right away. I would like to be with you. Are you feeling better now?

I send you a good, hearty handshake

T. van Gogh[75]

When Gauguin's *Breton Girls Dancing, Pont-Aven* arrived at Arles, the artist made the alteration, but the picture was not purchased by the collector who had requested it; it was sold only in September 1889. Nor did Degas buy the painting described by Theo. Since the gallery's records are so often inaccurate, the fact that Degas's name doesn't appear there would not be absolute proof of his reneging on his intention; but the picture was later included in Gauguin's auction sale of February 1891, which means that he still owned it at that time.[76] The two canvases definitely sold were bought by the painter Chéret and by Dupuis, who a few days later acquired still another work by Gauguin, the fourth to enter his collection. Early in December Theo sold one more, bringing to five the total number of paintings sold in less than two months, not to mention potteries and transactions that may have gone unrecorded. The artist received 1,440 francs for those five works; in addition, there were also Theo's monthly payments.

It would seem that Theo decided to keep whatever he received from Gauguin for the private collection he was slowly building, which meant that those paintings and drawings would not compete commercially with the ones Theo took on consignment for the gallery. Under these circumstances it is not surprising that Gauguin, until then unable to live from his work, should have been greatly impressed with Theo's efficiency. Indeed, he seemed to have every reason to believe that his most difficult days were over. Full of confidence he now wrote to Bernard, 'Such as the way is being prepared by [Theo] van Gogh, I believe it is possible for all the talented artists of our group to make it, since you have only to march straight ahead.'[77]

In the meantime Pissarro was faced with new worries and on September 17 asked Theo for help: 'It will be necessary to attempt the impossible; I am going to be in financial trouble toward October 1, with rent and debts due, I shall need at least 1,000 francs. I should be very thankful if you would help me out. As soon as I have something finished, I shall send it to you.'[78] Theo exhibited a group of Pissarro's recent works in September, and Fénéon reviewed the show with warm praise,[79] but nothing seems to have been sold. According to the gallery records, only one painting found a buyer, and that toward the end of November when Dupuis paid 400 francs for a pointillist picture for which the artist's share was 300.

Sisley's lot was even worse. Unable to sell any of the three paintings acquired from the artist in 1887, Theo apparently was in no position to help him. Toward the end of the year Sisley exhibited about a dozen recently completed landscapes at Georges Petit's, but Fénéon's review was more than tepid; he liked the canvases even less than those Monet had done at Antibes.[80]

Profoundly angered by Monet's attitude, Durand-Ruel, still in a precarious position, had refused to follow the artist's advice of negotiating with Boussod & Valadon in order to obtain some of Monet's recent paintings. But Theo, in view of his marked success, continued to acquire his works left

10 Paul Gauguin *Breton Girls Dancing* 1888, pastel

and right while waiting for the artist to get a new batch of pictures ready. In October Monet parted with only a single landscape, while Theo was able to purchase other works from some of his collectors, such as Dupuis and Desfossés, and even from the redoubtable critic Albert Wolff, who had so viciously derided the Impressionists in the early days but now was willing to cash in on their rising prices.

On December 24, after more than a year's courtship, Theo became affianced to Johanna Bonger, sister of his old friend Andries Bonger. The day before, at Arles, Vincent supposedly attacked Gauguin and cut off his own ear. Gauguin summoned Theo who rushed to Arles; on December 26 or 27, Theo and Gauguin went back to Paris.

On the last day of the year 1888 Monet turned over to Boussod & Valadon seven paintings for which he received 9,700 francs, plus half of the profits to come. This important transaction was doubtless prepared by Theo who apparently was back from Arles in time to conclude it personally.

		19300	Antibes	65 × 81	Cl. Monet	4. 6. 88
		19301	d°, vue du plateau Notre Dame	65 × 92	d°	4. 6. 88
		19302	Antibes, vue de la Salis	65 × 92	d°	4. 6. 88
		19303	La Mer et les Alpes	65 × 92	d°	4. 6. 88
69	74	19304	La Méditerranée par vent du mistral	65 × 92	d°	4. 6. 88
		19305	Montagne d'Esterel	65 × 92	d°	4. 6. 88
		19306	Plage de Juan-les-Pins	73 × 92	d°	4. 6. 88
		19307	Pins, cap d'Antibes	73 × 92	d°	4. 6. 88
		19308	Sous les pins, fin du jour	73 × 92	d°	4. 6. 88
31	75	19309	Courses	31 × 47	Degas	8. 6. 88
0		19310	Sheep shearing	104 × 180	Macbeth R. W.	8. 6. 88
0		19311	Cornish pastures	59 × 89	P. Belgrave	9. 6. 88
0	115	19312	La prière du matin	150 × 110 toile	Rosé	14. 6. 88
68	71	19313	Femme au bord d'une mare (anc. 18175)	46 × 37	Corot	14. 6. 88
40	71	19314	Femme au boa blanc	95 × 52	Corcos	15. 6. 88

cade	PNX2 TA.UN=	RANX	Boulevard à Mad. Minon 205 Bd St. Germain	B. "Boulevard à Artiste" arc. partage de Bénéfices.	27. 6. 88
Ifr cade PNCUN	PRX2	RINX	Boulevard à Dufonès	B. do	40ct 88
cade	PRNX PVE.PN=	RINX	Boulevard à Aubry.	B. do	14. 6. 88
cade	PRNX TO.RA=	RINX.	Boulevard à Ch. Keller	B. do	27. 3. 89
cadre	PRNX IE.TA=	R.INX.	Boulevard à Buglé.	♀ & II. do	27. 9. 89.
½cadre	PRNX PNC.UN I	RANN pm RIN RARN	Boulevard à J. Potin	B. do	120ct 88
cade PNCHA	PENX	ENX2	Boulevard à Boivin 64 R. de Lisbonne.	B. do	12. 6. 88.
cadre PNCUN	PENX.	RANX	Boulevard à Guillemard 73. R. de Courcelles.	B. do	14. 6. 88
cadre	PENX PTO.PN=	RINX	Boulevard à Aubry	B. do	29. 6. 88
cade panog.	⊂ RNX2 RA	R.INX. CNX RCNX.	Boulevard à Gallimard.	B. Boulevard à Artiste	5. 8. 89
	PRANX. TVRA not. CITA			II. Londres à H. Roberts	√
	TAN			II. Londres à New English Art Club.	√
cade à Rox	AOT.4N PCNX. ANX. PONX.			& ... 8 Key. ... Artiste	√
net.	EANX PNX2 RANX	EINX	F. Michel Vichy	B. 4. Michel Vichy Boulevard à de Gheus.	27. 6. 88
cade	PRNX BCI.CN=	RANX. conjart ANX net. RNX2	Londres à "The Lady's Pictorial"	... Boulevard à Artiste	25. 7. 88

Double page of the Boussod & Valadon ledgers for 1888

	No.	Titre	Dim.	Artiste	Date
8/104	19496	Foyer de la danse	57×83	Degas	12 Oct 88
0/124	19497	Tête d'Étude	65×53	de Lautrec	" — " — "
65/88	19498	Liowret Serpent	62×87	J. M. Swan	8 Oct 88
0/145	29499	L'arrêt devant l'auberge	68×88	Verschuur	8 Oct 88
80/84	19500	Route & Moulin	38×76	J. Maris	10 — " — "
	19501	Marché à Zutphen	69×49	Klinkenberg	11 — " — "
62/85	19502	Porte à S:	69×49	do	11 — " — "
	19503	Canal à LaHaye	64×49	do	11 — " — "
74/87	19504	Homme jouant à une porte	72×58½	Gérôme	17.10.88
74/211	19505	Sur le port	?	Clairin	20.10.88
57/96	19506	Bateau de pêcheur (anc 17302)	62×95	Isabey	19.10.88
51/116	19507	Le Réveil		Israelman	17.10.88
68/100	19508	Lock on the Stour		Constable	16.10.88
8/85	19509	Bretonnes		Gauguin	22.10.88
91/85	19510	Sous Bois - mare et Bûcheronne	54×45	Diaz	29.10.88

Double page of the Boussod & Valadon ledgers for 1888

	No.	Title	Dimensions	Artist	Date
17³ / 216	20962	Vaches au pâturage. A.	35 × 25	Trolyk	3.10.90.
	20963	" B.	33 × 24.	d°	3 "
	20964	Pâturage & soleil couchant	18½ × 26	d°	3 "
17¹	20965	Les petits pêcheurs	37 × 49	A. Neuhuys	3 "
17³	20966	Descente des Italiennes (1024)		Diaz	
	20967	Femme sous bois avec chien	23 × 19	"	11.10.90
167 / 192	20968	Danseuse (Esquisse)	32 × 25	Degas	8.10.90
0	20969	Femme assise		Cézanne	"
118	20970	Le premier pas	68 × 50	Motzmacker	11.10.90
169 / 189	20971	Le Bûcheron	45 × 28	Clausen	10.10.90
166 / 193	20972	Diane reposant (0593)	40½ × 33	J. F. Millet	14.10.90
17² / 179	20973	Enclos & vaches.	84½ × 124½	W. Maris	7.10.90
	20974	Pâturage & mare	84½ × 124½	d°	7.10.90
15¹ / 179	20975	Retour de la pêche	87½ × 67½	Mesdag	8.10.90
17¹ / 175	20976	Bruyère & petit garçon	17 × 23½	Mauve	8.10.90

RUR.ᴬᴺ EKUᴹ		La Haye à Kohn	H.	La Haye à Artiste	31.10.90
RUR.ᴬᴺ EKUᴹ		do	H.	do	9
PAT. AN			H.	do	
OOT. ᴬᴺ			X.D.A.J.N.Y.	La Haye à L. a. Fleischmann	
PC.T.AN.		F. Michel		Mr Ladmiral 73 Rue de Grenelle	11.10.90
127 cadre	TNXZ. OT.ᴬᴬ			H.C. Braune rue Taitbout	
	ANX 500		B.	Boulevard à Camondo & Martin	
	ENX 300		B.	do	
	CANX ANX2	Boulevard à Briandet	B.	Boulevard à Coudray	7.10.90
cadre	VRA PAS.ᴿᴬ		L.	Londres à Mme Ford	
	PE.N+2 PE.NX2	Soxelmeyer	N.Y.	New York à Sarson à St Louis	14.10.90
cadre	RPNX J.F.B. EAT	CRNX La Haye à MC Lebret	H.	La Haye à Artiste avec partage de bénéfices	30.1.91
cadre	RPNX J.F.B. EAT	ECOP.ᴬᴬ La Haye à Eff. Art. Limitées	H.	do avec partage de bénéfices	12.12.90
cadre	EPAN PIO	ANCN La Haye à Br Wassenaar v. Rosande	H.	La Haye à Artiste	6.6.91
	RRA	ENX Londres à Col Forster	H.	La Haye à Mme Maure	7.10.9.

Double page of the Boussod & Valadon ledgers for 1888

1889

It is not known whether Theo continued to subsidize Gauguin after the tragic events of Christmas 1888, but it seems doubtful that he did. Gauguin's list in his *carnet*, the only available source of information on this subject, indicates, without any mention of dates:

VAN GOGH: *Martinique*,	400	[W. 224?] *(5)*	
Drawings	50	[among them the two pastels, one from Martinique, one from Brittany, that belonged to Theo] *(10)*	
VINCENT: *Négresses* [*sic*], exchange		[W. 222] *(24)*	
(my portrait)		[W. 239, exchanged against van Gogh's Self-Portrait]	
VAN GOG [*sic*]: album	30	[series of zincographs first shown at the Volpini exhibition, 1889]	
VAN GOG: pot—gift			
VAN GOG: *Arlésiennes* (mistral)	300	[W. 300] *(11)*[81]	

The *Arlésiennes* painting must have been acquired during or after Gauguin's brief stay at Arles and could thus account for two payments of 150 francs. It is the only work that did not remain in Theo's collection. Since it does not appear on the Boussod & Valadon registers, it is not impossible that Theo himself sold it.[82]

In addition to these works either given, exchanged, or sold, there is a reference in Gauguin's list to 'Van Gog—300,' which may represent the price of the ceramic vase Theo had purchased.[83] Though not mentioned by Gauguin—doubtless through an oversight—there was also the portrait he had painted of Vincent in Arles which he had offered to Theo.[84] Gauguin had written to him on its subject, 'From a geographical point of view it may not be a very good likeness, but there is, I believe, something of his innermost nature, and if you do not have any objection, keep it, unless it displeases you.'[85] It is by no means certain that Theo accepted it as a gift; if he chose to pay for the picture, this likeness of his brother and the *Arlesian Women, Mistral (11)* would have been all the paintings Theo obtained in exchange for his remittances. Together they represent the equivalent of four monthly installments.

Certain is only that what happened in Arles did not put an end to Gauguin's commercial relations with Boussod & Valadon. He continued to send his recent canvases to Theo—no other dealer showed any interest in them—and the latter, though he did not always care for them as much as for the artist's previous work, nevertheless kept offering them to prospective customers. It seems that frequently at least a couple of Gauguin's pictures were hung on the mezzanine, for the artist wrote to his wife, 'I am exhibiting my works at Goupil's in Paris and they are creating quite a sensation, but they sell with great difficulty.'[86] Indeed, Theo managed to sell only three of his

44

11 Paul Gauguin *Arlesian Women, Mistral* 1888

paintings throughout the entire year of 1889, and in the fall Gauguin complained to Emile Bernard: 'Since last January I have sold 925 francs worth. At forty-two years of age to live on that, to buy paints, etc., is enough to upset . . . the most well-tempered soul.'[87] Although the gallery's ledger shows that Gauguin received 985 francs rather than 925 for the three sales that had totaled 1,200 francs, his share, even if some expenses such as frames had to be deducted, was still above 75 percent. On the other hand, Gauguin was not averse to conducting business behind Theo's back. When Redon informed him that one of his friends was interested in his ceramics, the artist replied: 'I have some at Goupil's, particularly a coupe that I regard as an exceptional piece. . . . Also a man's head. If your friend were interested in one of these pieces, I would take it from the Goupil Gallery to avoid having to pay the 25 percent commission.'[88]

While Gauguin's sales decreased from five in 1888 to three in 1889, Monet's were reduced from thirty in 1888 to twenty the following year. But Theo did sell six paintings by Pissarro in 1889, compared to four in 1888, and

seven works by Degas in contrast to four the previous year. On the whole, Theo's activities continued along much the same lines, although he seems to have experienced more difficulties, commercially as well as in his relations with his employers, with whose narrow-mindedness Vincent showed even less patience. Vincent went on talking about the association of Impressionists he wished his brother to create and direct for the mutual benefit of all the artists.

Not the least of Theo's problems may have been caused by Monet who, in January and late March 1889, sold three more pictures to Goupil under the old arrangement of shared profits, but none after that. The next time Theo purchased five landscapes from the artist—on June 20—he had to pay the *full* price, altogether 11,000 francs. These new conditions are the more surprising as Theo had held another exhibition of Monet's paintings in March. This show had prompted Octave Mirbeau to devote a long article to the artist and his recent 'incomparable canvases' in the much-read *Figaro* where the nasty Albert Wolff usually pontificated. 'I am now having an exhibition of Claude Monet . . . it is very successful,' Theo reported to Vincent. 'It will not be long before the public will be asking for pictures of the new school, for they certainly stir up the public mind.'[89]

In April 1889 twenty paintings by Monet were also shown at Goupil's London branch on New Bond Street under the title *Impressions by Claude Monet*. A note in the catalogue stated: 'Messrs Boussod, Valadon & Co., being desirous of presenting the various phases of French art to the English public, have arranged this exhibition of the works of M. Claude Monet in order to show the latest development of the Impressionist movement in France. They further preface the catalogue with the translation of an article [by Mirbeau] on Monet's work taken from *Le Figaro* of 10th March, 1889. This is a fair specimen of enthusiastic art-criticism dealing with a certain tendency in Art scarcely known to, and not at all recognized by the connoisseurs of England. As these works differ so entirely from anything hitherto shown in London, they should be considered for a short time before a final opinion on their merits is formed.'[90]

The critic for the *Illustrated London News* seems to have considered the exhibition for more than 'a short time'; he published favorable comments on many of the paintings. A brief review in the *Magazine of Art* called Monet an 'extremely adroit impressionist' and acknowledged his extraordinary influence on English and French painting, specifically comparing his *Prairie and Figures* with 'Mr Sargent's clever pictures at the New English Art Club.' It was probably no accident that Sargent acquired that canvas a few months later. This may have been the only work sold in London; most of the others seem to have been returned to Paris.

While Monet was steadily widening the circle of his admirers, the situation of Pissarro grew gradually worse. Early in March Theo had been able to sell a

12 Camille Pissarro *Flock of Sheep, Eragny* 1889

few of his watercolors (not listed in the ledger) and told the artist, 'Let us hope that the art buyers who have shown themselves so infrequently this winter will finally come and carry away some paintings.' But on March 30 he wrote to him again:

'Before leaving I wish to tell you how terribly sorry I am not to have sold something of yours during your difficult moments. It is surprising that among the so-called connoisseurs there aren't any who dare to give you a helping hand, but all they prefer to do is look rather than buy. Nevertheless, your immense talent will be recognized one day not only by words, but by actions. I do not know if I ought to urge you to send the new painting. I am leaving for Amsterdam this evening and I shall not return until the twenty-first [of April], my wedding taking place on the eighteenth [in Holland]. Immediately upon my return I shall be happy to give my particular attention to your paintings either with a one-man show, if you wish, or by presenting the new painting to collectors.'

On account of the slow turnover of Pissarro's works, Theo could take these only on consignment, whereas in April and May he was permitted to buy three pictures from Degas, which, however, remained in stock for at least two

years. But the most important acquisition was made at Christie's in London where, on May 25, 1889, a group of modern paintings sagaciously collected by the late Captain Henry Hill of Brighton, was sold at auction. Among them were six works by Degas, all of ballet subjects; one was purchased by Walter Sickert, another by Theo through Goupil's of London.[91] Theo was obviously very proud of this purchase and showed it to such friends as Pissarro and his son (an indication that he liked to discuss works of art with painters and was not merely interested in offering them to moneyed collectors). Lucien Pissarro later remembered 'that famous sale about which [Theo] van Gogh had spoken to us, where he had bought an earlier painting [by Degas], done in delicate gray tones, very carefully and very finely.'[92] Bought for 54 guineas (1,417 francs), the work was sold within a week to Manzi, a friend of Degas, for 4,000 francs.

Pissarro's pictures continued to move only slowly. It was not until June 22 that Theo could write to him: 'I have the pleasure of informing you that I have sold your painting *Flock of Sheep* [*12*] and that I have the sum of 300 francs net for you. It is not much, but I thought it better to accept than to wait. The client who bought it got a good deal.' The buyer was once more Dupuis.

Theo had been too optimistic when, in connection with the Monet exhibition, he had thought that the new school of painting would soon catch on with the general public. Other letters to Vincent, written later that same year, sound less cheerful and show him distressed by the fact that the pictures of the Impressionists were not selling. He writes, for instance, that Camille Pissarro, whose grit and human qualities he greatly admired, 'has great difficulty selling his work, and is having a hard time.'[93] By the end of the year Theo shows himself quite discouraged when he states, concerning Gauguin, whom by that time he obviously did not support anymore: 'I am fully aware of his talent, and I am fully aware of what he wants to do, but I have been unable to sell anything whatever for him, and yet I have all kinds of pictures of his. The public is most rebellious about things that are not made in "perfect order." . . . He is very unhappy because it has not been possible to find something for him on which he can live. . . .' And he adds sadly, 'Pissarro, too, is at his wit's end.'[94]

This situation was further aggravated by the worries for his brother, which weighed heavily on Theo, though he could now share them with his young wife. A few weeks after Vincent's voluntary confinement in the asylum of St-Rémy (a solution that by no means relieved Theo's anguish), the painter had a severe relapse within days of learning of Johanna's pregnancy. It seems doubtful whether Theo could ever truly enjoy his newfound bliss while Vincent lived in grim surroundings and bravely tried to sound unconcerned or even funny in his many letters.

Paris meanwhile was filled with the agitation of a noisy World's Fair that

almost completely ignored the new artistic currents opposed to academic precepts. Degas, who was represented in the art section, insisted that his works be removed; Gauguin, who was not, defiantly opened—with a group of friends—a separate exhibition in a café on the grounds of the fair. Theo did not consider this a very dignified solution and vetoed his brother's participation.

There were also heated discussions when that same year the French government bid at auction 553,000 francs for Millet's *Angelus* and then could not obtain approval for the expenditure. The American art dealer James Sutton, Durand-Ruel's sponsor in New York, solved the crisis by paying 580,000 francs for the picture, whereupon the reactionary critic Albert Wolff initiated a movement to keep the vastly overrated painting in France. Octave Mirbeau replied slyly that the work could have been obtained for about 1,500 francs some twenty years earlier, when the artist was alive and poor (pointedly adding that there were still great masters in that same condition, such as Pissarro).

Sutton exhibited *The Angelus* for a fee throughout the United States and is said to have made a fortune on the sale of reproductions (possibly engraved by Goupil) before offering it the following year for 750,000 francs to the insatiable Chauchard, anxious to uphold his reputation of acquiring expensive works of art (he also bought a painting by Meissonier for 850,000 francs in the same year). Yet the sensational amounts successively attained by *The Angelus* do not seem to have inspired any collectors with the desire to purchase modestly priced pictures in the hope that their value might likewise increase. Mirbeau's reference to Pissarro did not create the slightest change in the sale of his canvases. And it took the abnegation and devotion of Claude Monet to organize a subscription among his friends to raise a mere 20,000 francs—which he barely reached—in order to purchase from the artist's widow and offer to the Louvre Manet's *Olympia* (neither the French government nor M. Chauchard could be bothered with such piddling affairs). Strangely enough, Theo van Gogh is not listed among the contributors, though many of his clients are.

In July and August 1889, during the World's Fair, Monet and Rodin held their own combined show, but in more luxurious quarters than Gauguin. Still not reconciled with Durand-Ruel who, in 1888, had arranged a group exhibition of Renoir, Sisley, and Pissarro, from which Monet was excluded, the artist selected Petit's gallery for this vast retrospective. Surrounding Rodin's sculptures, there were no fewer than 125 paintings, executed between 1864 and 1889, among them several lent by collectors such as Aubry, Boivin, or Dupuis, who had purchased them from Theo. The catalogue preface was signed by Mirbeau. It was a grandiose manifestation. After it closed, Monet did not sell anything to Goupil for a while, so that Theo had to buy his works wherever he could find them, occasionally paying 4,500 and even 6,000 francs

for these. Between July and the end of 1889 he purchased a total of eleven pictures from various sources.

On September 13, Pissarro wistfully informed his son: 'Theo van Gogh sold a Monet to an American for 9,000 francs. But in general business is bad.'[95] The news was somewhat premature yet nevertheless true. The accounts of the gallery indicate that on October 12 (possibly the time it took for the money to reach Paris), a Mr A. Pope of New York—no doubt Alfred A. Pope of Cleveland and Farmington—actually paid 10,350 francs for one Monet landscape of haystacks in the snow and 6,500 for another of rocks at Belle-Isle, or $3,240 for the two. They had been purchased by the gallery only a few weeks earlier for 6,000 and 4,500 francs respectively. It looked, at least for a moment, as though Impressionism might be coming into 'big money,' yet these were record prices that Theo was not to duplicate; on the whole, the second part of Pissarro's statement remained equally true, business was bad.

In view of his manifold problems it is not certain whether Theo was able to add much to the private collection of the two brothers. The acquisition of only one work can be ascribed to 1889, an etching by Albert Besnard, presented by the artist with a dedication to Theo. Besnard, with Raffaëlli and de Nittis, belonged to the category of fashionable and successful 'Impressionists' whose literary and often anecdotal subject matter made them acceptable to those who *read* pictures and who were appalled by the 'lack of finish' in the works of Monet and his group. The high-society Impressionists were handled by both Georges Petit and Boussod & Valadon. It is true that Vincent was able to detect qualities—either technical or sentimental—in most contemporaries, from Carolus Duran to Meissonier, because he was awed by their skill or simply responded to their intentions and social tendencies. Theo was less partial to technical abilities, hence more critical. Not as enthusiastic, nor as forbearing, as his brother and more detached, he occasionally proved to be more subtle and perceptive; some of his judgments, even of friends, appear exceptionally pertinent. On the other hand, he was seldom able to speak his mind freely where artists linked to Boussod & Valadon were concerned. He was also a man with a tremendous sense of responsibility and—hidden behind his cool and slow manner—warm compassion. It cannot surprise, therefore, that others confided in him and appealed to his understanding and discretion.

It is in this light that an undated letter from Albert Besnard should be read. It shows Theo as the friend in need he was not only for his brother, but also for the many artists with whom he came into contact, even those with whom he did not form a close relationship:

Dear M. van Gogh,

I am in dire need of 200 francs by Sunday afternoon. You are the only person I can turn to. You can take in exchange a watercolor of your choice from those remaining at the house. I leave it to your discretion. I ask this favor of you so that I shall be able to get rid of a great, great nuisance.

Come see me tomorrow morning, you will choose. If you are not able to provide 200 francs immediately, I shall figure out how to manage; I would need at least 100. All this must remain a secret between the two of us. Here one must know nothing about all this, otherwise I would not have turned to you.

Do you understand?

A thousand friendly regards. . . .

Besnard[96]

Nothing more is known about this mysterious emergency, except that Theo's collection contains two works by Besnard, the etching dedicated to him in 1889 and an oil painting, but no watercolor.

As the year drew to a close, Theo again looked for a way to assist Pissarro, especially since the latter had promised to help find a place for Vincent, who was anxious to leave the asylum of St-Rémy and settle somewhere near Paris. On December 17 Theo wrote to the painter: 'It is sometimes exasperating to see the slowness with which collectors come to the new school in spite of all the arguments that one makes to show their value. They always think that only they are right and we are wrong. I am still in favor of a one-man show of your work, although you must not expect any definite sale, but I shall do what I can.'

Theo had every intention of keeping his word and to continue to push the painters he valued. Just the same, several of the artists with whom he had dealt previously or whose works he had handled, such as Sisley, Renoir, Lautrec, and Manet, do not appear at all on the gallery's books for 1889. But there was at least one newcomer, Odilon Redon, although his name does not show up on the firm's ledgers either. It has always been assumed that it was Emile Bernard, a great admirer of Redon's, who had introduced Andries Bonger, Theo's brother-in-law, to the artist in 1890;[97] Bonger was subsequently to form an important collection of Redon's work. But according to Redon's carefully kept accounts, in December 1889 he sold two paintings directly to Theo, which he recorded as:

Au ciel (peinture)		200 frs
Profil de femme	300 frs − 25 % =	225 frs
reçu de M. van Gogh—Goupil		425 frs

On May 5, 1890, Redon listed another transaction:

Vierge d'Aurore (13)	400 frs − 25 % =	300 frs

[reçu] de M. van Gogh (Goupil) pour M. Ernest Chausson[98]

This time the deal is entered into the accounts of the gallery under May 2, 1890, which indicates that Theo had received the painting on consignment from the artist. However, it is recorded as having cost only 100 francs and having been sold for 400. No doubt this is another of the many errors committed by the firm's bookkeeper, since it is much more likely that Redon's annotation is correct and that the gallery's commission in this affair was the usual 25 percent. The only strange thing about this transaction is that the collector who bought this work, the composer Chausson, was a longtime friend of the artist. Chausson either did not wish to approach Redon directly for fear that he would give rather than sell him what he might select, or he happened to see the picture in Theo's gallery where he had recently purchased a portrait by Degas and was soon to acquire a still life by Gauguin.

According to his accounts, on June 7, 1890, Redon received another 375 francs (500 less 25 percent) for *Tête mystique*, an oil, from 'M. Goupil,' but as there was no longer any M. Goupil active in the establishment, it must once more have been Theo van Gogh who concluded this deal, of which, once again, there is no trace in the gallery's books.

These are the only entries concerning Theo or Goupil to be found in Redon's notes. It is not surprising that they are not more numerous, since Vincent did not at all share Bernard's enthusiasm for Redon's work.[99]

1890

The few sales involving Redon are among the least important transactions of 1890. In retrospect, the year 1889 seems like a very quiet one compared to the events of 1890. In January Aurier's lengthy article on Vincent appeared, the first written on him, for which Theo and Emile Bernard had provided information. As Johanna's confinement approached, Vincent's and Theo's younger sister, Wilhelmina, came to Paris to help. Theo took her along on a visit to Degas, who received her most graciously, possibly because of his excellent relations with Theo. Degas said that she reminded him of figures in old Dutch paintings and made him want to visit the museums in Holland again;[100] he even dragged out some of his works to show her. It was probably on that occasion, on January 17, that Theo bought a *Danseuse avant l'exercice*.

Vincent had been invited by Octave Maus to participate in the 1890 exhibition of the Vingt, opening in Brussels on January 18, and Theo shipped several of his brother's paintings there. Meanwhile he also discussed with Pissarro the one-man show he had been planning for months. On January 17, he wrote the painter:

'We must arrange our exhibition with all the care that it merits, for not only must we sell some canvases, but we must also work so that you attain the rank that you deserve. I have begun by ordering simple frames in white or gray wood and oak for *The Haymakers* and the *Flock of Sheep* [*12*].[101] I believe that it would not be a bad

13 Odilon Redon *Vierge d'Aurore c.*1890

idea to make a catalogue after all. Tell me if you do not think it would be wise to include a preface. Kahn, Geffroy, or O. Mirbeau will surely take care of that. I would like this preface to be a rather comprehensive thing where, besides whatever the author may wish to say of you, he would stress the quality of the execution in such a way as to destroy the public's absurd prejudice against your [pointillist] technique. Is your large painting also intended for the exhibition?[102] It seems to me that we ought to hold it from the end of February to the end of March. What do you think? When do you plan to come to Paris? It appears very likely that we shall succeed!'

In the midst of these preoccupations a letter arrived from the doctor of the St-Rémy asylum saying that Vincent had had a new seizure. Theo replied on January 31, expressing the hope that the attack would be as light and short as several previous ones had been and announcing that that very day his son had been born and would be named Vincent after his uncle. The painter was soon able to reassure his brother about his health and Theo went on coping with his chores. Gauguin came to Paris from Brittany so penniless that he was looking for a job, any job. He had recently sent to the gallery a large wood relief *(14)* and probably brought with him some paintings which he left with Theo. By the end of February the Pissarro show was hung. It contained fifteen paintings and eleven gouaches, one lent by Clemenceau; the catalogue introduction was signed by Gustave Geffroy. A special note on the invitation indicated, 'The wood relief and the ceramic objects in the exhibition room are by Paul Gauguin.'

At about the same time Vincent went through a severe crisis that lasted for a number of weeks, during which he could not write nor even read nor have read to him the mail he received. Thus, it was not until later that he learned of his brother's letter of March 19, in which Theo had informed him: 'The exhibition of Pissarro's work is over; a lot of people came to see it, and five pieces were sold. For the moment it was all that we could hope for.'[103]

The gallery's records, however, show only four paintings sold, for a total of 4,800 francs, of which the artist received, between March 1 and 28 whenever a purchase was paid, altogether 3,150 francs. This amount is 450 francs short of the 75 percent that should have been Pissarro's share, but the private correspondence between the painter and Theo reveals that on January 28, well before the exhibition opened, Theo had sent Pissarro 500 francs as 'an advance on the business we will do.' There is no trace of this in the firm's ledgers, a fact that is particularly troubling because this is yet another factor that makes it impossible to evaluate Theo's activity with accuracy. In any case, Pissarro must have been pleased with the result of the show, since he expressed his satisfaction in two letters to Theo and invited him to spend Whitsuntide at Eragny. On April 9 Theo replied: 'You are really very kind to appreciate my poor attempts to make the public accept your painting. If I were able to do something, you would sell more quickly and at different prices. I do not despair about doing better and better, and in any

14 Paul Gauguin *Be in Love, You Will Be Happy* 1889, polychrome wood relief

case I shall always consider it an honor to have been able to do your exhibition. . . . When I see you, you always give me courage to persevere. . . .'

Theo needed all the courage he could muster. It was only toward the middle of April that Vincent was able to write again, though his head was still numb. It became clear that the asylum offered no cure and that he might be better off if he were brought north, where Pissarro began to look for suitable accommodations. During this time Gauguin had been busy in Paris trying to find the means not merely to subsist but which would enable him to turn his back on Europe forever and live in a distant tropical paradise where everything would be easy, at last. He finally found a prospective backer and immediately informed Theo of his newest project, which involved a major part of the more than forty of his canvases (plus sculptures and ceramics) accumulated in the gallery, where Theo had not been able to do anything with them since his last sale of September 1889. Gauguin had been furious to learn that Degas did not like his recent work as much as his previous pictures. Though he probably did not let on, Theo's attitude was the same, while Gauguin attributed the lack of sales to the bad influence of Degas.[104] But the artist was now determined to raise money any way possible, and sometime near the end of April, on the eve of his return to Brittany, he summed up the situation in a long letter to Theo:

> The deal I discussed with you has been made in principle. On Sunday the person came to approach the subject very frankly. It is Dr Charlopin, who invented a machine that ran at the World's Fair [1889]. He sold his invention[105] but has not yet *received* the money and that may take a month or two. He is determined, he says, to invest in the project, but I cannot involve myself *before having the money*. That is a most natural thing. Basically he is not going into the deal with a commercial purpose but in order to fill his home with furnishings and art objects.
>
> In this case I would leave for Madagascar and buy there a little earth hut and enlarge it myself as a skillful sculptor and live like a savage peasant. There I could, without financial worry, work at my art as I have not yet been able to do.
>
> For 5,000 francs I am delivering 38 canvases to him, 14 of which are at your place and are to be sent to him when the time comes, and five ceramic pots which are here.
>
> This sum is not much, but I also hope that in my absence you will do your best to sell other things.
>
> If you, too, could find a speculator who wishes to make a similar deal with the sculpted wood relief and paintings from among those at your gallery, he would make an excellent deal, I believe, and *so would I*. Lerolle or Chausson would perhaps do it, especially as they could resell through you at higher prices than they bought, which would result in their getting some pictures for nothing.
>
> In conclusion I leave you free to judge for yourself.
>
> I believe that then I could send you new beautiful things from Madagascar

56

done with great care, since there I would have models every day without cost.

I shall do little, but everything done carefully, very complete.[106]

These were indeed 'rock-bottom' prices, far below anything Gauguin had ever agreed to. If one counts the paintings at 125 francs apiece, thirty-eight would be worth 4,750 francs, and five ceramics at 50 francs each (instead of 150) would round out that amount to the 5,000 francs mentioned by Gauguin. Probably sometime later Gauguin sent an inventory which doubtless represents the works he had left on consignment with Boussod & Valadon:[107]

		frs
	Martinique, deux paysages, 300 frs chaque; le grand avec figures	[600]
toile de 50.		
[116 x 81 cm]	Marine, avec petites figures [W. 360?]	400
,,	Paysage avec cochons sur route [W. 255? 73 x 93]	500
,,	Paysage, coteaux avec garçon blouse bleue [W. 256?]	600
toile de 40.		
[100 x 65 cm]	Marine	300
toile de 30.		
[92 x 73 cm]	Effet de neige [W. 247?]	300
,,	Paysage touffu avec petites figures dans buisson [W. 310?]	400
,,	Famille sur l'herbe avec chien [W. 358]	400
,,	Plusieurs figures et veau	400
,,	Paysage d'hiver avec garçon et veau	400
,,	Femmes en prière et lutte d'anges [W. 245]	600
,,	Femmes nues se baignant [W. 215]	400
,,	Paysage d'Arles avec trois Arlésiennes [W. 307]	400
,,	Paysage d'Arles. Les mas [W. 309]	400
,,	Paysage d'Arles avec deux chiens [W. 310]	400
,,	Paysage d'automne avec deux petites figures [W. 368?]	400
,,	Femme, dos nu, avec cochons [W. 301]	400
,,	Femme nue dans la vague [W. 336]	400
,,	Paysage, buisson rouge avec cochons [W. 354?]	400
,,	Paysage, pommier rouge sur maison blanche	400
,,	Les deux pauvresses [W. 340?]	500
,,	Automne. Garçon et oie [W. 367]	400
,,	Bonjour M. Gauguin [W. 322? 113 x 92 cm]	400
,,	Marine, paysage avec joueur de flûte [W. 361]	300
,,	Petite fille assise avec tartine à la main [W. 344]	500
,,	Meules et poules [W. 351]	400
,,	Paysage d'hiver, route avec fond coteau et maisons	400
,,	Oies jouant dans l'eau [W. 277]	300
,,	Paysage avec figure et chien noir [W. 252?]	400
,,	Jésus avec cheveux rouges [W. 326]	600
,,	Calvaire breton [W. 328]	500
,,	Maisons avec clocher [W. 269?]	300
,,	Paysage, troncs d'arbres en hauteur [W. 311?]	300
toile de 20.		
[73 x 60 cm]	Paysage d'hiver avec ruisseau	300
,,	Nature morte, oranges	300
,,	Marine avec vache [W. 282?]	300
,,	Marine avec plage et petite baigneuse	300

,,	Marine avec deux petites filles [W. 286?]	250
,,	Marine, étude avec femmes dans les roches [W. 360?]	250
toile de 15.		
[65 × 54 cm]	Pastel, femme nue	200
toile de 20.	Paysage sans figures, printemps	250

'A ceramic statue at 700 francs [*15,II*]. Three hundred francs that M. Manzi advanced me are to be deducted.[108] See him about that. Several ceramic pots, 150 francs *on the average* according to your appraisal. Wood sculptures, two: 1,500 each.

'The large landscape with figures from Martinique is for sale at 1,500 francs, but 300 francs are to be deducted which [Theo] van Gogh advanced from his *personal account*.'

Gauguin did not specify which were the fourteen paintings to be delivered to Charlopin, but his list comprises exactly fourteen items priced between 200 and 300 francs, and these must be the ones he had in mind. It is not easy to identify all the works referred to by the artist, nor is it clear which is the *large* Martinique landscape with figures at the head of the list, priced at 300 francs, and the one mentioned at the very end, estimated at 1,500 francs, on which

15 Paul Gauguin *Eve* 1890, glazed stoneware

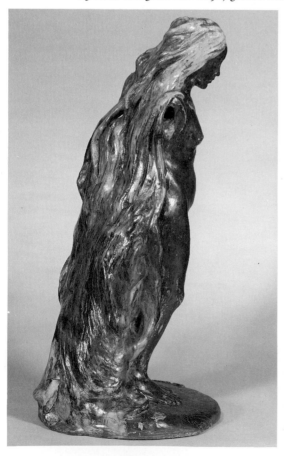
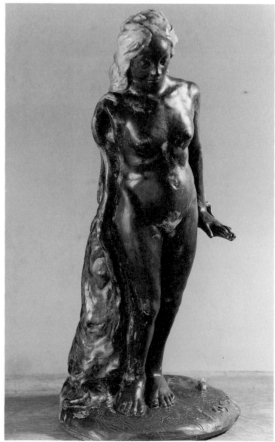

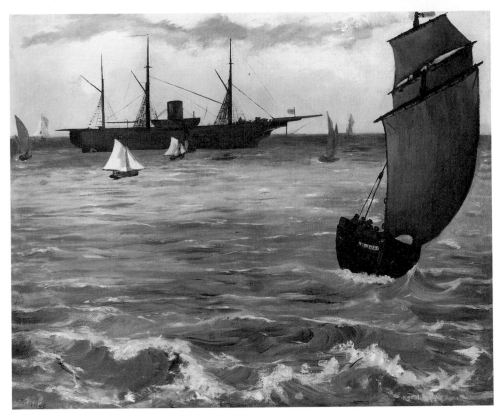

16 Edouard Manet *The 'Kearsarge' at Boulogne* 1864

Theo supposedly had lent Gauguin 300 francs.[109] The ceramic statue on which Manzi had paid an installment of 300 francs was eventually acquired by him.

Theo was not only skeptical about Gauguin's newest scheme, he must also have wondered how he was supposed to sell whatever the artist would leave with him—or would later send him from Madagascar—at prices anywhere near those he had tried to maintain when Gauguin himself was undercutting them in such a drastic way. But nothing had as yet been concluded with Charlopin and, as time passed, nothing more was to be heard.

While Vincent was getting ready to leave St-Rémy, Theo did his best to conduct business 'as usual.' Between the middle of January and the middle of May he acquired five canvases by Monet, though none directly from the artist; two of these were disposed of within a few months. On March 1, Manzi bought Manet's *Students from Salamanca* from Theo, but ten days later, for reasons unknown, the sale was cancelled. Instead, Theo obtained a seascape by Manet *(16)* which he sold immediately. During this same month he purchased four more works directly from Degas for a total of 5,000 francs (exactly the amount Gauguin tried to raise with thirty-eight paintings and

five ceramics). Two of the four were sold quickly, a third was kept by Etienne Boussod for his own collection.

On April 30, probably just before Gauguin returned to Brittany, Theo gave him 225 francs for a still life. This is the *first* time he purchased a work from the artist for the gallery instead of taking it on consignment, doubtless because Gauguin needed the money badly; however, it is also possible that Theo had given him the amount before but now agreed to accept a painting in exchange. (The picture was sold in August to Redon's friend Chausson.) At the beginning of May, Theo paid another visit to Degas and left with an early portrait of a man which he later sold to Dupuis.

Meanwhile Vincent's departure approached and Theo was greatly disturbed because his brother refused to be accompanied on the long overnight train trip to Paris; but he arrived in excellent spirits on the morning of Saturday, May 17, and for the first time met his sister-in-law Johanna and his infant nephew. Vincent spent four days with them and then proceeded to Auvers-sur-Oise where Dr Gachet, recommended by Pissarro, had agreed to 'keep an eye' on him.

It is not known which subjects the two brothers discussed during the few days they spent together at long last, but from references in the letters they exchanged subsequently it seems certain that they concerned some of the problems uppermost on their minds: Theo's dissatisfaction with his work for Boussod & Valadon, Vincent's desire to see an association of painters founded for the protection of their interests, and the hope of the two brothers that Theo would be able to establish himself as an independent dealer.

After Vincent left, Theo prepared a Raffaëlli exhibition. Vincent liked this artist for his representation of simple folk, and even Aurier, the Symbolist pundit, appreciated his minor talent. 'Last week,' Theo wrote his brother on June 2, 'I was kept busy by that Raffaëlli exhibition; we stayed open as late as ten o'clock at night.'[110] And three days later he reported, 'The exhibition gives me a lot of work, but also satisfaction.'[111]

Theo, his wife, and baby spent Sunday, June 8, with Vincent and Dr Gachet at Auvers. The painter told his brother of his plan of renting a small house in the village and apparently also spoke of his favorite project: organizing an exhibition of paintings in a Parisian café, as he had done during his 1886–88 sojourn in the city.

In Paris the following day Theo purchased from a Lyons collector a study by Monet for 2,000 francs which Monet himself acquired and on which the gallery did not charge a commission. The next day Theo bought two more works directly from Degas. Little more than a couple of weeks later he successfully bid on three lots at an auction: a landscape by Monet that went for 147 francs and two works by Manet that were knocked down for 99 and 840 francs respectively; it is possible that the cheaper items were pastels

rather than oils. Though Theo kept extremely busy, his frame of mind was somber. Despite his activities and his working late into the night, his earnings were low for a man who had to provide for a wife, a child, and a brother. But above all, the frictions with his employers became unbearable.

When his child fell ill toward the end of June, Theo was so worried that he seems to have lost some of his usual composure. It is nevertheless surprising that he now discussed the situation quite openly with his brother and revealed his anxieties and frustrations as well as his financial problems to the one person who, as he knew, felt 'guilty' about being a burden to him. But the load on his shoulders had become so heavy that Theo's letter of June 30 to Vincent was really more an outcry of anguish than a request for his brother's views: 'Can I,' Theo wrote,

'live without a thought for the morrow, and when I work all day long not earn enough to protect that good Jo[hanna] from worries over money matters, as those rats Boussod and Valadon are treating me as though I had just entered their business, and are keeping me on a short allowance? Can I, when I don't watch my expenses and have no extra entries and am short of money—can I tell them how matters stand, and if they should dare refuse me, oughtn't I to tell them at last, Gentlemen, I am going to take the plunge, and establish myself as a private dealer in my own house? While writing I think I am coming to the conclusion that this is my duty. . . .'[112]

Vincent's reply was strangely vague. He was greatly concerned about the health of his small nephew but shirked from discussing his brother's professional plans: 'What can I say about a future perhaps, perhaps, without the Boussods? That will be as it may, you have not spared yourself trouble for them, you have served them with exemplary loyalty at all times.'[113]

On July 5 Theo was able to reassure his brother; the child was well and he was making plans for Bastille Day 'to go visit Claude Monet with Valadon, who will be sure to annoy me that day, but I am glad I am going to see Monet's new pictures.' He even managed to joke about his business when he added: 'I have been quite lucky in business, although my sales of pictures don't amount to 800,000,000,000 frs., but among other things I have sold two Gauguins, for which I sent him the money. Pissarro wrote to tell me that he could not pay his rent; I shall send him a little advance upon the business we are going to do. It is true, his exhibition brought in something, but all of it went to plug leaks. He has an abscess in one eye. Poor old fellow.'[114]

The same day Theo also wrote to Pissarro, on whose behalf he had been trying to sell four large *dessus de porte* (overdoors) of the seasons which one of the artist's earliest patrons, Achille Arosa, had commissioned in 1872 at 100 francs apiece. Arosa had died and his heirs decided to dispose of the group. Pissarro must have been anxious to avoid a public sale, especially after the poor results of several recent ones. He apparently offered to find a buyer for the four canvases *(17–20)* and counted on the help of Theo van Gogh.

17 Camille Pissarro *Spring* (one of four overdoors) 1872

To Pissarro, as to any struggling artist, auctions were the worst threat to his current output. They threw on the market works already sold—and thus 'eliminated' from his production—which then entered into competition with recent and still unsold pictures. Not only was the artist deprived of any benefit from possible growth in value—a circumstance that outraged Vincent—but he stood to lose should there be nobody to sustain his prices. In Pissarro's case, with Durand-Ruel already overstocked and Theo unable to spend much money, low auction results could actually jeopardize the artist's rating and wipe out whatever increases he may have been able to obtain over the years. This could mean—and had meant so repeatedly in the past—that Pissarro might even have to *lower* his current prices according to those established at public sales. Though the Arosa paintings were no longer his and though he had been paid next to nothing for them, Pissarro justifiably feared the repercussions of low bidding. On July 5 Theo reported to Pissarro how he had fared in his mission and at the same time told him about his worries of the past weeks, without, however, mentioning his conflicts with those *rats* Boussod and Valadon.

Dear Sir,
It's still misery for—may I say it?—us other Impressionists. I tried the overdoors again at Mme Boivin's, but she says it is her husband and he says it is she who does not want them; even after having read your letter, he did not want me to hang a picture very high so that he might judge the effect.[115] Thus I can do only one thing, which is to send you the enclosed 500 francs in advance on the business that we will do and *we will do a lot, that is said and promised*, if you will just take good care of yourself and care for your eye.

62

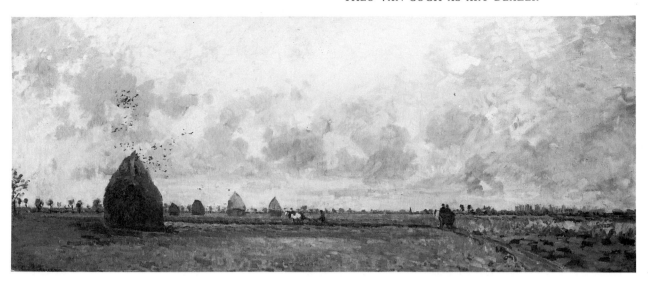

18 Camille Pissarro *Summer* (one of four overdoors) 1872

I have had great difficulties; we almost lost our little child. Cow's milk in Paris is poisoned by the dirty food and bad treatment of these animals. Donkey's milk has saved him and at the moment he is better and even thriving. But you can well understand that we must not travel at the present time. It is therefore not possible that we offer ourselves the pleasure of all three of us coming to visit you. But since on the fourteenth of this month I must be at Monet's with M. Valadon, I am inviting myself, along with my brother-in-law [Andries Bonger] and perhaps with my brother Vincent, to come spend that day with you. We will sleep anywhere, so don't worry about it. To see the great artist in his home and surroundings will give me pleasure.

When Miss Rogers comes, I shall show her all my paintings [by Pissarro]. When she came she asked me, referring to Monet, 'If I bought a small painting of his, do you think he would give me some lessons?' I told her the story about the young man going to show him his studies and saying to him, 'Ah, M. Monet, I admire your paintings so much, they all have the character of being made from nature.' 'If you have seen that, then what is it that you come to do in my house?' was his reply. She did not dare ask him the same thing and she cooled off. She *must* buy a painting of yours and not the least expensive. She ought to be able to afford a fine painting at the customary price and she must not let us down.

Best regards from me and my wife, also to Mme Pissarro. When you have something new, let me know.

The naïve Miss Rogers did not acquire any painting by Pissarro—or Monet— from Theo, who not only decided against the visit to Eragny, but didn't go to Giverny either. Nor did he succeed in buying anything from Monet. As a matter of fact, the gallery's ledger reveals no further purchases of works by

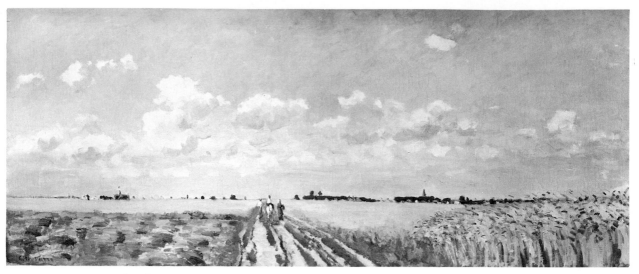

19 Camille Pissarro *Autumn* (one of four overdoors) 1872

Monet for the rest of 1890. It is of course impossible to establish whether this was because Messrs Boussod and Valadon had temporarily lost interest in the artist (they still had some two dozen paintings of his in stock), or whether they were unwilling to pay the prices he now demanded. M. Valadon's insistence on accompanying Theo to Giverny may well have meant that he feared his employee's enthusiasm for the master's recent work might lead to undesirable commitments.

Monet was then embarking on a new venture, foretold by his canvases from Antibes in 1888 where he had repeatedly returned to the same spot in order to paint virtually the same landscape at different times of the day. But now he was doing *systematic* series of various subjects: fields of poppies, poplar trees, and, especially, haystacks. He obviously wanted to keep these series together until they were shown before breaking them up and selling individual paintings. It is conceivable that prior to the projected visit on Bastille Day, Monet had informed Theo that he could not yet dispose of his last pictures; he may even have added that he wished to exhibit them in larger premises than those provided by the boulevard Montmartre gallery. Under these circumstances the trip to Giverny may simply have been called off.

As usual, the advance of 500 francs which—according to his letter—Theo had sent Pissarro does not appear on the firm's records. As to the two paintings by Gauguin which Theo had sold and paid for early in July, only *one* of them can be traced in the account book; it was acquired by Eugène Blot for 200 francs, of which the artist received the pittance of 150 francs, his lowest price ever. But Gauguin needed the money badly, as he had not heard from the inventor-speculator Charlopin about his massive 5,000-francs purchase.

64

20 Camille Pissarro *Winter* (one of four overdoors) 1872

Since Theo could not go to Auvers, Vincent came to Paris for a short visit. He found his brother and sister-in-law exhausted from their recent ordeal and still worried about their child. He therefore did not even discuss the vital matter of his allowance and went back to Auvers without being assured that he could count on the 150 francs a month he had received in the past. On the other hand, Theo probably told him that he intended to present an ultimatum to Messrs Boussod and Valadon, the exact terms of which are not known, though it is evident that Theo was now ready to risk his job in order to obtain satisfaction. This could, of course, also lead to his dismissal or resignation, as a result of which life might become very difficult for all of them.

Theo, however, must have been quite optimistic. At least Gauguin reported from Brittany to his friend Schuffenecker, 'Theo van Gogh wrote me a rather interesting letter in the sense that he believes he will *soon* have enough *power* in the firm to help me more effectively and more regularly; at the same time he would raise the prices of my paintings.'[116] Yet Vincent, who had always encouraged his brother to free himself of his shackles, now seems to have sensed the threat that this could present to his own condition. He did not share his brother's confidence, and his first reaction, far from being one of joy, was one of caution. 'You rather surprise me by seeming to wish to force the situation,' he wrote.[117]

In his next letter Vincent hinted at some friction with Dr Gachet, on whom Theo counted to watch over his brother's mental stability and physical well-being and concluded, 'I see no happy future at all.'[118] Fortunately, a letter from Johanna reassured him and, as he said, delivered him from his anguish. Nevertheless, the uncertainty about Theo's future disturbed him profoundly.

'It was no slight thing,' Vincent replied,

'when we all felt our daily bread was in danger, no slight thing when for reasons other than that we realize how fragile our existence is. Back here, I still felt very sad too and continued to feel the storm which threatens you weighing on me also. What is to be done—you see, I generally try to be fairly cheerful, but my life is also threatened at the very root, and my steps are also wavering. I feared—not altogether but yet a little—that being a burden to you, you felt me to be rather a thing to be dreaded, but Jo's letter proves to me clearly that you understand that for my part I am as much in toil and troubles as you are.'[119]

While Vincent devoted the Monday of July 14 to painting a view of the small town hall of Auvers gaily decorated with flags for Bastille Day, Theo got ready to leave with wife and child for their vacation in Holland, whence, however, he planned to return for one week before rejoining them during August. He was pleased that Vincent's apprehensions had been calmed and wrote him: 'We are very glad to learn that you are feeling less dispirited on account of the unsettled business questions than when you were here. The danger is really not as serious as you thought.' But he added, 'Although the eight days are past now, those gentlemen have not said a word about what they intend to do with me.'[120]

Whatever the decision taken by Messrs Boussod and Valadon, it must have been in some sense acceptable since Theo did not leave, though there is *no other* indication, no letter, no document to prove that Theo received satisfaction, only a vague mention in an undated letter from Vincent to Theo, 'Perhaps I might want to write you about a lot of things, but to begin with, the desire to do so has completely left me, moreover I feel it is useless.' And then these words, alluding to his brother's recent return from a week in Holland, 'I hope that you will have found those worthy gentlemen well disposed toward you.'[121]

Yet Vincent continued to worry. Since the immediate danger of having to live on a drastically reduced budget seemed over for the time being, he was now fretting about another subject, that of a union of artists such as he had always advocated. Except that suddenly he had lost all faith in such an undertaking. 'The painters themselves are more and more harassed,' he stated. 'Very well . . . but isn't the moment for trying to make them understand the usefulness of a union already gone? On the other hand a union, if it should take shape, would founder if the rest were to founder. Then perhaps you would say that the dealers might combine on behalf of the Impressionists, but that would be very short-lived. Altogether I think that personal initiative remains powerless, and having had the experience, would one start again?'[122]

Theo was deeply distressed upon reading this and had an intuition of trouble to come. 'I had a letter from Vincent which I again found completely

incomprehensible,' he wrote from Paris on July 25 to his wife.[123] But Vincent could not detach his confused mind from these problems. His next letter began with exactly the words used in his previous one: 'There are many things I should like to write you about, but I feel it is useless. I hope you have found those worthy gentlemen favorably disposed toward you.' And then he underlined a sentence expressing regret that it would be a long time before he would be able to discuss business calmly with his brother.

'The other painters,' he continued,

'whatever they think, instinctively remain at a distance from discussions about the present art trade.

'Well, the truth is, we can only make our pictures speak. But yet, my dear brother, there is this that I have always told you, and I repeat it once more with all the earnestness that can be expressed by the effort of a mind diligently fixed on trying to do as well as possible—I tell you again that I shall always consider you to be something more than a simple dealer in Corots, that through my mediation you have your part in the actual production of certain canvases, which will retain their calm even in the catastrophe.

'For this is what we have got to, and this is all or at least the main thing that I can have to tell you at a moment of comparative crisis. At a moment when things are very strained between dealers in pictures of dead artists, and living artists.

'Well, my own work, I am risking my life for it and my reason has half foundered because of it—that's all right—but you are not among the dealers in men as far as I know, and you can choose your side, I think, acting with humanity, but que veux-tu?'[124]

This was Vincent's last letter to his brother. It was found on him after he had shot himself in a field near Auvers on Sunday, July 27, 1890. The next morning, Theo was summoned to his bedside. Vincent died in his arms at one o'clock in the morning on Tuesday, July 29. He was buried the following day.

On July 31, M. Dupuis acquired a racing picture by Degas for 2,500 francs.

Theo was not to recover from the wound caused by Vincent's suicide, but he did whatever he could to keep busy, to devote himself to his family, and to honor the memory of his brother, though for several weeks he was too grief-stricken even to acknowledge the letters of condolences he received. One of these came from Gauguin, who simultaneously wrote to his friend Schuffenecker: 'I received the news of Vincent's death; it's a relief for him, knowing how he suffered. But it is different for his brother and we owed a great deal to Vincent's influence.'[125]

Theo went to join his family in Holland but by the middle of August returned to Paris. On September 12 he wrote to Dr Gachet: 'I still do not feel good about my health; my head is swimming and writing makes me a bit dizzy. My nerves still have the upper hand.'[126]

Theo's first project was to organize a comprehensive exhibition of

Vincent's work. Either because his gallery was too small, or because his relations with Messrs Boussod and Valadon were still strained, or simply because he felt it would be more dignified to hold it elsewhere, he approached Durand-Ruel, who came to look at the pictures, found them 'interesting,' and promised to think it over. Yet he openly admitted being weary of showing paintings that antagonized the general public. Durand-Ruel's position was indeed somewhat awkward. Theo was, after all, a competitor who, despite restricted means, had managed to become friendly and do business with some of 'his' artists, especially the most successful ones, Monet and Degas; besides, Vincent's style could hardly appeal to the man who had barely succeeded in imposing the Impressionist vision. Durand-Ruel was at that moment trying to reconcile himself with the various painters who had left his fold and at the same time take advantage of improved economic conditions. He was preparing the first issue of a periodical supporting the Impressionists, on whose behalf he now deployed a more confident activity both in France and the United States.[127] He had at last re-established commercial contacts with Monet who, without abandoning Boussod & Valadon, promised to exhibit his series of haystacks in Durand-Ruel's gallery. By the middle of September, Durand-Ruel finally declined to hold Vincent van Gogh's retrospective.[128]

Pissarro, on the other hand, actually solidified his connection with Theo and promised him first choice among his recent works. When Theo informed him, on September 30, that he had sold his *Fields at Eragny*, which he had had on consignment, to the steadily collecting Dupuis, he added:

'I am very happy that you said that you want me to be the first to see your paintings. You know that I like your last paintings as much as the earlier ones and that I show them. Therefore, if it is possible, I would like us to continue working together, but I find it distressing that the public comes there so slowly, as it does to all the Impressionists, or rather to the real artists. . . .

'As for the exhibition of my brother's works, the latest news is that it will not take place at Durand [-Ruel's]. He does not see any financial benefit in it, thus it would only be some [adverse] public opinions that he would have to listen to. If there is no financial obstacle, I am going to try to hold the exhibition at the Théâtre d'Application where Chéret and Renouard exhibited. Let us hope it's feasible. In any case, when you come to Paris now you will see things hanging in my house under more advantageous conditions than you could find elsewhere, I think.'

Indeed, Theo had just moved to larger quarters, where he could better display his brother's work. Preoccupied though he was with Vincent's recognition, Theo had to devote himself to his multiple duties at the gallery, including such assignments as the one of which he complained to Bernard, 'Next week I am burdened with a stranger to whom I must try to sell some ghastly paintings.'[129] But he also attended to more satisfying occupations, such as sending some pictures to an exhibition in Christiania (Oslo), where at least one seascape by Monet was sold. On October 5 he selected five works by

Pissarro—apparently three oils, one gouache, and one fan—for which they agreed on a price of 2,500 francs, subject to ratification by Messrs Boussod and Valadon. Two days later Theo purchased from the associates Camentron & Martin a sketch of a dancer by Degas, for 500 francs, as well as his first painting by Cézanne, a seated woman, for 300 francs.[130] It is possible that the Cézanne was 'forced' upon him because he could not obtain the Degas sketch without also taking the other work.

Yet the constant strain began to affect Theo's mind. On Saturday, October 10, Andries Bonger dispatched an alarmed letter to Dr Gachet on behalf of his sister:

'Since yesterday my brother-in-law van Gogh has been in such a state of over-excitement that we are seriously worried. If it were possible, we would be extremely grateful if you would go to see him tomorrow, making believe that you merely dropped in.

'Everything irritates him and makes him lose control.

'The excitability has been caused by a dispute with his employers, as a result of which he wishes to set up his own business without delay.

'The memory of his brother haunts him to such a degree that he is angry at all those who do not go along with his ideas.

'My sister is at the end of her strength and does not know what to do.

'I hope that it will be possible for you to come; if not, please have the kindness to write me a note of advice.'[131]

But events were racing toward the inevitable climax. On October 12, 1890, Theo had to be hospitalized. On the fourteenth he was taken to a private clinic for the mentally disturbed, directed by the famous Dr Blanche (whose son, a couple of years before, had purchased an important painting by Degas from Theo). A short while later Camille Pissarro reported to his son:

'It appears that Theo van Gogh was ill before his madness; he had uremia. For a week he was unable to urinate; added to that were the worries, the sadness, and a violent argument with his employers concerning a Decamps painting. As a result of all this, in a moment of exasperation, he thanked the Boussods and suddenly went mad. He wanted to rent [the Café] Le Tambourin in order to form an association of artists. Finally he became violent. He who so loved his wife and child wanted to kill them. In brief, they had to put him into Dr Blanche's sanatorium.'[132]

After he lost his mind Theo's first impulse had been to do exactly the things he and, especially, Vincent had always wanted to do. Besides trying to establish an association of artists, Theo also sent a telegram to Gauguin in Brittany, 'Departure for the tropics assured, money follows, Theo, Director.'[133] Gauguin was of course delighted until, waiting in vain for the promised funds, he began to realize that something was wrong (he even thought of a hoax).

In Paris, meanwhile, Pissarro went to the gallery for news of Theo and also to find out how matters stood concerning the deal he had concluded with him

on October 5 but which had not yet been approved by Theo's employers. 'I have just returned from the conference with Boussod and Valadon,' he informed his son. 'All is well; the purchase is recognized as valid. M. Boussod's son told me that I should not count on any continual purchases; nobody can replace this poor Theo van Gogh who, he said, would not hear talk of any painting but ours—and more and more persisted in believing only in the Impressionists. It is a great loss for all of us. . . .'[134]

Lucien Pissarro thereupon wrote to his fiancée in London: 'You probably remember the young man who showed us some pictures at the Maison Goupil at the time of your journey to Paris. This poor man has just gone mad. It is all very sad for his family and for all the Impressionist painters, for he was more than a dealer to them. Nobody took more to heart their affairs and at this moment there is not in Paris a man able to replace him.'[135]

But Messrs Boussod and Valadon were of course casting around for a successor to Theo and appointed Maurice Joyant, not yet thirty, who had gone to school with Lautrec and was a friend of Manzi's. Octave Maus, preparing the next exhibition of the Vingt in Brussels to which Gauguin was to be invited and which was also to present a Vincent van Gogh retrospective, immediately wrote to Joyant, having in all likelihood counted on Theo's assistance. Joyant replied:

'I do not actually have any work of the late Monsieur Vincent van Gogh in stock; all his paintings have remained in the family and I think it will be very easy at the time of your exhibition to obtain them by contacting M. van Gogh's brother-in-law.

'Monsieur Paul Gauguin ought to be at this moment at *Pouldu near Quimperlé*, *Finistère*. I have just written him to advise him of the sudden retirement of Monsieur [Theo] van Gogh and have not yet received a letter from him with his exact address.

'In any case, we are agents for several of his wood sculptures. We even have just received two new ones, and we would be very grateful if you could do something for this artist of great talent.'[136]

As soon as Gauguin received Joyant's announcement of Theo's 'sudden retirement' he seems to have written to Schuffenecker for further details. Was Theo stricken with a temporary affliction or was his illness incurable? Gauguin had the impression that the Goupil gallery was still interested in him, adding, 'Perhaps this is due to the influence of Manzy [*sic*] or of Degas, for I know this favor does not come from Pissarro.'[137] Looking for any possible ray of hope, Gauguin went so far as to state, 'Let us examine the situation in cold blood, one can perhaps make use of the van Gogh misfortune if one is skillful.'[138]

It is difficult to imagine how Gauguin planned to take advantage of the new situation, especially as he was once more debt-ridden in his Breton inn. 'You tell me,' he wrote to Schuffenecker, 'that my reputation is growing a great deal at the moment; I foresaw it coming after the van Gogh event. And that is

why I am rushing to Paris, to keep things stirring before they cool down and to try to benefit from it.'[139]

Maus meanwhile had written to his friend, the Belgian painter Eugène Boch, who had been acquainted with both van Gogh brothers (Vincent had even done his portrait) and whose sister, Anna Boch, was a member of the Vingt group (the previous year she had purchased one of Vincent's canvases shown in Brussels). Among the reasons that prompted Maus to enlist the help of Boch, then living near Paris, may have been the fact that the Boussod & Valadon gallery showed itself less anxious to cooperate than Joyant's letter seemed to indicate; another was that Boch had embarked upon a project to extricate Gauguin from his predicament. On November 4 Boch gave Maus the requested information:

'1. Gauguin's address is still Pouldu par Moëlan (Finistère), but I think he will leave as soon as he has received the money to come to Paris; in this case you could write to his friend *Bernard, 5, Avenue Beaulieu, Asnières.*

'2. Van Gogh's brother-in-law is Mr A. Bonger, 54, rue Blanche, Paris.—The last news of this poor [Theo] van Gogh was better, but I fear it will take a long time!

'To get back to Gauguin, I have found five people who want to buy one of his paintings; I am sending him 500 francs today; that will please him I think, this poor devil who has so much talent! Today I viewed at least thirty canvases at Boussod & Valadon, and together with Bernard I chose five works. The painting selected for you is very recent, 1890. . . . I hope you will like it.[140]

'Boussod & Valadon have written to Gauguin asking him to take back all his canvases; the employees do not like this kind of painting at all and laugh at it! I think the gallery will be closed to the Impressionists! . . . that's it!

'It's not necessary for these people to make a profit on Gauguin and they know nothing of our arrangement; all the canvases are to be transferred to the home of a friend, Mr Schuffnecker [sic], 12, rue Durand-Claye (*Ouest ceinture*), as well as the pots. As for the Vingt exhibition, I think you would do well to address yourself there.'[141]

Gauguin was not the only one to suffer from the new policy adopted by the gallery. Boussod's son didn't like Pissarro's pointillist style any more than Durand-Ruel, and the artist was asked to replace a view of Charing Cross Bridge *(21)*, one of the three pictures Theo had selected, with another work. Pissarro immediately did so for fear of seeing the entire deal cancelled. He must have been happy that a second canvas, *The Serpentine, Hyde Park*, was not returned too. As he explained somewhat later to his son: 'The salesman at Boussod & Valadon told me that my divisionist technique frightens the buyers; they are not able to get used to it, even those of Paris. He was able to sell *The Serpentine* only because one does not see the divisions [of tones] since the colors are very light, and that [sale] was to M. Gallimard, one of [Theo] van Gogh's sympathetic clients.'[142]

Gauguin's situation, despite the help from Eugène Boch, remained

extremely precarious. '[Theo] van Gogh's stroke of madness,' he wrote to Bernard, 'is a rotten break for me, and if Charlopin does not give me the wherewithal to go to Tahiti, I am washed out.'[143] But soon the Charlopin project collapsed and Gauguin informed Redon: 'Unfortunately everything misfires for me at the moment. My departure; the planned affair did not come off. [Theo] van Gogh has gone mad and the Goupil Gallery no longer wants anything to do with us. It's a real catastrophe!'[144]

With matters going from bad to worse Gauguin strongly opposed Bernard's plan of trying to arrange a van Gogh retrospective in Paris such as Theo had wished to organize. 'What a blunder!' he wrote to Bernard. 'You know how I like Vincent's art. But in view of public stupidity, it is not the time to remind people of van Gogh and his madness at the moment when his brother is in the same situation. Many people say our painting is insanity. It does us harm without doing Vincent any good.'[145] Now that Theo could do nothing for him, Gauguin was unwilling to let any piety or sentimentality obscure his quest for recognition.

On November 14 Camille Pissarro informed his son: 'I received a letter from the brother-in-law of [Theo] van Gogh. He writes that Theo is calmer and that it will be possible to take him to Holland.'[146]

But soon there was more bad news. On December 23 Pissarro announced to Lucien:

'I went to the Boussod and Valadon Gallery. Nothing has been decided. M. Joyant is still doing all he can, without any results. He has informed me that my best collector, M. Dupuis, whom you know, committed suicide. Isn't that extraordinary! What is most sad is that this overly honest youth killed himself because he believed he was bankrupt. His friends were heartbroken when they discovered that his affairs were not at all in bad shape. Those who have taken over his enterprise find that it is excellent! It appears that in order to raise some money he sold off his Degas works and other paintings to little Salvador Meyer when he could easily have found money at the Péreires, who asked for nothing better than to help him out during his temporary embarrassment. Is it not odd, this succession of events?—It takes a strong character not to be driven to desperation; inner strength is needed.'[147]

The dealer Meyer was proverbially known for his stinginess and it appears obvious that—had Theo van Gogh been around—Dupuis might have been able to save his business, his collection, and his life. His financial difficulties must have taken him by surprise, his last acquisition at Goupil's having been made at the end of September 1890, less than three months before his suicide. Whatever was left of his collection—he had bought eighteen works from Theo alone—was later sold at a poorly managed auction.

Theo died in Holland on January 25, 1891. Aurier published a short notice in the *Mercure de France*: 'We learn of the death of Theo van Gogh, the sympathetic and intelligent expert who worked so diligently to acquaint the public with the works of the independent and most audacious artists of

21 Camille Pissarro *Charing Cross Bridge, London* 1890

today!'[148] And Pissarro sadly wrote to Gauguin's wife in Copenhagen, 'The death of [Theo] van Gogh has dashed many hopes; this devoted friend had succeeded in finding some collectors, and it was at the Boussod & Valadon gallery that I was able to see and admire some very beautiful things of your husband's.'[149]

Gauguin was not to forget Theo quickly, though whenever he spoke of him it was mostly to commiserate on his own bad luck at having lost such a splendid promulgator. To a friend he later complained: 'When [Theo] van Gogh of Goupil went mad, I was done for. . . . Only van Gogh knew how to sell and to create a clientele; no one today knows how to tempt a collector.'[150]

However, Maurice Joyant actually tried to fill Theo's shoes. But being younger, new in the firm, and not connected with one of the original partners, he was even more subject to his employers' whims and tyranny than his predecessor had been. According to his somewhat oversimplified recollections, when Joyant was hastily offered Theo's position, M. Boussod had explained to him:

'Our managing director, van Gogh, besides being a sort of madman like his brother the painter, is in an asylum: you are replacing him, do what you wish. He accumulated some frightful things from contemporary painters which are the disgrace of our gallery. There were of course some Corots, Rousseaus, Daubignys,

but we have taken back this stock since it is wasted on you with your inexperience. You will also find a certain number of paintings by a landscape artist, Claude Monet, who is beginning to sell a bit in America, but he does too many of them. We have a contract to buy all his output and he is in the process of overstocking us with his landscapes, always of the same subjects. As for the rest, they are atrocities; try to manage the best you can and ask us nothing, otherwise the shop will be closed.'[151]

When he published these recollections more than thirty years later, Joyant was slightly in error about Monet still having an exclusive contract with Boussod & Valadon or about his finding a market only in the United States, since Theo, contrary to Durand-Ruel, had purposely endeavored—and successfully so—to sell Monet's paintings in France. But Joyant did remember with precision the contents of the inventory he took:

'Some Monets of Antibes, of Belle-Isle, *The Epte at Vétheuil*, some views of the Seine at Giverny; several Degas, dance scenes; about twenty Gauguins, [*Breton*] *Calvary*, *Christ* [*in the Garden of Olives*], his carved wood panels, and a terra cotta, a female nude *(15, II)*; numerous Pissarros, views of Eragny and of London, *The Serpentine*; some Raffaëllis . . . at least a dozen Guillaumins, and a group of paintings and sketches from Daumier's studio, some watercolors and two or three paintings by Jongkind . . . some Odilon Redons, with his lithos of the Temptation of St Anthony . . . some waxes and bronzes cast by Barye himself, a pastel of a red-headed nude woman . . . by M. Albert Besnard. . . . Finally, some Lautrecs.'[152]

As far as this can be checked against the ledgers of the gallery, the stock left by Theo comprised one painting each by Cézanne, Manet, and Renoir (not mentioned by Joyant), six works by Degas, five by Pissarro, and three by Sisley (these last had all been purchased back in 1887). Out of a total of seventy-three pictures by Monet which Theo had acquired over the years, twenty-four were still unsold (one was shortly to find a buyer in Oslo). The numerous works by Gauguin—paintings, sculptures, and ceramics, doubtless mostly those listed in his 'inventory'—had not cost the firm a penny, since they were on consignment and therefore were not recorded in the gallery's account books. The same applies to whatever works Guillaumin and Lautrec had deposited with Theo and apparently also to the lithographs by Redon which Joyant found.[153]

Despite what Joyant implied, it was certainly not true that there was no interest in Monet's paintings or no money to be made with them. In the course of 1891 Joyant sold sixteen of the canvases accumulated by Theo, yet this did not mean that he was liquidating his stock, since during the same year he also purchased sixteen more pictures by Monet from various sources, only six of which were bought directly from the artist. Nine of the newly acquired paintings were sold before the end of 1891, bringing the total to twenty-five, more works by Monet than the gallery had ever sold in a single year. As a matter of fact, dealing in Monet's works was no longer confined to the 'experimental' branch of the boulevard Montmartre; in 1892 even the main

74

gallery at the Opéra, where M. Boussod reigned supreme, began to handle the artist's paintings.

The transactions concerning the other Impressionists were much less spectacular. Joyant managed to move two of Sisley's three landscapes, as well as two of the Pissarro paintings that had been part of Theo's last deal; he also bought back (or traded) another work by Pissarro owned by Gallimard. In addition, in London the gallery sold a landscape by Pissarro, purchased from Durand-Ruel in 1888, and in New York an Italian landscape by Renoir, which it apparently had on consignment from Durand-Ruel. In Paris, Joyant disposed of three paintings by Gauguin and one by his friend Lautrec, consigned by the artists themselves. Finally, he sold one of Degas's pictures of dancers that was part of Theo's legacy, but he also bought two more works by Degas, which he sold toward the end of the year. It seems quite obvious that compared to these few and isolated deals, the brunt of Joyant's activity was concentrated on Monet.

Indeed, 1891 turned into the 'year of Monet.' In May his exhibition took place at Durand-Ruel's and was an instant success. It included fifteen paintings of haystacks and seven of other subjects; the catalogue introduction was by Gustave Geffroy. Of the twenty-two works, one each was lent by Clemenceau, Gallimard, and Sutton; Durand-Ruel was listed as owner of eleven; the balance was listed without indication of ownership, which must have meant that the paintings still belonged to the artist or were consigned to Durand-Ruel. In February and March, while preparing the exhibition, Monet had sold three haystack canvases to Boussod & Valadon, having by then completed his series and wanting to dispose of those works he did not intend to show with the others.

Pissarro was unable to sell anything to Joyant and did not get anywhere with Durand-Ruel either. Though the painter was in the process of abandoning his pointillist execution and was reverting to a more 'acceptable' technique, Durand-Ruel—at last rid of any competition from Theo or Boussod & Valadon—kept stalling. In April, even before Monet's exhibition opened, Pissarro wrote to his son:

'This is a bad moment for me, Durand-Ruel doesn't take my paintings. . . . People want nothing but Monets, apparently he can't paint enough pictures to meet the demand. Worst of all, they all want *Haystacks in the Setting Sun*! . . . Always the same story. Everything he does goes to America at prices of four, five, and six thousand francs. All this comes, as Durand-Ruel remarked to me, from not shocking the collectors! True enough!! . . . "What do you want," I replied, "one has to be built that way, advice is useless." But while waiting, we have to eat and pay our debts. It's hard!'[154]

On May 7 he reported: 'Monet has opened his show. . . . Well, it has just opened and every painting has already been sold for from 3,000 to 4,000

francs each! If I could only sell for one-fourth of that.'[155] But Pissarro had to be content with much less than one-fourth of these prices. The previous day the sale of the Arosa collection had taken place; it contained the overdoors of the four seasons which the artist had hoped to sell through Theo van Gogh. What Pissarro had feared and had tried to avoid did happen: the four large paintings *(17–20)* went unnoticed and were knocked down to the dealer Bernheim-Jeune for 1,100 francs, or 273 francs each.[156] By the end of the same year Pissarro informed his son that the collector Chéramy had purchased a fan of his from Durand-Ruel for 850 francs and was willing to pay 2,500 for *one* of the season paintings, except that it turned out to be too big. The artist added philosophically, 'Bernheim told me that these overdoor panels were a great success; little Meyer also told me that.'[157]

Things did not improve with an anonymous and poorly organized sale of June 10, 1891, which apparently included what remained of the Dupuis collection. The absence of illustrations, references, or descriptions in the catalogue seems to imply that the administrators of the estate were trying to rid themselves hastily of his belongings. Even though, according to Pissarro, Dupuis had, shortly before his suicide, sold his pictures by Degas and others (such as doubtless his four Gauguins) to 'little Meyer,' there were works by Degas, Monet, Pissarro, and Lautrec left which figured in the sale. Unfortunately, the auction comprised various properties and no evidence exists concerning the individual owners, who are not even mentioned in the *procès-verbal*.[158] Since French catalogues present lots in alphabetical order according to artist, the eight works by Degas, for instance, of which one definitely came from Dupuis, need not *all* have belonged to him.

The *procès-verbal* lists six different consignors, among whom must have been the executors of Dupuis's estate (or his heirs). None of the items in the sale can be identified with certitude as having belonged to Dupuis, yet among the works recorded in the Boussod & Valadon ledgers as sold to the collector were several that are listed in the catalogue of the June 10 auction.

It is not known how many works Dupuis may have purchased from other dealers (his name does not appear in any of Durand-Ruel's account books), nor what exactly he sold to Salvador Meyer. Considering merely what he bought from Theo van Gogh—or at least what can be found in the gallery's registers—one arrives at an impressive group, especially in view of the fact that these works were acquired before 1891, when there were hardly any systematic collectors of Impressionists outside of such personal friends of the painters as Caillebotte, Chocquet, de Bellio, Duret, and a few others.

From Theo, Dupuis had bought, in chronological order:

Sept. 2, 1887	MONET, *Tempête sur les côtes de Belle-Isle*	2,500 frs	
	No. 42 at the auction, sold to A. Migeon, 21, quai aux Fleurs, for		1,550 frs
Oct. 21, 1887	MONET, *Pyramides de Port-Coton, Belle-Isle*	2,400 frs	
Dec. 9, 1887	GUILLAUMIN, *Paysage, bords de rivière*	350 frs	
Dec. 12, 1887	GAUGUIN, *Baigneurs*	450 frs	
Mar. 1888	PISSARRO, *Petite gardeuse d'oies*, fan (documented though not recorded): No. 45 at the auction, sold as watercolor with broken glass, to Perrette, 10 rue Rossini, for		135 frs
Mar. 10, 1888	PISSARRO, *Maison de paysan*	500 frs	
	possibly the work sold hors catalogue as 'paysage, genre Pissarro,' to Portier, 54, rue Lepic, for		60 frs
Sept. 14, 1888	DEGAS, *Foyer de danse, ancien Opéra*	3,400 frs	
Sept. 14, 1888	MONET, *Pointe de Port-Coton, Belle-Isle* (65 x 80 cm)	2,600 frs	
	possibly the painting of the same dimensions as No. 41 at the auction, sold as *Récifs au bord de la Méditerranée* to Durand-Ruel for		800 frs
Oct. 11, 1888	LAUTREC, *Tête d'étude* (65 x 53 cm)	350 frs	
	No. 27 at the auction, sold as *Portrait de femme* (63 x 52 cm), aquarelle gouachée, to Thomas for		53 frs
Oct. 22, 1888	GAUGUIN, *Bretonnes*	600 frs	
Nov. 12, 1888	GAUGUIN, *Prairie avec deux chiens*	400 frs	
Nov. 13, 1888	GAUGUIN, *Vue de Pont-Aven*	500 frs	
June 24, 1889	PISSARRO, *Troupeau, soleil couchant*	400 frs	
	No. 44 at the auction, sold to Durand-Ruel for		630 frs
June 29, 1889	PISSARRO, *Rouen, effet de brouillard*	400 frs	
Sept. 21, 1889	DEGAS, *Tête de femme*	500 frs	
Oct. 3, 1889	MONET, *Faisans* [22]	1,900 frs	
	No. 40 at the auction, sold to Boussod		1,800 frs
Aug. 31, 1890	DEGAS, *Ancien portrait d'homme assis tenant son chapeau* (45 x 38 cm)	2,500 frs	
	No. 18 at the auction, *Portrait d'homme* (45 x 36 cm), sold to Hubert du Puy, Louviers, for		400 frs
Aug. 31, 1890	DEGAS, *Chevaux de course*	2,500 frs	
Sept. 25, 1890	Pissarro, *Champs à Eragny* (Dupuis's last purchase)	800 frs	

The works that did not appear in the auction catalogue were doubtless among those which Dupuis had sold to Meyer in a desperate attempt to ward off the impending financial disaster. The remarkable fact is that with few exceptions the pictures by Monet, Degas, Pissarro, and Lautrec included in the sale can be traced to Dupuis. The notable exception is a group of eight oils, pastels, and drawings by Degas, only one of which can be identified as purchased from Theo. Since it would seem that the Dupuis estate was the sole consignor

of modern works to this sale, it may well be that these items also belonged to the discerning Dupuis (but because they were not acquired from Boussod & Valadon, no cost prices for them are available):

Cat. No. 12	DEGAS, *Femme à sa toilette*, pastel, 68 x 68 cm; sold to Mayer (Salvador Meyer?) for	2,100 frs
Cat. No. 13	DEGAS, *Jeune dame coiffée par sa femme de chambre*, pastel, 72 x 58 cm; sol to Mayer for	2,600 frs
Cat. No. 14	DEGAS, *Après le bain*, pastel, 48 x 88 cm; sold to Durand-Ruel for	1,600 frs
Cat. No. 15	DEGAS, *La toilette*, pastel, 68 x 68 cm; sold to Hubert du Puy, Louviers, for	2,100 frs
Cat. no. 16	DEGAS, *Chez l'oculiste*, étude [huile], 32 x 23 cm; sold to Hubert du Puy, Louviers, for	250 frs
Cat. No. 17	DEGAS, *Trois femmes assises sur un divan*, aquarelle, 17 x 22 cm; sold to Hubert du Puy, Louviers, for	400 frs
Cat. No. 18	DEGAS, *Portrait d'homme*, 45 x 36 cm (this was the *Ancien portrait d'homme assis tenant son chapeau*, purchased from Theo for 2,500 frs); sold to Hubert du Puy, Louviers, for	400 frs
Cat. No. 19	DEGAS, *Deux femmes assises sur un canapé*, dessin, 11 x 21 cm; sold to Hubert du Puy, Louviers, for	400 frs

Finally, there was a second 'aquarelle gouachée' (more likely a 'peinture à la détrempe') by Lautrec: *The Model*, 73 × 67 cm, No. 26, sold for 60 francs to a bidder named Henri. The author of the sales catalogue obviously had been unable to decipher the artist's intertwined initials of H. T. Lautrec and consequently had listed his two works under the name *Hautrec*. There can be no doubt that, like No. 27, the *Study of a Head* acquired from Theo, this second work also belonged to Dupuis, evidently one of the very first purchasers of Lautrec's work. Nor can it be doubted that Boussod & Valadon's bookkeeper, who failed to transcribe this transaction, once more neglected his duties.

It is worth mentioning that among the buyers at the sale was one Hubert du Puy from Louviers who acquired four works by Degas. It is a moot question whether, despite the fancy spelling of his rather ordinary name, he was not a relative of the unfortunate Dupuis. But it is also possible—though not particularly plausible—that the clerk who rapidly took down the names of the successful bidders may have misspelled the gentleman's name.

Where comparative prices are available, it is evident that the Dupuis collection was literally dumped in such a way—and at such a bad moment, in June—that considerable amounts were lost even on the works of Monet and Degas, which were certainly in demand. Only one painting by Pissarro registered a modest gain of 230 francs, while Monet's *Pheasants, Woodcock,*

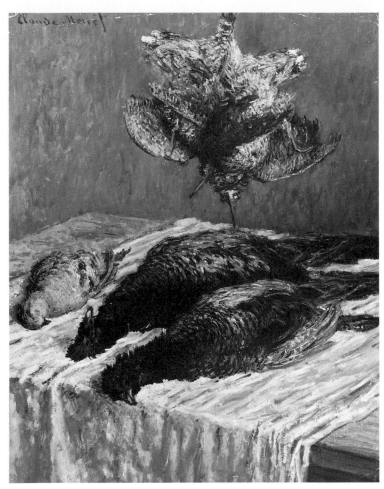

22 Claude Monet *Pheasants, Woodcock, and Partridge* 1879

and Partridge (22) brought almost what it had cost, whereas more than 2,000 francs were lost on Degas's early portrait of a man. Among the buyers were many dealers, such as Meyer, Thomas, Durand-Ruel, Portier, and—despite the contempt he professed for the Impressionists—even Boussod.

The disappointing Arosa and Dupuis auctions had been preceded by a public sale of thirty paintings by Gauguin which was much better prepared and advertised. The artist had returned to Paris from Britanny in November, obviously with the funds provided by Eugène Boch, and had set to work to exploit the favorable currents he thought he detected. Since the disappearance of Theo and the collapse of the Charlopin deal he was in desperate need to raise money, especially as he was now determined to leave for the Tropics forever. While living miserably through the winter, he systematically prepared the ground for an intensive fund-raising campaign. Among the first things he doubtless did was to retrieve most of the works left

with Goupil's, the more so as Joyant—in view of the hostile attitude of Messrs Boussod and Valadon—could not promise him a new exhibition. He did, however, manage to leave some pictures with Joyant, despite the fact that the gallery was supposed to liquidate his account. The artist was anxious to establish friendly relations with Theo's successor so that he might later send him paintings from Tahiti.

Gauguin may have tried, but to no avail, to persuade Durand-Ruel to hold a one-man show of his recent works. Instead, Durand-Ruel agreed to officiate as expert at the auction Gauguin finally scheduled for February 22, 1891. The painter feverishly enlisted the help of anybody he could think of, even Pissarro, who was asked to intercede with Octave Mirbeau for an article. Gauguin succeeded in obtaining write-ups or announcements in most of the Parisian papers and managed in other ways to draw attention to the event. Among the thirty canvases put on the auction block were works from Martinique, Arles, and Brittany. Only two of these brought less than 250 francs (Gauguin himself bought one of them back). The average price was 321 francs, considerably more than the 125 francs apiece Charlopin would have paid for thirty-eight pictures. Indeed, the bids did not compare unfavorably with some of the prices listed by the painter in 1890 for the works left with Theo (see pp. 57–58). Thus *Jacob Wrestling with the Angel* (or *Vision after the Sermon*), for which Gauguin had wanted 600 francs, brought 900 at the sale. This was actually the highest bid obtained; the second highest, of 505 francs, was paid by Degas's friend Manzi, whereas Degas himself paid the third highest for *La belle Angèle*, a painting Theo had particularly admired.[159] The total of about 9,350 francs represented—even minus certain expenses— much more than the amount pledged by Charlopin.[160]

Gauguin now found himself in command of a small fortune, but when his wife in Copenhagen, who was supporting their five children by giving French lessons or doing translations, asked for some money, she did not receive any. Nor did the artist repay Theo's widow the 300 francs Theo supposedly had advanced him. Instead, he lent 500 francs to a new supporter, the poet Charles Morice, and gave instructions that all proceeds from future sales transacted in his absence should be paid to Morice. On March 14 Joyant sold Gauguin's *Red Christ (Christ in the Garden of Olives)* to Octave Mirbeau for 500 francs. On April 4 the artist left Paris for Tahiti.

In May, Gauguin was represented at the Salon of the Société Nationale by three ceramics and a wood bas-relief; his address in the catalogue was given care of Boussod & Valadon, 19, boulevard Montmartre. On May 19, Joyant sold two more of his paintings—one, a Breton Calvary—to a collector from Cette, Jules Chavasse, who had also purchased two pictures at Gauguin's auction. Chavasse paid the gallery 450 francs for each, of which the artist's share, according to the ledger, was a total of 720 francs, which was remitted to Charles Morice. But in Gauguin's subsequent letters the matter becomes

rather confused, except for one thing: the painter never saw a cent of the money. Eventually he informed his only trustworthy friend, Daniel de Monfreid, that he had received encouraging news from Joyant, who on May 23, 1891, had paid Morice 853.25 francs. Adding to this the 500 francs he had lent the poet, Gauguin exclaimed: 'Morice gypped me out of 1,353 francs which would have saved my life. Shortly after my departure Joyant sold 1,100 francs worth of paintings, commission deducted.'[161] While this figure is somewhat higher than the one in the gallery's books, it is possible that a third transaction went unrecorded.

In December 1891 part of the estate of Jongkind, who had died earlier that year, was dispersed in two auctions that yielded unexpected results, especially for an artist who had not won official recognition and was not represented in any French museum. His paintings sold for between 8,000 and 10,000 francs, but one actually brought the unheard-of bid of 27,605 francs, the total of the two sales coming close to 300,000 francs. Just as low auction results in Paris immediately reflected on the reputations and values of living artists, so did favorable prices; they encouraged speculators to turn to other, still fairly 'cheap' painters in the hope of making good investments. At least that was the impression of Pissarro who, the day after the second Jongkind sale, apprised his son:

'Joyant has asked me for pictures. He is waiting for me to go to Eragny to visit me there. He said he wanted to buy old and new works, between 1,500 and 2,000 francs worth. I replied that he couldn't expect to get very much for so little money, that I sold my earlier work at high prices. He said he would take old and new things, that the moment to launch me had arrived, and he begged me to deal with his house. No one could have been friendlier, my dear. There's something behind this. It must be that the auction of Jongkind put an idea in his head.'[162]

Whether or not Pissarro's interpretation was correct, the fact is that in January 1892 the gallery witnessed a sudden flurry of activity, as though, at the beginning of the new year, Joyant had obtained funds for acquisitions and the assurance of a certain freedom of action. On the seventh of the month, he accepted from Monfreid the consignment of five ceramic pieces and ten paintings by Gauguin.[163] The following day he indeed bought three landscapes from Pissarro for a total of 2,400 francs, among them an early work of Pontoise, circa 1871 *(23)*, which, at 900 francs, was the most expensive of the lot. That very same day he also purchased four canvases from Monet for 3,750 francs each. And on January 12 he was able, for the first time, to obtain a painting directly from Renoir, for which he paid 600 francs. This last, as well as Pissarro's early landscape and many of Monet's pictures, went to the United States (in 1892, seven of Monet's works were sold to American collectors—such as Potter Palmer, Vanderbilt, Whittemore, and others—as compared to four sold in France, among which was a sunset apparently kept

by M. Valadon himself). Joyant even sold an important scene of the Moulin Rouge by his friend Lautrec to Charles Zidler, director of the famous dance hall, one of the painter's favorite hangouts.[164]

There was another new departure when, in May–June 1892, Joyant held an *Exposition de tableaux, pastels et dessins de Berthe Morisot,* who had not previously dealt with the gallery. It is possible that this project had actually been initiated by Theo van Gogh, who was acquainted with the artist. Since Durand-Ruel had never suggested a one-man show to her, Berthe Morisot readily accepted the proposition. Claude Monet, Chausson, Gallimard, and others bought pictures from her exhibition at Boussod & Valadon.

Camille Pissarro, on the other hand, finally made peace with Durand-Ruel, or rather Durand-Ruel made peace with him and gave him a large retrospective early in 1892 which proved to be a great success. On the whole, things were picking up and the most difficult times seemed definitely to be over. Now both Durand-Ruel and Joyant were interested in his new work.[165] In March 1893 Joyant at long last organized an exhibition of Sisley's paintings which, however, seems to have been only moderately successful. Sisley was the last Impressionist to find an audience. When Messrs Boussod and Valadon showed no interest in him, he eventually signed a contract with Georges Petit, the only one of Durand-Ruel's painters to do so.

If Sisley's works did not sell too well, those that Gauguin had left with the gallery did not sell at all. From Tahiti the artist sent a study of Tahitian women to Daniel de Monfreid with instructions to take it to Goupil: 'Perhaps it will sell because of its novelty.—And another thing! that Joyant, who talks more than he does; he still has not sold anything of mine since he has been with the gallery!'[166] This was not true, but the artist had not yet learned of the payments received by Morice, who never replied to his letters. To his wife Gauguin complained in a similar vein about Joyant: 'That poor boy is not much of a businessman. Since [Theo] van Gogh's death he hasn't been able to sell anything. If you had known van Gogh, you would have seen a serious man, devoted to the right cause. If he had not died like his brother, I would by now be well on my way. And it was only thanks to him that the firm of Goupil did something for us.'[167]

Though fairly enthusiastic, Joyant had not been able to sell any work by Gauguin since May 1891. In March 1893 he informed Daniel de Monfreid: 'Thus, as agreed, I am sending you the paintings and ceramics of Gauguin that I have, those left by you as well as those left by Gauguin himself, which remain after what has been sent to Madame Gauguin in Copenhagen.' There followed a list of eleven paintings, six gouaches, one pastel, two wood sculptures, nine ceramics, and one faïence piece.[168] Nothing of Gauguin's now remained with the gallery.

In May 1893, deeply disillusioned, Gauguin left Tahiti and arrived in Marseilles on August 3, completely broke. He immediately cabled Daniel de

23 Camille Pissarro *Path above Pontoise c.*1871

Monfreid and Joyant for funds, but it seems doubtful that, under the circumstances, Joyant could help. On October 5 Pissarro wrote to his son: 'I am informing you that Joyant has just left Boussod & Valadon. It seems that Joyant is wealthy in his own right. As Messrs Boussod and Valadon wanted to treat him as they treated poor Theo van Gogh, he left them in the lurch and is going, it is said, to set himself up with Manzi.'[169]

This was exactly what happened, and with Joyant's departure the era of Theo van Gogh at Goupil's, the era of dedication and commitment, of conviction and loyalty to art and artists was definitely ended. Of the works acquired by Theo very little was left in stock, Joyant having been more successful than Gauguin knew (yet he had seldom been permitted to replace what was sold). There remained only three landscapes by Monet and one work by Degas, as well as the lone Cézanne Theo had acquired in one of his last transactions, on October 8, 1890, for 300 francs; there was nothing by either Manet or Renoir. But there were also two paintings each by Sisley and Pissarro, purchased by Joyant, and Gauguin's *Breton Calvary*, which had been acquired shortly after the artist's departure for 450 francs by Jules Chavasse, who subsequently consigned it to the gallery for 900 francs.

By now the Impressionists had become a 'commercially rewarding' proposition, as indicated by the fact that even after Joyant had left, Messrs

24 (left) Paul Gauguin
Women by the River, Tahiti
1892

25 (right) Paul Gauguin
Snow Scene, Paris 1894

Boussod and Valadon continued to buy and sell them, preferably dealing in works by Monet. They also pursued their activity as publishers, issuing huge albums of photographic reproductions as well as excellent facsimiles after drawings by such artists as Rodin, among others. But even here they were outdone by Manzi who, around 1897, published a series of superb color reproductions of drawings by Degas, executed according to a new process invented by Manzi himself and printed under the supervision of the artist; their quality has seldom been equaled, let alone surpassed.[170]

In November 1890 Gauguin, once more without a dealer, succeeded where Theo van Gogh had failed on his brother's behalf. He managed to hold an exhibition of his Tahitian work at Durand-Ruel's, yet could not establish any lasting connection with the gallery. While in France, Gauguin remembered the works by Vincent which he had received as gifts or obtained in exchange for his own paintings but which he apparently had left in safekeeping with Theo. Early in 1894 he wrote to Theo's widow in Holland: 'For several years I have been traveling and as a result have not gotten around to recovering Vincent's paintings which belong to me.'

Johanna van Gogh–Bonger must have asked him how he wished her to proceed, for on April 14 Gauguin specified, 'Please send the canvases to me . . . by parcel post.' It would seem that Mrs van Gogh–Bonger added a study by Vincent as a present and asked the painter whether he in turn would send her one of his own works, for on May 4 Gauguin wrote her once more: 'I have received your letter and the roll of canvases. Many thanks for being so obliging and generous in this matter; I am going to send you a study as you requested.'[171] But now he also touched on the problem of his large Martinique canvas, explaining, 'The large painting you have of Martinique was delivered to you [by the Boussod & Valadon gallery] at the request of your brother [Andries Bonger], but it was not sold to Theo except for a moment as security against the 300 francs he had advanced me.'[172]

That Gauguin did not return the money advanced by Theo is obvious, since the work *(5)* remained with the latter's widow, and it is also unlikely that he asked her for payment of the balance (in 1890 he had estimated the painting at 1,500 francs). In any case, there is no mention of any monetary transaction in Gauguin's correspondence with Mrs van Gogh–Bonger. As a

matter of fact, the artist now sent her not one but two of his pictures, a tropical landscape from Tahiti and a winter scene he had just painted in Paris *(24, 25)*.

Meanwhile a new dealer had appeared on the scene, quite unlike Theo though interested in many of the same artists: Ambroise Vollard.[173] As early as October 1893, immediately after Joyant's departure—and before Gauguin went back to Tahiti, never to return—he concluded a strange deal with Boussod & Valadon, concerning Gauguin's *Breton Calvary* consigned by Chavasse for 900 francs, which was mysteriously 'depreciated' twice until Vollard secured it for only 200 francs, at which time he sold them an early and conventional view of the Seine by Gauguin for 500 francs, thus making 300 francs in this swap. (The early picture was sold five years later to Bernheim-Jeune for 300 francs, at a loss of 200.) In 1903 Mirbeau returned to Boussod & Valadon Gauguin's *Christ in the Garden of Olives (26)* at exactly the price he had paid in 1891, 500 francs, and Vollard bought it for 550 (the gallery made a ten percent commission on this deal instead of the usual twenty-five). Sometime before this Vollard had also taken the Cézanne off Messrs Boussod and Valadon's hands, paying 200 francs against the 300 it had cost them. It would seem that they lost in almost every deal with Vollard, and he may not have been the only one who took advantage of either their lack of interest or their incompetence. Since the days of Theo van Gogh, nobody at the gallery appears to have cared for the works and artists he had boosted.

What Theo had brought to the Boussod & Valadon establishment was an independent mind, a discriminating appreciation, and a true passion for art—precisely the prerequisites for anybody who concerns himself with the art of his own time. Any dealer in this field is faced with two quite distinct alternatives: profits are easily made by those who exploit popular tastes and fashionable currents, while they are made only in the very long run by those who proceed with discernment and who are endowed with the ability of detecting in the mass of contemporary production those achievements that are of historical and permanent value.

Theo van Gogh was among the very few to recognize original contributions and to sustain them, if not always with money—of which he had little—at least with warm encouragement and valiant efforts to spread his own convictions. Being younger than Durand-Ruel, he quite logically took an interest in younger artists, and if he preferred the lyrical divisionism of Pissarro to the stricter one of Seurat, or if he neglected Cézanne, this was not for lack of courage. He did not back new tendencies as a matter of policy, he backed them when they responded to his sensitivity; and he was not merely the brother and supporter of Vincent, but a man who fought his own battles and played a role in the slow victory of modern art. Had he lived, he might have ventured into other directions and worked with still younger painters who soon attracted various dealers. While Durand-Ruel remained riveted to

26 Paul Gauguin *Christ in the Garden of Olives (Christ rouge)* 1889

the men of his own generation (and really made his fortune with the works he had been unable to sell at low prices but for which he found a growing market once they had become expensive), Vollard was to serve as link between the Impressionists and radically new tendencies. At the same time Bernheim-Jeune, under the impulse of Félix Fénéon, turned to those young forces represented by Bonnard, Matisse, Cross, and Signac, while such newcomers as Kahnweiler went even beyond these.

Confined to the style that had provided their' success but proved completely out of tune with the new century—deprived of anybody who could guide them in the maze of conflicting endeavors—Boussod & Valadon were doomed. The curtain was finally rung down on them shortly after the First World War. On March 3, 1919, an auction was held at Georges Petit's under the heading *Vente Maison Boussod, Valadon et Cie pour cause de cessation de commerce.* The sale featured works by Corot, Daubigny, Ch. Jacque, Diaz, Dupré, Harpignies, Isabey, Henri Martin, Th. Rousseau, Troyon, and Ziem, as well as one by Detaille, and a pastel by Besnard, but not a single Impressionist.

IR. DR. V. W. VAN GOGH

ROZENLAANTJE

LAREN N.H. November
11th 1972

Dear Rewald,
Lately I have been
studying your text on
the Goupil books more
closely. The material
is extremely fascinating
and I have a better
idea now of what
my father actually
did. What he sold
makes an impressive
list: in 1888/9 some
11 Picasso's, 16 Sisleys', 74 Monets,
18 Degas, 11 Gauguin
(approximate figures).
Add to that the stock
Joyant found.

APPENDIX I

EXCERPTS FROM THE GOUPIL–BOUSSOD & VALADON LEDGERS

CÉZANNE: The number in brackets refers to L. Venturi, *Cézanne: son art, son oeuvre*, Paris, 1936.

DEGAS: The numbers in brackets refer to P.-A. Lemoisne, *Degas et son oeuvre*, Paris, 1946–49, vols. 2 and 3.

GAUGUIN: The numbers in brackets refer to G. Wildenstein, *Gauguin* (Catalogue), Paris, 1964, vol. 1.

MANET: The numbers in brackets refer to D. Rouart and D. Wildenstein, *Edouard Manet: Catalogue raisonné*, Lausanne–Paris, 1975.

MONET: The numbers in brackets refer to D. Wildenstein, *Claude Monet: Biographie et Catalogue raisonné*, Lausanne–

Paris, 1974–79, vols. 1–3. The works preceded by an asterisk were included in the London exhibition of 1889.

PISSARRO: The numbers in brackets refer to L.-R. Pissarro and L. Venturi, *Camille Pissarro: son art, son oeuvre*, Paris, 1939.

RENOIR: The number in brackets refers to F. Daulte, *Auguste Renoir, Figures (1860–1890)*, Lausanne, 1971.

SISLEY: The numbers in brackets refer to F. Daulte, *Alfred Sisley*, Lausanne, 1959.

TOULOUSE-LAUTREC: The number in brackets refers to M.-G. Dortu, *Toulouse-Lautrec et son oeuvre*, New York, 1971, vol. 2.

TITRE	DIMENSIONS	ACHETÉ A	DATE	PRIX[174]	VENDU A	DATE	PRIX
CÉZANNE							
Femme assise [V. 226]		Camentron & Martin	8-10-90	300	Vollard	3-6-99	200
DEGAS							
Femme accoudée près d'un pot de fleurs [L. 125] (3)	72×90	l'artiste	22-07-87	4 000	Boivin	28-02-89	5 500
Courses [L. 679]	31×47	,,	8-06-88	2 000	Gallimard	5-08-89	2 400
Quatre chevans de course [L. 446]		,,	9-07-88	1 200	Boivin	12-07-88	1 800
Foyer de la danse, ancien Opéra		Brame	12-09-88	2 200	Dupuis	14-09-88	3 400
Foyer de la danse [L. 430]	57×83	G. Petit	12-10-88	5 220	Blanche	29-11-88	8 000
Danseuses, Contrebasses	22×16	l'artiste	16-04-89	600	Heilbut	28-08-91	700
Deux danseuses	22×16	,,	14-05-89	1 200	I. Cook (N.Y.)	9-09-92	2600 ($500)
Danseuse bleue et contrebasse		,,	23-05-89	600	Brame	26-04-92	950
Maître de ballet [L. 341]		Christie's	28-05-89	1 417	Manzi	3-06-89	4 000
Tête de femme		Heymann	10-08-89	400	Dupuis	21-09-89	500
La répétition	40×53	Arnold & Tripp	7-09-89	2 500	Gallimard	12-11-89	3 500

TITRE	DIMENSIONS	ACHETÉ A	DATE	PRIX[174]	VENDU A	DATE	PRIX
Deux danseuses [L. 425]	61×47	Desfossés	4-11-89	5 000	Gallimard	13-11-89	6 000
Danseuse avant l'exercice	62×48	l'artiste	17-01-90	1 050	Mme Adam	7-06-90	1 600
Portrait de M. Roman [L. 133]		,,	8-03-90	750	Chausson	8-03-90	1 500
Portrait de femme		,,	,,	750	Goupy	28-04-94	1 000
Paysanne auvergnate		,,	,,	2 000	Gallimard	28-03-90	400
Violoniste suédoise		,,	,,	1 500	Etienne Boussod		
Ancien portrait d'homme assis tenant son chapeau [L. 102]	45×38	,,	9-05-90	2 000	Dupuis	31-07-90	2 500
Etude d'Anglaise	40×32	,,	10-06-90	1 000	Heilbut	12-06-93	1 500
Etude de femme	40×32	,,	,,	1 000	Dowdeswell (Londres)	27-09-90	1 200
Chevaux de course	26×35	Mathias Camentron & Martin	3-07-90	2 000	Dupuis	31-07-90	2 500
Danseuse (esquisse)	32×25		8-10-90	500	de Bellio	2-04-92	550
Dans l'atelier [L. 326]	41×28	M. Lévy	13-03-91	2 250	Drummond [Montreal]	23-12-91	3 500
Groupe de trois danseuses [L. 512]	73×59	J. S. Forbes (Londres)	25-07-91	2 875	Potter Palmer (N.Y.)	18-09-91	5 037 ($969)
GAUGUIN							
Baigneuses [*Baigneurs*; W. 272]	61×73	l'artiste	28-12-87	300	Dupuis	26-12-87	450
Bretonnes [W. 201]		,,	22-10-88	510	,,	22-10-88	600
Mare au bord d'une route [W. 266]	73×60	,,	10-11-88	220	Chéret	10-11-88	300
Prairie avec deux chiens [W. 265]	60×73	,,	12-11-88	360	Dupuis	12-11-88	400
Vue de Pont-Aven [W. 195 ?]	60×73	,,	17-11-88	300	,,	13-11-88	500
Pêcheurs bretons [W. 262]	60×73	,,	4-12-88	250	Clapisson	4-12-88	400
Berger et bergère [W. 250]	[92×73]	,,	21-03-89	360	Mlle A. Bock [Boch]	21-03-89	400
Négresse[s] à la Martinique [W. 227]	[61×76]	,,	22-06-89	225	Lerolle	18-06-89	300
Bretonnes dansant en rond [W. 251] (I)	92×72	,,	19-09-89	400	Montandon	16-09-89	500
Oranges dans un vase [W. 401 ?]		,,	30-04-90	225	Chausson	19-08-90	300
Chien courant dans l'herbe	55×65	,,	3-07-90	150	Blot	5-07-90	200
Christ rouge [W. 326] (26)	95×75	,,	14-03-91	400	Mirbeau	14-03-91	500
Les dindons [W. 276]	[92×73]	,,	19-05-91	360	Chavanne	19-05-91	450
Calvaire breton [W. 328]	91×72,5	,,	,,	360	Chavanne	,,	450

TITRE	DIMENSIONS	ACHETÉ A	DATE	PRIX[174]	VENDU A	DATE	PRIX
Le calvaire breton [W. 328]	91×72,5	Chavanne	14-10-93	900	Vollard	14-10-93	600
Vue de la Seine, effet de neige [W. 13]	90,5×63,25	Vollard	"	500	Bernheim	27-12-98	300
Christ rouge (ou Christ au Jardin des Oliviers) [W. 326] (26)	95×75	Mirbeau	[6-11] 1903	500	Vollard	6-11-1903	550
GUILLAUMIN							
Paysage, bords de rivière	53×65	l'artiste	9-12-87	200	Dupuis	7-12-87	350
Paysage	65×81	"	1-10-88		Pontremoli	17-01-90	150
Paysage en Auvergne	65×92	"	17-01-90	250	Pontremoli	17-01-90	350
Rivière, vaches et maisons		"	4-04-91	150	Decap	4-04-91	200
MANET							
Marine	60×45	Bourgeois	22-10-86	100	Boggs		200
Les étudiants [de Salamanque] [R.W. 28]	75×92	Gatti	1-03-90	1 200	Manzi	1-03-90 annulé	1 380
L'Alabama à l'ancre [R.W. 75]	75×92	Gatti	10-03-90	2 000	Goupy	10-03-90	4 000
Noix [R.W. 119]	26×46	Hôtel des Ventes	26-06-90	99	Manzi & Joyant	27-04-94	200
Marine	20×37	"	"	840	Dowdeswell	27-08-90	2 000
MONET							
Vernon [Vétheuil] [W. 531] (1)	50×62	Bernheim-Jeune	7-04-85	680	Desfossés	7-04-85	
Pointes de rochers à Port Goulphar [W. 1091]	82×65	l'artiste	7-04-87	1 400	Poidatz	20-04-87	2 800
Grottes du port d'Aumoy [W. 1114]	60×81	"	23-04-87	1 500	Aubry	28-04-87	2 500
Coucher de soleil à Belle-Isle [W. 1098]	59×73	"	10-05-87	1 200	Desfossés	10-05-87	1 800
*Pyramide de Port-Coton [W. 1087]	66×65	"	"	1 500	Dupuis	21-10-87	2 400
Etretat [W. 1048]	68×85	"	17-05-87	1 300	Leclanché	24-05-87	1 800
Belle-Isle, Coucher de soleil [W. 1103]	75×60	"	"	1 200	Heilbuth	5-12-89	1 800
Plage, effet de printemps	76×60	"	"	1 200			
Belle-Isle, effet de pluie [W. 1112]	66×65	"	23-05-87	1 200	Clapisson	23-05-87	1 800
Tempête sur les côtes de Belle-Isle [W. 1119]	73×59	"	11-07-87	1 500	Dupuis	2-09-87	2 500
Prairie de Limetz	73×93	"	1-10-87	1 700	Guyotin	22-02-88	2 000

TITRE	DIMENSIONS	ACHETÉ A	DATE	PRIX[174]	VENDU À	DATE	PRIX
*Champ de coquelicots [W. 1146]	73x93	l'artiste	1-10-87	1 600 ou 1 500	Drummont	23-12-91	3 500
Port Goulphar, temps de brume [W. 1101]	82x65	,,	,,	1 500	Poidatz	10-01-88	2 400
Roche Guibel, Belle-Isle	65x82	,,	22-10-87	1 500	Guyotin	22-02-88	1 700
Roches du Lion [W. 1092]	59x73	,,	,,	1 000	Sainsère	27-03-95	1 000
Moulins, bord de rivière [W. 170]	70x40	Portier	13-12-87	500	Guyotin	17-12-87	600
Les pins à Varengeville [W. 798] (n° 59, vente Charles Leroux)	59x73	Hôtel des Ventes	29-02-88	1 050	Leclanché	29-02-88	1 500
Poste des douaniers à Pourville [W. 738]	59x79	,,	3-03-88	1 050	Talamon	6-03-88	1 250
*Maison de villageois (au pied du coteau, effet d'automne) [W. 975]	68x83	,,	,,	1 200	Eastman	20-03-91	4 707
Pointe de Port-Coton (Belle-Isle) [W. 1091]	65x80	,,	19-03-88	1 200	Chase (N.Y.) ; Dupuis	14-09-88	($922) ; 2 600
*Le dégel à Argenteuil [W. 255]	52,5x71,5	Durand-Ruel	9-04-88	1 200	Faure	14-04-94	2 000
*Bateaux à Argenteuil [W. 372]	59x79	,,	,,	1 200	Lulling	31-08-91	2 500 ou 1 500
*Le moulin d'Orgemont [W. 254]	58x79	l'artiste	21-04-88	1 200	Heilbuth	4-08-93	3 000
Village de Bennecourt [W. 1125]	65x81	l'artiste (avec partage de bénéfices 50/50)	4-06-88	1 500	Richardson	21-04-88	2 200
Vue du Cap d'Antibes [W. 1175]	65x81	,,	,,	1 000	Pope (Cleveland)	5-08-89	3 200 ($615)
Antibes [W. 1158]	65x81	,,	,,	1 000	Mme Ellissen	27-06-88	2 500
Antibes, vue du Plateau Notre-Dame [W. 1171]	65x92	,,	,,	1 200	Desfossés	4-10-88	2 800
Antibes, vue de la Salis [W. 1167]	65x92	,,	,,	1 200	Aubry	14-06-88	2 800
La mer et les Alpes [W. 1179]	65x92	,,	,,	1 200	Keller	27-03-89	2 800
*La Méditerranée par vent de mistral [W. 1181]	65x92	,,	,,	1 200	Buglé (L. Bouglé?)	27-08-89	2 800
Montagnes de l'Esterel [W. 1192]	65x92	,,	,,	1 200	G. Petit	12-10-88	2 520
Plage de Juan-les-Pins [W. 1187]	73x92	,,	,,	1 300	Boivin	12-06-88	3 000
Plage, Cap d'Antibes [W. 1190]	73x92	,,	,,	1 300	Guillemard	14-06-88	2 500
Sous les pins, fin du jour [W. 1191] (8)	73x92	,,	,,	1 300	Aubry	29-06-88	2 800
Route bordée de maisons	39,5x53	Mancini	6-07-88	1 200	Goupy	11-09-88	600
Pyramides à Port-Coton [W. 1087]	66x65	Dupuis	14-09-88	1 500	Gallimard	5-08-89	1 850
Belle-Isle, le chenal [W. 1098]	60x74	Desfossés	10-10-88	1 600	G. W. Vanderbilt	12-02-92	5 330 ($1 025)

TITRE	DIMENSIONS	ACHETÉ A	DATE	PRIX[174]	VENDU A	DATE	PRIX
La mer vue de la falaise de Pourville [W. 1170]	58x78	A. Wolff	11-10-88	1 200	Nunès	21-11-88	2 200
Antibes, vue de la Salis, lever de soleil	66x83	l'artiste	11-10-88	1 000	J. Johnson (N.Y.)	25-08-89	3 640 ($700)
Prairie de Limetz [W. 1201]	72x90	l'artiste (avec partage de bénéfices 50/50)	31-12-88	1 300	L. Grunbaum	12-03-89	3 000
*Moulin de Limetz	90x72	"	"	1 300	Lulling	31-07-91	2 500
*Prairie à Giverny	69x81	"	"	1 200	Robertson	31-01-91	3 000
*Les pins à Juan-les-Pins [W. 1188]	72x90	"	"	1 300	Williams & Everett (N.Y.)	18-04-91	5 148
Antibes, temps clair [W. 1174]	64x79	l'artiste (avec partage de bénéfices 50/50)	"	1 000	Eastman Chase (N.Y.)	20-03-91	4 212 ($810)
*Un tournant de l'Epte [W. 1209]	72x90	"	"	1 300	Elkins (N.Y.)	23-11-91	6 240 ($1 200)
*Prairie avec figures [W. 1204]	81x81	"	"	1 300	J. Sargent (Londres)	20-09-89	3 000
*Marine, temps de pluie [W. 1044]	60x74	Comtesse de Noé	25-01-89	1 000	Ach. de Christiania	3-12-90	1 600
Antibes [W. 1168]	74x94	l'artiste (avec partage de bénéfices 50/50)	9-02-89	1 300	Taconet	6-02-89	3 000
Les meules	72x90	"	28-02-89	1 200	Robertson	26-02-89	2 520
Rochers au bord de la Méditerranée [W. 1185]	60x74	"	27-03-89	1 000	Goupy	16-03-89	2 500
Vervet [W. 1233]		l'artiste (sans partage)	20-06-89	2 000	Elkins (N.Y.)	23-11-91	6 500 ($1 250)
*Les meules, effet de neige [W. 1215]		"	"	2 500	Oppenheim	22-06-89	4 500
Antibes, vue de la Salis [W. 1169]		"	"	2 500	Mme d'Arc	4-08-91	3 000
Rocher Blond (Creuse) [W. 1237]		"	"	2 000	Williams & Everett (N.Y.)	20-02-91	5 850 ($1 125)
Les Eaux Semblantes [W. 1219]		"	"	2 000	"	5-02-91	5 148 ($990)
Canal en Hollande	48x74	Th. Duret	4-07-89	1 000	Goupy	25-02-91	1 300
Coucher de soleil	46x73	"	8-07-89	1 000	Manzi	13-08-89	800
Fruits [W. 544]	90x68	Marsault	13-08-89	500	Dupuis	2-10-89	1 900
Faisans [W. 551] (22)	90x68	"	"	500			

TITRE	DIMENSIONS	ACHETÉ A	DATE	PRIX[174]	VENDU A	DATE	PRIX
Rochers à Belle-Isle [W. 1102]		Guillemard	28-08-89	4 500	A. Pope (N.Y.)	12-10-89	6 500 ($1 250)
Les meules, effet de neige [W. 1215]	60x80	Oppenheim	21-09-89	6 000	"	"	10 350
Vétheuil, temps de neige	94x70	Coqueret	7-10-89	700	Pontremoli	9-11-89	1 500
Esquisse (non signée)	41,5x63,5	"	"	200	[P.C.] Brooks	19-10-89	300
Route, effet d'hiver		Aman Gautier	29-10-89	200	G. Goupy	10-12-89	600
Falaise à Yport		Guyotin	21-12-89	700	Gerard	18-12-89	900
Falaise de Pourville	58x78	L. Nunès	31-12-89	1 200	Eastman Chase (N.Y.)	30-03-91	4 446 ($855)
Les pins [W. 1193]	65x92	G. Petit	15-01-90	1 800	Cte de la Rochefoucauld	25-05-90	2 500
Le dégel à Argenteuil [W. 355]	55x62	H. Garnier	21-02-90	500	Drake del Castillo	14-04-90	1 200
Bord de rivière, hiver [W. 514]	65x50	Vayson	15-03-90	300	C. J. Lawrence (N.Y.)	26-12-91	3 300
La Seine à Vétheuil, matin [W. 673]	68x90	Hôtel des Ventes	10-05-90	1 837	Mme d'Arc	6-03-91	2 500
Effet de neige [W. 509]	60x81	"	"	1 071	Williams & Everett (N.Y.)	11-03-91	4 212 ($810)
Etude de paysages		Gillet	9-06-90	2 000	Claude Monet	9-06-90	2 000
Vue de Hollande	35x72	Hôtel des Ventes	26-06-90	147	E. Calland (Londres)	22-06-95	625
Antibes vue de la Salis [W. 1178]		J. G. Johnson (N.Y.)	15-01-91	1 560 ($300)	Lambert (N.Y.)	30-01-91	4 680 ($900)
Meules, effet de neige [W. 1276]	65x100	l'artiste	5-02-91	3 000	Lonquety	6-02-91	4 500
Meules, grand soleil [W. 1267]	65x100	"	"	3 000	Pope (N.Y.)		7 020 ($1 350)
Meules, temps de neige	65x100	"	26-03-91	3 000	Thiébaut	6-04-91	4 500
Rivière et maisons	54x65	G. Sortais	27-05-91	1 400	Chavane	1-06-91	2 200
Poste des douaniers à Pourville [W. 742]	58x71	Bessemans	6-06-91	2 100	Lulling	31-08-91	3 200
Nature morte, faisans [W. 551] (22)	87x67	Hôtel des Ventes	10-06-91	1 890	Lonquety	23-11-92	3 400
Meules, effet de gelée blanche	65x100	l'artiste	17-07-91	3 000	Chavane	14-08-91	4 000
Les tulipes [W. 1068]		C. Ferris Thomson	31-08-91	2 550	Montaignac (G. Petit)	31-08-91	2 900
Meules, effet de printemps	65x91	l'artiste	26-09-91	3 000	Lulling	31-08-91	4 300
Creuse, soleil couchant [W. 1226]	73x73	"	"	2 500	Valadon	8-02-92	3 000
Vue générale d'Antibes [W. 1173]	66x81	"	21-10-91	2 500	Eastman Chase (N.Y.)	30-12-91	5 200 ($1 000)

TITRE	DIMENSIONS	ACHETÉ A	DATE	PRIX[174]	VENDU A	DATE	PRIX
Bateau à Argenteuil [W. 372]	59x79	[racheté à Lulling?]	31-12-91	1 200	H. Whitmore [Whittemore] (N.Y.)	21-05-93	5 200 ($1 000)
Moulin de Limetz	90x72	,,	,,	1 900	Potter Palmer (N.Y.)	10-05-92	6 000
Poste des douaniers à Pourville [W. 742]	58x71	,,	,,	2 100	Potter Palmer (N.Y.)	30-11-92	5 200 ($1 000)
Meules, neige	65x91	[racheté à Oppenheim ?]	,,	3 000	H. Whitmore [Whittemore] (N.Y.)	14-12-92	6 500 ($1 250)
Trois peupliers, effet violet	92x73	l'artiste	8-01-92	3 750	G. J. Seney (N.Y.)	21-02-92	6 500 ($1 250)
Trois peupliers, effet rose	92x73	,,	,,	3 750			
Trois peupliers, effet d'automne [W. 1306]	92x73	,,	,,	3 750			
Marine, falaise [W. 731]		S. P. Avery (à N.Y.)	4-01-92	1 100	Seney (à N.Y.)	26-02-92	6 500 ($1 250)
Rangée de peupliers [W. 1293]	100x65	l'artiste	8-01-92	3 750	Potter Palmer (N.Y.)	9-03-92	6 500 ($1 250)
Jeune femme faisant tapisserie [W. 366]		Bernheim-Jeune	8-02-92	1 600	Gallimard	8-02-92	2 500
Route, effet de neige	53x64	E. Duez	15-02-92	2 500	Gallimard	24-12-92	3 500
PISSARRO							
Paysage	24x17	Nicolas	29-03-84	125	Guyotin	29-03-84	150
Récolte des foins [P. 713]	65x50	l'artiste	8-08-87	400	Aubry	8-08-87	600
Marché de Pontoise [P. 576]	80x65	,,	15-12-87	340	Guyotin	15-12-87	400
Cueillette des pommes [P. 726]	61x73	,,	18-03-88	300	Desfossés	26-07-89	400
Maison de paysan [P. 710]	61x73	,,	,,	300	Dupuis	10-03-88	500
Paysage, plein soleil [P. 709]	55x65	,,	17-03-88	300	Buglé [Bouglé ?]	22-11-88	600
Vue de Pontoise [P. 210]	51x79	Durand-Ruel	9-04-88	500	A. Young (Londres)	9-06-91	1 500 (ou 1 200)
Rouen, effet de brouillard [P. 719]	40x45	l'artiste	22-11-88	300	Dupuis	29-06-89	400
Troupeau, soleil couchant [P. 736]	60x72	l'artiste	24-06-89	300	Dupuis	24-06-89	400
Prairie à Eragny [P. 733]	60x72	,,	26-07-89	300	Desfossés	26-07-89	400
Matin d'automne	60x72	,,	,,	300	E. A. Walcott (N.Y.)	14-03-92	1 500 ($300)

TITRE	DIMENSIONS	ACHETÉ A	DATE	PRIX[174]	VENDU A	DATE	PRIX
Paysage à Auvers [P. 512]	60x72	,,	,,	300	Oppenheim	3-01-90	600
Glaneuses [P. 730 ?]	65x81	,,	28-09-89	620	Buglé [ou Bouglé ?]	27-09-89	800
Gardeuse d'oies couchée [P. 1398]	80x63	,,	16-11-89	800	Gallimard	13-11-89	550
Prairie à Saint-Charles [P. 732 ?]		,,	1-03-90	900	Buglé [Bouglé ?]	1-03-90	500
Les faneuses [P. 729]	62x74	,,	8-03-90	900	Thiébault	8-03-90	1 500
Paysanne gardant ses chèvres (dé-trempe)		,,	22-03-90	600	Gallimard	22-03-90	800
Meule et moutons		,,	28-03-90	750	Dr Marcigny	28-03-90	1 000
Champs à Eragny [avec laboureur]	55x72	,,	25-09-90	600	Dupuis	25-09-90	800
The Serpentine à Londres [P. 744]	55x72	,,	18-10-90	650	Serven [?]	17-01-91	800
Pont à Charing Cross [P. 745] *(21)*	60x92	,,	,,	650	Elkins (N.Y.)	23-11-91	3 380 ($650)
Ramasseurs de pommes de terre [P. 755]	65x80	,,	18-10-90	650	D. Fitzgerald	21-11-92	1 820 ($350)
Gardeuse d'oies couchée		Gallimard	17-01-91	400	Potter Palmer (N.Y.)	9-03-92	2 600 ($500)
Soleil couchant à Eragny	65x81	l'artiste	8-01-92	800	A. A. Pope (Cleveland)	11-10-93	1 820 ($350)
Sente de la justice à Pontoise (23)	52x81	,,	,,	900			
Pommiers en fleurs à Bazincourt	80x73	,,	,,	700	Chavasse (Cette)	21-06-95	1 500

REDON

TITRE	DIMENSIONS	ACHETÉ A	DATE	PRIX[174]	VENDU A	DATE	PRIX
Vierge d'Aurore (13)	66x45	l'artiste	5-05-90	100 [sic]	E. Chausson	2-05-90	400

RENOIR

TITRE	DIMENSIONS	ACHETÉ A	DATE	PRIX[174]	VENDU A	DATE	PRIX
Jardin	50x62	Pottier	18-04-85	450	Desfossés	14-04-85	350
Canotiers [D. 305] *(4)* [54x65]	50x32	Legrand	21-11-87	200	Guyotin	22-11-87	2 600
Vue de Naples (9)	60x81	Inglis	18-07-88	275 (ou 270)	Durand-Ruel (à N.Y.)	24-12-91	
Vue d'Italie		Durand-Ruel (N.Y.)	30-12-91	3 640 ($700)	Eastman Chase (N.Y.)	30-12-91	4 600 ($900)
Vue du Mourillon		l'artiste	12-01-92	600	C. Lambert (N.Y.)	19-02-92	1 850 ($300)

TITRE	DIMENSIONS	ACHETÉ A	DATE	PRIX[174]	VENDU A	DATE	PRIX
SISLEY							
Hiver	55 x 42	l'artiste	20-03-85	300	Desfossés	20-03-85	400
Premiers jours d'Automne [D. 648]	66 x 92	„	14-05-87	700	G. Viau	20-06-95	1 000
Plateau de Roche Contart	54 x 73	„	22-06-87	500	Chapuy	11-06-91	700
La maison abandonnée [D. 652]	54 x 73	„	„	500	Widener (N.Y.)	23-11-91	2 000 ($500)
La Seine [D. 314] (3)	65 x 54	Dubourg	13-08-87	225	Aubry	10-08-87	325
Vue de Chatou	55 x 45	Legrand	21-11-87	125	Guyotin	22-11-87	200
Moret	55 x 45	„	„	145	„	„	200
La Seine	50 x 40	„	„	145	„	„	150
Porte de Bourgogne		Haseltine (N.Y.)	12-02-92	1 400 ($300)			
Marine		„	„	390 ($75)			
La route [D. 570]	[60 x 73]	„	„	390 ($75)	E. A. Walcott	14-03-92	1 500 ($300)
TOULOUSE-LAUTREC							
Tête d'étude	65 x 53	l'artiste	12-10-88	200	Dupuis	11-10-88	350
Coin du Moulin de la Galette		„	6-06-91	375	Chavanne	1-06-91	500
La Goulue entre deux valses [D. 422/423]	[80 x 60]	„	5-07-92	300	Zidler	5-07-92	400

APPENDIX II

INDEX OF SOME OF THE COLLECTORS AND DEALERS WHOSE NAMES APPEAR IN THE GOUPIL LEDGERS

The Goupil records often spell names inaccurately, which makes identification difficult. Where no further information could be gathered, this index merely gives the address as provided by the ledgers.

Further details on many American collectors can be found in H. Huth, 'Impressionism Comes to America,' *Gazette des Beaux-Arts*, Apr. 1946.

ADAM, Hyppolyte. Banker in Boulogne. Had four daughters; commissioned Renoir to do portraits of two of these in 1887. In 1891 invited Renoir to his estate in Lavandou. Collection divided among his daughters, eventually disposed of by them and their children.

ARNOLD & TRIPP. Paris art dealers and experts; had an exclusive contract with the painter Harpignies.

AUBRY, P. Paris collector. Posthumous (and anonymous) sale of his collection at Petit's, May 12, 1897. Included, among others, 13 paintings by Jongkind, 11 by Sisley, and 5 by Monet, but not the work by Pissarro acquired from Theo van Gogh in Aug. 1887. Monet's *Umbrella Pines, Cap d'Antibes (8)*, bought for 2,800 francs, brought 6,300; his *Antibes, View of Salis*, acquired for the same price, fetched 7,500 francs, and Sisley's *The Seine* [at Suresnes] *(3)*, which had cost 150 francs in Aug. 1887, was knocked down for 2,350. Nevertheless, both Monet and Durand-Ruel were disappointed with the results of this auction.

AVERY, Samuel P. Important New York art dealer, first at 86 Fifth Avenue, later at number 368. Acted as William H. Vanderbilt's adviser. Bequeathed a fine collection of modern prints to the New York Public Library.

BELLIO, Georges de. Rumanian collector established in Paris, 2, rue Alfred Stevens. Personal friend of most of the Impressionists from whom he often bought directly, particularly when they needed help. Acquired two works by Gauguin at the latter's 1891 auction. Part of his collection bequeathed by his daughter, Mme Donop de Monchy, to the Musée Marmottan, Paris. See R. Niculescu, 'Georges de Bellio, l'ami des impressionnistes,' *Paragone*, nos. 247 and 249 (1970).

BERNHEIM-JEUNE (Bernheim-fils). Art dealers and experts, established in Paris, rue Laffitte, since 1878. Later also publishers; the gallery still exists.

BESSEMANS. 31, rue Victor Massé, Paris.

BLANCHE, Jacques-Emile. Painter, son and grandson of famous alienists. Born in 1861; supposedly bought works by Monet cheaply from Durand-Ruel in 1886. In 1888 acquired an important painting by Degas from Theo van Gogh. Became well known as painter of portraits of celebrities and wrote several volumes of articulate recollections and critical essays.

BLOT, Eugène. Parisian collector, 48, rue des Archives. Became a dealer in 1907; his son later succeeded him. Friend of Guillaumin, with whom he signed a contract. At first important sale of his collection, comprising 244 lots, May 9–10, 1900, prices were so low he had to buy in a great many of the works, among them Cézanne's *Blue Vase*, now in the Louvre. A second auction was held on May 10, 1906; a third, on June 2, 1933; and a last, posthumous one on Apr. 23, 1937. Wrote a small volume of recollections, *Histoire d'une collection de tableaux modernes* (Paris, 1934).

BOCH, Anna. Belgian painter, member of the Brussels group Les Vingt. In 1889 bought a painting by Gauguin from Theo van Gogh, and in 1890 acquired a canvas by Vincent. Her brother, Eugène Boch, also a painter, visited Vincent in Arles in 1888 and sat for his portrait (now in the Louvre). He later helped Gauguin after Theo became ill.

BOGGS, Frank M. American painter (1855–1926) who settled in Paris in 1881 and became a French citizen. Exchanged a painting of Honfleur with Vincent and bought a work by Manet from Theo van Gogh.

BOIVIN. Collector; 64, rue de Lisbonne, Paris. Owner of a sugar refinery, he assembled an important collection of Impressionists, dealing directly with Sisley. Quite a few works by Monet and Degas are still owned by various descendants, though the important canvas by Degas *(2)* was sold around 1920.

BOUGLÉ (often spelled 'Buglé' in the ledgers). Collector; lent a painting by Pissarro to the exhibition of the artist organized by Theo van Gogh in 1890.

BOURGEOIS. 42, rue Blanche, Paris.

BRAME, Hector. Parisian art dealer. Specialized in the School of Barbizon; friend of Paul Durand-Ruel, often owned paintings jointly with him. Gallery still exists; directed by his son Paul until his death in 1971, and now his grandson, Philippe.

CAMENTRON & MARTIN. See under Martin.

CHAPUY. Picture restorer.

CHAUSSON, Ernest. Composer; collector; friend of Degas and especially Redon. Posthumous sale of his collection held in Paris, June 5, 1936, but still life by Gauguin and Redon's *Vierge d'Aurore (13)* which he had purchased from Theo van Gogh, not included.

CHAVASSE, Jules (Cette). Collector. Bought two paintings by Gauguin at the artist's 1891 sale. The Jules Chavasse sale of June 22, 1922, included 12 works by Redon, 1 by Renoir, and several sculptures by Rodin, but none of the paintings acquired from Theo van Gogh. (The ledgers also list a buyer named Chavane.)

CHÉRET, Jules. Painter. Famous for his posters; no trace of his collection can be found.

CLAPISSON, Léon-Marie. Parisian stockbroker and collector. From 1872 friendly with Renoir who painted his portrait in 1883. Lent a gouache by Pissarro to the Impressionist group show of 1881. Collection

sold anonymously at the Hôtel Drouot, Apr. 28, 1894; catalogue lists Gauguin's *Fishermen* but not Monet's Belle-Isle landscape acquired from Theo van Gogh. There were, however, 3 other works by Monet, 3 by Renoir, 8 by Sisley, and 1 gouache by Pissarro, dated 1885.

DESFOSSÉS, Victor. Important Parisian collector. Lent a painting by Pissarro to the artist's exhibition organized by Theo van Gogh in 1890. Posthumous sale of his collection on Apr. 28, 1899, featured 4 paintings by Monet, 3 by Pissarro, and 1 by Sisley, which, however, were not all the works he had purchased from Theo van Gogh. Small sale after the death of his widow, held in Paris on May 6–7, 1929, contained nothing of interest. On the Desfossés collection, see the special chapter in G. Lafenestre, *Artistes et amateurs* (Paris, n.d. [*c.*1900]), pp. 326–41.

DOWDESWELL & DOWDESWELL. Art dealers in London. Worked closely with Durand-Ruel, who in 1883 organized an Impressionist exhibition in their galleries.

DRAKE DEL CASTILLO. Collector, lived in the outskirts of Paris. Owned a work by Degas (L. 820), now in the Courtauld Art Galleries, University of London.

DUBOURG. Rue St-Roche, Paris. Started as framer. His son worked for Georges Petit before opening his own gallery, boulevard Haussmann, which he directed until his death *c.*1980.

DUEZ, Ernest. Painter, 29, boulevard Berthier, Paris. Friend of Manet's; lent a painting by Monet to the Impressionist group exhibition of 1879.

DUPUIS (sometimes erroneously spelled 'Dupuy'). Possibly Theo van Gogh's most important client, committed suicide late in 1890 because he thought himself ruined. On his collection and the group of his pictures sold anonymously on June 10, 1891, see pp. 76–79.

DURET, Théodore (1838–1927). Journalist, art critic, and collector; historian and personal friend of the Impressionists; 20, rue des Capucines, Paris. First sale of his collection held Mar. 19, 1894, but as early as

1889 he sold two paintings by Monet to Theo van Gogh.

ELLISSON, Mme. 205, boulevard St-Germain, Paris.

FAURE, Jean-Baptiste. 52, boulevard Haussmann, Paris. Famous baritone at the Paris Opera. Since 1861 assembled, on the advice of Durand-Ruel, an important collection of modern paintings, obtained mostly at extremely low prices. A first auction, mainly of his Barbizon pictures, was held on June 7, 1873; a second sale took place on Apr. 29, 1878. According to a note by Philippe Burty (courtesy the late Jean Diéterle), Faure, for this last sale, had obtained in advance a guaranteed minimum from the experts Brame and Petit, but the results fell far short of expectations. Many of the works, quite a few of which had to be bought in, were mediocre, except for 11 Corots, 3 Manets, and a group of Jongkinds.

Faure continued to collect, with special emphasis on Manet, who painted several portraits of him. He eventually made his collection accessible to choice visitors. Durand-Ruel later promoted the Faure collection and sold part of it through various exhibitions, such as one held Mar. 1906 in Paris, *17 Tableaux de Claude Monet de la Collection Faure*, but Monet's *Hoarfrost*, which the singer had purchased from Theo van Gogh, was not included. That same year Durand-Ruel also showed 24 Manets from Faure's collection; this exhibition subsequently traveled to London, Berlin, and Stuttgart, with the number of works decreasing as pictures were sold. Faure was then 77 years old, which may explain why he began to dispose of his collection, for it seems that he was not in need of money.

See Anthea E. Callen, 'Jean-Baptiste Faure, 1830–1914: A Study of a Patron and Collector of the Impressionists and their Contemporaries' (Master's thesis, University of Leicester, 1971). On Faure and Manet, see *Gazette des Beaux-Arts*, Mar. 1974.

FITZGERALD, Desmond. American collector. Bought Impressionist works from the first exhibition organized by Durand-Ruel in New York, 1886; wrote preface for a show which Durand-Ruel held in Boston, Mar. 1891 (comprising works by Monet, Pissarro, and Sisley). Posthumous sale of his collection, New York, Apr. 21–22, 1927, included 9 works by Monet, 2 by Sisley, and 1 each by Degas, Pissarro, and Renoir.

FORBES. London art dealer, former employee of Goupil, and British client or agent for Durand-Ruel, as well as Arnold & Tripp. His stock of some 20 important paintings was bought in 1896 and split into three shares by Glaenzer, Chatain, and Boussod & Valadon.

GALLIMARD, Paul. 79, rue St.-Lazare, Paris. Particularly friendly with Renoir and Carrière. He assembled an important collection of modern paintings, the bulk of which was sold privately after his death by his three sons. One of these, Gaston, founded the famous publishing house.

GARNIER, Henri. Parisian art dealer.

GAUTIER, Amand. Painter, 22, rue Tourlaque, Paris. Friend of Dr Gachet in Auvers-sur-Oise; particularly close to Courbet, whom he greatly admired.

GILLET. Important industrialist and collector in Lyons.

GILLOT. Collector. 79, rue Madame, Paris.

GOUPY, G. Collector, 10, rue Charlot, Paris. The sale of his collection took place Mar. 30, 1898, featuring 5 paintings by Monet (3 of which were purchased from Theo van Gogh), 1 by Degas (not the one acquired from Theo van Gogh), 2 by Manet (1 of which came from Theo van Gogh), 3 each by Pissarro and Guillaumin, and 1 each by Renoir and Sisley.

GUILLEMARD. Rue de Courcelles, Paris.

GUYOTIN. 'Marchand-amateur.' Rue Grange-Batelière, Paris.

HEILBUT or HEILBUTH. Bought 2 works by Monet and 2 by Degas from Theo van Gogh. Identity difficult to establish. A well-known painter, Ferdinand Heilbuth, apparently of Austrian origin, lived in Paris, rue Ampère. The contents of his studio and his collection were sold at the Hôtel Drouot on May 19–21, 1890 (but two of the purchases from Boussod & Valadon were made *after* that date). There was also a Heilbuth domiciled in Hamburg,

and a Danish businessman, Paul Herman Heilbuth, born 1861, who began by collecting mostly old masters. He apparently was too young to be a client of Theo van Gogh's and acquired whatever Impressionist paintings he owned well after the turn of the century (information courtesy Hanne Finsen, Copenhagen).

HEYMANN. Paris art dealer, friend of Portier's; dealt with Degas and Monet; Pissarro's relations with him were rather unsatisfactory.

HULBUT. 102, rue de Grenelle, Paris. (Identical with Heilbut?)

INGLIS, James S. American dealer associated with Cottier & Co., New York.

JOHNSON, John G. Important American collector; collection bequeathed to the Philadelphia Museum. Concentrated mostly on old masters but also owned 3 works by Degas, 2 by Monet, and 1 each by Pissarro and Sisley, as well as a painting by Vincent van Gogh of doubtful authenticity. There exists a catalogue of his collection published by the Philadelphia Museum.

LAMBERT, Catholina. New Jersey collector at whose sale, Feb. 21–24, 1916, appeared 8 paintings by Sisley, 7 by Pissarro, 6 by Monet, 4 by Renoir, 3 by Boudin, and no fewer than 29 by Monticelli, whose personal friend he had been.

LA ROCHEFOUCAULD, Comte Antoine de. Rue Fortuny, Paris. Painter and collector who for several years supported Emile Bernard and subsidized the Rosicrucian movement. Was among the bidders at Gauguin's 1891 auction, his address then being 18, boulevard des Invalides. (There was also a Comte Aymar de La Rochefoucauld, a painter who in 1873 exhibited at Durand-Ruel's.)

LAWRENCE, Cyrus J. New York collector, bought paintings from the first Impressionist exhibition organized by Durand-Ruel in New York, 1886. Posthumous sale at the American Art Galleries, New York, Jan. 21, 1900, included 5 paintings by Monet, among them *Edge of the River, Winter* [*Vétheuil, Winter*], purchased in Dec. 1891 for 3,300 francs ($634), which brought $2,650. Another canvas by Monet reached

$4,600, a price considered sensational. Also owned 2 works each by Pissarro and Sisley.

LECLANCHÉ, Maurice. Early Parisian collector of Impressionists. Bought a work by Gauguin at the artist's second auction sale of 1895.

LEGRAND. 40, rue Blanche, Paris; a dealer at 122 bis, rue Laffitte. As early as 1876 lent one painting each by Renoir and Sisley to the second Impressionist group exhibition. As a competitor of Durand-Ruel worked closely with Goupil in Paris and Knoedler in New York.

LEROLLE, Henry. Painter and collector, close friend of Renoir and Degas, many of whose important works he owned. Renoir did several likenesses of his two daughters, Yvonne and Christine, who later married two sons of Degas's intimate friend Henri Rouart (a third Rouart son married Julie Manet, daughter of Berthe Morisot and niece of Manet). Representative of a special type of highly cultured *haute bourgeoisie* in France, with a keen interest in and independent taste for painting, music, and literature, though his own work was rather conservative. See M. Denis, *Henry Lerolle et ses amis* (Paris, 1932).

MANCINI. 9, rue Chaptal, Paris (this is the address of the Goupil printing shop).

MANZI, Michel (1849–1915). Draftsman, engraver, printer, and eventually art dealer in Paris, 9, rue Forest. Of Italian origin, from 1881 directed Goupil's print shop for reproductions. In 1893 associated with Maurice Joyant, Theo van Gogh's successor at Boussod & Valadon, under the name Manzi & Joyant. Friend of Degas, who did his portrait (L. 995). Private collection auctioned in 1919 (Mar. 13–14), contained many works by Degas and Lautrec, as well as 1 painting each by Manet and Pissarro, also Gauguin's *Ia Orana Maria* (now in the Metropolitan Museum, New York), but none of the pictures he had bought from Theo van Gogh or acquired at Gauguin's auction of 1891.

MARTIN, Firmin. Associated with Camentron, rue Laffitte, Paris. Lent several landscapes by Sisley to the Impressionist exhibition of 1876. Pissarro preferred to deal

with Portier rather than Martin, who used to roam the Hôtel Drouot for cheap purchases. Bought the contents of Daumier's studio after the artist's death. Posthumous sale held Apr. 4–7, 1892.

MIRBEAU, Octave. Novelist, art critic, collector, untiring defender and friend of the Impressionists. Posthumous sale of his collection held Feb. 24, 1919; a second sale took place after the death of his widow (who apparently had bought in a number of works in 1919) on June 6, 1932. Mirbeau's frequently very aggressive writings on art have been assembled in two volumes, *Des artistes* (Paris, 1922). See also J.-H. Rosny Aîné, *Portraits et souvenirs* (Paris, 1945).

MONTAIGNAC, I. First employed by Georges Petit in whose gallery he played a role similar to that of Theo van Gogh at Goupil's. Later became the Paris representative of James F. Sutton, big art wheeler-dealer of New York, on whose behalf he worked closely with Durand-Ruel and Boussod & Valadon, among others. But after about 1891 began to deal directly with Monet and Pissarro. The posthumous sale of his collection was announced in Paris for Dec. 3–4, 1917, yet did not take place. The entire collection (including 5 works by Sisley, 4 by Pissarro, and 2 by Monet) was acquired by a group of Danish speculators and auctioned in New York, together with other pictures, on Apr. 6, 1922.

NUNÈS, Lionel. Parisian art dealer associated with Fiquet. A distant relative of Camille Pissarro, who frequently was critical of him in his letters to his son. Apparently did not enjoy an unblemished reputation. In 1886 lent a pastel by Guillaumin to the last Impressionist group exhibition.

PALMER, Potter. Important Chicago collector. His wife was a friend of Mary Cassatt, who helped her assemble one of the first and best selected collections of Impressionists in the United States. See on this subject, A. B. Saarinen, *The Proud Possessors* (New York, 1958), pp. 3–24.

PETIT, Georges. Parisian art dealer, most important and active rival of Durand-Ruel. As owner of a spacious and luxurious gallery at 8, rue de Sèze in the heart of Paris (between the Madeleine and the Opéra), he evinced an interest in the Impressionists at the end of their 'lean years,' once their works began to find a market. Thus he invited them to his yearly *Expositions Internationales*, organized a huge Monet-Rodin retrospective in 1889, and eventually managed to detach Sisley from Durand-Ruel. At the same time he also dealt in Salon painters and handled the works of many successful and fashionable artists of the period, rivaling Boussod & Valadon. He enjoyed the reputation of being a 'formidable salesman.' Most important Paris auctions (such as those of the Chocquet collection in 1899 and later of the Degas estate) were held on his premises because the Hôtel Drouot accommodations were insufficient. This fact only increased his rivalry with Durand-Ruel, since Petit did not care to have his competitor officiate as 'expert' at public sales held in his gallery.

As early as 1883, when Manet's heirs contemplated a public auction of the contents of his studio, the artist's mother objected to its being organized at Petit's: 'A plot is being hatched to put Petit in charge of selling the paintings. It would be supreme ingratitude not to assign this to Durand-Ruel, who was an admirer and the first purchaser of our dear Edouard. Petit did not like his paintings and never bought any from him. . . .' Finally, both Petit and Durand-Ruel presided over the Manet sale.

POIDATZ, Henri. Director of the influential Paris daily *Le Matin*. The pictures he purchased from Theo van Gogh seem to have been sold before his death in 1905; they did not appear in his estate.

POPE, Alfred A. American collector of Cleveland, Ohio, and Farmington, Conn. Friend of Harris Whittemore of Naugatuck, Conn., who had met Mary Cassatt in Paris and had assembled a distinguished collection. Whittemore encouraged Pope to buy Impressionist pictures; both were among the first collectors of modern French art in the United States. A chapter on Pope's collection appeared in J. La Farge and A. F. Jaccacci, *Noteworthy Paintings in American Private Collections* (New York, 1907); works by Cassatt, Daumier, Degas, Manet, Monet,

Puvis de Chavannes, Renoir, Whistler, and others are listed and described, though not one of the 3 Monets and the lone Pissarro *(23)* which he had purchased from Boussod & Valadon. Monet's *View of Cap d'Antibes* and *Haystacks, Sunlight* remained in the collection, now the Hill-Stead Museum, Farmington, Conn. (of which a catalogue exists). Monet's *Rocks at Belle-Isle*, the Pontoise landscape by Pissarro, as well as a number of other works were sold by Pope's daughter.

PORTIER, Arsène. Like Tanguy, a dealer in paints and paintings. Established in the rue Fontaine in Paris, at the corner of the rue La Rochefoucauld. Friend of Guillaumin's, he also did business with Pissarro and Degas. Lived at 54, rue Lepic, in the same building as the van Gogh brothers.

ROBERTSON, R. Austin (?). Agent for the American Art Association of James F. Sutton and associated with the latter. Pissarro once tried to explain to him—in English—the merits of Monet's work.

SAINSÈRE, Olivier. Prefect in the French provinces until assigned to duties in Paris, 1893. At that time began to visit art exhibitions and to assemble an outstanding collection of modern art. Eventually became *Conseiller d'Etat* and close collaborator of Poincaré's while the latter was president.

SENEY, George I. New York banker and collector of 'current pictures,' the authenticity of many of which was questioned on the occasion of a judiciary sale in New York in 1885. Rapidly remade a fortune and began to collect once more, buying several paintings at Durand-Ruel's first exhibition in New York, 1886. Bequeathed a painting by Lerolle to the Metropolitan Museum. See W. Towner, *The Elegant Auctioneers* (New York, 1970).

THIÉBAULT or THIÉBAUT. Owner of the famous Barbedienne foundry.

THOMSON, C. Ferris. Representative of Boussod & Valadon in London.

TRIPP. See Arnold & Tripp.

VANDERBILT, George V. American collector. In 1898 bought two paintings by Manet from Durand-Ruel, one of them, *Repose (Le Repos)*, now in the Museum of Art, Rhode Island School of Design, Providence.

VIAU, George. 47, boulevard Haussmann, Paris; dentist, collector, and personal friend of most of the Impressionists from whom he purchased directly. At the beginning of 1894 recommended Vollard—who had just opened a small gallery—to Pissarro. His first collection was sold in Paris on Mar. 4, 21, and 22, 1907. Formed a new collection, sold in two posthumous auctions in Paris, Dec. 11, 1942 (under the German occupation) and June 22, 1948.

VOLLARD, Ambroise. Dealer; appeared on the Paris art scene at a historic moment, to fill a recent void, after the death of both Theo van Gogh (1891) and *père* Tanguy (1893). Dealt with Boussod & Valadon as early as 1893, the very year he opened a small shop on the rue Laffitte where, in 1895, he organized the first one-man show of Cézanne, followed in 1897 by the largest Vincent van Gogh retrospective held until then in Paris. Also dealt in works of Gauguin, Renoir, and Degas, obtained directly from these artists; later turned to Picasso, Rouault, Bonnard, and other painters of the next generation. See his *Recollections of a Picture Dealer* (Boston, 1936).

WHITTEMORE, Harris. See under Pope, Alfred A.

WILLIAMS & EVERETT. Art dealers in New York.

WOLFF, Albert. 65, rue du Rocher, Paris. Journalist and 'very Parisian' art critic, extremely hostile toward the Impressionists whom he attacked with vicious irony. Characterized by Pissarro as 'influential, brazen, and insolent.' Mirbeau never let pass an occasion to express his utter contempt for this opportunist.

YOUNG, A. Picture dealer in London.

NOTES

This study could not have been written without the generosity and patience of the late Jean Diéterle, Paris, who not only gave me access to the records of the Goupil galleries (Boussod & Valadon Successeurs), but, despite his great age, untiringly assisted me throughout my research and answered countless queries, drawing on a wealth of knowledge that he may have been the last, and only one, to possess. The co-author of a supplement to the catalogue of Corot's paintings by A. Robaut, M. Diéterle worked in his early years with the art dealer Le Roy, who occasionally bought pictures together with the Boussod & Valadon gallery. When the last member of the Boussod family, owner of the majority of the firm's stock, died in January 1918, the partnership was liquidated and Le Roy obtained, among others, the Goupil–Boussod & Valadon ledgers. They later passed into the hands of M. Diéterle when he succeeded Le Roy.

After his father's recent death, M. Pierre Diéterle was equally obliging. M. Charles Durand-Ruel, Paris, provided supplementary information from the archives of the firm founded by his grandfather. Theo van Gogh's son, the late Ing. Dr V. W. van Gogh, Laren, most kindly communicated unpublished documents from among his father's papers, as did the late Arï Redon, Paris, who transcribed entries from his father's account books concerning Theo van Gogh. I am also indebted to M. Pierre Angrand, Paris, for what was then a still-unpublished letter by Vincent van Gogh to his uncle Charles Angrand; to M. Denis Rouart, Paris, for information concerning his grandmother Berthe Morisot; to Mrs Merete Bodelsen, Copenhagen, for the minute care with which she read the passages concerning Gauguin and his work; to Mark Roskill, Amherst, Mass., who also helped with the identification of Gauguin's paintings; to M. François Daulte, Lausanne, for information relating to the paintings of Renoir and Sisley handled by Theo van Gogh; to M. Daniel Wildenstein and the staff of the Wildenstein Foundation, Paris, for data on Monet and photographs of his work; to Mme M.-J. Chartrain-Hebbelinck, Brussels, for the communication of still-unpublished documents from the archives of Octave Maus; to John Richardson, New York, for the records of the Henry Hill sale at Christie's in 1889; to Robert Ratcliffe, London, John House, London, and especially Mrs Anthea E. Callen, Leicester, England, for information concerning the Monet exhibition in London in 1889; to the late Helmut Ripperger, chief librarian of the Knoedler Galleries, New York, and his staff, who were helpful in many ways. Finally, I owe a profound debt of gratitude to the late Ludovic-Rodo Pissarro who, around 1937, gave me access to his father's papers where I found the unpublished letters of Theo van Gogh to Camille Pissarro. I am also indebted to Prof. Lee Johnson for his help.

Not all the facts related here are unknown, of course. A number of documents concerning Theo van Gogh and his activity as art dealer have already appeared in print or were first published in my *Post-Impressionism: From van Gogh to Gauguin* (New York, 1956). However, in order to round out the present account, based primarily on the Goupil records, it seemed advisable to include here all the pertinent material, particularly since some of it may appear in a different light when seen in this specific context.

Some of the documents, still unknown when this study first appeared, have since been published in various forms. This applies particularly to Gauguin's letters to Vincent, Theo, and Johanna van Gogh, edited by Douglas Cooper in 1983. However, since quotes from these letters constitute one of the major contributions of the late Ing. Vincent W. van Gogh to this essay, it appeared justified to maintain the original form of the notes, referring in each case to an 'unpublished document, courtesy Ing. Dr V. W. van Gogh, Laren.'

1. H. Lauzac, *Goupil* (Paris, 1864); reprinted in *Verzamelde Brieven van Vincent van Gogh* (Amsterdam, 1954), 4: 302–4. See also, the entry on Goupil in G. Vapereau, *Diction-naire universel des contemporains* (Paris, 1870), p. 790. For a photograph and short biography of Adolphe Goupil (1806–93) see the catalogue of the J.-L. Gérome exhi-bition, Vesoul, 1981, p. 168. This text, however, confuses the painter van Gogh with his namesake and uncle. The sale of the latter's collection took place in 1889: Coll. de feu *Vincent van Gogh de Princenhage, ancien associé de la maison Goupil & Cie.*, The Hague, Apr. 2–3, 1889.

2. See Foreword by Charles R. Henschel (grandson of Michel Knoedler) in *Catalogue of an Exhibition . . . on the Occasion of Knoedler One Hundred Years, 1846–1946* (New York, Apr. 1946). According to Henschel, the New York gallery was established in 1846 rather than 1848. J. A. Kouwenhoven, *The Columbia Historical Portrait of New York* (New York, 1953), p. 187, reports that in the late 1840s Goupil & Co. of New York published a series titled *Views of American Cities*. Goupil also established an International Art Union which seems to have been inspired by the American Art Union founded in 1840. This latter organization was dedicated to distrib-uting reproductions of paintings to a wide public. With the membership fees of $5.00 a year the Union bought pictures to be engraved for distribution; at the end of each year a lottery was held for members with the original paintings as prizes. The Union was highly successful until the courts stepped in with anti-lottery injunctions in 1850.

3. Albert Goupil not only accompanied his brother-in-law Gérome on his trips to Africa, but also avidly collected Oriental trappings. He occupied a sumptuous home at 7, rue Chaptal, next to the firm's printing shop, with lavish Moresque rooms that may have been used by the painter as backdrop for his elaborate scenes of Moroccan harems and interiors. See the catalogue of the posthumous sale of Albert Goupil's col-lection, furnishings, etc., Paris, Apr. 28, 1888.

4. Article reprinted in L. Venturi, *Archives de l'Impressionnisme* (Paris, 1939), 2: 323.

5. See catalogue of the exhibition *High Class Continental Pictures by Modern Artists*, London, Goupil, 25 Bedford Street, Strand, May 1876.

6. Information courtesy the late Ing. Dr V. W. van Gogh, Laren.

7. For some of the collectors and dealers named in this article or in the firm's ledgers, see Appendix II.

8. Portier, a friend of Guillaumin's, was a dealer to whom Theo had entrusted some of the paintings Vincent sent him from Holland, in the vain hope that he might be able to sell them. When, in 1886, Theo and his brother moved to 54, rue Lepic, on the slope of Montmartre, Portier lived in the same building.

9. Vincent van Gogh to his sister Wil [Arles, June–July 1888], no. W. 4. The numbers of the letters are those established in *Verza-melde Brieven* (see note 1) and in subsequent American and French editions. With some exceptions, the translations given here are taken from *The Complete Letters of Vincent van Gogh*, 3 vols. (Greenwich, Conn., [1958]).

10. This painting cannot be identified; Boggs's name is listed neither in P. Jamot, G. Wildenstein, G. Bataille, *Manet* (Paris, 1932), nor by A. Tabarant, *Manet et ses oeuvres* (Paris, 1947), or D. Rouart and D. Wildenstein, *Edouard Manet* (Lausanne-Paris, 1975).

11. It would seem that the bookkeeper or bookkeepers (there are different handwrit-ings) recorded acquisitions whenever pur-chase slips were handed in by the personnel, foreign purchases being transcribed with some delay as the information reached the Paris office. Transactions were listed in the following order: 1. Stock number; 2. title of work [not always accurate]; 3. dimensions [not always available and sometimes in-correct; no indications of height or width are ever given]; 4. name of the artist; 5. date of purchase; 6. purchase price; 7. sale price [both amounts were coded, the key to the code being the word

PRECAUTION

1 2 3 4 5 6 7 8 9 0

with x and z frequently used for additional zeros; sometimes costs of frames and other incidentals, as well as depreciations, are also mentioned]; 8. where or by which branch sold to whom [names of purchasers often being misspelled]; 9. from whom acquired, with indication of branch; 10. date of sale. Where no date of sale and no purchaser are indicated, the transaction is recorded in a subsequent ledger with mention of the stock number (pp. 38–43).

For greater clarity, a different sequence has been adopted for the transcription of these records in Appendix I.

Mrs Bodelsen has pointed out to the author that these ledgers represent the firm's stock books, which were only one of several records usually kept by art dealers. The gallery doubtless also had a *journal* reporting the day-by-day business, such as consignments and the dates they were withdrawn. In addition, Theo must have kept the customary *grand livre*, in which each artist had a column of his own, registering sales, payments, and advances. These records do not seem to have survived. But the unexplained numbers at the extreme left of the ledgers may refer to page numbers in such books.

As long as a painting had not been sold, the title and stock number were not crossed out. When the firm finished with one stock book and started another, the unsold paintings were naturally transferred to the new book.

12. Their collection, now part of the Rijksmuseum Vincent van Gogh, Amsterdam, contains two paintings by Frank Boggs (1855–1926), both dedicated to Vincent; see *Collectie Theo van Gogh*, Stedelijk Museum, Amsterdam, 1960, nos. 21 and 22.

13. Angrand did not agree to the exchange; his picture is now in the Ny Carlsberg Glyptotek, Copenhagen. See Rewald, *Post-Impressionism*, pp. 48–49.

14. See B. Welsh-Ovcharov, *Angrand and van Gogh* (Utrecht–The Hague, 1971), p. 38.

15. See M. Joyant, *H. de Toulouse-Lautrec* (Paris, 1926), pp. 120–21.

16. Monet to Paul Durand-Ruel, May 13, 1887; see Venturi, *Archives*, 1: 325–26.

17. Monet to Paul Durand-Ruel, Mar. 22, 1892; ibid., p. 344.

18. Camille to Lucien Pissarro, May 9, 1891; see Camille Pissarro, *Lettres à son fils Lucien* (Paris, 1950), p. 243; English edition (New York, 1943), p. 168.

19. Though this is not generally known, Durand-Ruel did *not* have any written contracts with his painters, their relationships being based on oral agreements and mutual confidence. Only Puvis de Chavannes once insisted that the dealer sign some papers, when he feared that Durand-Ruel might come to harm during his expeditions to America and that his pictures might be seized by creditors or otherwise lost. (Information courtesy M. Charles Durand-Ruel, Paris.) Under these circumstances nothing prevented the artists from selling elsewhere, especially when Durand-Ruel found himself unable to make promised payments.

20. Unpublished documents, courtesy the late Ing. Dr V. W. van Gogh, Laren.

21. Vincent to Theo van Gogh [Arles, May–June 1888], no. 493. (On the other hand, Theo did not purchase any works by Degas for his own collection.)

22. Gauguin to his wife [Paris], Dec. 6, 1887; see *Lettres de Gauguin à sa femme et à ses amis* (Paris, 1946), p. 121, no. LIX (here newly transcribed from the original).

23. Vincent van Gogh to Gauguin [Arles, Sept.–Oct. 1888], no. 544 a.

24. Vincent to Theo van Gogh [Arles, June 1888], no. 500.

25. See *Tableaux Aquarelles et Dessins de l'Ecole Moderne: Vente par suite de renouvellement de l'ancienne Société Goupil et Cie, Avec le concours de MM. Boussod, Valadon & Cie.*, Paris, May 25–27, 1887.

26. 'It may be from the excellent Mauve that I have inherited an unlimited admiration for Meissonier,' Vincent wrote to Aurier. [St-Rémy, Feb. 12, 1890], no. 626 a.

27. See L.-R. Pissarro and L. Venturi, *Camille Pissarro: Son art, son oeuvre* (Paris,

1939); these fans were probably nos. 1638–1640, all dated 1887.

28. All letters from Theo van Gogh to Camille Pissarro are unpublished documents, courtesy the late L.-R. Pissarro.

29. See Lucien Pissarro's letter to his father, Paris, Mar. 12, 1888; Pissarro, *Lettres*, p. 166, French ed. This fan was no. 1640 of the group referred to in note 27.

30. F. Fénéon, 'Calendrier de décembre 1887'; reprinted in F. Fénéon, *Oeuvres plus que complètes* (Geneva, 1970), 1: 90.

31. See Fénéon, 'Calendrier de janvier [1888]'; reprinted Fénéon, *Oeuvres*, pp. 95–96. Fénéon's descriptions make it possible to identify Nos. 1089, 1008, 1010, and 891 of P.-A. Lemoisne, *Degas et son oeuvre* (Paris, 1946), vol. 3, as among the works shown; despite the dates assigned to them by Lemoisne, all must obviously have been executed before 1888.

The identification of Gauguin's copies after works exhibited in 1888 as well as the redating of these works by Degas is provided by M. Bodelsen, 'Gauguin the Collector,' *Burlington Magazine*, Sept. 1970, p. 612, Appendix A.

32. Gauguin to his wife [Paris, end of Dec. 1887]; Gauguin, *Lettres*, p. 123, no. LX (here dated differently).

33. See R. Huyghe, *Le Carnet de Paul Gauguin* (Paris, 1952); the list appears on pp. 222–28 of the facsimile of the sketchbook; the last entry was made after Gauguin's auction sale of Feb. 22, 1891. (The original sketchbook now belongs to the Israel Museum, Jerusalem, gift of Sam Salz.)

It is unfortunately impossible to establish with certitude *which* Martinique painting Theo acquired for 400 francs. The brothers owned two Martinique pictures; one (W. 222) *(5)* was exchanged for a work by Vincent and is unmistakably described by him in a letter to his sister (no. W. 5); the other (W. 224), the largest of Gauguin's Martinique compositions with figures, seems to correspond exactly to Vincent's description—in the same letter—of the painting Theo had acquired for 400 francs, a price confirmed in letter no. 561 to Theo. Yet Gauguin repeatedly mentioned a 'large

landscape with figures from Martinique' for which he expected the unusually high price of 1,500 francs and against which he had borrowed 300 francs from Theo. In his *carnet* Gauguin lists *separately* the picture sold to Theo for 400 francs, the one swapped with Vincent, and the 300-francs loan from Theo. In 1894, in a letter to Theo's widow, Gauguin specifies once more, concerning the 'large painting from Martinique,' which she had taken to Holland, that it had *not* been sold to her husband who had merely advanced 300 francs on it. It appears difficult to reconcile the fact that a painting which Theo had purchased for 400 francs could be identical with one on which, according to Gauguin, he had allowed a 300-francs loan. However, there is no other *large* painting from Martinique, at least not with figures.

This riddle is not clarified by other references in Vincent's correspondence to the Martinique painting acquired by Theo. During the summer of 1888 Vincent tried to induce his affluent painter-friend John Russell to buy one of the Martinique pictures and recommended *Conversation* (*Négresses causant*; W. 227) which—strangely enough—he himself had not seen. But Russell had no time to inspect it at Theo's gallery and wrote to Vincent that he didn't much like Gauguin's work anyhow, adding 'That big one of yours unfortunately swamps in my *opinion*' (no. 501 b). Vincent thereupon suggested to his brother, 'If we prod Russell, perhaps he will take the Gauguin that you bought, and if there is no other way of helping Gauguin, what should be done?' (no. 516, with a lengthy discussion of the price, etc.). But nothing came of this project, possibly because Theo was unwilling to part with the picture. See also below, note 109.

34. This way of reaching the amount of 900 francs mentioned by Gauguin has been suggested by Mrs Bodelsen. See also below, notes 65 and 81.

35. In any case, the fact that Vincent had seen the picture is confirmed by his mentioning it in two letters to his sister Wil, written from Arles in Aug. 1888 (nos. W. 5 and W. 6), not only saying that Theo had bought it 'some time ago' from Gauguin, but

describing it in a way that indicates he knew the painting well.

36. Theo to Vincent van Gogh [Paris], Oct. 27, 1888, no. T. 3.

37. The sale of works 'offered by subscription' took place on Mar. 2 and 3, 1888, 'for the benefit of Mlle Marguerite Pillet' (daughter of the former auctioneer Charles Pillet). Among the donors were many artists, collectors, and dealers, though of modern painters there were only Pissarro, Seurat, Signac, and Dubois-Pillet. Seurat contributed a drawing catalogued under no. 82 as *Eden Concert (7)*, now in the Rijksmuseum Vincent van Gogh, Amsterdam. It is recorded as no. 688 in C. M. de Hauke, *Seurat et son oeuvre* (Paris, 1961), with the indication that it came from the artist's estate. This is clearly an error, since Theo van Gogh died several weeks *before* Seurat, and since Theo's purchase of the drawing is mentioned by Lucien Pissarro in a letter to his father of Mar. 12, 1888 (Pissarro, *Lettres*, p. 166, French ed.).

38. Vincent to Theo van Gogh [Arles, Mar. 10, 1888], no. 468. Vincent probably had seen the drawing, which had been exhibited at the Indépendants in Paris the previous year and was also reproduced in *La Vie Moderne* of April 9, 1887.

39. Vincent to Theo van Gogh [Arles, Mar.–Apr. 1888], no. 474.

40. See Vincent's letter to Theo van Gogh [Arles, Mar. 1888], no. 469.

41. Theo van Gogh quoted in Gauguin's letter to Emile Bernard [Arles, 1888]; Gauguin, *Lettres*, p. 136, no. LXVIII. This letter cannot have been written in Pont-Aven, as indicated, but evidently dates from Arles where Vincent must have shown his brother's letter to Gauguin; other evidence also proves that it was written after Gauguin had received Theo's letter reprinted on p. 35.

42. See Camille Pissarro's letter to his son, Eragny [Mar. 15, 1888]; Pissarro, *Lettres*, p. 167 (English ed., p. 123). The paintings in question are Pissarro-Venturi, *Pissarro*, nos. 710 and 709.

43. F. Fénéon, 'Calendrier de mars [1888]'; reprinted Fénéon, *Oeuvres*, pp. 102–3. *Apple Pickers* is Pissarro-Venturi, *Pissarro*, no. 726; the two others can be identified, thanks to Fénéon's descriptions, as nos. 722 and 715.

44. See Fénéon, 'Calendrier d'avril [1888]'; reprinted Fénéon, *Oeuvres*, p. 111.

45. Monet to Paul Durand-Ruel, Sept. 24, 1888; Venturi, *Archives*, 1: 329–30.

46. Vincent van Gogh to John Russell [Arles, end of June–beginning of July 1888], no. 501 a.

47. Vincent van Gogh to Emile Bernard [Arles, end of June 1888], no. B 8. Theo sent his brother an article by Geffroy on the exhibition, to which Vincent replied: 'What he says is really very good. I should so like to see that exhibition!' [Arles, June 1888], no. 501.

48. Gauguin to Emile Schuffenecker [Pont-Aven, middle of June 1888]; Gauguin, *Lettres*, pp. 131–32, no. LXV (here newly transcribed from the original).

49. Fénéon, 'Calendrier de juin [1888]'; reprinted Fénéon, *Oeuvres*, p. 113.

50. See Camille Pissarro's letter to his son Lucien, July 8, 1888; Pissarro, *Lettres*, p. 171 (English ed., pp. 126–27).

51. H. Schlittgen, *Erinnerungen* (Munich, 1926), p. 199.

52. G. Kahn, 'Au temps du pointillisme,' *Mercure de France*, May 1, 1924, p. 18.

53. His name is sometimes spelled Dupuy in the ledgers. Yet one of two paintings of Port-Coton (Belle-Isle) by Monet, listed in the Goupil records as sold to 'Dupuy,' was lent by 'Dupuis' to the 1889 Monet retrospective.

54. Information courtesy the late Denis Rouart, Paris, based on the recollections of his mother, Berthe Morisot's daughter.

55. Vincent to Theo van Gogh [Arles, second half of July 1888], no. 513.

56. Vincent to Theo van Gogh, Arles, July 29, 1888, no. 514.

57. Vincent van Gogh to his sister, Wil [Arles, June–July 1888], no. W. 4.

58. Vincent to Theo van Gogh [Arles, beginning of May 1888], no. 483.

59. Unpublished document, courtesy the late Ing. Dr V. W. van Gogh, Laren. The

letter is dated only 'Vendredi, 6 h ½'; Degas supposedly went to Cauterets in Aug. 1888, but the only 2,000-francs purchase in the gallery's records dates from June 8 of that year (there is *no* indication concerning *two* payments: 500 plus 1,500 francs).

60. Renoir's *Bay of Naples (9)* was bought by Durand-Ruel from the artist on May 22, 1882, and sold to Inglis on May 1, 1883. Boussod & Valadon purchased it from Inglis on July 18, 1888, and sold it to Durand-Ruel on Dec. 24, 1891. It was subsequently acquired by Mrs Potter Palmer of Chicago from whom Durand-Ruel—once more—bought it on June 28, 1894; the gallery kept it until 1911, when it was bought by Arthur E. Emmons, whose widow bequeathed it to the Metropolitan Museum, New York. Information courtesy M. François Daulte, Lausanne.

61. See Vincent's letter to Theo van Gogh [Arles, beginning of Sept. 1888], no. 534.

62. Theo to Vincent van Gogh, Paris, May 21, 1889, no. T 9.

63. B. v. H. [Boele van Gensbrock], in *De Nederlandsche Spectator*, Aug. 26, 1893. This article was brought to my attention by the late M. E. Tralbaut, Antwerp.

64. Vincent to Theo van Gogh [Arles, Oct. 1888], no. 550.

65. According to two letters from Gauguin to Theo van Gogh, of May 22 and June 1888, courtesy the late Ing. Dr V. W. van Gogh, Laren, Theo received these drawings with considerable delay because Bernard, to whom Gauguin had entrusted them, sent them to his mother who thought they were for her. Gauguin thereupon wrote to Bernard: 'I am very embarrassed about the two drawings your mother has kept. They are not mine but belong to [Theo] van Gogh, who sent me 50 francs this summer for a drawing.' This letter was doubtless written from Arles the first half of Dec. 1888, Gauguin, *Lettres*, p. 155, no. LXXVIII; its contents correspond to a letter from Vincent to Theo van Gogh [Arles, Nov. 1888], no. 560, which says, 'You will receive two drawings from Gauguin in return for the 50 francs you sent him to Brittany.'

Bernard's sister, Madeleine, had believed that the pastel sketch *(10)* for *Breton Girls Dancing, Pont-Aven (I)* was actually meant for her. To replace it, Gauguin sent her a ceramic pot 'which is more expressive of me than the drawing of little girls.' See M. Bodelsen, *Gauguin's Ceramics* (London, 1964), p. 72 and note 46. See also note 81 below.

66. Vincent to Theo van Gogh [Arles, beginning of June 1888], no. 496.

67. Gauguin to Vincent van Gogh [Pont-Aven, Sept. 1888]; see Rewald, *Post-Impressionism*, p. 238.

68. Gauguin to Emile Schuffenecker, Quimperlé, Oct. 16, 1888; see Gauguin, *Lettres*, p. 147, no. LXXIII.

69. Vincent to Theo van Gogh [Arles, middle of Sept. 1888], no. 538.

70. Draft of a letter from Vincent van Gogh to Gauguin, included in a letter to Theo [Arles, June 1888], no. 494 a.

71. Vincent to Theo van Gogh [Arles, second half of Sept. 1888], no. 538.

72. Vincent to Theo van Gogh [Arles, second half of Sept. 1888], no. 538 a.

73. Gauguin to Emile Schuffenecker, Quimperlé, Oct. 8, 1888; see Gauguin, *Lettres*, p. 141, no. LXXI.

74. See Theo van Gogh's letter to Vincent [Paris], Oct. 23, 1888, no. T 2.

75. Theo van Gogh to Gauguin, Paris, Nov. 13, 1888; see M. Bodelsen, 'An Unpublished Letter to Theo van Gogh,' *Burlington Magazine*, June 1957, p. 200.

76. See G. Wildenstein, *Gauguin* (Paris, 1964); *Breton Girls Dancing, Pont-Aven (I)* is no. 251. The picture Degas had planned to acquire is no. 249.

77. Gauguin to Emile Bernard [Arles, beginning of Nov. 1888], Gauguin, *Lettres*, p. 150, no. LXXV.

78. Camille Pissarro to Theo van Gogh, Sept. 17, 1888; unpublished document, courtesy the late Ing. Dr V. W. van Gogh, Laren.

79. See Fénéon, 'Calendrier de Septembre [1888]'; reprinted Fénéon, *Oeuvres*, p. 118.

80. See F. Fénéon, 'Tableaux de Sisley,' *La*

Cravache, Dec. 15, 1888; reprinted Fénéon, *Oeuvres*, p. 133.

81. See Huyghe, *Carnet de Gauguin*, facsimile pp. 226–27. It should be mentioned that when Gauguin, Pissarro, and their friends spoke of 'van Gogh,' they always meant Theo, whereas his brother was referred to as 'Vincent.'

In the collection left by Theo there were no drawings proper by Gauguin, but two pastels. One, a Martinique subject, may have been purchased by Theo on that Sunday visit in Dec. 1887; the other *(10)*, a study for W. 251 *(I)*, a Breton subject, must have been one of the 'drawings' Bernard was to deliver to Theo in the fall of 1888 (see note 65 above). As to Gauguin's drawing of an Arlesian woman, after which Vincent did several painted versions, it apparently was not given to van Gogh but remained with Gauguin or was eventually returned to him.

Concerning the exchange, Gauguin wrote 'Négresses,' though the picture, as described by Vincent (see note 33), shows only one Negro woman.

On the subject of his self-portrait (W. 239), Gauguin had written from Brittany to Theo, in Oct. 1888: 'The portrait I made for him is not for sale. It was made for him [Vincent], exchange or no exchange.' (Unpublished document, courtesy the late Ing. Dr V. W. van Gogh, Laren.)

82. According to Wildenstein, *Gauguin*, no. 300, Schuffenecker's daughter identified this work as having once belonged to her father. This may have been the only canvas by Gauguin which Theo did not keep. Since Theo's widow, as far as her son remembers, had no dealings with Schuffenecker, it would seem more likely that the picture was sold by Theo himself, who knew Schuffenecker and was acquainted with his enthusiasm for the work Gauguin had done in Arles.

83. The ceramic piece Gauguin gave to Theo is now in the van Gogh museum in Amsterdam. For the piece Theo had taken in Oct. 1880, the so-called *Cleopatra* vase, see Bodelsen, *Gauguin's Ceramics*, p. 159 and note 12, figs. 110, 111.

84. Wildenstein, *Gauguin*, no. 296. Wildenstein also attributes to Gauguin a landscape,

no. 225, conceding that one might be tempted to ascribe it to Laval were it not that it belonged to Theo van Gogh. But this is by no means an inescapable conclusion; Vincent had exchanged at least one painting with Laval and Theo could well have purchased another. The painting supposedly represents a landscape of Martinique, where Laval had accompanied Gauguin. It not only shows no stylistic connection with Gauguin's work, but does not appear on Gauguin's *carnet* list.

85. Gauguin to Theo van Gogh [Arles, end of Dec. 1888]; unpublished document, courtesy the late Ing. Dr V. W. van Gogh, Laren.

86. Gauguin to his wife [Le Pouldu, Nov. 1889]; see Gauguin, *Lettres*, p. 160, no. LXXXII (there dated end of June 1889). In Feb. 1889 Gauguin had told his wife that business in Paris was very bad, 'crashes every day at the exchange' (ibid., p. 156, no. LXXIX).

87. Gauguin to Emile Bernard [Le Pouldu, Nov. 1889]; ibid., p. 174, no. XCII.

88. Gauguin to Odilon Redon [1889–90]; see *Lettres à Odilon Redon* (Paris, 1960), p. 191. The coupe mentioned by Gauguin is, according to Bodelsen, the one reproduced in her book, *Gauguin's Ceramics*, figs. 65 and 66, mentioned pp. 159–60.

89. Theo to Vincent van Gogh, Paris, Mar. 16, 1889, no. T 4. Mirbeau's article appeared in *Le Figaro*, Mar. 10, 1889; it is reprinted in O. Mirbeau, *Des artistes* (Paris, 1922), 1: 88–96.

90. The exhibition opened around Apr. 13. The catalogue (courtesy Mrs Anthea E. Callen, Leicester) lists the following twenty works (those which can be identified are preceded by an asterisk in the ledger in Appendix I): I. *The Pyramid Rock, Port Coton*. II. *Field of Poppies*. III. *Moulin de Limets*. IV. *The Pines at Juan les Pins*. V. *The Mediterranean (Vent de Mistral)*. VI. *Prairie and Figures (Temps couvert)* [cannot be identified]. VII. *Antibes* [cannot be identified]. VIII. *Study of Boats* [not to be found in the Paris ledger]. IX. *Chrysanthemums* [not to be found in the Paris ledger]. X. *Prairie and Figures*. XI. *Maisons de Villageois*. XII. *Marine (Tempest)* [cannot

be identified]. XIII. *Vétheuil (Fog)* [not to be found in the Paris ledger]. XIV. *Thaw at Argenteuil.* XV. *Port du Havre (Effet de nuit)* [not to be found in the Paris ledger]. XVI. *Moulin d'Orgemont.* XVII. *Un Tournant de l'Epte.* XVIII. *Marine (Rainy Weather).* XIX. *Boats at Argenteuil.* XX. *Prairie de Giverny.*

A lengthy, anonymous review in the *Illustrated London News* of April 20 provides condensed descriptions of several of the exhibits; a shorter notice appeared in the 'Chronicle of Art' section of the *Magazine of Art* in June (after the Monet show had been succeeded by a group of 'Small and Select Works in Oil by Mr A. D. Peppercorn'). On this Monet exhibition, see also B. Laughton, *Philip Wilson Steer* (Oxford, 1971), pp. 19–20 and note 14.

91. On this sale, see D. Cooper, *The Courtauld Collection* (London, 1954), p. 61, note 4. Cooper identified the painting bought by Sickert, but not the one purchased for Theo van Gogh. Goupil's also acquired a second picture at the sale, no. 31, but this may have been destined for the London branch or for a client.

All six works by Degas from the Hill sale have since been identified by R. Pickvance, 'Degas's Dancers: 1872–6,' *Burlington Magazine*, June 1963, Appendix, p. 266.

92. Lucien to Camille Pissarro [London, early May 1891]; Pissarro, *Lettres*, p. 239.

93. Theo to Vincent van Gogh, Paris, Sept. 5, 1889, no. T 16.

94. Theo to Vincent van Gogh, Paris, Dec. 22, 1889, no. T 22.

95. Camille to Lucien Pissarro, Paris, Sept. 13, 1889; Pissarro, *Lettres*, p. 184 (English ed., p. 137).

96. Albert Besnard to Theo van Gogh, undated; unpublished document, courtesy the late Ing. Dr V. W. van Gogh, Laren.

97. Bernard met Bonger for the first time at Vincent's funeral in Auvers on July 30, 1890, and they became fast friends. By that time Theo had already had dealings with Redon on several occasions. According to the catalogue of the exhibition *André Bonger en zijn Kunstenaarsvrienden: Redon–Bernard–*

van Gogh, Amsterdam, Rijksmuseum, 1972, Bonger met Redon only in 1894, well after Theo's death.

98. Unpublished excerpts from Redon's account books, courtesy the late Arï Redon, Paris.

99. See Vincent's letter to Theo van Gogh [Arles] July 29 [1888], no. 514.

100. See Theo's letter to Vincent van Gogh, Paris, Feb. 9, 1890, no. 514.

101. The works are nos. 729 and 736 (the latter not reproduced) in Pissarro-Venturi, *Pissarro*.

102. This is *Gelée blanche*, ibid., no. 722, which was indeed to be included in the exhibition.

103. Theo to Vincent van Gogh, Paris, Mar. 19, 1890, no. T 29.

104. 'It is especially Degas who, among those close to [Theo] van Gogh, is the author of the whole disaster.' Gauguin to Emile Bernard [Le Pouldu, Nov. 1889]; Gauguin, *Lettres*, p. 174, no. XCII.

105. Dr Charlopin was supposed to receive 12 million francs for his invention.

106. Gauguin to Theo van Gogh [Paris, Apr. 1890]; partly unpublished document, Archives Nationales, Paris (Bequest of Albert S. Henraux).

107. It is not always easy—and sometimes even impossible—to identify the works in question; where there is no certitude, the reference to the number in Wildenstein, *Gauguin*, is accompanied by a question mark. In some cases, where a discrepancy of dimensions prevents definite identification, the measurements of the work that Gauguin *may* have meant are given in brackets, together with the Wildenstein reference. The same procedure has been followed in Appendix I.

108. See C. Gray, *Sculpture and Ceramics of Paul Gauguin* (Baltimore, 1963), nos. 76 *(15, II)* and 87.

109. Mrs Bodelsen has advanced a very interesting hypothesis in this connection. She believes that the letter addressed to Theo (quoted on p. 56) and the inventory list were *not* written at the same time. According

to her, the list may have been sent to Theo's successor, possibly at the time of Gauguin's departure for Tahiti, in Apr. 1891 (this would explain why these two documents are not in the van Gogh archives but may originally have been preserved by Joyant). In any case, some of Gauguin's prices are now higher than in Theo's days and he states specifically, 'The large landscape with figures from Martinique is for sale at 1,500 francs, but 300 francs are to be deducted which [Theo] van Gogh advanced me from his *personal account*.'

Gauguin may conceivably have presumed that—after the deaths of both Vincent and Theo—nobody knew that Theo had paid him 400 (not 300) francs outright for this canvas, and that he could now try to sell it once more. This would explain the conflicting references to the large Martinique landscape with figures (see note 33 above). But Joyant was—anyhow—unable to sell this work on Gauguin's behalf because Theo's widow, on her brother's advice, had taken it with her to Holland. When Gauguin subsequently tried to obtain it from her, she apparently refused to surrender it, having doubtless learned from her husband that he had *acquired* it from the artist. See note 171 and Gauguin's letters to Johanna van Gogh–Bonger quoted on pp. 84–85.

110. Theo to Vincent van Gogh, Paris, June 2, 1890, no. T 35.

111. Theo to Vincent van Gogh, Paris, June 5, 1890, no. T 36. Raffaëlli enjoyed a tremendous popularity. In 1895 Sutton organized a one-man show in New York. Boussod & Valadon, Durand-Ruel, and Knoedler handled his work, also Vollard when he first opened a small shop. Among his admirers were such staunch supporters of the Impressionists as Octave Mirbeau and Gustave Geffroy, as well as Albert Aurier.

112. Theo to Vincent van Gogh, Paris, June 30, 1890, no. T 39.

113. Vincent to Theo van Gogh [Auvers, though not June 30, 1890, as indicated, but probably in the course of July], no. 646.

114. Theo to Vincent van Gogh, Paris, July 5, 1890, no. T 40.

115. The artist had made the point that the pictures should be hung quite high in order to be properly appreciated. When they were subsequently included in the sale of the collection of M. A[chille] A[rosa], Paris, Hôtel Drouot, May 8, 1891, the author of the catalogue introduction, Charles Yriarte, felt compelled to specify, 'Four of the canvases by Pissaro [*sic*], the *Four Seasons*, modest enough subjects although already very advanced, were commissioned as overdoors and for more than twenty years we have seen them in place; one must take this position into account when judging these works.' See also note 156.

116. Gauguin to Emile Schuffenecker [Pont-Aven, July 1890, not June as indicated]; Gauguin, *Lettres*, p. 190, no. CIV.

117. Vincent to Theo and Johanna van Gogh [Auvers, middle of July 1890], no. 649.

118. Vincent to Theo and Johanna van Gogh [Auvers, same date as previous letter], no. 648.

119. Vincent to Theo and Johanna van Gogh [Auvers, second half of July 1890], no. 649.

120. Theo to Vincent van Gogh [Paris, July 14, 1890], no. T 41.

121. Vincent to Theo van Gogh [Auvers, July 23, 1890], no. 651.

122. Ibid.

123. Theo to Johanna van Gogh, Paris, July 25, 1890; see *Verzamelde Brieven van Vincent van Gogh*, introduction by J. van Gogh–Bonger (Amsterdam, 1952), vol. I, p. XLVIII.

124. Vincent to Theo van Gogh, Auvers, [July 27, 1890?], no. 652.

125. Gauguin to Emile Schuffenecker [Moëlan, Aug. 1890]; see C. Roger-Marx, 'Lettres inédites de Vincent van Gogh et de Paul Gauguin,' *Europe*, Feb. 15, 1939, no. 194.

126. Theo van Gogh to Dr Gachet, Paris, Sept. 12, 1890; see P. Gachet, *Lettres impressionnistes au Dr. Gachet et à Murer* (Paris, 1957), p. 153.

127. See Venturi, *Archives*, p. 85.

128. On Durand-Ruel's negotiations with Theo's widow, see the chapter on 'The

posthumous fate of Vincent van Gogh 1890–1970.'

129. Theo van Gogh to Emile Bernard, Paris, Sept. 18, 1890; see Bernard's introduction to *Lettres de Vincent van Gogh à Emile Bernard* (Paris, 1911), pp. 2–3.

130. This painting cannot be identified with certitude, especially because the ledger does not mention its size. But Vollard, who subsequently acquired it from Boussod & Valadon, did tell Venturi, when the latter was preparing his catalogue of Cézanne's oeuvre, that he had purchased this work (V. 226)—representing a seated woman—from Theo van Gogh. This seems peculiar, since Theo did not know Vollard. However, when Vollard bought the painting in 1899, he may well have been told that it was originally part of Theo van Gogh's stock; hence the misunderstanding. The picture may have belonged previously to Guillaumin, who certainly knew *père* Martin, a modest dealer in Impressionist works since 1868; it is not unlikely that he consigned it to him and his partner.

Vollard's ledger reads: 'bought from Boussod Cézanne oil, portrait of a woman in gray, 46 × 78 cm[?], seated, her hands crossed, 200 francs.' This entry is not dated.

131. Andries Bonger to Dr Gachet, Paris, Oct. 10, 1890; see P. Gachet, *Deux amis des Impressionnistes: Le Dr. Gachet et Murer* (Paris, 1956), pp. 125–26.

132. Camille to Lucien Pissarro, Paris, Oct. 18, 1890; Pissarro, *Lettres*, pp. 188–89. This letter appears only in the French edition.

133. Theo van Gogh to Gauguin [Paris, Oct. 1890]; see A. Alexandre, *Paul Gauguin: Sa vie et le sens de son oeuvre* (Paris, 1930), p. 108.

134. See note 132.

135. Lucien Pissarro to his fiancée, Esther Bensusan [Paris, Oct. 1890]; see W. S. Meadmore, *Lucien Pissarro: Un coeur simple* (London, 1962), p. 51.

136. Joyant to Octave Maus, Paris, Oct. 17 (or 27?), 1890; the date cannot be read but looks more like 17 than 27. Unpublished document, Maus Archives, Brussels, cour-

tesy Mme M.-J. Chartrain-Hebbelinck, Brussels.

137. Gauguin to Emile Schuffenecker [Le Pouldu, Oct.–Nov. 1890]; see Alexandre, *Gauguin*, p. 113. Gauguin knew that Manzi had acquired one of his Breton seascapes, which is listed in his *carnet* (Huyghe, *Carnet de Gauguin*, p. 224) as 'Manzy [*sic*]—Marine—300.' That it was sold by Theo—although this is not recorded in the gallery's ledger—is established by a letter of 1899 in which the artist discusses the aging process of pigments and specifically mentions 'a Breton seascape . . . which [Theo] van Gogh had sold to Manzi.' See Gauguin, *Lettres de Gauguin à Daniel de Monfreid* (Paris, 1950), p. 144.

138. Gauguin to Emile Schuffenecker [Le Pouldu, Oct.–Nov. 1890]; see Roger-Marx, 'Lettres inédites de van Gogh et Gauguin.'

139. Letter cited in note 137.

140. The work in question is Wildenstein, *Gauguin*, no. 398; for himself Boch selected W. 253. His sister also owned a painting by Gauguin (W. 250), which she had bought from Theo in Mar. 1889 for 400 francs. The price of 100 francs each for five pictures reveals the artist's desperation. That the 500 francs he received from Boch were not a down payment but a *full* settlement is confirmed by the fact that in his *carnet* (Huyghe, *Carnet de Gauguin*, p. 222) Gauguin wrote down: 'Bogh [*sic*]—5 tabl.—500.'

141. Eugène Boch to Octave Maus, Moret, Nov. 4, 1890; unpublished document, Maus Archives, Brussels, courtesy Mme M.-J. Chartrain-Hebbelinck, Brussels. A subsequent letter from Schuffenecker to Maus indicates that he lent three ceramic pieces to the exhibition. Theo's widow helped with the van Gogh retrospective.

142. Camille to Lucien Pissarro, Paris, Apr. 3, 1893; unpublished portion.

143. Gauguin to Emile Bernard [Le Pouldu, Oct.–Nov. 1890]; Gauguin, *Lettres*, p. 204, no. CXIII.

144. Gauguin to Odilon Redon [Paris, Nov. 1890]; Gauguin, *Lettres à Redon*, p. 194.

145. Same as note 143.

146. Camille to Lucien Pissarro [Eragny, Nov. 1890]; Pissarro, *Lettres*, p. 189 (English ed., p. 139).

147. Camille to Lucien Pissarro, Paris, Dec. 23, 1890; ibid., p. 197 (English ed., p. 143); partly unpublished document.

148. Albert Aurier in *Mercure de France*, Mar. 1891.

149. Camille Pissarro to Mette Gauguin, Eragny, Mar. 19, 1891; Haavard Rostrup, 'Gauguin et le Danemark,' *Gazette des Beaux-Arts*, Jan.–Feb. 1956.

150. Gauguin to Daniel de Monfreid; excerpts from two different letters, Tahiti, June 1892 and Feb. 14, 1897; see Gauguin, *Lettres de Gauguin à Daniel de Monfreid*, pp. 58 and 99.

151. See Joyant, *H. de Toulouse-Lautrec*, p. 118.

152. Ibid., pp. 118–19.

153. Redon seems to have left a number of his lithographic series and single lithographs with Boussod & Valadon and periodically to have jotted down receipts when accounts with the gallery were settled. His books reveal the following transactions: Mar. 1891, for 5 lithographs and the drawing (copy) *Profil de Lumière* (less the frame)—84.50 francs; Apr. 16, a lithograph—7.50 francs; June 13, 1 drawing and several lithographs—100 francs; Oct. 21, 1 lithograph (*Yeux clos*)—7.50 francs; Mar. 8, 1892, 1 album and 1 lithograph—30 francs; Oct. 20, 1 lithograph (*Parsifal*)—7.50 francs; Mar. 11, 1893, for various lithographs—75 francs. Redon's last entry concerning Boussod & Valadon reads: 'Consignment withdrawn 20 February 1894.' Information courtesy the late Ari Redon, Paris.

154. Camille to Lucien Pissarro, Paris, Apr. 3, 1891; Pissarro, *Lettres*, p. 229 (English ed., pp. 159–60).

155. Camille to Lucien Pissarro, Paris, May 7, 1891; ibid., p. 240 (English ed., p. 167).

156. See note 115; the four paintings are Pissarro-Venturi, *Pissarro*, nos. 183–186. They appeared at a Sotheby auction, London, Dec. 1, 1971, lot 8, and were sold for £220,000.

157. Camille to Lucien Pissarro, Eragny, Dec. 26, 1891; Pissarro, *Lettres*, p. 273 (English ed., pp. 191–92).

158. *Procès-verbal de la ventre anonyme du 10 juin 1891*, *Etude de Me Paul Chevallier*, Archives de la Seine, Paris, courtesy Wildenstein Foundation, Paris. Only buyers are named in this document and where an item was bought in, the consignor is given as purchaser with the mention: *owner*. For none of the works that can be traced to Dupuis's collection does such an indication appear in the record.

159. See Theo's letter to Vincent van Gogh [Paris], Oct. 11, 1889, no. T 19. It was *after* the auction that Degas added Gauguin's Martinique landscape (W. 230) to his collection. This information is based on an unpublished note by Degas: 'Gauguin—Martinique landscape, huts, negroes beneath trees—at left, on the horizon, a windmill. Exchanged with Manzi after the first [Gauguin] sale at the Hôtel [Drouot].' Document courtesy M. Philippe Brame, Paris.

160. For a list of the paintings sold—though not all of them are identified—with prices and names of buyers, see the catalogue of the Gauguin exhibition, Paris, Orangerie des Tuileries, summer 1949, pp. 95–96.

161. Gauguin to Daniel de Monfreid [Tahiti], Feb. 11, 1893; see Gauguin, *Lettres de Gauguin à Daniel de Monfreid*, p. 65. In a letter to his wife (Gauguin, *Lettres*, p. 239, no. CXXXV) Gauguin gives a slightly different account and arrives at a slightly different figure.

162. Camille to Lucien Pissarro, Paris, Dec. 9, 1891; Pissarro, *Lettres*, p. 269 (English ed., p. 188).

163. See J. Loize, *Les Amitiés du peintre Georges–Daniel de Monfreid et ses reliques de Gauguin* ([Paris?], 1951), p. 94, no. 138.

164. The painting is *La Goulue Entering the Moulin-Rouge*, The Museum of Modern Art, New York (Bequest of Mrs David M. Levy). There is some confusion concerning this picture in M. G. Dortu, *Toulouse-Lautrec et son oeuvre* (New York, 1971), vol. 2, where it is reproduced as no. 422 with the

relevant note appearing under no. 423 (and vice versa).

165. 'Joyant has explicitly advised me to let him be one of the first to see my paintings of London.' Camille to Lucien Pissarro, Paris, May 15, 1892; Pissarro, *Lettres*, p. 284.

166. Gauguin to Daniel de Monfreid [Tahiti], May 1892; see Gauguin, *Lettres de Gauguin à Daniel de Monfreid*, p. 56.

167. Gauguin to his wife [Tahiti, Nov. 5, 1892]; Gauguin, *Lettres*, p. 235, no. CXXXII.

168. See Loize, *Les Amitiés*, p. 94, no. 138.

169. Camille to Lucien Pissarro [Paris], Oct. 5, 1893; Pissarro, *Lettres*, p. 314 (English ed., p. 218). It was shortly after Joyant's departure that Redon withdrew the lithographs he had consigned to the gallery (see note 153).

170. By 1912 books published by Goupil still carried the insignia 'G' but underneath the firm's name was: 'Manzi, Joyant & Cie, Editeurs-Imprimeurs, Successeurs. 24, Boulevard des Capucines.'

171. It is possible that Theo's widow asked for a painting in payment for the 300 francs her husband had lent the artist. This may have prompted Gauguin to request once more the return of the large Martinique landscape against restitution of the so-called 300-francs advance. But Johanna van Gogh–Bonger knew better than to send him this picture (see note 109), while she complied where other works were concerned.

172. Excerpts from three unpublished letters from Gauguin to Johanna van Gogh–Bonger, 1894, courtesy the late Ing. Dr V. W. van Gogh, Laren.

173. On Vollard's direct dealings with Gauguin see the chapter on Gauguin's letters to Vollard and Fontainas.

174. A comparative note on prices throughout the years can be found in Thomas E. Norton, *100 Years of Collecting in America* (New York, 1984), p. 231. Depending on which index one chooses to utilize, current values would compare with turn-of-the-century values on a ratio of between five and ten to one. Information courtesy Mr David T. Schiff, New York.

27 Edgar Degas Detail of *Ballet Dancer, Dressed* 1880

Degas's Sculpture

In memory of Albert S. Henraux

Degas the Artist

'If I could start my education as a painter all over again today,' the aged Redon put down in one of his notebooks, 'I think that for the growth and greater development of my faculties I should do many copies of the human body; I should dissect it, analyze it, and even model it—in order to reconstitute it profusely from memory, without trouble.'

Edgar Degas did just that. He analyzed, dissected, and even modeled the human body, but he did not do it merely to acquire the sort of knowledge that could be of service to the painter; he did it just as much to satisfy the sculptor in him. Always thirsty for new means of expression, he felt his responsibility as an artist too keenly ever to try new techniques without wanting to master them completely. To tell the truth, he did not try them, he learned them. He had no sooner begun to model than he must have understood that the handling of wax would not only increase his faculties, but also offer him a new field of exploration.

Few were the realms of art that did not attract Degas, nor did he attempt any of them without discovering new aspects. With the unfailing instinct that distinguishes those who pursue a determined goal, he was always able to perceive and appropriate the elements that could be of use to his conceptions. Taking advantage of these elements with an absolute contempt for conventions, he was guided by a high-minded conscience for which any audacity was justified as long as it served art. It is on account of this attitude that Degas the draftsman, the painter, the engraver, the sculptor, and even Degas the poet are not separate beings, but one single personality: Degas *the artist*. Yet, while rigorously bending himself to the exigencies of these various crafts, he practiced each one as if he knew nothing about the others; for he did not merely have 'violins d'Ingres,' he was master of several instruments. Thus, when painting, he was a painter and nothing else; but when modeling, he forgot about being a painter. Such was his need for self-expression and so insatiable was his avidity for perfection that all the techniques of art were not enough to exhaust his inventive powers.

First published by Pantheon Books, New York, 1944. This text appeared without notes

Painting and Modeling

The Italian Renaissance had seen painters who were inventors, architects, sculptors, and poets, but in France this kind of 'complete genius' was unknown. Still, during the whole nineteenth century French painters had felt themselves drawn to sculpture, experiencing the desire to explore that third dimension the illusion of which they tried to create in their painted works, just as a number of sculptors, such as Barye and Carpeaux, had taken up the brush to conquer color. Géricault was as much a sculptor as a painter, but the 'sculpting' painters—Courbet, Daumier, and later, Gauguin—all tackled the third dimension in a somewhat experimental spirit. The case of Renoir alone is different; when at the end of his life he turned to sculpture, Renoir obeyed an imperious need that was betrayed to an equal degree in his paintings, for with him form tended more and more to take shape in volume. His painting itself became 'plastic,' the bodies of his nudes seem to have been modeled in their flesh color, and the dabs of his brush are related to the finger marks of one who models clay. The high point of his art is his conquest of volume.

The painting of Degas developed along lines absolutely opposed to Renoir's. It brought him gradually to reduce his emphasis on line in painting in order to seek the pictorial. His last pastels are multicolored fireworks where all precision of form disappears in favor of a texture that glitters with hatchings. And yet Degas is the only one among all these painter-sculptors who brought to sculpture more than an occasional or belated interest. As early as 1880 he devoted nearly as much time to modeling as to painting, or to his pastels or drawings. If the place this activity occupied in his life does not show up in his other works, if we do not observe in them that link which intimately unites the later paintings and sculptures of Renoir, it is precisely because Degas was not a painter who models, nor a sculptor who paints. Even though nearly all his statuettes represent aspects of problems which sometimes preoccupied the painter for long periods, even though the same postures of models are to be found in his paintings, pastels, and drawings, as well as in his statuettes, these last are never seen with the eyes of a painter or a draftsman, they are conceived by a sculptor who seeks nothing but form.

Whereas Rodin's grandiloquence of genius does not always succeed in concealing certain weaknesses as soon as the vibrations of his pathos no longer resonate in us, Degas carefully avoids all literary phraseology, all that is not essential, all that is accidental, in order to seek nothing but movement and volume. His cold and at the same time passionate realism saves him as much from verboseness as from blind submission to nature. As in the case of his entire work, Degas will not stand for the slightest concession to the taste of the day; he seeks form and not effect, he seeks it where others do not dare approach it: in action. He knows that to give the impression of mass, one must conceive it. This—strange as it may seem—is a great and rare discovery, one

that only a born sculptor could make. To it another can be added, which Degas expressed thus, 'In art, nothing must seem accidental, not even motion.'

In his youth Degas had thought himself to be, in his own words, 'born above all to be a draftsman.' But his worship of line could not keep him from recognizing it as an abstraction, nor from seeking to reconcile it with color and form. Thus he was to make the flamboyant pastels where the line itself is colored—line and color being indivisible—and to strive as a sculptor to give form to the instantaneous, which generally is bound to line. 'Drawing is a way of thinking,' Degas used to say; so is modeling.

Degas Sculptor

Paul Valéry who, when young, knew the aged Degas, remarked—and this remark was perhaps suggested by the painter himself—that 'there is an enormous difference between seeing something without a pencil in hand, and seeing it *while drawing it*, or rather that what one sees are two quite different things. . . . Drawing an object from life gives the eye a certain commanding power which is fed by our will. One must therefore *will* in order to *see*, and this willed sight has drawing at the same time as an end and as a means.' In like manner Degas must have realized that unless one models its forms one does not know, or rather, one never *possesses* the mass of a body, all the more so as the eye can take in only one single aspect at a time. Of course one can feel it, but feeling does not go below the surface, does not communicate the secrets of its structure. What is true for drawing is thus also true for modeling; there is an enormous difference between seeing something and seeing it *while modeling it*. Only then does one grasp the mechanism of the movements of the body, the relations between proportions and equilibrium, as well as the play between the convex and the concave. Only then can one conceive the body in its entire unity.

Obviously a knowledge of the secrets of mass was to be of profit to the painter—despite his stressing of the pictorial element—but it is nonetheless true that the painter first had to forget nearly all his science in order to learn these secrets. As painter or as draftsman Degas was naturally aware of the impermanence of outlines; he knew they were not real limits, but he could treat them as such, choosing the aspect he wished to represent and, if need be, disregarding to a certain extent the invisible parts. The sculptor has no such choice; even if he limits himself to a few characteristic profiles, he must connect them in the form. To represent a horse from two sides Degas the draftsman could make one single drawing with a *crayon gras*, then take an impression on another sheet and in full freedom draw this reversed picture (see, for instance, drawings 130a of the third and 335 of the fourth sales of Degas's studio). It goes without saying that the sculptor can never resort to

such subterfuges. For him the various parts are not only not interchangeable, but they do not exist in themselves and can only be conceived in relation to the rest.

Thanks to his inborn sense of the exigencies of form, Degas does not seem to have had any special difficulty in learning the rudiments of sculpture. Yet one can assume that modeling taxed his patience heavily. For a painter, and especially for a painter surrounded by such friends as the Impressionists whose every effort tended toward the immediate representation of received sensations, there is no process more exasperatingly slow than modeling; this operation is not merely a question of physical effort, it also demands a constant attention to material details such as the armature, the dampness of the clay, or the hardness of the wax, not to mention all the difficulties of casting. But Degas permitted himself this sacrifice of time and energy since what he sought above all was the satisfaction given by the work. It is nonetheless true that he was always to remain ignorant of the 'tricks of the trade,' as he preferred, owing to a certain spirit of independence, his self-taught and often rather primitive methods to the cold science of the experts. Fearing neither roundabout ways nor failures, he sometimes even hesitated to make use of advice—even though solicited—if he thought he could achieve his ends by his own means. Thus, he preferred improvised armatures to the perfected and stable structures that experienced technicians would prepare for him. Doubtless he saw in them hindrances to his inspiration and felt himself tied down to the ready-made armature, whereas the one he patched together any old way, and which he amplified and transformed according to his needs, left a greater margin for improvisation. The result was that his more or less well-balanced modelings often collapsed or cracked; but it would seem Degas was prepared to pay this price to preserve his freedom.

'This devil of a fellow wants to do sculpture,' the sculptor Bartholomé once said of his friend Degas, 'but he doesn't want to submit to the laws of that medium. In order for a piece of sculpture to be solid, it has to be established on a rationally prepared skeleton, otherwise a moment comes when everything collapses. I cannot get this into his head. When an arm goes beyond the sphere of equilibrium and threatens to fall, he reinforces it with a match! In this way he has lost some sculptures which were very beautiful in their movement. But he doesn't care, which is deplorable! . . . I am therefore obliged to become angry with him so as to make him understand how ridiculous his stubbornness is.'

In nearly half a century of work Degas made a considerable number of statuettes. Many collapsed under his fingers, many did not resist the ravages of time, only comparatively few have been saved; but enough are left to give us more than a memento of that art to which Degas devoted so much work, without yet wanting to share its fruits with others. As the only statuette he ever exhibited—the *Ballet Dancer, Dressed (III),* in 1881—aroused no more

than cheap curiosity, not to mention alarm, Degas preferred to work for himself alone. In any case, since he was rarely satisfied with his own work, he could hardly find satisfaction in the opinions of others, even if flattering. Shortly afterward he stopped exhibiting even his paintings, no longer feeling any desire to communicate with the rest of the world.

There were few, therefore, who even knew that Degas sculpted; still fewer were those to whom the artist deigned to show his work. When age dimmed his eyesight to the point where he had to give up his paintbrushes and pencils entirely, he gave himself over exclusively to modeling. In kneading clay or wax he did with his fingers what he could no longer do with his eyes. As his self-imposed loneliness became more and more complete, the semidarkness he lived in made him more and more irritable and caused him to avoid with some surliness all contact with the outside world. In the enormous solitude of his studio his statuettes were his only consolation. 'Here in this studio I'm always working with wax,' he writes in 1903 to a friend, adding, 'Without work, what a dismal old age!' When the young Aristide Maillol dared to ask him whether it was true he was doing sculptures, Degas answered angrily, 'Who told you this?' On being informed that Maillol had learned it from one of Degas's own friends, the artist said solemnly, 'Yes, I model, and perhaps one of these days I shall be cast in bronze!'

Degas was never cast in bronze. Aside from a few statuettes he had cast in plaster, and a few others he kept in his apartment in glass cases, his modelings lay covered with dust in various corners of his studio, the dried-up pieces of clay beginning to fritter and the pieces of wax falling apart or melting. Many were broken to the point where all repair had become impossible. According to the report of Paul Durand-Ruel, who made the inventory of Degas's possessions, he found 'about 150 pieces scattered over his three floors in every possible place. Most of them were in pieces, some almost reduced to dust.' If one bears in mind the fact that Degas was obliged to move five years before his death, and that he probably had to leave in his old studio all those works that had already gone to pieces, not to mention those that had crumbled in his hands, the material of which he had used in new works, the total number of statuettes modeled by Degas must exceed by far the number in Durand-Ruel's inventory. At any rate, of the 150 pieces found after the death of the artist, only about 30 were in good condition, 30 others were badly broken, and the remainder, still according to Durand-Ruel, were almost valueless.

Since it is more or less sheer chance that saw to the preservation of Degas's sculpture, the rescued works offer but a fragmentary aspect of his activity. Obviously the more recent modelings are better represented than those made as early as 1865. This disproportion makes it particularly difficult to establish the chronology of the statuettes, all the more so as it is perhaps not always the more significant works that have survived. Moreover we know very little about these works—mainly because only a few friends were allowed to enter

the intimacy of Degas's studio. And these were nearly all artists, little inclined to write about what they had seen or heard. All that we know of the working habits of the nearly blind old sculptor is a detailed account based on the memories of a model, if not written by her.

The Beginnings: Studies of Horses

Although no information concerning Degas's beginnings as a sculptor has come down to us, one can most likely presume that the artist began with bas-reliefs, which form the logical link between the two-dimensional art and sculpture in the real sense. The sculptor Bartholomé remembered seeing him make, before 1870, a large bas-relief in clay which represented young girls, half life-size, gathering apples. Only a smaller version of it has been preserved.

P.-A. Lemoisne relates that Degas had been on quite friendly terms with the sculptor Cuvelier, who was a specialist in horse studies and who, between 1865 and 1870, exhibited in the Salons equestrian portraits done in wax with precision and delicacy, though with a certain dryness. These works, whose novelty created a surprise, could not have failed to influence Degas, the beginner. Degas had always shown great interest in horses and had made use of this animal in his very first compositions. But he had been content to represent it from profile, as in *Semiramis Founding a Town* and *The Misfortunes of the Town of Orléans*, or from other angles, not too complicated from the point of view of pose and perspective. These were historical

28 Edgar Degas
Horse at Trough
1866–68

29 Edgar Degas *Mademoiselle Fiocre in the Ballet 'La Source'* 1866–68

compositions for which the artist made many extremely detailed studies, but the general handling of which depended only on his skill and his powers of invention. When a little later Degas began to represent scenes of contemporary life, he found himself tied down to scenes he had observed. Thus, when painting, between 1866 and 1868, *Mademoiselle Fiocre in the Ballet 'La Source' (29)*, Degas faced the problem of having to introduce a horse into his composition not as he might have imagined it for the occasion, but as it actually appeared in the scene he was picturing. Desiring to make a realistic work, and doubtlessly inspired by the example of his friend Cuvelier, Degas then had the idea to model a horse in the same attitude he had observed in the ballet *(28)*. By placing the horse in wax in the desired angle, he could later make use of it as a model for his painting. If these suppositions are

123

correct—and the similarity between the modeled and the painted horse makes this interpretation inevitable—Degas would have begun to model in order to acquire information for his paintings. That this ballet horse was one of the first he modeled is proved not only by the date of the painting, but also by the pose of the animal, for it seems only logical that the artist first modeled standing horses before attempting more complicated poses.

Having taken up modeling as an aid to painting, Degas could not fail to discover new possibilities in this means of expression which were later to encourage him to use them as ends in themselves. It is at this time, a few years before 1870, that Degas began to frequent racetracks and to bring back mental notes, if not sketches, which enabled him to make paintings representing the horses, the jockeys, the various phases of the races, and the crowd at Longchamp. With the aid of these notes, helped in turn by the example of his friend and by his own ambition, he was also going to try to model horses in action. According to his dogma that 'one must treat the same subject ten times, even a hundred times,' Degas then used the various techniques at his disposal, not in order to subordinate them to one another,

30 Edgar Degas
Rearing Horse
1865–81

31 Edgar Degas *Horse Trotting, the Feet not Touching the Ground* 1865–81

but to approach his subject from many different angles: line, color, and mass.

Fascinated by the fiery elegance of horses, Degas did all he could to preserve in wax their nervous agitation, their gracious pride *(30)*. Little by little he attempted poses that were more and more taken in full movement; he was not even afraid of the task of showing a trotting horse at the moment when none of its feet touch the earth *(31)*. Degas was so passionately absorbed in the studies of the movements of thoroughbreds that in 1888—at a time several years after he had started a series of pastels showing women washing—he wrote, 'I haven't yet done enough horses. The women must wait in their tubs.'

This letter invalidates the statement of Lemoisne that Degas had ceased modeling horses after the death of his friend Cuvelier, who was killed during the siege of Paris in 1871. According to Lemoisne, Degas later made use of the horses he had executed or begun as models for his pictures of races after doing them over again and modifying them several times. There is reason to doubt this assertion, even though Lemoisne has in general proved to be well informed and drew his information from Degas himself. Indeed it seems

hardly likely that the artist 'altered' his statuettes to adapt them to the requirements of his paintings. He was too far advanced in his studies of movement not to know that the poses of a horse are not interchangeable, but that its whole body follows the play of each muscle. It is certain he often went over his statuettes again, but it was to perfect rather than to transform them. Those statuettes of horses which have survived show such real science of observation and execution that it is hard to imagine how Degas could have made the slightest alteration without destroying their harmony and being obliged to do the whole animal over again. In any case, there is no reason to think Degas referred to his statuettes for his pictures of horse races, especially as at that period he scorned the use of models and worked mostly from memory. It is not easy to believe that the man who could impregnate his mind with the attitudes of horses at Longchamp so vividly as to be able to model them later in his studio had need of models in order to draw or paint these same horses. Doubtlessly Degas found in his own modeling many suggestions which assisted him in the working out of his pictures of horse races; yet he found them while actually modeling rather than while studying the finished statuette. To shape with his fingers what his eyes had seen must have given him a complete command over the things he observed, but it seems doubtful that there was between his statuettes and his paintings any other bond than that same passionate search for movement.

Ballet Dancer, Dressed, 1880–1881

There is no knowledge of when Degas began to model the human form, or whether his *Ballet Dancer, Dressed (III)* is really his first attempt; it is in any case the first figure whose date is known. Since the pose is relatively simple compared with those he was later to preserve in wax, we may presume that, as in the case of his horses, he started out with more or less easy problems and progressed to veritable feats of equilibrium.

It was around 1879 that this little girl from the children's ballet class of the Opera, with a body that was still frail and inflexible, must have started posing for Degas. He probably first drew her in her tutu or nude, apparently attracted by the angular shapes of her slender legs and of her arms crossed over her flat chest. Was he already thinking of a statuette? Was he experimenting with different poses? We have no idea, but as soon as he had found what he was seeking—the child in this standing pose, one foot before the other, her hands clasped behind her back, the head raised with an indescribable expression of effrontery—he made a series of sketches definitely intended as a preparation for his statuette, or rather for his statuettes, since Degas was first to model the little dancer while nude before commencing the work he had in mind. These studies show his young model nude and dressed and are the only known case of Degas's making drawings for

32 Edgar Degas *Study in the Nude for 'Ballet Dancer, Dressed'* 1879–80

one of his modelings. It is true that it was a question of an especially important work, not only on account of the format (three-quarters life-size), but also on account of the innovations he was planning and of his intention to exhibit this statuette, and thus for the first time present himself before the public as a sculptor.

Degas's innovations were rather unexpected: the statuette was to wear a real bodice, a gauze tutu, and shoes, and a real silk ribbon was to tie the hair behind the neck; in addition, he intended to tint the wax to make it look even more lifelike. This out-and-out realism naturally demanded very careful preparation, for the least exaggeration would not have failed to render grotesque this attempt to bring together elements which were not normally destined to harmonize, and even less to be incorporated in a statuette. For it was a statuette Degas wished to create—not a doll.

Having first modeled the child nude *(32)*—to familiarize himself with the forms of her body and also, doubtlessly, to prepare himself better for clothing the figure—Degas proceeded with the final work. He probably had the little shoes and the bodice made to order; the latter he was to cover, in process of work, with a thin layer of wax which helped unite it with the rest of the work while preserving its special texture. All the details that the artist had merely suggested in the nude statuette are minutely elaborated in the dressed figure, right down to the folds in the stockings below the knees. The somewhat rough workmanship of the preliminary work is replaced by a smooth treatment such as Degas had never yet used. The features, which at first were only sketched in, are finished with the greatest care *(27)*. Renoir tells of having seen in this wax dancer 'a mouth, a mere hint, but what draftsmanship!' Yet, he adds regretfully, that on the repeated assurance that he had forgotten to do the mouth, Degas had given in to his friend Bartholomé and done the mouth over again, thus losing its original qualities. It is probable that Renoir got the two statuettes confused, since that of the little nude dancer indeed shows a mouth traced in the wax with great clearness and much more 'drawn' than that of the dressed dancer. In Degas's own words, only one feature mattered to him— the nose; that of his statuette distinguished itself by an air of impertinence which the eyes and mouth do nothing but increase in the dressed statuette, whereas the somewhat brutal mouth of the nude statuette lessens it. One is at leisure to doubt, moreover, whether Bartholomé had the slightest influence on the style researches of his friend, but it is true that he assisted Degas in the technical details of the execution, and it was he who, the day before the exhibition, removed the recalcitrant iron tips of the armature which protruded here and there from the little dancer's body.

Degas had promised his statuette for the Impressionist exhibition of 1880 and had it included in the catalogue. The exhibition opened on the first of April, but since—according to his version—he was not able to finish his statuette in time, he did not in the end send it.

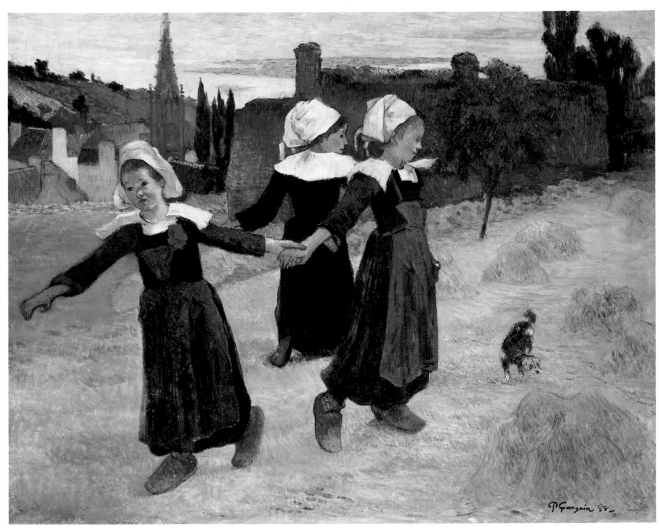

1 Paul Gauguin *Breton Girls Dancing, Pont-Aven* 1888

II Paul Gauguin *Eve* 1890

III Edgar Degas *Ballet Dancer, Dressed* 1880

IV Georges Seurat *Bathing at Asnières* (detail) 1884

v Georges Seurat *Eiffel Tower* 1890

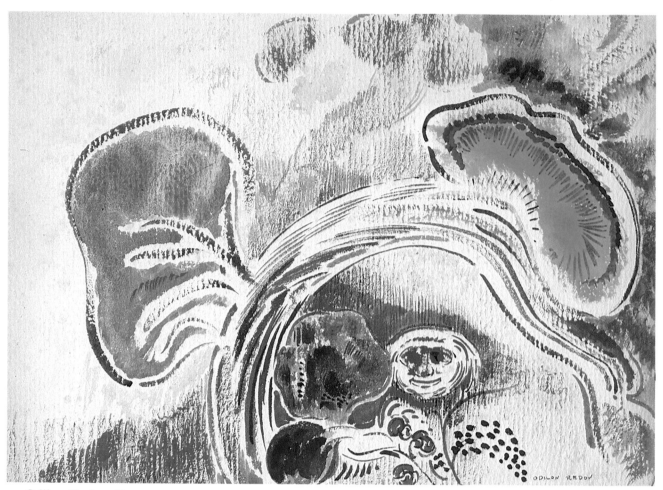

VI Odilon Redon *Fantasy c.* 1910

VII Henri Matisse *Open Window, Collioure* 1905

VIII Vincent van Gogh *The Yellow Chair* 1888/89

Degas's contribution to this exhibition was in any case so great—he was to exhibit some ten important paintings or drawings—that it is not altogether impossible for the artist to have preferred to hold back his statuette in order to show it off to greater advantage. As a matter of fact, when he sent it to the Impressionist exhibition the following year, he sent with it merely a few other works of secondary importance, thereby putting it in the limelight. While it waited for a whole year in Degas's studio, the *Ballet Dancer, Dressed* did not fail to be noticed by the painter's friends and rare visitors, and knowledge of it had spread in the artistic circles of Paris. This was to assure in advance a curious interest in it when it was at last exhibited in 1881.

It was inevitable that this statuette should become the object of lively arguments; the astonishment it caused and the amazement of most visitors before its lifelike and unexpected accoutrements prompted many of them to be more concerned with Degas's innovations than with the work itself. Yet even hostile critics could not hold back a certain respect for the effort achieved.

'The result is almost frightening,' wrote Paul Mantz in *Le Temps*.

'The wretched child stands in a cheap gauze dress, with a blue ribbon around her waist [?] and shoes on her feet. . . . Terrifying, because she is without thought, she brings forward, with bestial impudence, her face or rather her little phiz. . . . In this nasty little figure, there is still—with an intention dictated by the mind of a Baudelaire-like philosopher—something which comes of an observant and loyal artist. It's the perfect truthfulness of gesture, the almost mechanical accuracy of movement, the artificial grace of the pose, the uncouth inelegance of the schoolgirl. . . . As for the expression of the face, it is obviously studied. Mr Degas dreamed of an ideal of ugliness. The happy man! He has achieved it. . . . If he continues to model and if he keeps his style, he will have a little niche in the history of the cruel arts.'

To the cautious reserve evinced by this critic is opposed the warm-hearted enthusiasm with which J.-K. Huysmans welcomed Degas's statuette:

'The chief attraction of his exhibition is not, this year, to be found among his drawings or paintings . . . it is one single figure of wax . . . from which the public, quite bewildered and embarrassed, runs away. The frightful realism of this statuette evidently makes people uncomfortable; all its ideas on sculpture, on those cold, inanimate white objects, on those memorable imitations copied over and over for centuries, are upset. The fact is that, at one blow, Mr Degas has overthrown the traditions of sculpture as he long ago weakened the conventions of painting. . . .

'The head is painted and slightly thrown back, the chin sticks out, half opening the mouth in the sickly and gray face, which is drawn and prematurely old; her hands are clasped behind her back; her flat chest is molded by a white bodice the stuff of which is covered with wax, her legs are in position for a battle—remarkable legs inured to exercise, nervous and twisted, topped by the muslin skirt as though by a tent, her straight neck is surrounded by a leek-green ribbon [?]; her hair—real horse hair—which falls on her shoulders, has in the chignon a ribbon like the one in the neck—

such is the dancer who comes to life under one's gaze and seems ready to leave her pedestal.

'Both refined and barbaric with her complicated costume and her painted flesh which throbs, furrowed by moving muscles, this statuette is the only really modern attempt I know in sculpture.'

Degas was not to renew this attempt, thus forfeiting the 'little niche in the history of the cruel arts' which the critic of *Le Temps* had predicted for him. From then on he exhibited no more sculptures, and he made no more statuettes dressed in real clothes, although George Moore tells in his memories of having seen in Degas's studio 'much decaying sculpture—dancing girls modelled in red wax, some dressed in muslin skirts, strange dolls—dolls if you will, but dolls modelled by a man of genius.' Since he probably considered his attempts as an experience that had to be approached and not as a vein to be worked, Degas was now to devote himself to other problems. If he made any more statuettes of ballet girls dressed in their tutus—he made at least one which has been preserved—he modeled their skirts in the wax itself, as the rest of the body. It is not without interest to add that the *Ballet Dancer, Dressed*, hailed by Huysmans as 'the only really modern attempt in sculpture,' was not only to remain alone among Degas's sculptures, but was also to find no imitators. In the history of modern sculpture it occupies a place by itself, bearing witness to a brilliant audacity and a clever inventiveness which knew how to defy the rules of the craft and to put to use the most heterogeneous elements, bending them to the artist's sublime will.

Only a few years ago Sacha Guitry said about this sculpture:

'Yes, this little life-size dancer is the objet d'art that I desire the most in the world. The skirt she is wearing is of genuine tarlatan, the ribbon that braids her tresses is a real satin ribbon. She is the image of poverty, degeneration, and obedience. She is the *apotheosis* of Art and Sculpture, as well as of painting and drawing.

'And then, she is something else besides, something that has no name. She is a kind of hallucinating mummy. And yet, she is life itself. She is something unique. So removed is she from the ordinary that she is an example quite unparalleled. She is definitive. She is at the same time a sketch and the finished work. She is perfection personified. You would have to go a long way, a very long way, right to Egypt and into its ancient past to discover a work of art to equal her.

'She is only a little dancer from the Opera—this she is forever. Degas *worked* at her all his life. He did twenty pictures of her, a hundred pastels, and a thousand drawings. He may have done five thousand sketches. And all these sketches, all these drawings, all these pastels, all these pictures, just to attain this! She is the essence of them all. She is their synthesis and their proof.

'For to hold her in such a way, motionless for eternity, how many times must he have seen her coming, going, sponging herself, combing her hair, and dressing. How he must have known her slightest movement to create this immobility that conveys at the same instant the very feeling of movement itself.'

The Busts

The *Ballet Dancer, Dressed* holds an exceptional place among Degas's statuettes, not only on account of her accoutrements, but also on account of the manner in which she was modeled. Degas was to abandon almost completely the smooth workmanship, the careful finish that distinguishes this work and would acquire an increasingly free and spontaneous technique which gives his sculptures a real air of having been *modeled*. It goes without saying that with a rougher texture the artist had to give up the finicky elaboration of details in favor of an 'impressionistic' treatment which Degas the sculptor adopted without worrying about Degas the painter, who had not been able to find in Impressionism a vehicle for his perceptions. Degas was thus never again to make a statuette whose face was modeled with such attention to details as that of his dressed dancer. Even in his busts the surface was from then on to keep that look of modeled matter which gives it an air of having been seized from life and which admirably hides the unrelenting effort and the numerous periods of work Degas devoted to his works in sculpture.

Only three of Degas's busts have been preserved, and we know neither their date of execution nor whom they represent. But Degas must have modeled many other portraits of his friends; we have information concerning at least two more. One was the portrait of his friend, the Venetian painter Zandomeneghi, which Renoir considered 'extraordinary,' regretting that the author hid it with the excuse that it was not finished. This bust is probably the one mentioned by Meier-Graefe, who may have had his information from Renoir himself. 'A friend of his,' he writes, 'told me that Degas made an admirable bust of a painter who was for a time a kind of pupil of Degas. The bust in question was never completed, because the model, in spite of all his veneration for Degas, found the task of sitting more strenuous than he could bear.'

The other bust on which we have information, but which no longer exists, was of the young Hortense Valpinçon, the daughter of intimate friends of Degas. In the fall of 1884 the artist had gone to visit them for a few weeks at Ménil-Hubert, their estate in Normandy. As he was getting ready to go back to Paris, the mother of young Hortense made use of an ingenious trick to make him stay: she reproached him for not having done a portrait of her daughter. Although he clearly saw through the ruse, Degas set himself to work and wrote to his friend Ludovic Halévy: 'I am held here, or rather I hold myself here, to finish a bust with arms. It is slow work, even though quite amusing. And the interest I arouse rather resembles malicious curiosity. That is why I am doing my best to make a good likeness and even something more.'

According to the recollections of his model, Degas had undertaken at first only the head, then he had made a bust, finally to decide on a life-size sculpture down to the middle of the thighs, to which he devoted his entire

days. The work appears to have progressed rather slowly, to judge from another letter where Degas speaks to his old friend Henri Rouart about the 'large bust with arms of young Hortense, and which I am finishing with much patience and effort. . . . Heavens! How I floundered at first; and how little we know what we are about when we do not trust to expert knowledge. It is useless to say we can do anything with naïveté; we may perhaps get there, but so sloppily!'

Since, indeed, he knew none of the tricks of the trade, Degas must have lost an infinite amount of time in his struggle with the refractory material. One can easily conceive the difficulties he must have encountered in trying to adapt the armature, which he had first made only for the head, to the needs of a bust down to the waist. When he was in Paris, his friend Bartholomé used to help out in such a case; originally a painter himself, Bartholomé had turned to sculpture, to which he gave himself exclusively after the death of his wife in 1887. Degas greatly admired his skill, but was often too obstinate to take advantage of the advice or the help offered by his friend. From Ménil-Hubert he confides to him his worries:

'To keep busy, I have started plowing into a great bust with arms, in clay mixed with little pebbles. . . . On the whole one only amuses oneself with what one doesn't know—when one is as crazy as I. And except for my legs, which are driving up into my torso, and my arms, which are tiring out my stomach as a result of constantly reaching up, it isn't going too badly. Around the end of this week I shall certainly be back in Paris, and I will have to . . . start off again for Normandy with a molder, to insure the reproduction of the work and to make it last. The family [Valpinçon] are and will be watching as Norman peasants, with distrust written on their faces and lodged in their hearts.'

Nearly three weeks after writing this letter, Degas is still at Ménil-Hubert, kept there by his work. He then writes again to Bartholomé, on October 3, to tell him:

'As for the bust, suffice it for you to know that it is not finished, that it is terribly slow, and that I am returning to Paris. . . . There are two arms—this I have told you—suffice it for you to know that there is one behind the back—the one whose hand can be seen. I am probably the only person who finds it all right.' [And Degas adds a little sketch.]

At last back in Paris, Degas was indeed to start out again for Ménil-Hubert, but unaccompanied by a molder. He took with him a little bag of plaster, which turned out to be absolutely insufficient for the bust. Too impatient to wait for more plaster to be sent from Paris, Degas decided to use ordinary plaster. . . . Both the bust and the mold broke during the operation. For several months Degas was to preserve in his Paris studio the back of the bust

by moistening it from time to time. But even this fragment eventually collapsed, and of the *Bust with Arms* nothing now remains.

The three small busts that have been preserved seem only minor works in spite of their interest as psychological studies; as such they complete the long list of painted and drawn portraits left by Degas.

Research in Movement

In comparison with the vast amount of information which we possess concerning the lost bust of Hortense Valpinçon, we know practically nothing about Degas's later sculptures, least of all about his studies of movement. We do not even know whether models posed for them, but there is every reason to think so; at least it is certain Degas used models from about 1900 on. But after the *Ballet Dancer, Dressed* Degas seems to have made no more preparatory drawings for his figures. As he showed a more and more marked preference for a limited number of poses, he drew and modeled the same attitudes over and over again, yet without the drawings and sculptures being linked together as are the various stages of a gestation. It would rather seem as if the draftsman confided to the paper, and the sculptor to the plastic material, the solution of a problem that occupied them simultaneously and that each devoted himself to this solution strictly within the limits of his medium. The fact that the draftsman and the painter often worked from the same model holding the same pose was simply due to the circumstance that a certain pose so excited their curiosity that both found in it the material for extended research covering several years. Thus Degas often asked of his models the same more or less difficult poses; around 1910, for instance, he started on a statuette for which the model had to stand on her left leg, while her right hand held her right foot raised from behind. Ten years earlier, Degas had already modeled a statuette showing exactly the same attitude *(34)* and, in 1909, had started, then abandoned an identical statuette. It goes without saying he had, in this case too, made numerous drawings representing the pose, just as for all his statuettes of dancers and women at their toilet there are drawings or pastels in corresponding poses. But these could hardly be called preparatory studies, because Degas was trying to render forms by the interplay of lines and the opposition between light and dark rather than by imitating volumes. It is at any rate significant that in his drawings for the *Ballet Dancer*—the nude and the dressed one—Degas had assembled on one and the same sheet views of the back and profile of his model, since all her aspects were of concern to the sculptor, whereas later he no longer thought of his modeling as he drew and exclusively devoted himself to the viewpoint that attracts the draftsman, leaving it to the sculptor to explore the other aspects. The sculptor soon understood that he was not able to arrive, in his own drawings, at the real

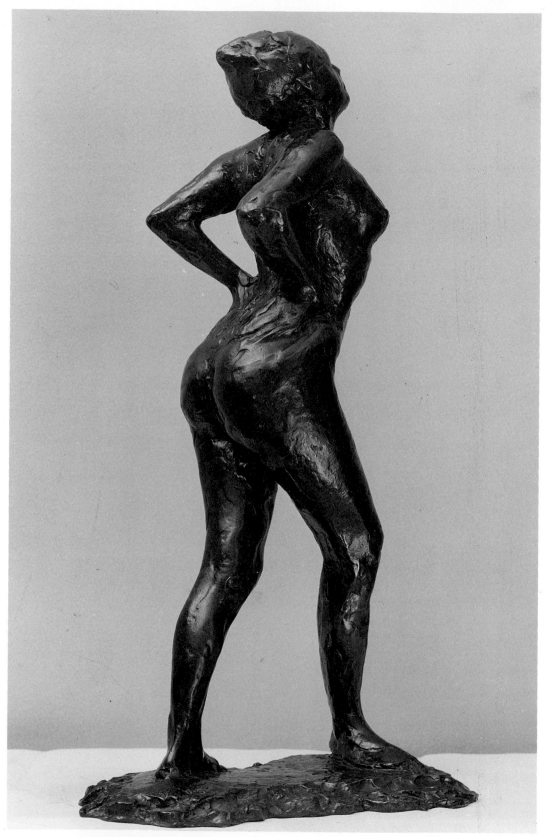

33 Edgar Degas *Dancer at Rest, Hands behind Her Back, Right Leg Forward* 1882–95

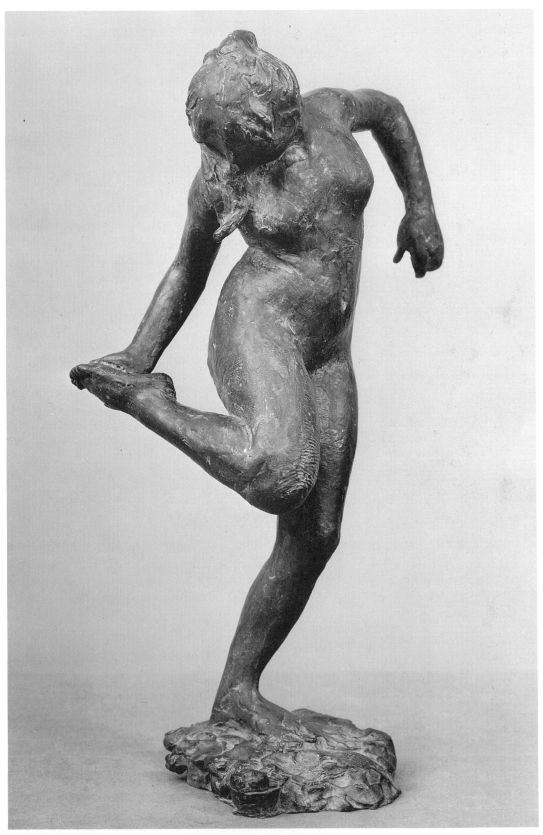

34 Edgar Degas *Dancer Looking at the Sole of Her Right Foot* *c*.1900

approach to the problems of mass. He discovered that sculpture is not merely a drawing in relief, that relief alone does not make a work plastic, and that what distinguishes a stone from a piece of sculpture is not relief but the conception of mass. It was then that he wrote to his friend Bartholomé: 'Aside from bas-reliefs, is it not possible that sculpture should be the singular art of giving an idea of forms while cheating at the same time on relief? It is relief which spoils everything, which most deceives, and it is in it that people believe.'

Degas's efforts were thus not directed simply toward relief, but toward the conception of mass, and he does not conceive it as being imprisoned by the limits of a stone which forces on the sculptor its static laws. He seeks mass in movement. 'It is the movement of things and people which amuses and even consoles me,' he writes to his friend Henri Rouart. 'If the leaves of trees did not move, how sad the trees would be, and we too.'

It was in his passionate search for movement that all the statuettes of dancers doing arabesques, bowing, rubbing their knees, or putting their

35 Edgar Degas *The Tub* 1886

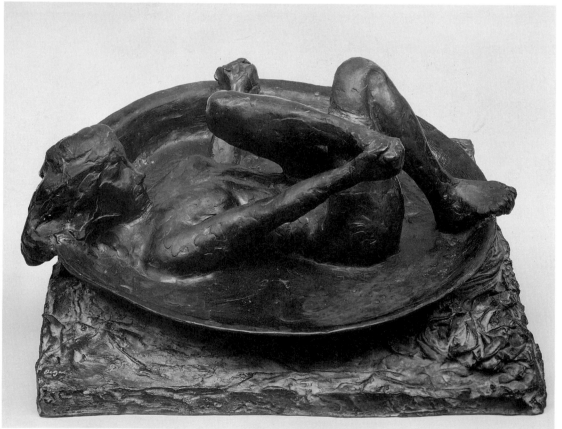

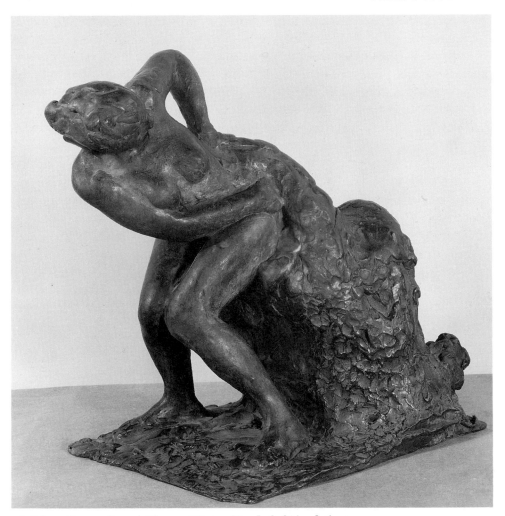

36 Edgar Degas *Seated Woman Wiping Her Left Side* 1896–1911

stockings on and of women arranging their hair, stretching, rubbing their necks, and so on were created *(33, 35–37)*. All of these women are caught in poses which represent one single instant, in an arrested movement that is pregnant with the movement just completed and the one about to follow. To use Baudelaire's words, Degas 'loved the human body as a material harmony, as a beautiful architecture with the addition of movement.'

While Degas had excelled at first with very smooth modeling, his technique toward the end became increasingly choppy and rough. His hands modeled the clay with more energy, less care, and their very feverishness seemed to be transmitted to the material. But this feverishness has nothing disordered about it; it corresponds to the almost youthful fire which so many great masters come to in their old age. The care for detail has disappeared;

145

both hand and eye go after what is essential with the raw strength that comes from knowledge and experience.

We find this same strength in the summary outlines of his drawings and of his last pastels which are marked by a superb violence of color. A grandiose vision is that of this old man who, in a profusion of forms, lines, and colors, arrives at the pinnacle of a life filled with daring. The movements to which he had devoted such research he now represents in a style which is itself teeming with agitation—by vibrating lines and forms that seem alive. In his hands wax is no longer an inert material; his fingers mold it almost with frenzy, constructing masses which no longer borrow from nature the smooth surface of human bodies, but express, right down to their rough texture, the pulsations of life and the breath of the creator.

That Degas's increasing blindness played a part in his change of technique cannot be doubted, for there came a time when his eyes were of hardly any help to his hands. But to attribute the style of his old age entirely to his bad eyesight would be to mistake the whole development of his art. A life like that of Degas does not end with 'accidents.' When he could no longer see, he knew he had to stop working, for work that is but nearly right can never be a consolation for someone who rarely found satisfaction in perfection itself.

Degas at Work

The studio in which Degas did most of his modeling was the one in the rue Victor Massé, where he occupied three stories of a house opposite the famous Bal Tabarin. Degas had an apartment on the third floor, where he slept, whereas the floor above was given over to his collection; most notable among the rooms was a large drawing room full of paintings and drawings, and a little dining room which had a glass case full of curios, and several of Degas's statuettes—in wax or in plaster—under glass. The fifth floor was his studio. It was spacious but dark, for the large window, which formed all the north side, was almost entirely covered by a cloth curtain that reached down quite low. Only a dim light filtered in, reaching with difficulty to the end of the room. Everywhere this weak light was intercepted by cupboards, numerous easels entangled with each other, sculptor's stands, tables, armchairs, stools, several screens, and even a bathtub which Degas used for his bathers. The corners were no less littered; a number of empty frames were lined up beside empty stretchers, rolls of cloth, and paper. The doors and high walls of maroon color were bare, with neither drawings nor paintings. Degas used to put away all his works in cardboard folders and cupboards, or else he stacked them in a little room behind his studio. As for his more-or-less finished sculptures, they were kept on a long table at the end of the studio, where they waited, either to be

37 Edgar Degas *Woman Arranging Her Hair* 1896–1911

continued or to disintegrate slowly. This table, like all the rest of the studio, was covered with a thick layer of dust.

Degas had only a small space in the front of the studio, just below the window, in which to work. It was there, between the model stand surrounded by a screen, between the sculptor's easel and a stove, that he spent his mornings. He engaged his models four or five times a week, sometimes twice a day, and often continued to work after their departure. Dressed in a long sculptor's smock, he walked incessantly back and forth between the model and his statuette, using his thumb to get information which his tired eyes refused to give him. Even though, with his eyes almost closed behind their glasses, he constantly examined the outlines of the nude body to compare them with those of his work, and although he was seated very close to the model, he could only dimly distinguish her shape and had to get up at every instant to feel with his hand the curve of the hip or the position of a muscle which his thumb would model in clay. With the plumb line he made certain that the poses of the model and of his statuette were absolutely identical; so great was his uncertainty, so small his confidence in his perceptive faculties, that he was even reduced to using a pair of calipers—he who once liked to boast that he worked entirely from memory. These calipers he manipulated rather clumsily and with such sudden gestures that his models did not always escape red gashes on their legs or arms. Having checked the points of the large proportional calipers by means of measurements on the wall, he placed them on his figurine which he approached so closely that his long white hair often touched it. He did not cease working while the model rested.

Posing for Degas was not easy; the hours were long, and the artist was so exacting that some models refused to work for him. The sight of a rounded back or a listlessly extended hand could make him roar with anger. He had a profound aversion for all so-called graceful poses, which were so popular in other studios, and nearly always insisted on poses that were full of action. But the difficulty of obtaining well-balanced poses was one of the lesser obstacles Degas encountered in his modelings; far more serious were those presented by the material itself.

Having become weary of clay—of its handling and the damp cloths it required—Degas had tried to use Plasticine, although, as he said, it disgusted him. It is true that, in a spirit of economy, he liked to stuff his various materials with little disks of cork, which periodically kept coming to the surface, and in the most unexpected places, making constant repairs necessary. When he had decided to use wax, he insisted, again for the same reason, on making his own, which always became too friable. With the wax Degas mixed convenient but coarse materials, such as tallow, which hardly increased the durability of his figures. Wax appealed to him because of its warm and lacquered reds and blacks. According to Paul Gsell, one of his bathers was a miracle of polychromy, 'She was warmly tinted and as

translucent as honey, and the bucket streaked with green and red harmonized perfectly with the golden amber of the wax.'

The difficulties Degas encountered in the handling of these materials were mainly due to the inadequacy of his improvised armatures, which gave him many an unpleasant surprise and filled him with violent anger. Faithfully attached to the fatal habit of experimenting—even though he himself deplored it—Degas used to suspend with strings or support with props the projecting masses. As he frequently forgot to make thicker the parts around the joints, he could not prevent arms from falling and the dried-out material from developing cracks. Elsewhere he would use wire that was too thin, which bent under the weight of the wax, or he made use of brush handles insecurely tied together, which would suddenly fall apart, dragging down with them the parts they were to uphold. Yet all these accidents, which so infuriated Degas, need not have been so frequent had not his very methods of work practically provoked them: sometimes, when he was trying to improve a pose, Degas would simply pull an elbow aside, raise a knee, or twist a torso until his statuette could no longer resist these constant shocks. These changes of pose were therefore often accompanied by the collapse of the entire work. Degas would then start at once on a new statuette, but not always with the same enthusiasm; sometimes he would leave it after working for several weeks, put it away on the long table at the back of his studio and turn to something else. Degas generally took good care of the works that he put away on the long table, since he always had the firm intention of working on them again, when he should become tired of his new work. It was this habit of leaving and taking them up again which was particularly fatal to the statuettes. When they had stayed in their corner for months, sometimes for a whole year, they were badly suited to be worked on again. Often, the very first time Degas came back to them, an arm or a leg would drop off. He would mend it at once, only to find, a few days later, another accident somewhere else. As long as the figure was modeled in Plasticine, he could put it in shape again, but those in clay could almost never stand up against the tinkering. They would suddenly collapse, and before their pathetic remains all hope of a resurrection had to be abandoned. (Nearly all the information in this section has been derived, sometimes literally, from A. Michel, 'Degas et son modèle,' *Mercure de France*, Feb. 1 and 16, 1919.)

Since he could work only with difficulty because of his failing eyesight and had to struggle with courage and rage against all these accidents, Degas's statuettes proceeded very slowly. Sometimes, even if he had been working for three months, his model could discern no progress. But despite all mishaps, the artist was not sparing of his efforts, especially as modeling was the only work of which he was capable. Every day he suffered more from his disability and the slowness that it imposed on him; in 1910 he pitifully exclaimed in a letter to his friend Alexis Rouart, 'I don't ever seem to get

through with my confounded sculpture.' Around 1911 Lemoisne relates that Degas still spent all his time in his studio, working at his sculpture, but a year later the artist was forced to leave the building in the rue Victor Massé where he had lived for a quarter of a century to make way for the wreckers. He rented an apartment and a studio—right near his former home—in a house on the boulevard de Clichy. Degas was to do no more work. As his eyesight continued to fail, and as he felt uprooted after his enforced moving, he let himself slip into a demoralizing idleness. Even his growing fame did not make him leave his solitude, nor help him come out of his depression, since it could do nothing to relieve the powerlessness of his hands.

'Degas lives alone and almost blind, seeing nobody, without any kind of occupation,' Paul Lafond wrote to George Moore. Thus did he spend his last years. He died in his apartment on the boulevard de Clichy, on September 27, 1917, in his eighty-third year, without having modeled anymore.

The Casting

Of about 150 more or less well-preserved works in sculpture discovered in the studio and the apartment of Degas after his death, of which but 3 had been previously cast in plaster, only about 70 were either intact or could be repaired. After Paul Durand-Ruel had made the inventory, these were deposited under Bartholomé's supervision in the cellar of the founder Hébrard, to protect them from German bombardments. Hébrard was to cast them at the end of the war and actually began to do so at the close of the year 1919.

Wherever this was possible, the wax and clay originals were to be cast in the exact condition in which Degas had left them, but in many cases minor repairs and adjustments were necessary before the casting. Thus certain cracks had to be mended and dislocated members to be readjusted, as for instance the arms of the *Ballet Dancer, Dressed* which had fallen off. The parts of the armature that showed were suppressed wherever possible, but had to be maintained in cases where they link two separate parts, or where they replace unfinished details. From all that is known, these repairs and adjustments were executed by Degas's friend Bartholomé.

The process chosen for the reproduction was the *cire perdue* or lost-wax technique in which A.-A. Hébrard was the greatest master of his day. The extremely complicated *cire perdue* process has the great advantage over all other methods in that it achieves the highest possible fidelity to the original whose very surface—the surface kneaded by the artist—is so faithfully reproduced that even fingerprints reappear on the bronze casts. This process requires that first a piece-mold in plaster be made from the wax or clay statuette, from which a so-called original plaster model is then cast. The

150

plaster model serves for the entire edition of bronze casts, which was, in the case of Degas's sculptures, limited to twenty-two copies of each work. Therefore twenty-two negative molds of thick elastic gelatine or glue were made from every original plaster model.

A glue mold consists of two halves which, put together, contain an empty space of the shape and volume of the statuette. Its inside is covered with a thin layer of hot wax, and then filled with a core of fire-resisting material. Solid bars of wax are attached to the wax layer in order later to provide channels through which the molten bronze can flow to all parts of the sculpture or through which the air can escape. Pins hold the core suspended in the mold after the wax has been melted out. This melting out is obtained by placing the wax model, encased in its mold, in an oven and baking it until the wax is 'lost.' The thin layer of air thus created in the shape of the sculpture, as well as the empty channels, are now ready to be filled with melted bronze poured into the mold. When the metal has cooled, the mold is broken away, and the sculpture appears. All the channels and air vents have become solid bronze. They have to be cut away and the surface of the bronze has to be cleaned. Once this is done, a chemical treatment provides the patina. For Degas's sculptures a special effort was made to retain the different colors of the wax originals through oxidation.

Altogether seventy-three sculptures by Degas were cast in bronze. Of these, seventy-two were cast between 1919 and 1921, and the seventy-third, *Ballet Dancer*, *Dressed*, sometime later.

Of the twenty-two bronze copies cast from every individual sculpture, twenty were marked A to T and destined for sale, while of the remaining two, one was reserved for the founder and the other for the heirs of the artist. These two copies were especially marked, the one for the heirs bearing the letters HER. To each sculpture also was assigned its serial number, running from 1 to 72; only the *Ballet Dancer*, *Dressed* was marked neither by a number nor by letters. Therefore, with the exception of this one, each bronze cast bears an Arabic numeral, which identifies the sculpture, and a letter, which indicates to which of the twenty sets it belongs. Each bronze also shows the signature of Degas *incised* and the stamp of the founder (*cire perdue*, A.-A. Hébrard) *in relief*.

A seventy-fourth statuette (*Woman Walking in the Street* or *The Schoolgirl*) was cast subsequently and was not included in the various exhibitions of Degas's works in sculpture.

Degas's Bronzes—an Afterword

In memory of Frank Perls

Degas's work in sculpture has had a strange fate, from almost total neglect to an apotheosis that goes far beyond the expectations of even those who admired it back in the days when the fragile pieces—often precariously balanced—cluttered the artist's studio. Only after the master's death was the founder Adrien A. Hébrard able to save them from what would have been slow but complete disintegration. Yet when Hébrard first exhibited a set of the expertly cast bronzes in 1921, public reaction was not altogether favorable. For what Degas had accomplished in three dimensions was what he had done also with color and line: to endow his subjects with a new reality, to see and depict them as they had never been shown before. For proof it is sufficient to compare his many figures of dancers—especially his famous *Ballet Dancer, Dressed (III)*—with the photographs of young members of the Paris Opera Ballet as they were generally represented in those days *(38)*.

It took amazing perception and even courage for Mary Cassatt to write to her friend, Mrs H. O. Havemeyer, 'I have studied Degas's bronzes for months. I believe he will live to be greater as a sculptor than as a painter.' Not surprisingly, Mrs Havemeyer was the first to reserve a complete set—indeed the set numbered A—of the newly cast bronzes, which she subsequently lent to the Metropolitan Museum in New York. Durand-Ruel purchased set B and exhibited it in New York in 1922. The Leicester Galleries showed another set in London in 1923 with a catalogue foreword by Walter Sickert. The Lefevre Gallery acquired two complete sets in the early 1950s, which were eventually split up and all the pieces sold individually, as was the case with practically all those that went to dealers.

With the help of the founder and the artist's heirs, the Louvre acquired set P in 1930, at the very time Mrs Havemeyer bequeathed her set (with the exception of two pieces) to the Metropolitan Museum. A third complete set is owned by the Ny Carlsberg Glyptotek in Copenhagen. Only this last museum arranged at an early date for the permanent display of the entire series. The Metropolitan Museum, on the other hand, for many years treated the Havemeyer gift with a certain embarrassment. As late as 1946 its *Bulletin*

First published as the Introduction for the catalogue of an exhibition, The Lefevre Gallery, London, 1976

38 Photograph of
a ballet dancer

published an article in which Degas's 'clay studies' were seen as the 'principal amusement' of his old age and called sketches or experiments that 'cannot be considered as serious works in sculpture in the academic sense of the word.' But the ultimate insult came with the statement, 'It has been remarked by certain critics that the reduplication of these unfinished sketches in twenty sets of bronzes . . . is rather too plainly a franc-stretching gesture on the part of the [artist's] heirs.'

The *Bulletin* nobly resisted the temptation to reveal who these critics were. It seems doubtful whether, during the thirty years that have elapsed since, anybody can be found to subscribe to such a base insinuation. Quite to the contrary, the demand for Degas's bronzes has steadily risen, and so have their prices.

Since the first catalogue of Degas's sculpture was issued (with some difficulty because the topic did not appear promising to the publisher), a great deal has been written on the subject. That catalogue, published in New York

in 1944, had to be established without access to any French sources and thus contained some rather serious errors. The most grievous of these was the affirmation, 'All the original wax and clay statuettes were destroyed after the casting with the exception of the wax figure for *La petite danseuse de quatorze ans* [*Ballet Dancer, Dressed*], which is now in the Louvre.'

I was able to correct these inaccuracies in the second edition of the catalogue (Zurich, 1956) and also to complete the bibliography. Among the important studies that have appeared since are: M. Beaulieu, 'Les Sculptures de Degas: Essai de chronologie,' *La Revue du Louvre*, no. 6 (1969), T. Reff, 'To Make Sculpture Modern,' in *Degas: The Artist's Mind* (New York, 1976), and C. W. Millard, *The Sculpture of Edgar Degas* (Princeton, 1976).

Unfortunately, Degas's sculpture has attracted not only scholars. The supreme confirmation of the high regard in which it is now held comes from those who ransack the work of all great masters: forgers!

In the case of Degas, counterfeits present themselves in two different forms. The more easily found out are attempts to adorn pieces by other, little-known artists with Degas's signature in the hope that they will thus command higher prices. None of these were of course included in Hébrard's initial exhibition of 1921, though some—cast in his foundry—bear his founder's mark, which was carefully preserved after the name of the original artist had been deleted. This type of fraud is likely to go on as long as there are crooks who imagine that they can find buyers for such wares.

The more dangerous fakes are so-called *surmoulages*, for which a mold is made from a genuine cast which then serves for new, more-or-less unlimited editions. These fraudulent casts carry the same markings and signature that appear in the original from which the mold was made, though they are usually more faint and blurred; they differ slightly in size and considerably in weight from their model, since the alloy used is not identical with the secret one employed by Hébrard. Just the same, it is not always easy to detect such *surmoulages* at first sight, especially when they cannot be compared with a genuine cast.

A few years ago I discovered an authentic small Degas bronze in a foundry near Lucca. When I asked what it was doing there, I was told that it had been brought in by a Degas heir(!). Hébrard allegedly having failed to make the number of casts allotted to all the other pieces, the foundry had been requested to 'complete' the set by casting the 'missing' number. This, of course, was a lie, but whether the founder was aware of it or not escapes my knowledge. I am afraid that much illegal casting is done in Italy where expert craftsmen are still to be found. Needless to add, such Italian foundries discreetly refrain from putting their own mark on these pieces.

It seems that the records concerning various manufacturing details, and especially the alloy used for Degas's bronzes, were kept by the director of Hébrard's foundry, A. Palazzolo. Born in Milan in 1883, he had learned in

Italy a remarkable method of applying the *cire perdue* process without actually losing the original wax piece, a method he later perfected in Paris. Around 1910, Palazzolo had known Degas and given him technical advice on how to reinforce his armatures. It was Palazzolo who was responsible for the excellent casts of the artist's salvageable statuettes. Late in his life, Palazzolo retired to Milan and there released some Degas bronzes that carried casting numbers like the others but—in addition—were stamped FR MODELE (for 'Founder's Model'), as well as with Palazzolo's monogram, AP, underneath the base.

As a matter of fact, Hébrard had never bothered to list all the Degas casts made in his foundry or to specify exactly how they were marked. The catalogue of the 1921 exhibition held at Hébrard's gallery on the rue Royale had stated that twenty-two casts of each piece had been made, of which twenty, numbered A to T, were for sale, the two remaining sets being reserved for the founder and for the artist's heirs, 'each bearing a mark indicating their destination.' The set for the heirs was marked HER (for 'héritiers').

Unfortunately, even this summary explanation was not altogether correct. While the work was in progress and before the sets had been marked, Hébrard discovered that some of the heirs—who disagreed with each other about the casting, the rights, etc.—did not care for their share of the set that was to be split up among them. He made a deal with them, buying back their pieces. Whereas the founder did cast a complete set for himself, marked HER (though he was not an heir), he marked HERD (for 'héritiers Degas') those casts that went to the heirs who wished to receive their due. But the part of the heir's edition which he had repurchased (about one half of the entire series) was not marked HERD; instead Hébrard marked it HER, similar to his own set. As a result, there are pieces outside the A to T sets of which one is marked HER and one HERD, yet there are also others of which there exist two casts marked HER and none marked HERD. Most of these two sets have in the meantime come on the market, though the phrasing of the 1921 announcement had implied that they were not for sale. If this sounds confusing, it actually is!

Then, in the early fifties, came the startling and exciting revelation that the original wax pieces still existed in the cellar of Hébrard's house on the Ile de la Cité in Paris (so that the *cire perdue* casting was almost a misnomer, although the casts were indeed made from duplicate wax models that melted in the process). The original wax statuettes were exhibited at the Knoedler Galleries in New York in 1955 and were acquired by the American collector Paul Mellon, who presented several of them to the Louvre. A little later appeared two plaster casts of the *Ballet Dancer, Dressed* originating in Hébrard's foundry, both since sold in the United States. And now The Lefevre Gallery has been able to secure from Hébrard's heirs the set being exhibited here, which is marked MODELE (plus the bronze number and the Hébrard stamp).

When I went to examine the newly emerged wax pieces in Hébrard's cellar

prior to their being shipped to Knoedler's, I was able to make brief notes on these pieces for inclusion in the second printing of my book on Degas's sculpture. On that occasion I also noticed the set of bronzes now being shown, but paid no special attention to it and thus did not realize that it bore a mark different from the others with which I was familiar. Had this been pointed out to me, I would have mentioned this fact in the new edition of my catalogue.

At the very time when I saw these bronzes at Hébrard's without paying any attention to them, Jean Adhémar alluded to the set in an interview with Palazzolo ('Before the Degas Bronzes,' *Art News*, November 1955). His article not only explained the complicated and ingenious method of casting that had saved the wax originals, it also stated specifically that Hébrard himself, surprised and delighted with the technique used by the Italian craftsman, 'decided to make a bronze master cast of each figurine, checking it meticulously against the original.' (The same system was apparently also used for the works of other artists.) It is quite obvious that the set which is shown here represents these master casts, since this is consistent with its marking: MODELE.

It is regrettable that, through sheer negligence, no mention was ever made of this set. It is true that it was not for sale and had remained in Hébrard's cellar for more than half a century. Nevertheless, there can be no question but that it is a genuine set made at the time when the other series were cast. This, like the 'discovery' of the original waxes, is an unexpected event, a supplement to an edition that was not quite as strictly limited and not quite as consistently marked as we had been led to believe. Hébrard, of course, did not realize that his casts would become subject to close scrutiny (or that there would be unauthorized *surmoulages*), nor did he think of any evil when he failed to mention this entire set. But for us these careful casts represent a felicitous occasion, the more so since, as the French say, one should never complain *que la mariée est trop belle*!

Seurat: The meaning of the Dots

To Meyer Schapiro

No other painter of the nineteenth century adhered so strictly to a set of theories as Seurat and few painters in history actually allowed their theories to dominate their work to such an extent. Any who did could not always escape the danger of losing their perceptiveness and of surrendering their spontaneity to their theories. By far the majority of painters preferred merely to observe some general rules of their choice, rules elastic enough to permit occasional trespassing. Moreover, most artists formulated their views only after many years of work, deriving their theories from their experience rather than confining this experience to the narrow path of preconceived ideas.

The case of Seurat is different. One might almost say that he did not touch his brushes before he had made up his mind as to what he wanted, and that his concepts were established before he applied them to his work. Thus from the very beginning his evolution followed a line carefully planned by himself. The object of this evolution seems to have been the perfecting of Seurat's system which then would automatically be reflected in the greater beauty of his canvases. The series of rules to which he adhered during the short span of his life was of such mathematical precision that the slightest infringement would have threatened to destroy the harmony of his paintings. Yet Seurat never considered these rules as curbs to his freedom of expression; they were to him the solemn guide toward truth, a challenge rather than a restriction to eye and mind. They were also, as he did not hesitate to admit in a letter to his friend Signac, a means to 'finding something new, an art entirely of my own.'

Seurat was barely twenty when he began, around 1878, to study systematically Chevreul's *Principles of Harmony and Contrast of Colors* as well as other theoretical treatises. He was fascinated by the idea that color is controlled by fixed laws which 'can be taught like music.' Among these laws was the one established by Chevreul, according to which 'under the *simultaneous contrast of colors* are included all the modifications which differently colored objects appear to undergo in their physical composition, and in the height of tone of their respective colors, when seen simultaneously.' One of the basic elements of this simultaneous contrast is the fact that two adjacent colors influence each other mutually, each imposing on

First published in *Art News*, April 1949. This article appeared without notes

its neighbor its own complementary (the light one becomes lighter, the dark one darker).

So as to study more carefully the interplay of colors and their complementaries, Seurat established, after Chevreul's principles, a color wheel on which he brought together all the hues of the rainbow, related to one another by a number of intermediate colors *(39)*. In addition to these, Seurat also used white, which he mixed on his palette with the colors of this circle, thereby obtaining a host of *tones*, ranging from a color with only a trace of white in it to almost pure white. His color wheel could thus be completed in such a way that the pure hues would be assembled in the center, whence they would slowly work toward white, a uniform ring of pure white forming the periphery. With the aid of this wheel, Seurat could easily locate the complementary of any color or tone.

39 Color wheel drawn by Seurat after O. N. Rood
(published in France in 1881)

With such a methodically arranged palette Seurat endeavored to treat his subjects according to the various optical laws established by Chevreul, Rood, Maxwell, and others. Whereas the Impressionists had merely followed their 'sensations' and observed empirically the simultaneous contrast of colors, he wished to control these sensations through the rigorous observation of scientific laws. How Seurat proceeded was explained in 1887 by his friend Félix Fénéon in an article that presents a faithful transcription of Seurat's views. First the painter puts on his canvas pigments which represent the local color, that is the color the represented surface would assume in a completely

40 Georges Seurat *A Sunday Afternoon on the Island of La Grande Jatte* 1886

white light (or if seen from very close by). This color is then 'achromatized' by additional strokes which correspond to *a*. the portion of colored light which reflects itself, without alteration, on that surface (usually a solar orange); *b*. the feeble portion of colored light which penetrates beyond the surface and which is reflected after having been modified by a partial absorption; *c*. reflection from surrounding objects; and *d*. ambient complementary colors.

How the application of these concepts affected the execution of a painting has best been described in Fénéon's analysis of Seurat's *Grande Jatte (40)*, painted between 1884 and 1886, the first major work to reflect his completed theory. 'Take this grass plot in the shadow,' Fénéon wrote.

'Most of the strokes render the local value of the grass; others, orange-tinted and thinly scattered, express the hardly felt action of the sun; bits of purple introduce the complement to green; a cyanic blue, provoked by the proximity of a plot of grass in the sun, accumulates its siftings toward the line of demarcation, and at that point progressively rarefies them. Only two elements come together to produce the grass plot in the sun, green and orange-tinted light, any interaction being impossible under the furious beat of the sun's rays. Black being the absence of light, the black dog is colored by the reactions of the grass; its dominant color is therefore

159

deep purple, but it is also attacked by the dark blue arising from neighboring spaces of light.'

A similar interplay of local colors and reactions can be observed in Seurat's *Fishing Fleet at Port-en-Bressin (41)*, though the light is here more evenly diffused and the contrasts are therefore less strong. Just the same, the artist isolated on his canvas the various color elements in a dosage regulated with mathematical strictness. So precise was his method that, given the color of an object, of its surroundings, and of the conditions of light, he could actually establish beforehand the exact colors or tones he would assemble on his canvas. And indeed, extreme mental concentration enabled Seurat to keep on working late into the night, despite the treacherous character of artificial lighting. He had no more to consult Chevreul's color wheel than a true poet has to count syllables; the law of simultaneous contrast had become the guiding principle of his thinking.

Inseparable from these concepts was Seurat's particular technique of painting. Since all colors and tones have to interpenetrate each other so as to produce the exact coloration of a given surface under given light conditions, it was impossible to mix them on the palette. Physical experiments had proven that the mixture of pigments eventually leads to black. The only mixture that could produce the desired effect was *optical mixture*, which thus became a decisive factor of Seurat's execution. Having assembled on his canvas the individual color elements present in nature, he assigned to the onlooker's retina the task of mixing them again.

With his tiny brush strokes in the form of dots, Seurat could accumulate on a small surface a great variety of colors or tones, each corresponding to one of the elements that contribute to the appearance of the colored object. At a certain distance—which varies according to the size of the dots chosen for the specific work—these tiny particles will fuse optically. And this optical mixture has the advantage of producing a far greater intensity than any mixture of pigments could *(IV, V)*.

Seurat's technique has often led to the belief that an execution in dots, labeled *pointillism*, was an intrinsic part of the artist's system. Actually these dots are merely the most appropriate means of achieving optical mixture, a by-product rather than an essential feature of what he himself preferred to call *chromo-luminarism*. Some artists among his followers and friends, such as Cross and Signac, experimented with small square strokes (not unlike the stones in mosaics) and obtained similar results, though the optical blending did not always proceed as smoothly. Seurat's pointillist technique was actually regarded by many friends as an unavoidable inconvenience because it tended to be too obvious. Signac even considered to a certain degree as failures all works in which the execution forced itself upon the onlooker's attention instead of guiding him toward a more complete enjoyment of the

41 Georges Seurat *Fishing Fleet at Port-en-Bressin* 1888

work itself. It is therefore easy to understand how impatient these painters were with a public that focused its interest on this technical detail without grasping the true character of Seurat's innovations, that is, strict observation of the simultaneous contrast and optical mixture.

A number of artists employed the pointillist technique without using Seurat's color scheme or observing the law of contrasts, thus losing the sole benefit that could be derived from it. Seurat himself, on the other hand, often abandoned this slow and meticulous execution when he painted on the spot those small wooden panels on which he assembled all the 'data' for his large canvases. There he frequently used broad and sweeping brush strokes similar to those of the Impressionists. His colors, however, were pure, the elements balanced, and the law of contrasts observed. In spite of all the physical experiments on which he based his technique, it might even be said that the luminosity achieved in these small panels sometimes surpasses that of the larger canvases, possibly because of their greater concentration. The process of breaking up the phenomenon of light into its parts, though it allowed for infinite subtleties, often had a somewhat diluting effect and may account for

42 Georges Seurat *The Side-Show* 1887–88

the occasional paleness or lusterless effects of some of Seurat's paintings. But another reason for this, according to such students of his work as Fénéon and Signac, is the fact that he sometimes used pigments of poor quality which have since changed and darkened, thus altering the effects he had striven for.

Whereas Seurat's sunbathed land- and seascapes are usually done in light, warm colors and are even of a delicate monotony, his gaslit scenes such as *The Side-Show (42)* or *The High-Kick (43)*, with their yellow sources of light and blue complementaries, show much stronger colorations. These compositions also reveal with more emphasis than his representations of nature-at-rest another element of Seurat's system: the role of lines and curves. In a method where color harmonies follow the dictate of physical and optical laws, structure, composition, and line necessarily attain paramount importance, since here the artist can intervene more freely and impose his creative will upon these 'ingredients' of his work. Theory-minded as he was, Seurat eventually also established general rules, an aesthetic of lines, to round out his system.

In his drawings—and Seurat devoted two early years exclusively to the art of black and white—he had achieved a perfect mastery of balancing light and dark masses. The rough texture of his *papier Ingres* somewhat opposed itself

162

43 Georges Seurat *The High-Kick* 1890

to solid black surfaces, since its concavities were never completely penetrated by Seurat's crayon. Thus even the dark masses in his drawings often maintain a certain 'spotty' aspect, as if they were sprinkled with almost imperceptible lighter dots *(45)*. At the same time the preoccupation with gradation and contrast that appears in Seurat's paintings also governed his work with the soft and velvety conté crayon. Signac was actually to exclaim later, 'These drawings in values, even simple sketches, are so studied in contrast and

163

44 Georges Seurat *Echo*, study for *Bathing at Asnières* 1883–84, conté crayon

gradation that one could paint from them without seeing the model again.' It is not impossible that Seurat himself sometimes proceeded in this fashion.

Whereas linear arabesques were necessarily excluded from his drawings for the benefit of values, Seurat, in his paintings, insisted on outlines with a rigor that has sometimes led to the reproach of dryness. His figures are usually seen exclusively from front, back, or profile. The silhouettes of the personages in such compositions as *A Sunday Afternoon on the Island of La Grande Jatte*, *The Side-Show*, or *The High-Kick* are simplified to the extreme, and their straight lines or curves are repeated and echoed throughout the entire canvas.

164

45 Georges Seurat *Trombone Player*, study for *The Side-Show* 1887, conté crayon

The Side-Show with its insistence on verticals and horizontals and *The High-Kick* with its predominant diagonals are composed in accordance with an aesthetic of lines destined to convey calm for the former and gaiety for the latter. Here again no hazard is allowed; everything is carefully calculated to sustain Seurat's scientific color harmonies by an equally methodical system of linear equilibrium, which had been established by Seurat's friend Charles Henry.

Seurat was rather jealous of his system and did not always view with a friendly eye the efforts of some of the artists grouped around him to apply his

165

theories to their own work. At one time he even considered abstaining from showing his canvases so as not to furnish others with examples of his method. But Fénéon pointed out repeatedly that the knowledge of optical laws does not make one a painter (nor the mastery of solfeggio a composer). Eventually Seurat decided not only to exhibit his works, but even to put his theory down in writing, if only to assert an uncontested priority over the followers who had become too numerous for his taste.

In 1890, less than a year before his premature death at the age of thirty-one, Seurat, after numerous drafts, summed up in a few clear formulas the principles that had guided his work. He expressed himself not so much as a painter but rather as a savant who condenses in short and unambiguous sentences the result of years of research. What might have been partly intuition at his beginnings, strengthened by scientific data, had now crystallized into certitude. If he had ever known any doubt, there is certainly no trace of it in this explanation which he mailed to a friend.

'Aesthetic.
'Art is Harmony. Harmony is the analogy of contrary and of similar elements of *tone*, of *color*, and of *line* considered according to their dominants and under the influence of light, in gay, calm, or sad combinations.

'The contraries are: for *tone*: a more luminous, or lighter, shade against a darker; for *color*: the complementaries, i.e., a certain red opposed to its complementary, etc.; for *line*: those forming a right angle.

'Gaiety of *tone* is given by the luminous dominant; of *color*, by the warm dominant; of *line*, by lines above the horizontal.

'Calm of *tone* is given by an equivalence of light and dark; of *color*, by an equivalence of warm and cold; and of *line*, by horizontals.

'Sadness of *tone* is given by the dominance of dark; of *color*, by the dominance of cold colors; and of *line*, by downward directions.

'Technique.
'Taking for granted the phenomena of the duration of a light-impression on the retina: a synthesis follows as a result. The means of expression is the optical mixture of tones and colors (both of local colors and of the illuminating color—sun, oil lamp, gas lamp, etc.); i.e., of the lights and their reactions (shadows) according to the laws of contrast, gradation, and irradiation.'

This theory, as Fénéon insisted, is useful or worthless according to who uses it. In Seurat's hands it became an instrument for masterpieces not so much because it was scientifically correct, but because his genius made it live. To

observe life around him and to synthesize it in his work remained a problem that could be supported by this system, but not inspired by it.

It seems idle to speculate how Seurat's theories and art would have evolved had he lived longer, but Signac—and no one was placed better to know—always emphatically insisted that his friend would never have given up pure colors and the observation of simultaneous contrasts; his execution only might have been perfected to eliminate as far as possible its inconveniences.

Seurat himself remained impassive in the midst of the discussions that raged around his ideas and his paintings. Like Copernicus he knew that he was right and did not have to depend on the approval of others. What he could not foresee was that posterity would show little concern for his theories, but boundless admiration for his paintings. It is not even certain whether this attitude would have met with his approval, for his pride in his system, in the application of scientific discoveries to works of art, was immense and once led him to remark to a friend: 'They see poetry in what I have done. No, I apply my method and that is all there is to it.'

Paul Gauguin—Letters to Ambroise Vollard and André Fontainas

In memory of Gerstle Mack

Gauguin's relations with Ambroise Vollard have always been cloaked in mystery. The only thing known for certain was that the two men were not congenial. There was nothing surprising in that, since Paul Gauguin had never been on good terms with anybody except his devoted friend Daniel de Monfreid.

Whenever he was questioned about his acquaintance and correspondence with the painter, Vollard would preserve an obstinate silence. But if Vollard remained mute, Gauguin's writings, edited after his death, contain frequent vituperations against the dealer. His letters to Monfreid referred to Vollard with great bitterness. Indeed, Gauguin expressed himself so vehemently that when the documents were first published, it was considered inadvisable to print Vollard's name, which was therefore replaced by the letter R. It was simple for the painter's friends to identify the person for whom R stood, and there can be little doubt that Vollard himself knew very well that this initial designated him.

It is difficult to understand why Vollard never explained his connection with Gauguin, why he never tried to confound those who accused him of having allowed Gauguin to die of starvation. With the letters the painter wrote him it would have been easy for Vollard to prove that he had indeed fulfilled his obligations and had sent Gauguin the money owed him. When, toward the end of his life, Vollard published his *Recollections of a Picture Dealer*, he had an excellent opportunity to devote a chapter to Gauguin and his relations with him. He did not do so. In fact he mentioned the painter only incidentally in his rambling book.

Not until after Vollard's death were a score of letters and receipts from Gauguin found among his papers, as well as a voluminous correspondence with Monfreid about the painter. While these documents do not completely solve the mystery surrounding the personal relations between the artist and his dealer, they at least throw some light on their business arrangements. They show that Vollard's offer to send Gauguin monthly remittances rescued

First published by Grabhorn Press, San Francisco, 1943

the painter from a desperate situation. They also indicate that Gauguin received a similar offer from a private collector, proving that his pictures had begun to find eager purchasers. Moreover, these letters contain information concerning the prices paid by Vollard—extremely low even for that time. Finally, they reveal that Vollard's negligence and procrastination helped undermine the painter's last reserves of strength. In fairness to Vollard, however, it must be realized that carelessness was one of the fundamental traits of his personality, just as impatience and violence were innate characteristics of Gauguin. In these documents Gauguin makes almost no effort to hide his antipathy for Vollard, and it is possible that the latter felt a reciprocal dislike—if, indeed, his habitual indifference left room for such a sentiment.

The story of his relations with Vollard constitutes a special chapter in Gauguin's turbulent career. That chapter covers only the last three years of his life, but to explain fully his letters to Vollard, it seems necessary to go back further into the artist's life in order to find all the events, incidents, and experiences that led inevitably to the illness, loneliness, and discouragement from which he suffered so acutely during his last years. Remarkable for his rare virtues as well as for his numerous faults, violent and gentle, sophisticated and naïve, disillusioned and enthusiastic, suspicious and trustful, all at the same time, Gauguin regarded Vollard as a swindler and a thief—in short, as the devil himself. Nevertheless, he made a bargain with him. Who can say whether he won or lost? But Vollard's silence might imply that Gauguin was not on the winning side.

The story of Gauguin's life is well known. He was born in Paris in 1848, the second child of the liberal journalist Clovis Gauguin and of the daughter of Flora Tristan, author of works colored by the socialist doctrines of Saint-Simon. No doubt it was from this grandmother, to whom Proudhon attributed genius, as well as from his father that Gauguin inherited his delight in the written word. All his life he liked to formulate ideas, proclaim theories, start controversies, publish articles, and write his recollections. In addition to notebooks filled with neat and legible handwriting, which compose his written work, he expressed himself in numerous letters. Although his syntax was far from perfect and his style sometimes exhibited constructions clumsily borrowed from writers of the Symbolist school, Gauguin possessed the ability to clothe his thoughts in his own characteristic language. His rough-hewn, lively phrases, his vivid descriptions, his painfully dry accounts constitute a curiously picturesque jumble which appears to reflect clearly his unruly, confused, and willful nature.

Gauguin's nature also finds expression in his handwriting, which exhibits at first glance a light feminine touch and suggests a restless spirit; it indicates fine intelligence and sound logic, but at the same time marked sentimentality;

it denotes great worldliness but also colossal extravagance; it evokes an extremely stubborn man who possesses, nevertheless, an unstable and easily swayed character, a gentle disposition with a tendency to hysteria; it represents a violent and dictatorial but not always courageous person—on the contrary, someone rather shy and timid. Gauguin's handwriting also shows traces of his immense artistic capabilities, especially in the field of decoration, as well as eroticism without much sensuality, and an inclination toward alcoholism. It suggests above all a man very sure of himself yet given to black moods, too self-centered to be truly sociable, but still with great powers of adaptation.

Combined with these conflicting forces struggling violently within himself, the exceptional circumstances of his life turned Gauguin into the extraordinary being that can be discovered in his painted and written works. His career was so crammed with adventures of all kinds that even a matter-of-fact account cannot decrease its dramatic interest.

Paul Gauguin was three years old when his parents took him to Peru. The president of that country was a relative of his mother. His father died on the voyage, and his mother remained in Lima for four years. When she returned to France she settled with her children at Orléans, where Paul finished his studies at the lycée. In 1865, at the age of seventeen, he went to sea as an apprentice pilot in the merchant marine, sailing between Rio and Le Havre for several years. In 1871, after his mother's death, he gave up the sea and took a position in a broker's office in Paris.

For eleven years Gauguin followed a business career. In November 1873 he married a young Danish girl, Sophie Gad, and established a household soon made lively by their children. Assured of ample means by his well-placed investments, he led a pleasant, comfortable life. On Sundays he liked to paint and in 1876 was ambitious enough to send a landscape to the Salon. It was accepted; this encouraged him to continue his efforts and devote all his free hours to painting. At the same time he felt the need to change the direction of his studies, since he could not find the guidance he wanted in the academic works of the Salon. Thus he began to haunt exhibitions and art galleries. His amazing instinct immediately attracted him to the scorned and ridiculed works then being shown at the paint-shop of *père* Tanguy and at Durand-Ruel's. Gauguin not only admired them, but bought them; he began to build up a collection unique for that period. Indeed, if his brush had not brought him renown, his name would still have been linked to the history of Impressionism as were those of the collectors Victor Chocquet or Dr Gachet of Auvers. Who else, about 1880, could boast of owning works by such masters as Daumier, Manet, Renoir, Monet, Cézanne, Pissarro, Sisley, Guillaumin, Jongkind, and several others?

Naturally Gauguin made efforts to meet the artists he admired. He soon became acquainted with Camille Pissarro, who was always ready to help

beginners. It was Pissarro who first showed his new friend's pictures to his colleagues and succeeded in having them included in the fifth Impressionist exhibition in 1880.

During the next few years Camille Pissarro continued to provide Gauguin with advice. He introduced him to Cézanne and Guillaumin. In the summer of 1881 all four worked together at Pontoise, where Pissarro lived. In 1881 as well as 1882 Gauguin was represented at the Impressionist exhibitions by about ten works—mostly paintings, but also a few attempts at sculpture. Under the influence of Pissarro—he did not come under Cézanne's influence until several years later—Gauguin painted landscapes in the Impressionist manner. His color and technique betrayed a certain timidity that was not without charm. At that period his works were characterized by a delicacy and freshness which in no respect foreshadowed those Tahitian pictures upon which his fame would ultimately rest.

With his whole being consecrated to painting, Gauguin no longer lived except during his hours of liberty from his office. The financial crash of 1882 soon forced him to abandon his bank job, with the result that he was able to paint 'every day.' He moved with his family to Rouen, where Pissarro was working, but soon found living expenses too high. Madame Gauguin, made unhappy by the change in her placid and well-ordered existence, now persuaded her husband that an easier life awaited them in Denmark. She hoped above all that the insistence of her family would induce Gauguin to resume his profitable business career. But the sojourn in Copenhagen turned out to be a complete failure. Gauguin could not earn enough to support his wife and five children. In the field of art he had no better success. An exhibition of his work in Copenhaggen was forced to close after only five days. And his in-laws, instead of helping to relieve the discouraged painter, completely alone in unaccustomed surroundings, treated him with the contempt that the bourgeois is apt to feel for an unsuccessful artist. This hostile atmosphere bred further misunderstandings between Gauguin and his wife. He resolved to return alone to Paris, where he arrived in June 1885 without a penny. He obtained employment as a billposter in the Paris railway stations. Ill health obliged him to stop work and spend several weeks in a hospital. But no misfortune, no poverty could force him to abandon his dreams of art.

At the eighth and last Impressionist exhibition, held in 1886, Gauguin was represented by nineteen pictures painted in Normandy, in Denmark, and in Brittany. Early in 1886 he had moved to the little village of Pont-Aven in Brittany, where he found peace, new subjects, and an economical existence. He worked furiously and did not return to Paris until almost the end of that year. It was then that Gauguin became acquainted with both Theo van Gogh, employed at the Goupil gallery, and his elder brother, Vincent, just arrived in Paris to begin his experiments in Impressionism.

171

Worn out by continuous and endless privations and overcome by an irresistible desire to escape, Gauguin suddenly decided to set out for Panama and persuaded a friend, the painter Charles Laval, to accompany him. They left France in April 1887. For several weeks Gauguin worked as a common laborer with the diggers of the Panama canal and so earned the price of his passage to Martinique. No sooner had he landed on the island, but he fell in love with its exotic beauty and felt certain that, at last, he had found the ideal background for his work. But neither he nor Charles Laval could endure the climate. The two artists, both ill, returned to France.

Completely penniless when he reached Paris at the beginning of 1888, Gauguin was obliged to accept the hospitality of his friend Emile Schuffenecker. Theo van Gogh organized a small exhibition of his work, which had no success whatever. Finally the artist returned to Pont-Aven, where he barely managed to exist. He was so poor that sometimes he could not even paint for want of canvas and colors. Vincent, living at Arles in southern France, persuaded Gauguin to join him in the Midi, where they could reduce their expenses by living together. At Vincent's request, Theo promised to send a small monthly remittance to Gauguin in exchange for pictures. Thus Theo van Gogh became the first to give Gauguin a regular allowance.

At the end of October 1888 Gauguin arrived at Arles but he cared little for life in the small Provençal town. Their divergent temperaments and opinions soon caused Vincent and Gauguin to quarrel violently. Vincent suffered a nervous breakdown which culminated in an attack of insanity. Once Vincent had been taken to the hospital, Gauguin went back to Paris.

Gauguin spent all of 1889 in Brittany again, first at Pont-Aven, later in a neighboring village, Le Pouldu. After his departure from Arles he appears to have received no regular remittances from Theo van Gogh, who was unable to support both his brother and Gauguin. Nevertheless Theo from time to time advanced Gauguin money on his paintings and did his best to sell his work. Fortunately, Gauguin found an admirer and pupil in the Dutch artist Meyer de Haan, who tactfully paid his bills at the inn. Soon Gauguin was surrounded by a group of young painters who looked upon him as their master and came under the influence of his art and theories. They were attracted to Gauguin's paintings by their unexpected qualities and the originality they discovered in them. His powerful, harsh pictures impressed them especially by the boldness of their conception, the unusual technique, the naked brutality of the forms, the radical simplifications of drawing, the brilliance of the pure bright colors, the ornamental character of the composition, and the deliberate flatness of the planes.

During the Exposition Universelle in Paris in 1889 Gauguin and his friends showed their works in a café on the Champ de Mars, where Gauguin was represented by pictures painted in Martinique, Arles, and Brittany. The exhibition had a certain success as a novelty and led Gauguin to hope that he

had found a new patron. In a letter to Theo van Gogh he reported having met a doctor-inventor who had agreed to pay him 5,000 francs for about forty paintings. With this money he planned to go to Madagascar, where he would buy a little shanty, work at his art, and 'live like a wild peasant.' But the project came to nothing. Gauguin returned to Brittany, where he spent all the following year.

At that time the pictures Gauguin sent Theo van Gogh varied in price from 300 to 600 francs, the majority being marked 400 francs. The sole exception was a large painting executed in Martinique, for which he fixed a price of 1,500 francs:

In spite of these low prices, they found no purchasers. Very few dealers would even attempt to sell them. Paul Durand-Ruel, who handled the works of Pissarro, Sisley, Monet, Degas, and Renoir, concentrated his efforts on these painters without always achieving a steady sale. He took practically no interest in such non-Impressionist painters as Cézanne, van Gogh, Toulouse-Lautrec, Seurat, or Gauguin. The color merchant *père* Tanguy, a simple soul who delighted in all artistic impertinences, willingly exhibited pictures by these men in his window; however, his little shop was frequented principally by artists and critics who examined and discussed, but bought nothing. For many years this shop was the shrine of modern art, but the trade in ideas was more active than that in paintings.

The only person to truly champion Gauguin's work remained Theo van Gogh, until Vincent's suicide in July 1890 sealed his own fate; he died a few months after his brother. However, at the very time when Gauguin lost Theo van Gogh's support, he met another man who—with extraordinary devotion—was thenceforth to take charge of his often complicated affairs. After a very difficult year in Brittany, Gauguin again felt the need to escape stirring within him. He turned his thoughts first to Madagascar, then to French Indochina, and finally fixed on Tahiti. It was at the end of 1890, when he went back to Paris to prepare for his voyage, that he met the painter Daniel de Monfreid at Schuffenecker's studio. From his first meeting to his death Gauguin made Daniel de Monfreid his confidant; with complete unselfishness Monfreid became for many years Gauguin's only link between Europe and Tahiti.

Before his departure Gauguin organized a public auction of his works at prices ranging between 250 and 500 francs. Among the buyers was Edgar Degas. The sale brought in almost 10,000 francs, and a little later, at the beginning of April 1891, Gauguin sailed for the remote French colony.

Soon discontented with the too-European life of Papeete, Gauguin retired into the jungle to live in the native manner, sharing his hut with Tehoura, his *vahiné*, a very young girl with the beauty of a goddess. The pictures he painted at this time combine a certain symbolism, an exotic flavor, vague harmonies, and broadly conceived forms. With profound insight Gauguin

173

knew how to create arrangements of tones and lines to obtain the desired effects. He deliberately abandoned the direct observation of nature that Pissarro had taught him, in order to portray a summary and free interpretation of scenes of Maori life. His will and his sometimes literary aspirations gave his work its decorative stamp and guided his vision. Thus the novelty of his art consisted not only in his subject, but also in his conception of the subject, in his efforts to reconcile the barbarous character of Maori idols with the sensitivity of a European artist.

Yet the enthusiasm of the first few months was soon supplanted by bitter resignation; hunger and poverty again became Gauguin's daily guests. He fell ill and spat such alarming quantities of blood that he thought the end must be near. Finally, in desperation, he begged to be repatriated. On August 30, 1893, he arrived at Marseilles with 4 francs in his pocket. In Paris, unexpected news awaited him: an uncle had died and left him a small legacy of 13,000 francs. At last he was able to spend money liberally, if only for a short time, and that is exactly what he did, for prudent reckoning was inconsistent with his temperament.

In November 1893 Gauguin held an exhibition of his new works at Durand-Ruel's, which was a financial disaster. To explain this disappointment to his wife in Denmark, Gauguin wrote that he had fixed very high prices, 2,000 to 3,000 francs on an average, adding, 'The only thing to do is wait, and broadly speaking I was right, for a price of 1,000 francs doesn't seem overwhelming in the present state of the market.' Gauguin's prices do seem rather high for a 'beginner,' if one considers that in those years some of the best works of Renoir were priced about 4,000 francs, that Pissarro had much difficulty in obtaining 1,000 to 2,000 francs for a picture, and that at the Tanguy sale in 1894 six canvases by Cézanne were sold for 45 to 215 francs each. Yet, at the same time, Monet asked 15,000 francs apiece for the Cathedrals he had just executed in Rouen; the collector Faure refused to sell a ballet rehearsal by Degas for less than 10,000; and Manet's paintings brought from 8,000 to 12,000 francs.

In 1894 Gauguin once more spent the whole summer at Pont-Aven. During a brawl with a group of sailors, his ankle was broken and he remained immobilized for weeks. In such great pain that he could not sleep, the artist soon abandoned himself to his favorite dream: life in the Tropics. In spite of his terrible experiences, in spite of the hunger and illness he had suffered on the other side of the world, he decided to return there, this time forever. As soon as the condition of his foot permitted, he went back to Paris to dispose of everything he owned. He sold about fifty pictures at public auction for more than 15,000 francs, at an average price of about 300 francs apiece.

According to a letter Gauguin wrote his wife, the proceeds of this sale amounted to 23,640 francs, but of this sum only 1,370 francs represented bona fide sales; all the other pictures were bought by Gauguin himself, under

different names, in order to maintain the prices. After he had paid expenses and taxes, the net result was a deficit of 450 francs. However, it is more than probable that Gauguin deliberately made the auction appear more of a failure than it really was, so that his wife should not expect any money from him. His friend Charles Morice only mentions that, dissatisfied with the prices offered for his paintings, the artist bought *some* of them back. In spite of the low prices brought by his works, Gauguin did in fact reach Tahiti with enough money to pay for the construction of a large hut and to defray all his expenses there for almost a year.

Gauguin has been severely criticized for not having taken advantage of the offers supposedly made to him by a well-known picture dealer. According to Charles Morice those offers would have permitted him to live in France, in Paris or elsewhere, while he turned out pictures at will, receiving for them 'a modest but firmly fixed price.' It is difficult to understand how Gauguin could have refused such an offer, since it corresponded exactly to his dearest wishes. It must therefore be assumed either that the proposed conditions were unacceptable, or that the call of the Tropics was too insistent. Gauguin was in a hurry to leave Europe forever.

Before his departure, Gauguin made some arrangements with his friend Chaudet and a picture dealer named Levy. The former undertook to collect the money still owed Gauguin, more than 4,000 francs in all; the latter assured him that he would sell his pictures without fail. Both told him, 'Whatever happens, you may be sure you will have enough to live on.'

Cheered by this promise, Gauguin sailed for Tahiti in February 1895. He never saw France again.

During his last sojourn in France, between August 1893 and the commencement of 1895, Gauguin became acquainted with Ambroise Vollard. Vollard had come to Paris to study law but, finding himself unable to resist his yearning for some connection with the world of art, had installed himself about 1890 as a dealer in prints and paintings in two small attic rooms at the lower end of the avenue de Saint-Ouen. In 1893 he rented a modest shop in the rue Laffitte, where all dealers in Paris were then located.

In January 1894 Camille Pissarro wrote to his son Lucien in London apropos of Vollard: 'A young man . . . has opened a small gallery in the rue Laffitte. He shows nothing but pictures by the younger painters. There are some very fine early works by Gauguin, as well as paintings by Sisley, Redon, Raffaëlli, de Groux. . . . He likes only our school of painting or works by artists whose talents have developed along similar lines. He is very enthusiastic and knows his job. He is already beginning to attract the attention of certain collectors who like to poke about.'

But Pissarro was to change his opinion of the young dealer and, a few years later, wrote to his son, 'You may be very sure that Vollard is interested only in

painters who sell readily, in big names—he doesn't give a damn for the others.'

At that time, the graphic and typographic arts were enjoying a revival of popularity thanks to the efforts of William Morris, Charles Shannon, and Charles Ricketts—with whom Lucien Pissarro had joined forces—in England, and of Lepère in France, who was about to edit a new magazine, *L'Image*. Since 1889 Ricketts and Shannon had been publishing, although very irregularly, their *Dial* in Chelsea, and in 1893 they had finished an illustrated edition of *Daphnis and Chloe*. In France, *L'Escarmouche*, a small paper of brief existence (1893–94), reproduced lithographs by Angrand, Bonnard, Toulouse-Lautrec, and others. At the same time Rémy de Gourmont and Alfred Jarry (creator of the grotesque character Ubu whom Vollard later 'adopted') inaugurated the review *L'Ymagier* which, during its short life from 1894 to 1895, devoted itself to the *images d'Épinal* and to works by artists of the Pont-Aven group, especially Gauguin, Filiger, Roy, Seguin, and Emile Bernard. In 1895 the *Revue Blanche*, following the example of *L'Estampe Originale* and *L'Epreuve*, published an album of lithographs by its favorite illustrators, among them Toulouse-Lautrec and Bonnard.

Camille Pissarro, deeply interested in the new attempts to create a bond between woodcut illustrations and typography, did not fail to call Vollard's attention to this movement. He showed him the beautifully illustrated *Queen of the Fishes* published by his son Lucien in 1895 on his own press in England which 'disheartened Vollard by its perfection.' It occurred to Vollard to ask Lucien to illustrate a volume by Verlaine. But Camille Pissarro promptly warned his son not to entertain any illusions: 'This confounded Vollard is so capricious that one can never count on him. He has so many ideas that he cannot possibly carry out all he plans to do.' As a matter of fact Vollard did not publish any books illustrated by either of the Pissarros, but a few years later commissioned Bonnard to make lithographs for *Daphnis and Chloe* as well as for Verlaine's *Parallèlement*.

Although Vollard had a strong preference for Beardsley, Pissarro advised him to publish, instead, a book illustrated with lithographs by Degas. When Vollard opened an exhibition of prints in the summer of 1896, Pissarro merely commented that it contained 'some good things and some atrocities.'

The young Vollard did not have a very definite taste in art and at the beginning showed little discrimination. Yet, well aware of his lack of judgment, he gladly accepted the advice of others. He had the great good fortune to receive the counsel of such far-sighted and disinterested men as Camille Pissarro and Edgar Degas, and he was intelligent enough to follow it. Therefore, after having held an exhibition of Manet's drawings, among others, Vollard yielded to Pissarro's insistence and went in search of Paul Cézanne, whose first one-man show he presented to the public at the end of 1895, after Gauguin's final departure.

While Gauguin toiled, almost forgotten, in the distant Tropics, the painters who were his friends acquired the habit of visiting Vollard's little gallery, which soon turned into a gathering place for artists of the new school. Thus, in the world of art Vollard's establishment became the successor to *père* Tanguy's shop. But Vollard possessed neither the verve of the recently deceased merchant, nor the benevolent wisdom of a Theo van Gogh. Under the mask of an often exaggerated indifference Vollard concealed a shrewd business sense combined with a cautious prudence incapable of enthusiasm. His somewhat undeveloped ideas led him to buy anything unconventional, without always enabling him to distinguish between genuine originality and mere mannerism, or the pursuit of novelty for its own sake. Nothing illustrates this weakness better than the two *Albums d'Estampes Originales* published by Vollard in 1896 and 1897. Among the fifty-four lithographs they contain one finds, side by side with works by Cézanne, Toulouse-Lautrec, Renoir, Bonnard, and Redon, prints of more than doubtful quality executed by artists who were less than mediocre. Although he must have known that Gauguin had produced lithographs and woodcuts of considerable importance, Vollard does not appear to have sought his collaboration in these two albums. At that time, however, Gauguin's friends were already familiar with his prints, and in January 1895 the editors of *L'Ymagier* mentioned in a short notice that they had seen his 'beautiful new woodcuts and his studies from Tahiti, which were at once classic and barbaric, purposeful and spirited.' But despite such publicly expressed admiration for Gauguin's prints, Vollard—even by the time he was regularly buying and selling the artist's paintings—continued to manifest little desire for his graphic output.

At first Vollard does not appear to have taken much interest in Gauguin's Tahitian work; he paid more attention to the young artists in Gauguin's group at Pont-Aven: Emile Bernard, Maurice Denis, Armand Seguin, Paul Sérusier, and others. Nevertheless, these men, together with the faithful Daniel de Monfreid, found ways to stimulate his interest in the absent painter. But his relations with Gauguin show clearly that Vollard did not begin to take up the painter's work until after he had fairly good reason to believe that it would sell. This fact, which Gauguin did not fail to perceive, gave rise to his surly attitude toward the dealer.

When he reached Tahiti, Gauguin purchased a plot of ground, had a comfortable cabin erected on it, and set to work. Since his friends in France failed to fulfill their promises to send him money, he took note, with increasing anxiety, of the rapid shrinking of his capital. After a year's residence in the Tropics Gauguin found himself once more obliged to live on debts and hope. It was then, in June 1896, that he made the following proposal to his friend Monfreid: he would agree to send fifteen pictures and several drawings a year to a group of fifteen private collectors, who would distribute these works among themselves and, in turn, guarantee him a

monthly income of 200 francs for five years, each collector to pay 160 francs per painting. Actually Gauguin still estimated the value of his pictures at 400 francs apiece, but on account of his extreme poverty he could see no way of selling the necessary number except at reduced rates. Yet even at these low prices Daniel de Monfreid was unable to find the fifteen collectors needed to assure the painter a tranquil existence.

In July 1896 Gauguin, worn out and ill, was forced to enter the hospital although he had no money for medical bills. In October he received a little cash and paid some of his debts, only to contract others almost immediately. At last, in December, Vollard bought three of Gauguin's pictures from Chaudet, who sent the money to Tahiti. In January 1897 Gauguin returned to the hospital; and when he left it he found his cabin in such dilapidated condition that he was obliged to go into debt again. A little later, in April, Gauguin received a letter from Vollard, who apparently had been able to sell the pictures purchased from Chaudet and who now applied directly to the painter for drawings and lithographs, as well as sculptured models to be cast in bronze. Gauguin's answer constitutes his first letter to the dealer.

PAUL GAUGUIN TO AMBROISE VOLLARD

[Tahiti, April 1897]

Dear Monsieur Vollard,
I have just received your letter with many requests, many propositions, but I find myself unable to discern its true meaning.

I have no old drawings here, since I left everything with Chaudet who takes care of my affairs. As to new ones!! I have not yet found, like Maufra, the trick of making drawings that sell. But should I have an inspiration, I shall send you some.

Why is it impossible to make prints on 'papier report'? On the contrary, I believe that that is the most practical thing to do between Tahiti and Paris. As for retouching the [lithographic] stones, Seguin could do this very well, the more so as in this matter, as in any other, I neither search for, nor find, technical perfection. (There is no scarcity in makers of *proper lithographs*.) Thus, if you feel like it, send me paper and money; you'll have to take risks and pay advances, especially since during my stay in Paris I tried my hand at woodcuts and prints without any results as far as money goes. I therefore have good reason to be skeptical on this subject.

You also want wood sculptures, models for bronze casts, etc. . . . For four years now all those things have been in Paris with no sales. Either they are bad, and then the new ones I might make would also be bad, and thus unsalable, or else they are works of art.—In that case why don't you sell them? Yet I believe that my large statue in ceramics, the *Tueuse* [*Oviri*], is an exceptional piece such as no ceramist has made until now and that, in addition, it would look very well cast in bronze (without retouching and without patina). In this way the buyer

would not only have the ceramic piece itself, but also a bronze edition with which to make money. And the mask, *Head of a Savage*, what a beautiful bronze it would make, and not expensive. I am convinced that you could easily find thirty collectors who would pay 100 francs, which would mean 3,000 francs, or 2,000 after deduction of expenses. Why don't you consider this?

Hoping to hear from you soon, I am, with best regards,

P. Gauguin

Some poor attempts at making woodcuts, but my eyesight is becoming very bad for this kind of work. I don't have any good wood and for the prints!!! no press.

Gauguin was of course perfectly aware of the fact that this reply was not exactly conducive to satisfactory commercial relations with Vollard. In a letter to Monfreid he explained that he had 'replied a little ironically, saying that those things [in which Vollard was interested] had already been in existence a long time without bringing me any profit.'

It seems peculiar that, in spite of his difficulties, Gauguin did not consider—at this time—the possibility of collaboration with Vollard. He who usually clung tenaciously to the slightest hope now deliberately dismissed the suggested arrangement with the dealer of the rue Laffitte, doing so with undisguised sarcasm. And this at a time when his circumstances were growing worse day by day! Plagued by illness and debts, Gauguin soon found himself unable to obtain any credit or even to buy bread. For several weeks he had nothing to eat except the guavas and mangoes he picked and the shrimp he caught. While his strength ebbed as he waited in vain for news and money from France, Gauguin drew upon all his remaining energy to execute the large picture *Where do we come from? What are we? Where are we going?* Then in February 1898, having completed this splendid composition, painted as if created in a mood of supreme ecstasy, he tried to commit suicide. But his body was still strong enough to resist the effects of poison.

A little later Gauguin received a few more remittances. Unwilling, however, to resume his existence of eternal uncertainty, and fearing that his property would be attached for debt, he applied for a clerical position in Papeete. When enough money arrived to free him from that bondage he had to re-enter the hospital before he could begin to paint again. He sent a parcel of pictures to Daniel de Monfreid, stipulating that a different painting should be exhibited in Vollard's gallery each month. At the end of 1898 Monfreid was able to send him news of two successive sales to Vollard, who first bought four pictures for a total of 600 francs and then nine for 1,000 francs—that is, at extremely low prices.

In January 1899 Vollard held an exhibition of Gauguin's works organized by Daniel de Monfreid, comprising pictures recently arrived from Tahiti,

among them the large canvas *Where do we come from? What are we? Where are we going?* This time Gaugin's paintings attracted attention even among those who until now had remained unmoved by the violent beauty of his art. In the *Mercure de France* André Fontainas, poet and critic, reviewed the show in a long article marked, if not by admiration, at least by real sympathy: 'I do not like M. Paul Gauguin's painting very much,' he wrote.

'For a long time I was repelled by it and spoke of it slightingly, perhaps a little brusquely: I knew almost nothing about it. This time I examined with care his few recent canvases now on exhibition at Vollard's gallery in the rue Laffitte; and if my opinion of them has changed very little, at least I have become aware of a new and growing respect, solid and profound, for the serious, thoughtful, and sincere work of this painter. I have tried to understand it, I believe I have grasped some of his motives and impulses, I have caught myself discussing and criticizing them, becoming enthusiastic over some while disregarding others. Yet even after this careful study I have never been as moved or excited as I have been by certain other painters. I have sought for the causes of my indifference and believe I have found them.

'I do not criticize M. Gauguin either for his drawing, so often disparaged, or for his exoticism; I should be more apt to praise him for them if, in truth, there were any need to do so. Indeed what other analysis of drawing should one accept than that of Balzac in the *Chef d'oeuvre inconnu*: "Line is the means by which the effect of light on an object makes itself manifest. Form is . . . an instrument for the dissemination of ideas, sensations; it is poetry. The mission of art is not to copy nature but to express it." Therefore I acknowledge M. Gauguin's right to express himself as he sees fit, on condition that he inspires in the mind of the spectator sensations, ideas, anything at all that will produce a vision similar to his own. In this respect, I admit, M. Gauguin is irreproachable. He has created his own drawing even though it may resemble that of van Gogh or Cézanne; his aggressive drawing, new and precise in pattern, has a positive effect; indeed it would be impossible to find fault with it.

'The same holds true for his exoticism. Everyone is at liberty to choose either a commonplace or an unusual setting, as he pleases. That in itself is of no importance. The essential—since I cannot see in these pictures an exact representation of scenes in Tahiti or in the Marquesas—is that the art of the painter must convey to us an image, true or false (it does not matter), of a tropic land, luxuriant and primitive, covered with gigantic dense jungle growth, a land of deep waters and violent contrasts of light and air, peopled by a dignified race, modest and unspoiled. That M. Gauguin should have abandoned the too artificial simplicity of Brittany for his oceanic mirages is yet another proof of his complete sincerity. Out there on his enchanted island he is no longer concerned with the absurd mania for playing at restoring the great archaic romance of Brittany, so tedious after all. He no longer need worry about his reputation among the literary aesthetes; he is alive in the midst of distant seas, and the pictures he sends to his friends from time to time continue to prove to us that he is working.

'What impresses the beholder at once is the careful study of arrangement in his canvases, which are primarily decorative. The landscapes that compose their

profound, subdued harmony are organized not so much for crude picturesque effect as for the purpose, almost always achieved, of creating warm, brooding wellsprings for the surging emotions. If the violent oppositions of such full and vibrant tones, which do not blend and never merge into one another through intermediate values, first distract and then rivet the attention, it must also be admitted that while they are often glowing, bold, and exultant, they sometimes lose their effect by monotonous repetition, by the juxtaposition, irritating in the long run, of a startling red and a vibrant green, identical in value and intensity. And yet it is undoubtedly the landscape that satisfies and even exalts one in M. Gauguin's painting. He has invented a new and broad method of painting landscapes by synthesis and, in the words that he himself wrote in the *Mercure de France*, by "seeking to express the harmony between human life and that of animals and plants in compositions in which I have allowed the deep voice of the earth to play an important part."

'At Vollard's, hanging not far from an extremely delicate landscape painted some years ago, in which figures at the water's edge are watching the reflection of the sun sparkling on the waves, there is a purely decorative picture conceived in this manner and, I believe, very characteristic of the artist's personality. In the midst of the somber blues and greens, noble animal and vegetable forms intermingle, composing a pure pattern. Nothing more; a perfect harmony of form and color.

'There is also a landscape of varied yellows spread out like a delicate curtain of thin golden rain. Here and there the green of some strange leaf, the repeated detail of bright red berries. A man in a sarong reaches toward the low branches of a tree. All this—the light, the graceful effort of the gesture, the grouping of objects and colors—compose a simple and exquisite picture.

'If only M. Gauguin were always like that! Or if he would paint as he does when he shows us ceremonial dancers lingering under the trees amid thick undergrowth, or nude women bathing surrounded by gorgeous, strangely illumined vegetation. But too often the people of his dreams, dry, colorless, and rigid, vaguely represent forms poorly conceived by an imagination untrained in metaphysics, of which the meaning is doubtful and the expression is arbitrary. Such canvases leave no impression but that of deplorable error, for abstractions are not communicated through concrete images unless, in the artist's own mind, they have already taken shape in some natural allegory that gives them life. That is the lesson taught by the noble example Puvis de Chavannes gives us through his art. To represent a philosophical ideal he creates harmonious groups of figures whose attitudes convey to us a dream analogous to his own. In the large picture exhibited by M. Gauguin, nothing—not even the two graceful and pensive figures standing so tranquilly and beautifully, or the masterful evocation of a mysterious idol—would reveal to us the meaning of the allegory, if he had not taken the trouble to write high up in a corner of the canvas: "Where do we come from? What are we? Where are we going?"

'However, in spite of the outlandishness of these near-savages, to which one becomes accustomed, the interest is diverted from the naked woman crouching in the foreground and again becomes fixed wholly upon the charm of the setting in which the action takes place.

'But if I point out the grace of a woman half-reclining on a sort of couch, magnificent and curious, in the open air, I prefer not to dwell on other paintings

181

which show the persistent efforts of an obstinate innovator in all the willfulness, slightly brutal, of his struggle.

'In other respects M. Gauguin is without doubt an unusually gifted painter, from whom the opportunity of displaying the vigorous energy of his temperament by the execution of an important decorative composition on the walls of a public edifice has been too long withheld. There we could see exactly what he is capable of doing, and if he would guard against a tendency toward abstraction, I am sure we should see powerful and truly harmonious creations produced by his hand.'

As soon as Gauguin read this article, he decided to answer the author.

PAUL GAUGUIN TO ANDRÉ FONTAINAS

Tahiti, March 1899

> Un grand sommeil noir
> Tombe sur ma vie
> Dormez, tout espoir
> Dormez, toute envie.
> *Verlaine*

Monsieur Fontainas,

In the January number of the *Mercure de France* you have two interesting articles, 'Rembrandt' and 'The Vollard Gallery.' In the latter you mention me. In spite of your dislike you have tried to make an honest study of the art, or rather the work, of a painter who has no emotional effect upon you. A rare phenomenon among critics.

I have always felt that it was the duty of a painter never to answer criticisms, even hostile ones—especially hostile ones; nor flattering ones either, because those are often dictated by friendship.

This time, without departing from my habitual reserve, I have an irresistible desire to write to you, a caprice if you will, and—like all emotional people—I am not good at resisting. Since this is merely a personal letter, it is not a real answer but simply a chat on art; your article prompts and evokes it.

We painters, we who are condemned to penury, accept the material difficulties of life without complaining, but we suffer from them insofar as they constitute a hindrance to work. How much time we lose in seeking our daily bread! The most menial tasks, dilapidated studios, and a thousand other obstacles. All these create despondency, followed by impotence, rage, violence. Such things do not concern you at all, I mention them only to convince both of us that you have good reason to point out numerous defects, violence, monotony of tone, clashing colors, etc. Yes, all these probably exist, do exist. Sometimes, however, they are unintentional. Are not these repetitions of tones, these monotonous color harmonies (in the musical sense) analogous to oriental chants sung in a shrill voice to the accompaniment of pulsating notes which intensify them by contrast? Beethoven uses them frequently (as I understand it) in the *Sonata Pathétique*, for example. Delacroix, too, with his repeated

harmonies of brown and dull velvet, a somber cloak suggesting tragedy. You often go to the Louvre; with what I have said in mind, look closely at Cimabue. Think also of the musical role color will henceforth play in modern painting. Color, which is vibration just as music is, is able to attain what is most universal yet at the same time most elusive in nature: its inner force.

Here near my cabin, in complete silence, amid the intoxicating perfumes of nature, I dream of violent harmonies. A delight enhanced by I know not what sacred horror I divine in the infinite. An aroma of long-vanished joy that I breathe in the present. Animal figures rigid as statues, with something indescribably solemn and religious in the rhythm of their pose, in their strange immobility. In eyes that dream, the troubled surface of an unfathomable enigma.

Night is here. All is at rest. My eyes close in order to see without actually understanding the dream that flees before me in infinite space; and I experience the languorous sensation produced by the mournful procession of my hopes.

In praise of certain pictures that I considered unimportant you exclaim, 'If only Gauguin were always like that!' But I don't want to be always like that.

'In the large panel that Gauguin exhibits there is nothing that explains the meaning of the allegory.' Yes, there is; my dream is intangible, it comprises no allegory; as Mallarmé said, 'It is a musical poem, it needs no libretto.' Consequently, the essence of a work, unsubstantial and out of reach, consists precisely of 'that which is not expressed; it flows by implication from the lines without color or words; it is not a material structure.'

Standing before one of my pictures of Tahiti, Mallarmé also remarked, 'It is amazing that one can put so much mystery in so much brilliance.'

To go back to the panel: the idol is there not as a literary symbol, but as a statue, yet perhaps less of a statue than the animal figures, less animal also, combining my dream before my cabin with all nature, dominating our primitive soul, the unearthly consolation of our sufferings to the extent that they are vague and incomprehensible before the mystery of our origin and of our future.

And all this sings with sadness in my soul and in my design while I paint and dream at the same time with no tangible allegory within my reach—due perhaps to a lack of literary education.

Awakening with my work finished, I ask myself, 'Where do we come from? What are we? Where are we going?' A thought which no longer has anything to do with the canvas, expressed in words quite apart on the wall that surrounds it. Not a title but a signature.

You see, although I understand very well the value of words—abstract and concrete—in the dictionary, I no longer grasp them in painting. I have tried to interpret my vision in an appropriate décor without recourse to literary means and with all the simplicity the medium permits: a difficult job. You may say that I have failed, but do not reproach me for having tried, nor should you advise me to change my goal, to dally with other ideas already accepted, sanctified. Puvis de Chavannes is the perfect example. Of course Puvis overwhelms me with his talent and experience, which I lack; I admire him as

much as you do and more, but for entirely different reasons (and—don't be annoyed—with more understanding). Each of us belongs to his own period.

The government is right not to give me an order for a decoration for a public building which might clash with the ideas of the majority, and it would be even more reprehensible for me to accept it, since I should have no alternative but to cheat or lie to myself.

At my exhibition at Durand-Ruel's [in 1893] a young man who didn't understand my pictures asked Degas to explain them to him. Smiling, he recited a fable by La Fontaine. 'You see,' he said, 'Gauguin is the thin wolf without the collar [that is, he prefers liberty with starvation to servitude with abundance].'

After fifteen years of struggle we are beginning to free ourselves from the influence of the Academy, from all this confusion of formulas apart from which there has been no hope of salvation, honor, or money: drawing, color, composition, sincerity in the presence of nature, and so on. Only yesterday some mathematician (Charles Henry) tried to prove to us that we should use unchangeable light and color.

Now the danger is past. Yes, we are free, and yet I see still another danger flickering on the horizon; I want to discuss it with you. This long and boring letter has been written with only that in view. Criticism of today, when it is serious, intelligent, full of good intentions, tends to impose on us a method of thinking and dreaming which might become another bondage. Preoccupied with what concerns it particularly, its own field, literature, it will lose sight of what concerns us, painting. If that is true, I shall be impertinent enough to quote Mallarmé, 'A critic is someone who meddles with something that is none of his business.'

In his memory will you permit me to offer you this sketch of him, hastily dashed off, a vague recollection of a beautiful and beloved face, radiant even in the shadows. Not a gift, but an appeal for the indulgence I need for my foolishness and violence.

Very cordially
Paul Gauguin

To his letter André Fontainas replied with an explanation of his article and sent Gauguin his book of verse, *Crépuscules*, published in 1897. The painter answered at once, having in the meantime studied some of Fontainas's criticism in the *Mercure de France*, especially his article on the pastels of La Tour.

PAUL GAUGUIN TO ANDRÉ FONTAINAS

Tahiti, August 1899

Dear Sir:
I believe that any misunderstanding between us has now been cleared up, if indeed there ever was one; but I remember almost nothing of the contents of my letter.

As near as I can recall, however, my basic thought in writing to you was not to suggest for a moment that you belonged in the same category as those professional newspaper critics to whom criticism is often a synonym for blackmail. Ah, good heavens, no! And that is exactly why I did write to you, as I write only to those I respect. And if I said (look at my letter) that critics are people who meddle in what is none of their business, I meant that whole clique who, in every period and in conformity with the prevailing taste, have dictated to painters, 'You will think thus and so, or else you will be at our mercy.'

Speaking of cliques, I see by your letter that you have plunged bravely into the fray in order to rescue one of your colleagues who had committed himself unwisely. Most certainly your intention was very honorable, and I admire it, but I do not entirely believe that either these enthusiasms or these denunciations have much effect, besides these stupid readers are not worth bothering about. Such things should be reserved for artists.

You may defend or damn Falguière, but will it change his statue of Balzac? People have said of me that my art is vulgar, the art of a Papuan savage. Perhaps they are right and therefore have the right to say so. I don't know, but what does it matter? In the first place, I do not know how to change either for better or worse. My work, the most severe critic of all, expresses, and will continue to express, what I am, whether a failure or success. Some of my friends say that I have a strong and virile soul; while other artists, especially the younger ones, grieve over hostile criticism and are sometimes shattered by it. I pity them. Puvis de Chavannes, profoundly depressed by reading an unfavorable article, said to me one day: 'But what is the matter with them that they don't understand? The picture'—it was his *Pêcheur* [*Poor Fisherman*]—'is really quite simple.'

I replied, 'Unto you it is given to know the mysteries of the kingdom of God, but to others in parables, that seeing they might not see, and hearing they might not understand.'

You give me great pleasure, very great pleasure, by admitting that you were wrong in your belief that my compositions, like those of Puvis de Chavannes, emanated from an abstract idea which I sought to vivify through plastic representation, and that my letter helped a little to explain my work to you.

I act not at random but deliberately, as my intellectual nature dictates, somewhat in the manner of the Bible in which doctrine (especially in connection with Christ) expresses itself in a symbolic form presenting a double aspect, a form which, on the one hand, materializes the pure idea so as to make it more perceptible and assumes the guise of the supernatural; this is the literal, superficial, figurative, mysterious meaning of a parable. And on the other hand, there is the spirit of the parable: not its figurative but its representational, explicit meaning.

As I have never attempted to explain my art except through my pictures themselves, I have always been misunderstood until now; and yet there is one writer—and that astonishes me, as I had not suspected that he was interested in painting (A. Delaroche, author of the remarkable article entitled 'D'un point

de vue esthétique')—who seems to have understood me in his description of one of my pictures:

'In a ring of strange colors, like the waves of a liquid brew, diabolic or divine, one knows not which, the waters of mystery spout into the parched lips of the unknown.'

But I have talked enough about myself—it bores me.

Of course I read your articles. Because of my extreme poverty the *Mercure de France* is sent to me without charges; and it is indeed a joy to me as I am a great reader, not because literature instructs me—my brain is impervious to instruction—but because in my solitude—

O beata solitudo!

O sola beatitudo!

as St Bernard says—reading puts me in communion with others without obliging me to meet crowds of people who always frighten me. That is one of the ornaments of my solitude. Ah! Monsieur Fontainas, if instead of writing criticism concerned with Modern Art, you would entitle them 'Ornaments of Solitude,' we should understand each other completely, or at least I should understand you better, for I am a reader and love good literature.

Twelve years ago I made a trip to Saint-Quentin just to study La Tour's work. As he is not well represented in the Louvre, I had the impression that I would understand him better in Saint-Quentin [where La Tour was born and to whose museum a great number of his pastels were donated by his family]. I don't know why, but in the Louvre I had always classed him with Gainsborough. In Saint-Quentin this resemblance vanishes. La Tour is very French and very 'Gentilhomme,' and if there is a quality I admire in painting it is just that. Of course I am not speaking of the elegance of his models.

It is not the mighty sword of a Bayard, but rather the court rapier of a marquis; not the bludgeon of a Michelangelo, but the stiletto of La Tour. The lines are as pure as Raphael's, the composition of the curves always harmonious and significant.

Fortunately the *Mercure* arrived just in time to remind me of something I once enjoyed but had almost forgotten and to enable me to share your pleasure in the portrait of *La Chanteuse*. In your delightful article you also recall names that are dear to me: Degas, Manet, for whom I have boundless admiration. And you make me see again that beautiful portrait of Mlle Samary [by Renoir] I once saw at the Beaux-Arts exhibition of portraits of the century [in 1883].

Apropos of this I shall tell you a little anecdote. I visited the exhibition with someone who detested Manet, Renoir, and the Impressionists. He called this portrait an abomination. To distract him I drew his attention to a large portrait, *The Artist's Parents*. The tiny signature was invisible. 'Now then,' he cried, 'this is real painting!' 'But it is by Manet,' I said. He was furious, and ever since that day we have been irreconcilable enemies.

And here, my dear sir, are many reasons why I should like to have more of your writings in the guise of ornaments of solitude.

Forgive my symbols, parables, and other ineptitudes, and believe me

Ever yours, Paul Gauguin

Apparently encouraged by the success of his exhibit of Gauguin's works, Vollard decided to buy all Gauguin's new pictures from Daniel de Monfreid. The latter, who had heretofore found it extremely difficult from time to time to sell one or two of his friend's paintings in order to send him an occasional remittance, considered it his duty to accept Vollard's niggardly offer and sold him the pictures at a very low price—probably lower than the one paid previously by Vollard. When Gauguin learned of the transaction he unhesitatingly called it a 'disaster.'

'Of course I am not satisfied!' he wrote Monfreid.

Naturally, my dear Daniel, it is not your fault, and perhaps I should have done the same thing in your place; but it is really very bad luck. And you know my opinion of Vollard, who is the most voracious kind of crocodile. You say there were eight small pictures—are canvases of 28 by 35 inches as small as all that? So now there is nothing left in your exhibition to be sold, and Vollard, with what he already had in hand, has enough to keep him busy for a year. That means that all the collectors who might buy my works are at Vollard's mercy. If a number of my old pictures had been sold cheap to a private buyer, no harm would have been done—but for Vollard to own all the new ones is a disaster. The man has no shame, he is willing to exploit anyone's poverty for a few sous, and next time, emboldened by his success, he will offer you half the price. — And poor Chaudet, ill just at the crucial moment. And yet if you two should find yourselves tomorrow, for reasons beyond your control, unable to look out for me, who would do it? I know Degas and Rouart; they would have advised Vollard to buy the pictures, preferring to purchase them from him than from you, for a small difference in price; in that way they would not be ashamed to acquire them at a bargain. — Once again the future looks very dark, believe me. I am still very ill and don't know when I shall be able to work. So you will receive no new pictures before September 1900. . . . Why didn't I die last year! I am almost fifty-one years old, burned out, completely exhausted. My eyesight is growing worse every day; consequently I am beginning to lack the energy required for this constant struggle. — To come back to business: hereafter sell as you think fit to private collectors, but nothing to Vollard except at fair prices; especially since Vollard never makes an offer until he has already secured a client, and a 25 percent commission does not satisfy him. And it doesn't matter what one says to him; he doesn't give a damn as long as he is successful.

Gauguin was quite right when he guessed that the interest taken in his work by Edgar Degas and his friend the painter and collector Henri Rouart had inspired Vollard's purchases. At Gauguin's suggestion Monfreid discussed the matter with Degas himself, explaining that it would be more profitable both for him and for Gauguin if he were to buy pictures without Vollard's intervention. Degas asked to be informed thereafter whenever new pictures should arrive from Tahiti.

187

But Gauguin's concern over difficulties connected with sales was thrust aside by more pressing problems. In the spring of 1899 he had only 100 francs left and was soon forced to go into debt again. In August he wrote to Monfreid: 'I have no more canvas for pictures, and besides I am too discouraged to paint, too constantly preoccupied with the struggle for mere existence. And then what is the use, if my works are fated only to accumulate in your house—which must be a nuisance for you—or to be sold wholesale to Vollard for a crust of bread?'

In the autumn Gauguin's spirits as well as his health improved, for he received a letter from Maurice Denis advising him that Degas and Rouart were outbidding each other for his pictures, that dealers were propagandizing his name, and that his paintings brought 'fine prices' at public sales. But what good did such news do, when at the same time Monfreid had moved away from Paris and Chaudet was ill, which meant that Gauguin, as he had feared, no longer had anyone in Paris to look after his affairs; when Vollard, who wanted to buy his large composition, hesitated to make an offer; and when he had no more money or paint—not even a milligram of vermilion, his favorite color?

The close of 1899 found Gauguin once more in a state of deep depression; both his legs were covered with eczema, he was burdened with debts, and he saw no prospect of relief, however slight. On the contrary, the month of January 1900 brought him yet another reverse: the news of the death of Chaudet, who owed him about 2,000 francs—a debt of which Gauguin possessed no legally valid proof. But at the same time the painter received a letter and a small sum of money from Emmanuel Bibesco, a great admirer of his work who wished to buy one of his pictures, as well as a letter from Vollard which rekindled his hopes and marked a decisive turning point in his life.

AMBROISE VOLLARD TO PAUL GAUGUIN

[Paris, end of 1899]

Dear Monsieur Gauguin,

You will receive, at approximately the same time as this letter, two parcels containing about sixty sheets of Ingres paper and some watercolors. I am sending these in the hope that you will be good enough to make me some sketches in pencil washed with watercolor, covering the entire paper—something like the drawings you made in Brittany some time ago and afterward colored with pastels. I will buy all you make at the rate of 40 francs each. Then if you care to do some flower paintings for the price of the pictures I bought from Daniel I will take a whole series of them; in short I am willing to buy everything you do; the only stipulations are that we must come to an understanding with regard to prices and that the pictures must be painted on good canvas, which I could send you, and with good colors, which I could also have sent to you.

Needless to say, everything would be paid for in cash as soon as received. If I dwell so insistently on the question of price, it is because your work is so different from what people are accustomed to that nobody will buy it.

I have purchased all of Cézanne's paintings that were in his studio. I have already held three or four exhibitions of them; they are beginning to catch on with the public.

Yours truly
Ambroise Vollard

PAUL GAUGUIN TO AMBROISE VOLLARD

[Tahiti] January 1900

I shall begin by copying your letter to me, so that you can see that I reply to it point by point. [Here follows a copy of Vollard's letter.]

To start with, I am afraid your sheets of Ingres paper will not be of much use to me (very poor for watercolors). I am very finicky about paper; moreover, your requirement that the entire paper must be covered worries me so that I would never dare begin work. Now an artist (if you consider me such, and not a mere machine for turning out orders) can do well only what he feels, and to the devil with dimensions! I have tried all sorts of things in Brittany and throughout my life; I like to experiment, but if my work must be limited to watercolor, pastel, or anything else, all the spirit goes out of it. You would lose by it too, since it would look monotonous when exhibited. Patrons of art differ in taste: one likes vigorous work, another prefers it sweet as sugar. I have just done a series of experiments in drawings with which I am fairly well pleased, and I am sending you a tiny sample. It looks like a print, but it isn't. I used a thick ink instead of pencil, that's all.

You mention flower paintings. I really don't know which ones you mean, although I have done only a few, and that is because (as you have doubtless perceived) I do not copy nature—today even less than formerly. With me, everything happens in my exuberant imagination, and when I tire of painting figures (which I like best), I begin a still life and finish it without any model.

Besides, this is not really a land of flowers. And you add (which seems contradictory) that you will take everything I paint. I should like to understand clearly. Do you mean flowers only, or figures and landscapes as well?

The trouble is, you see, that with these delays of five months between a letter and its reply, we might discuss the matter for a long time without arriving at any conclusion in two years.

You say that if you dwell on the question of price it is because my work is so different from that of other painters that nobody wants it. The statement is harsh, if not exaggerated. I am a little skeptical about it because, first, I saw pictures by Claude Monet sold for 20 francs about 1875 and bought a Renoir myself for 30 francs. Moreover, I made a collection of paintings by all the Impressionists which I bought at a very low figure when nobody would have them. Now they are in Denmark in the house of my brother-in-law, the famous

Georg Brandes, who will not sell them at any price. Twelve Cézannes among them.

As for myself, when I was in Paris my pictures sold for from 2,000 down to, at the lowest, 500 francs.

No! The truth is, it is the dealer who fixes the prices, if he knows his business, if he is really enthusiastic, and above all, if the work is good. Good painting always has a value.

And I have had a letter from Maurice Denis, who keeps closely in touch with what goes on in Paris. He tells me that Degas and Rouart are bidding against each other for my pictures and that my work brings pretty good prices at auction. So much for your statement that nobody will buy them. It would stagger anyone, no matter how inured to shocks he might be.

But I do not want to become involved in all that, and I am rearranging my life in Tahiti so as to renounce painting more and more (to retire from the stage, as they say) and take up some kind of hack work in a government office in Tahiti or do a little farming on my property. As for pictures now stored in Paris, they will help to supply my daily black bread.

Next month I shall send, by someone traveling to France, about 475 woodcuts—25 to 30 numbered prints have been made from each block and the blocks then destroyed. Half of the blocks have been used twice, and I am the only person who can make prints that way. I shall give Daniel instructions covering them. They should be profitable to a dealer, I think, because there are so few prints of each. I am asking 2,500 francs for the lot, or else 4,000 if sold by the piece. Half the money at once and the balance in three months.

Let us take up the question of prices. The last prices you paid Daniel were really astounding, unless they were a mistake; and if I had been there, or informed, I should have refused them at once. Prices only half as high as I received ten years ago!!! Therefore they cannot be allowed to serve as a precedent. But Daniel thought he was doing the right thing, so I had to agree with him and could do nothing but congratulate him on it, because he has much too noble a nature for it to be possible that we should ever have a misunderstanding.

Well, despite the fact that nobody wants my work because it is different from that of others (strange, illogical public which demands the greatest possible originality from a painter and yet will not accept him unless he resembles all the others—and parenthetically, I do resemble those who resemble me, that is, those who imitate me), you want to do business with me—which is not easy at this distance—and you ask for an understanding with regard to prices. You know very well that if I had cared to make a business of my art I could have earned plenty of money by being shrewd, by exploiting Neine de Bretagne and other people devoid of talent; but I should not have become what I am and what I intend to be, a great artist. By this I mean to tell you that you must work in harmony with me and rely on my word.

I am willing to accept low prices (an average of 200 francs for each canvas, pictures such as I am accustomed to paint, of various subjects)—a maximum of 25 pictures a year. You will send me canvas and colors at your expense

(according to the instructions I shall give Daniel). And for drawings, an average of 30 francs each, whatever their dimensions, whether in watercolor or not (the few small drawings of mine that Theo van Gogh sold at Goupil's cost an average of 60 francs and the lowest price for a picture was 300 francs, but people did want to buy them from him).

This is my final proposition, and I can assure you (with my word as an artist for guarantee) that I shall send you only art and not merchandise produced merely to earn money.

If you reject it, it will be useless to discuss the matter again.

There is another thing which is a *sine qua non*, as you will readily see. If I have no money I shall be obliged, as I told you, to find employment in Tahiti, and in that case I cannot devote myself wholly to art and fulfill my obligations to you. Therefore, if you accept my proposal, as soon as you receive this letter you will have to send me 300 francs every month, to be deducted from your payments for my work, which I shall be able to send you only from time to time as opportunities present themselves. However, I have enough pictures in storage [with Daniel de Monfreid] to cover these advances.

This is the *sine qua non*, which may upset you but which, as you must see, is absolutely essential to the arrangement, because obviously one must eat. And since you are a dealer, I do not imagine that you proposed this transaction without having considered it seriously; therefore it must be feasible. I have always said, and Theo van Gogh used to think so too, that a dealer could make a great deal of money out of my work. Because, first, I am fifty-one years old and have one of the best artistic reputations in France and other countries, and, having begun to paint very late in life, my pictures are very few in number, and most of them are owned in Denmark and Sweden. Hence there is no reason to fear in my case, as in that of other painters, the production of a tremendous number of pictures which must be continually repurchased. If my wife did not keep all the money for herself whenever she sells a picture, I should long ago have sold everything I paint in Denmark, and things do not come back to Paris from there. So from the standpoint of a dealer it is only a matter of good will and patience, not of a large investment as in the case of Claude Monet. I estimate the number of canvases I have done since I first began to paint at not more than three hundred, a hundred of which do not count because they were immature works. In this total are included about fifty pictures in foreign collections and a few in France belonging to people of real taste who will not sell them. As you see, there are only a few to be disposed of. That is a matter worth considering, especially since my average price of 200 francs is the price of a beginner, not of a man with a well-established reputation.

Now I think I have answered every point in your letter. It remains for me to congratulate you on your purchase of Cézanne's work as a commercial transaction, not a humanitarian one, since Cézanne is exceedingly rich.

I shall send this letter to Daniel, who will give it to you, and who handles all my affairs.

You will find it easier to come to an agreement after ten minutes of conversation with him, if you are willing, than after two years of

correspondence with Tahiti. And there is a very good chance that I shall be dead within two years, since I am in a very poor state of health.

Yours truly
Paul Gauguin

The disdainful tone of this letter was intended to impress Vollard, for actually Gauguin's need was so great that he was again on the point of giving up his art to seek a position as bookkeeper in Papeete. At the same time that he wrote to Vollard, Gauguin sent a letter to Monfreid to explain his real situation:

> I enclose my reply [to Vollard] so that you can read it carefully and then deal with him by quoting my letter and maintaining an air of supreme indifference, because I feel that Vollard intends to take advantage of me. . . . However that may be, I don't care if Vollard or anybody else makes a lot of money out of me if it will keep me off the rocks; later we can see about tightening the reins. . . . Look—I know this is a very delicate affair to handle with such an unimaginative and crafty person, but it cannot succeed (if it does succeed) unless we make him understand clearly that it is he who is anxious to come to an agreement, not I. (God knows, all the same, how badly I need it!) Also (and this he must take or leave) that it must be settled immediately and with provision for payment in advance. In this connection you are authorized to come down from 300 francs a month to 200, but that is my very lowest figure. And you may reduce the price of each picture from 200 to 175 francs. It is understood that if he takes any prints, they will be paid for separately, and in addition.

Evidently this proposal meant that Gauguin would, if Vollard agreed, be obliged to deliver thirteen to twenty paintings yearly, these being credited to his account at 200 or 175 francs apiece.

Gauguin waited anxiously for an answer and wondered what would become of him if he failed to reach an understanding with Vollard, his last remaining hope. Contrary to all expectations, Vollard accepted Gauguin's conditions. He ordered colors and canvas to be sent to the painter and, in March 1900—that is, as soon as Gauguin's reply reached him—forwarded the first remittance of 300 francs, which he followed with similar amounts in April, May, June, and so on. But Gauguin had no time to be surprised at this prompt compliance with his demands, for he received, simultaneously with Vollard's first payment, a letter from his new admirer, the Rumanian prince Emmanuel Bibesco, who had been in touch with Daniel de Monfreid.

EMMANUEL BIBESCO TO PAUL GAUGUIN

69, rue de Courcelles
Paris, 28 March [1900]

Today, Sir, I shall proceed to amplify my last letter, which was a little vague and incomplete. Though I am only a lover of fine painting, a disinterested and

enthusiastic admirer of your diverse and stimulating work, I am willing to offer you the same arrangement as that proposed to you by a dealer who is dominated only by the desire to speculate and make money. I do not think that your pictures will find themselves in very bad company in my house. As you suggest, you could send twenty to twenty-four canvases a year. I would pay an average of 200 to 250 francs apiece and 30 francs for each drawing. I would send you 300 francs every month on account, in addition to whatever canvas and paints you need. All that I desire is to please you and leave you entirely free to choose your own subjects, so that your temperament may develop as it will. Daniel has told me that you are not definitely pledged to Vollard and that you could secure your release from him either by giving him two pictures or by repaying him the money he has already sent you, which I could arrange for you through the intervention of Monsieur Daniel.

I shall close, Sir, with the expression of my sincere admiration.

Emmanuel Bibesco

I have just sent Daniel de Monfreid 250 francs so that he can forward to you the remittances you mention.

For reasons that are impossible to guess, Gauguin did not see fit to accept this offer, although it appeared to be exactly what he wanted. Would it not have made him independent of Vollard, while assuring him of the same monthly income he was going to obtain from the dealer? Apparently its only effect on Gauguin was to make him adopt an even more haughty attitude toward Vollard, now that he could count on obtaining similar conditions elsewhere. And, no doubt in order that he might substitute Prince Bibesco at some future time, Gauguin took good care not to sign a contract with Vollard that would have bound him for any definite period. He merely stipulated a maximum of twenty-five pictures a year to be delivered to Vollard.

After six months, during which he did not touch his brushes, Gauguin received his colors at last and set to work again, in spite of the suffering caused by the open sores on his legs.

PAUL GAUGUIN TO AMBROISE VOLLARD

[Tahiti] August 1900

Dear Monsieur Vollard:

In a hurry as usual, for the post sometimes delivers our letters after the departure [of the returning mail steamer]. I did not write last month because I received no letter from you, which troubled me a good deal since I am paying off my arrears little by little every month. However I hope that your letter has been only delayed, due to the fact that you did not notice that the mails leave two days earlier each month. Inquire at the post office about the new mail services by way of San Francisco, which will be regular and faster.

The month before last I wrote you that I had not received your shipment of canvas and colors. That was a mistake, but I did not receive the notice and the

bill of lading until five days after the steamer left. You can see how efficient Tahiti is!!

Your tubes of color are very small for the thick kind of painting you want, but I hope you will send more soon. On the other hand, the canvases seem very good; we shall know more about them after I have tried them and they have dried for some time.

I received your letter enclosing 300 francs; it is very annoying that you did not remember to write last month because my funds were running very low. Another thing that bothers me is that you did not receive the pictures and prints I sent you in charge of a planter on his way to France. Have they gone astray? If so, when will they be found? If they ever are found. The Exposition Universelle [in Paris] would have offered a good opportunity to show them.

<div style="text-align:center">Cordially
Paul Gauguin</div>

In September 1900 Gauguin received a letter from Vollard asking the price of his large canvas *Where do we come from? What are we? Where are we going?* At the same time Vollard inquired if he might buy, at 200 francs each, several of Gauguin's pictures then in the possession of Monfreid and of the painter Maufra. Gauguin wrote at once to Daniel: 'This looks as if Vollard is anxious to pick up as many as possible very cheaply; therefore, he must be watched closely. This is to warn you to sell as many as you can to other buyers, at good prices, so that in a year we can make him dance to our tune.'

PAUL GAUGUIN TO AMBROISE VOLLARD

<div style="text-align:right">[Tahiti] September 1900</div>

Dear Monsieur Vollard:

As usual I am writing to you on the run, as it were, as the steamer is about to leave immediately. For the last month I have been gravely ill with influenza, unable even to think of working.

I am terribly worried because I have heard nothing from either you or Daniel concerning the pictures which, as I wrote you, I sent to Paris in charge of a planter. Evidently you have never received them. In addition to the paintings, there were a number of very special prints which, I think, would have been just the thing for you. If they have not reached you, it is certainly bad luck and a great loss to me. Last month I wrote to this Monsieur Orsini to inquire what had happened to these pictures.

Don't speak of Maufra to me!! He has repeated the same old lies over and over again, now that Chaudet is dead. Tell him plainly that you will buy nothing from him because whatever works of mine he owns were presented to him by Chaudet at my request.

I am not sure about the large canvas you mention. I should prefer to keep it until later; in any event I think 1,500 francs a very reasonable price and that you could easily find a buyer at 2,000 francs. The picture I sold to Manzi for 2,000 francs [*Ia Orana Maria*] was much less important.

194

So far you have had a reply to every letter you have written to me. I began to write as soon as I received your first message.

In haste yours

Paul Gauguin

Received 600 francs.

PAUL GAUGUIN TO AMBROISE VOLLARD

[Tahiti] October 1900

Dear Monsieur Vollard:

I have received your letter; there is very little for me to say since I have answered all your questions in my previous letters. But the arrival of your letter without any money in it inconveniences me seriously, and this is the second time it has happened. As you know, I must pay my debts and at the same time provide for my living expenses and fulfill my obligations, and in a small country like Tahiti, I assure you, it is not easy to put off creditors.

As for Chaudet's brother, I cannot understand why he should demand a receipt before he sends what should have been sent a long time ago, and besides, it is only a small part of what is due me, which I had given up for lost. When I write to Daniel I shall send him a receipt to be given to Chaudet's brother.

Cordially
Paul Gauguin

In November 1900 Gauguin learned from Monfreid that his paintings and prints had finally arrived in France. But if his works reached Vollard safely, Vollard's money trickled out to Tahiti in very irregular installments. Confronted by these new delays and uncertainties, which exasperated him to the utmost, Gauguin began to regret his refusal of Prince Bibesco's offer and wrote to Daniel: 'I wish you would keep in touch with Bibesco, for I may break away from Vollard any minute if he continues to play tricks on me. . . . Vollard has had the cheek to send me 200 francs, "hoping" to send me 400 next month—which means that next month he will owe me 600 francs. You will understand that I cannot work under such conditions. So I beg you to make a new arrangement with Bibesco. If Bibesco accepts, as soon as he has sent the first 300 francs you can tell Vollard what I think of him. There are still enough of my pictures in Paris to recompense him. I shall write him a letter to that effect. . . .'

PAUL GAUGUIN TO AMBROISE VOLLARD

[Tahiti, November 1900]

Dear Monsieur Vollard:

Received by your letter dated October 200 francs, and you think (without being certain) that you will send me 400 francs by the next post.

I must call your attention to the fact that you sent me nothing in August or September, which was a cruel disappointment. You now owe me 600 francs. The rainy season has set in, and I have been obliged to have an entire new roof put on my shack so as not to sleep in a pool. So I owe money to people to whom I promised payment and who think I have cheated them.

To earn enough money for food I have had to go to work as an accountant, which is insufferable.

You cause me to regret that I did not make my business arrangements with someone else. If you are not in a position to make me the necessary advances, it would have been better to tell me so frankly.

<div style="text-align:right">Paul Gauguin</div>

Even before he received this letter, Vollard, evidently suspecting Gauguin's dissatisfaction and perhaps yielding to Monfreid's persuasion, had resolved to increase Gauguin's monthly income from 300 to 350 francs. Vollard now wanted to monopolize all the painter's production and was willing to pay a little more to secure it. When he informed Monfreid of his decision, the latter replied on December 27, 1900: 'You are quite right to send Gauguin somewhat larger remittances; they will revive his courage—which he needs, because of his health. Moreover they will inspire him with greater confidence in you, from which you will derive the benefit. . . . '

A short while later Vollard also began to credit Gauguin's pictures at 250 francs apiece instead of 200. But the painter, not yet aware of these increases, addressed another angry letter to Vollard.

PAUL GAUGUIN TO AMBROISE VOLLARD

<div style="text-align:right">[Tahiti] December 1900</div>

Monsieur Vollard:

I have received your letter and the check for 400 francs. I do not understand your business methods and I assure you I deeply regret that M. Bibesco is not my patron. One delay after another, and you fail to explain them convincingly. Your letter of the 3d containing 300 francs never reached me, and if it had gone astray the statement from the Crédit Lyonnais would have indicated that you had drawn a check for 200. But the letter from the Crédit Lyonnais (I don't know if you noticed this) tells you that on the 3d you drew only one check for 400.

You must realize that although I am far away, I still have my wits about me. So according to our agreement you still owe me 600 francs. Your first remittance was sent in March and this last one of 400 francs in November, which makes nine months at 300 francs, or 2,700 francs in all, while I have received only 2,100 francs; and the Crédit Lyonnais has the duplicate records.

Now, if I agreed to do what you asked for such ridiculous prices (you know they are), it was because I was in dire need at the time, and I consented on condition that your remittances should be sent regularly.

By this time you will have received several pictures sent before our arrangement was made and which were unfortunately greatly delayed in transit. Also a box of prints of which I have given Daniel the prices.

Yours truly
Paul Gauguin

Continue to send money by check through the Crédit Lyonnais.

I have received no parcels yet, but shipments via New Zealand take longer to arrive.

That same month Gauguin wrote again to Monfreid with regard to Vollard: 'If only I had some money! I should write to him at once without mincing my words, since he has broken his promise with all these delays, "Sir, you have advanced me such and such a sum, here it is—our contract is finished."'

To add to Gauguin's irritation, his physical condition made it impossible for him to work, while lack of money prevented him from taking a course of treatment at the hospital, where the charges were twelve francs per day. Fortunately, Monfreid succeeded in selling two pictures for 600 francs each, more than twice the price paid by Vollard. The money arrived at the end of the year. Gauguin immediately entered the hospital and there received Vollard's anxiously awaited letters, checks, and colors.

AMBROISE VOLLARD TO PAUL GAUGUIN

Paris, November 30—1900

Dear Monsieur Gauguin:

Herewith check for three hundred francs on the Crédit Lyonnais. I have time for only two words, the post being about to leave.

Yours truly
Vollard

P.S. I have reopened my letter to tell you that Charles Morice asked me to send him some of your pictures for an exhibition and lecture, but Daniel de Monfreid, whom I consulted as you told me to do on all such matters, opposed it firmly for good reasons.

Vollard

PAUL GAUGUIN TO AMBROISE VOLLARD

[Tahiti] January 1901

Dear Sir:

Forgive me for replying on the back of your own letter. I am at the hospital, very ill.

Received 300 francs.

Yours truly
Paul Gauguin

PAUL GAUGUIN TO AMBROISE VOLLARD

[Tahiti] February 1901

Dear Sir:

I have received a topsy-turvy batch of mail, part taking two months via Marseilles and part one month via San Francisco, so that your more recent letter arrived before the one written earlier. I acknowledge receipt of 600 francs, which exactly settles our account to date, as you yourself agree.

I am just out of the hospital, barely recovered from the influenza which laid low everyone in Tahiti (a real disaster).

Will you kindly send me a large palette that folds in two?

Don't worry anymore about my shipments of pictures from here; hereafter I shall send them through a commercial agency, insured against every accident.

I don't remember if I wrote you last month that I received the three boxes of color; anyway I acknowledge them again; they are just what I wanted.

If you see Chaudet's brother tell him that is is very extraordinary that he should keep me waiting for years for the small amount he admits he owes me.

Yours truly
Paul Gauguin

On February 25 Gauguin wrote complacently to Monfreid: 'Vollard has sent me the balance of what he owed me, after some delay. He seems now to be very much afraid that I shall desert him, which shows that he is very deeply interested in this business. As usual he doesn't give me many details. Thus, he says that he received ten pictures from you and that he was very well pleased with them, but he doesn't say that he has credited them to my account or at what rate: 200 francs or the 250 francs he has promised to pay me henceforth.'

After Vollard had augmented his monthly remittances as well as the price of his pictures, Gauguin abandoned the heretofore unpleasant tone of his letters. That did not prevent Vollard from complaining about them to Monfreid, who soothed him tactfully: 'I cannot see in what way Gauguin is disagreeable to you. And (between ourselves) you know that Gauguin is not agreeable to anyone in the world. Let us be satisfied that he is fulfilling his contract.'

But though he faithfully observed his obligations to Vollard, Gauguin continued to keep in mind the possibility of breaking away from the dealer, or of forcing him to raise his prices still higher. No later than June 1901 he wrote Monfreid, 'If I have a few thousand-franc notes a year from now, I shall try to make Vollard increase the prices of my pictures; if he won't do it, he can go without them.' And to an objection expressed by his friend, Gauguin responded: 'You are foolish to worry about the canvases that you sold over Vollard's head. I did not contract with him for all of them; the maximum was 25 canvases.'

With the money he was now receiving regularly from France Gauguin

could manage and again devote himself to his painting. But as if fate had condemned him never to enjoy complete tranquillity, the eczema on his legs and other calamities combined to keep him in a state of nervous tension.

PAUL GAUGUIN TO AMBROISE VOLLARD

[Tahiti] April 1901

Dear Sir:

I have received, a fortnight apart and by two different routes, your two remittances of 350 francs each; also duplicate advices of preceding payments, which were unnecessary since everything is in order to date.

At present Tahiti is stricken by a terrible calamity: an influenza epidemic that is killing off a great many old people and weakening the others, so my work is not progressing rapidly. At the same time the threatened outbreak of bubonic plague rumored in San Francisco has placed our ships in quarantine, resulting in a rise in prices. If this keeps up, the cost of living here will become so high that I shall be forced to move to the Marquesas; as a matter of fact, that might not be so bad, as it would give me entirely new subjects for my pictures. Well, we shall see, and if I do move I shall send you my new address in good time.

Yours truly
Paul Gauguin

PAUL GAUGUIN TO AMBROISE VOLLARD

[Tahiti] May 1901

Dear Sir:

The mails have arrived very late; but I received no letter from you. Nevertheless, the Caisse Agricole has been notified by the Crédit Lyonnais about your check for 350 francs. Perhaps the duplicate will come in a few days by way of Marseilles—although that route takes two months, while San Francisco requires only one month. Well, we must trust to luck and hope it comes soon, otherwise I shall have to wait four months more.

From now on send my remittances through the head office of the Tahiti Société Commerciale in Hamburg, which will pay me in the Marquesas on order from Hamburg.

So communicate with that firm, which will give you all necessary information. Here is the address: Messrs Scharf and Kayser, Ferdinand-strasse 30, Hamburg.

Address letters to me henceforth: Monsieur Gauguin, La Dominique, Marquesas Islands, Colony of Oceania.

For parcel post, address packages to the Société Commerciale, Tahiti, to be forwarded to M. Gauguin. . . .

Communications between us will be slow, five or six months must elapse between the posting of a letter and the receipt of an answer. So I ask you to take

charge of as many of my affairs as you can possibly handle, in collaboration with Daniel, in whom you can have complete confidence and who has my authority to look after them himself, in order to avoid long delays.

Yes, I have decided to go to the Marquesas, partly on account of my health and, above all, for the sake of my work. There will be delays, I know, but we shall both gain by the change, for I have overdone Tahiti a little and there I shall find quite new subjects which will make me do good work. Then you will have fresh things to exhibit and sell to your clients. So write me to the Marquesas as soon as you receive this. Even if I should not be gone when your letter arrives, it will still reach me, for all mail passes first through Tahiti, and the Société Commerciale has an office in Tahiti and a branch in the Marquesas. For the remittance of money it is altogether safe.

I have not yet received the canvas you promised me. The kind you sent before is very difficult to work on and absorbs a great deal of paint. What I need is unsized canvas and a separate parcel of glue for sizing. Or else canvas which you may have simply sized but not prepared with oil; with the glue you send I shall add a second coating mixed with white. I also need a good many tubes of white, for I shall be out of it in a little while.

<div style="text-align:right">Yours truly
Paul Gauguin</div>

PAUL GAUGUIN TO AMBROISE VOLLARD

<div style="text-align:right">Tahiti, August 1901</div>

Dear Monsieur Vollard,

I am leaving for the Marquesas in a few days. I received your last remittance of 350 francs, again by way of Marseilles which takes two months instead of the one by the American route. Hereafter find out exactly when the post leaves, because it will take some time to reach me in the Marquesas. I urge you not to register your letters, for I should have to move heaven and earth to get them. If you send them through the Hamburg agency as I suggested, there will be nothing to worry about.

I shall send you only a few pictures before I go, because all of those I have commenced need a few minor touches to finish them, and between my illness and all the commotion of my departure I could not work on them. Another thing, a stroke of bad luck: just before I went to the hospital I put in a box twenty-three very careful drawings which would have pleased you very much. When I unpacked them I found them all in a thousand fragments, ruined by a family of rats. I am still waiting for the Japanese paper and the canvas for painting you were going to send me!!!

<div style="text-align:right">Yours very truly
Paul Gauguin</div>

[Tahiti] September 1901

Dear Monsieur Vollard:

Enclosed is the bill of lading to be presented at Marseilles for the delivery of a case of pictures.

As I wrote you last time, the Société Commerciale paid me 685 francs on your order, but I have not yet received the notification from you.

No matter! Since the Société pays when directed to by its own head office.

Yours truly

Paul Gauguin

Just before he finally left for the Marquesas, after having sold his land and cabin in Tahiti for 4,500 francs, Gauguin wrote Monfreid: 'You will say that the more money I have, the more I want, but I wish that right now you would sell as many of my pictures as possible. This is why: as soon as I have saved enough to assure my livelihood for a year or two in advance, I shall quit Vollard, not rudely, but politely. Then, for fear of running out of my work, he will buy all of my old pictures that he has turned up his nose at heretofore; and if he wants any more new ones, he will have to pay a decent price for them, at least 500 francs. While I shall keep strictly to the letter of any agreement I make with him, I do not intend to let myself be exploited by a man who allowed me to remain miserably poor for years in order to obtain my pictures at ludicrous prices—a system he has followed on general principle for a long time, for he has also picked up all he could get from Emile Bernard and others.'

At the same time Gauguin requested his friend to take his woodcuts out of Vollard's hands, since the dealer refused to pay the price he asked—a price, incidentally, that Monfreid himself called 'exorbitant' in a letter to Vollard. Gauguin had demanded 5 francs a print for woodcuts of which twenty-five or thirty numbered copies had been made. This price, considered high at a time when nobody paid the slightest attention to Gauguin's prints, was determined by the esteem in which the artist himself held them. In a letter to Daniel he wrote: 'It is just because these prints recall the primitive era of wood engraving that they are interesting, woodcuts as illustrations having now become more and more like photogravure: loathsome. I am convinced that in time my woodcuts, so different from anything that is being produced in that medium, will have some value.'

But that time was far in the future. Even in 1909, when prints by Manet, Toulouse-Lautrec, or Degas brought relatively high prices, some of Gauguin's finest woodcuts did not attract bids of more than 5 francs each at the Hôtel Drouot. Vollard, too, who had always been profoundly interested in the graphic arts, had no idea of the real value of Gauguin's prints. In 1900 he had brought out his first book—one of the finest of the Vollard series of

publications—Verlaine's *Parallèlement* illustrated by Pierre Bonnard; and he was preparing an edition of *Daphnis and Chloe*, likewise with Bonnard's lithographs, as well as books illustrated by Maurice Denis, Armand Séguin, and Emile Bernard, all friends if not disciples of Gauguin since his sojourn at Pont-Aven. Nevertheless, Vollard did nothing with Gauguin's prints except return them to Monfreid.

In November 1901, after a silence of more than two months, Gauguin wrote again to Monfreid, this time from La Dominique (Hiva Hoa) in the Marquesas. He had had a large studio built for himself in the Atuana district and announced that he had already started to work but had no more canvas, and added, 'I am waiting impatiently for the supplies Vollard promised to send me a year ago, canvas, colors, and zinc white.' Gauguin was also waiting for a remittance from Vollard, who had at last sold the large painting *Where do we come from? What are we? Where are we going?*, for only 1,500 francs.

PAUL GAUGUIN TO AMBROISE VOLLARD

[La Dominique] March 1902

Dear Sir:

By the next steamer I shall send you about twenty pictures. When they arrive please compute my exact account and send me whatever balance is due me. In the collection I am sending you there are some canvases of slight importance, but there are others which will make up for them. Incidentally, these small pictures often cost me more trouble than the large ones; moreover, you have certain clients who prefer the little ones because their apartments lack space. My work is going well now, though not without some preliminary difficulty and a good deal of expense, and I hope to send you enough every six months to repay you well.

Please be good enough to send me by post the flower seeds mentioned on the enclosed list; get them from the firm of Vilmorin, that is the place where one can be sure of getting fresh seeds.

Mollard has written me something about 300 francs he paid you. He also tells me that 'apparently' I sent a shipment of pictures to M. Svelinksi [Slewinski] a Polish painter living at Le Pouldu. This worries me, as it is quite mysterious and I wish you would clear it up in case there has been some fraudulent transaction; I don't know by whom, perhaps Chaudet, who has sold pictures of mine to Bauchy, among others, but has never sent me the money. In any event it is very curious and concerns you as well as me.

The post has arrived without a line from you; your last letter was dated October 4. Since then I have received nothing from you except a notification of a remittance of 342 francs 88 centimes from Lambuy in October. I would be greatly obliged if you would send money to the Hamburg office a little while before the post leaves so that their remittance and your notification will reach me at the same time. Fortunately I have a little credit at the Société

Commerciale, otherwise all my plans would be upset and it would be hard for me to keep on working.

Your shipment of colors has arrived but I cannot get them until after the steamer leaves, so I cannot write anything about them. Having no letter from you I do not know whether you received my pictures, so I shall wait before I try to have them traced. It would be a nuisance to have to do that because communications between the Marquesas and France are irregular and slow.

In haste yours

Paul Gauguin

PAUL GAUGUIN TO AMBROISE VOLLARD

[La Dominique, March 1902]

Dear Monsieur Vollard,

I shall take just a few minutes to write again.

I have opened your box.

Canvas and glue—perfect.

Japanese paper—perfect.

But the colors!!! It is easy to see you are not a painter. What do you expect me to do with six tubes of white and of terre verte, which I seldom use? I have only one small tube of carmine lake left.

So you must send me immediately:

20 tubes of white

4 large tubes carmine lake

2 ,, ,, light vermilion

10 ,, ,, emerald green

5 ,, ,, yellow ocher

2 ,, ,, ocher de Ru [?]

2 ,, ,, red ocher

Powdered color—Charron blue, $\frac{1}{2}$ liter, large tube.

I know this means a large outlay, but I can't help it. Now that I am in the mood for work I shall simply devour paints. So buy Lefranc's decorators' colors, they cost only one-third as much, especially since you get a dealer's discount, and they are much better.

I close in a hurry.

Paul Gauguin

PAUL GAUGUIN TO AMBROISE VOLLARD

[La Dominique] March 1902

Dear Monsieur Vollard:

I have received your letter dated December 27, 1901, advising me of a remittance of 650 francs plus 1,000 francs, which, after deductions for exchange, commissions, etc., comes to 1,618 francs net. To date one monthly remittance of 350 francs is missing. Since I came to the Marquesas you have

203

sent 350 in August, 350 in September, 350 plus 300 from Bauchy in November, 250 plus 1,000 in December.

The error noted by Scharf is only a clerical error, I inadvertently signed the receipt for 277 francs instead of 277 marks. There is no need to do anything about it.

What does worry me is the case of pictures. I am sending instructions to Papeete at once to have the forwarding company take steps to trace it.

Did you send to Marseilles the order for the delivery of the case with the bill of lading I sent you? Because I think that only you yourself or your authorized agent can get possession of the case, which should have reached Marseilles by steamer in November.

You will soon have to arrange to send me more canvas, because (figure it out for yourself) one meter of this canvas makes only two pictures.

I must close in a hurry.

<div align="right">Cordially yours
Paul Gauguin</div>

<div align="center">PAUL GAUGUIN TO AMBROISE VOLLARD</div>

<div align="right">[La Dominique] April 1902</div>

Dear Monsieur Vollard:

I received your letter advising me of the remittance of 700 francs, which has been paid me and which makes our account even.

I am sending you a consignment of pictures, as I already informed you. Let us hope that more will reach you at regular intervals and that they will please you.

I am very uneasy about Daniel who has not written me by the last four posts. Has anything happened to him? Let me know.

<div align="right">Yours truly
Paul Gauguin</div>

Meanwhile Daniel de Monfreid had painted a self-portrait which Gauguin had asked for, as he wanted to hang it in his cabin; and in June 1902 Monfreid sent it to Vollard to be shipped out with the next consignment of canvas, paints, and seeds. Gauguin in turn had sent a box of twenty pictures to Vollard. He wrote Monfreid: 'From now on I shall put aside any money I may receive outside of Vollard's 350 francs a month; it will not be a hardship, for I am now not only out of debt, but have even saved a little. Besides, I can live very well, without depriving myself of anything, for 250 francs a month, since the cost of living is much lower than in Tahiti.'

Gauguin also wrote that he had received letters from Vollard asking for sculptures, and that he had told him to apply to Monfreid. Gauguin added: 'From the tone of his letter (I know the sly fox) I can see that his dealings in my work are going very well and that he needs more and more of them. One

must admit that he is clever and that he is well known among collectors of good pictures.'

But Vollard allowed several months to elapse without writing to him, and Gauguin began to wonder if his last shipment of paintings had failed to please the dealer.

About this time, to relieve the monotony of his solitude, Gauguin took up his pen to write out his recollections and stir up a few controversies. As early as 1899, with the assistance and support of a politically ambitious colonist, he had published a paper in Tahiti, *Les Guêpes*, a monthly printed on four pages. Then he had started a little magazine of his own, mimeographed on the kind of paper used by schoolboys and illustrated with his wood engravings, with the title *Le Sourire—A Serious Journal*, which he afterward changed to the more appropriate *Le Sourire—A Malicious Journal*.

Now, at La Dominique, Gauguin wrote several letters more or less intended for publication, in which he discussed the colonial government, the courts of justice, and the police. But at the same time he began to jot down a few reminiscences, a few opinions, and a few theories full of bitterness and acidity. One of the principal problems that preoccupied him concerned his relations with his unfortunate friend Vincent van Gogh, some of whose letters had been published in the *Mercure de France* in 1894.

'I have been wanting to write about van Gogh for a long time,' Gauguin noted, and he added, 'Surely it is merely a coincidence that several men with whom I have associated and conversed in the course of my life have gone mad.' In order to explain exactly what had happened between him and Vincent, Gauguin began to write down his version of his visit to Arles and decided to send it to André Fontainas. He added a few lines concerning his artistic relations with Vincent, lines inspired by the phrase so often employed by his critics and even by Fontainas himself, 'Gauguin's drawing reminds one just a little bit of van Gogh's.'

PAUL GAUGUIN TO ANDRÉ FONTAINAS

<div align="right">Marquesas Islands, September 1902</div>

Dear Monsieur Fontainas:
I am sending you this short manuscript written in haste, in the hope that if, after having read it, you approve of it, you will ask the *Mercure de France* to publish it.

I am not sending it direct to the *Mercure* for two reasons: the first is that, as you are the magazine's art critic, you might suspect me of committing an impropriety I did not intend. The second is that, as I am poor and receive the *Mercure* gratuitously, it might be better for me to remain in the background.

What I have written has no literary pretensions, only a profound conviction which I should like to communicate to others. I have already given you my ideas on this subject in a few lines written some time ago, which you were kind

enough to answer and, at the same time, to send me your excellent book.

Do not be surprised if I bring up this matter again. But I know you are above such pettiness; your love of beauty saves you from it. If my manuscript is not published I should be grateful if you would send it to my friend the painter G. Daniel [de Monfreid], Domaine de St Clément, near Villegranche-de-Conflent (Pyrénées Orientales).

'Although Gauguin's drawing reminds one just a little bit of van Gogh's. . . .' For your information, and in justice to me, reread some letters of van Gogh to his brother published in the *Mercure*:

'Gauguin's arrival at Arles is going to change my manner of painting very greatly. . . . '

In his letter to Aurier, 'I owe much to Gauguin.'

If you have the opportunity, examine van Gogh's work executed both before and after my stay with him at Arles. Van Gogh, influenced by the experiments of the neo-Impressionists, always used to paint with strong oppositions of one complementary tone on another, yellow on violet, etc., while later, following my instructions and advice, he painted quite differently. He put yellow sunflowers on a yellow background, etc., and learned the orchestration of a pure tone from all the derivatives of that tone. Then, in his landscapes, all the litter of still life objects which had once been necessary was replaced by tonalities of solid colors in conformity with the total harmony; hence the literary or, if you prefer, explanatory element became of secondary importance.

Naturally this procedure made his drawing more flexible. No doubt this is merely a question of craftsmanship, but it is very important just the same.

But as all this forced him into further experimentation befitting his intelligence and ardent temperament, he thereby developed his originality and personality.

All this, which is between ourselves, is to point out to you that I have no desire to diminish van Gogh's reputation even if I claim credit for a tiny share in it; and also to show you that the critic must see all and know all, and that he is liable to make mistakes even though he does so in good faith.

If I, the artist with sealed lips, have had reason to be proud of my influence upon van Gogh's noble nature, the situation is quite different with respect to my relationships with many of the Brittany painters, especially the young Emile Bernard. At that time he was nineteen years old and very clever at imitating the Middle Ages; today, the neo-Impressionists; tomorrow, the Florentines; the day after that, etc.

After having admitted to van Gogh, to all of the Brittany group, and to me—in a letter I have carefully saved—that he had drunk from my spring, Bernard took it into his head to announce, in my absence, that I derived all my inspiration from his work.

Today he is a full-grown man and exhibits nice things, and for that I thank heaven.

From the very beginning until now my work (as one can see) forms one indivisible whole, with all the gradations due to the education of an artist. I have remained silent about all that and shall continue to do so, as I am

convinced that truth becomes manifest not through controversy, but in the work one has produced. Moreover, my completely isolated existence proves sufficiently how little I seek elusive glory. My pleasure is to recognize talent in others.

And if I write you all this, it is because I value your esteem and would not want you to misunderstand my manuscript nor see in it an attempt to achieve notoriety. No. Only I become very angry when I see a man like Pissarro abused and ask myself whose turn it will be tomorrow.

When someone abuses me that is another thing. It doesn't annoy me, and I say to myself, 'Well! Perhaps I am somebody after all.'

Believe me, ever devotedly,

<div style="text-align: center">Paul Gauguin</div>

As soon as he had posted this letter and the article to Fontainas, Gauguin wrote a letter to the governor of Tahiti and sent a copy of it to the *Mercure de France*. The painter complained of excessive taxes, the slowness of the mail boats, the unsatisfactory distribution of provisions, and the incompetence of the colonial officials. At the same time he addressed another letter, expressing his opinion of a certain law concerning the straying of pigs, to the president of the Conseil Général des Etablissements Français de l'Océanie at Papeete.

In the midst of this feverish literary activity the state of his finances reminded Gauguin that he had heard nothing from Vollard for a long time.

<div style="text-align: center">PAUL GAUGUIN TO AMBROISE VOLLARD</div>

<div style="text-align: right">[La Dominique] December 1902</div>

Dear Monsieur Vollard:

Just a hasty line. In fact I have nothing to say to you except that for almost four months you have neglected to send me not only news of yourself, but notifications of remittances from the Scharf office, with the exception of 700 francs that reached Tahiti in October.

[Scratched out but still legible: Not only am I greatly in need of money but I am also profoundly worried about the future.]

Has my shipment of pictures arrived at its destination and thus settled my account? At any rate, when you do not write for several posts in succession, I always get very nervous.

<div style="text-align: center">Yours truly
Paul Gauguin</div>

In January 1903 a violent typhoon devastated Atuana; by a sheer miracle Gauguin's house remained intact. That was the only grace his destiny accorded him, for his eczema prevented him from working for several weeks, and his eyesight again began to cause him grave anxiety. Uneasily, Gauguin asked himself for the first time what would become of him if Vollard had cast

him off, now that Vollard neither wrote nor sent him money nor the parcel of canvas and colors, so long overdue, which should also have contained the seeds and the portrait Monfreid had painted for him.

Because the lack of colors, combined with his physical discomfort, made it impossible for him to paint, and also because solitude rendered him more and more irritable, Gauguin went on penning argumentative letters. He wrote to Baron Denys Cochin, a collector and political figure in France, to tell him how disgraceful, how unworthy of France he considered the outrages committed by the police in the Marquesas; he wrote to one of the local magistrates complaining of the way the investigation of a murder case had been handled by the police; he addressed himself to the Inspecteurs des Colonies, who were then visiting the Marquesas, to suggest firmer control over the police and the reduction of certain excessive penalties.

While Gauguin was playing the part of a champion of justice, he continued, during his long, sleepless nights, to set down his more or less confused thoughts in a large notebook which he embellished with numerous drawings, some Japanese prints, extracts from articles, etc. He also inserted some of his controversial letters. Thus, during the months of January and February 1903 he communed with himself at great length, stripping himself bare of grudges and memories. 'This is not a book,' he wrote repeatedly. 'I feel an urge to chat, so I write instead of talking.'

The manuscript, which he entitled *Avant et Après*, was scarcely finished when Gauguin at last received a reply from André Fontainas, who wrote, among other things, that Gauguin's works were no longer to be seen in Paris. Gauguin deduced that 'Vollard is hiding some of my pictures; that is a devious method of increasing their value which may be effective but all the same is a little too slow . . . for me.'

At that moment, however, the rejection of his article by the *Mercure de France* seemed more important. They could not publish it, Fontainas wrote, because they considered it 'out of date.' But Gauguin was convinced that behind this too obvious excuse lurked the persistent enmity of Camille Mauclair, the well-known contributor to the *Mercure*, who had long ago declared that Gauguin's work was 'revolting in its vulgarity and brutality.' So the refusal of the editors to publish his article was no surprise to the painter; and his disappointment was less keen than it might have been because he had thought of a new idea which he was anxious to discuss with Fontainas.

[La Dominique] February 1903

Dear Monsieur Fontainas,

I am not surprised by what you write in your kind letter concerning the rejection of my article by the *Mercure*; I had a premonition of it. There are men connected with the *Mercure*, for example Mauclair, who must not be offended. That is the real reason for the rejection, not—as they allege—that the article is out of date.

So much the better, and this is why: I have just written a whole collection of notes—childhood memories, the whys and wherefores of my intuitions, of my intellectual evolution; also what I have seen and heard (including my opinions of people and things); my art, that of others, my likes and dislikes. It is not a literary work in the usual sense, but something quite different: the civilized man face to face with the barbarian. Therefore the style must be appropriate, unadorned as a naked man, often shocking. Well, that is easy for me. I am not a writer.

I shall send you the manuscript by the next mail. When you read between the lines you will understand my personal and malicious desire to have the book published. I WANT it done, no matter how unpretentiously; I do not care to have it read by many, only a few.

But why do I appeal to you, a man I do not know intimately? That is inherent in my strange nature, my instinct—I have an irrational confidence in you, even at this distance. I am trusting you with an important matter, a heavy task, a responsibility. I am writing to one of my friends about this same business; permit me to introduce him to you as a distinguished gentleman and an artist of great worth, too modest to make himself known: Georges Daniel de Monfreid, Domaine de St Clément, Corneille-de-Conflent.

I shall tell him to sacrifice (at any price he can get) every item shown in my first exhibition of paintings from Tahiti in order to raise the amount required for this publication.

So if you do undertake this mission—and I am sure you would not wish to disillusion me and make me very unhappy—please withdraw what I wrote for the *Mercure* and put it in the book wherever you think it would be most suitable.

You might look up Delagrave's son (at the Delagrave Press). This young man spent his term of military service on a warship that touched at Tahiti and, as he is acquainted with all the publishers, very kindly offered to help me if I ever wanted to have anything published.

The drawings are executed in the same manner as the writing. Very unusual, sometimes brutal.

I should be very grateful (whatever happens) if in remembrance of me you would accept the manuscript with its sketches to be kept in some odd corner as a barbaric curio, not treasured among your valued possessions. This is neither a payment nor an exchange of gifts.

We natives of the Marquesas know nothing of such things; we know only how, on occasion, to offer a friendly hand—a hand without gloves.

In your kind letter you say, 'Why do we no longer see your work? Do you underrate yourself to that extent?'

No, I don't underrate myself, quite the contrary; but this is what has happened. For several years I have had eczema from my feet to my knees and, especially during the past year, I have suffered so much that it has been impossible for me to work regularly; sometimes I do not touch my brushes for two months. In spite of that, from time to time I send just enough pictures to Vollard to enable me to buy a hard-earned crust of bread and a few medicines. I believe Vollard hides the pictures, no doubt with an eye to speculation. But I think that if you should ask to see them sometime, he would show them to you.

If I can ever find relief from pain, even though not a complete cure, it will not be so bad; for my brain continues to function, and I shall then take up my work again and try to finish conscientiously what I have started.

In fact this is the only consideration that stops me, in my most miserable hours, from blowing out my brains. My faith is invincible. So you see, my dear sir, that I do not underrate myself. I am afraid of only one thing: that I may go blind. If that happens I am done for.

Believe me, ever yours

Paul Gauguin

The fear of blindness stimulated Gauguin's desire to devote himself once more to painting. He therefore wrote insistently to Vollard urging him to send the colors, canvases, and other supplies for which he had waited so long.

PAUL GAUGUIN TO AMBROISE VOLLARD

[La Dominique] March 26, 1903

Dear Monsieur Vollard:

Your last letter contained 500 francs in bank notes and announced a remittance of 500 francs through the Scharf agency. I received the 500 francs all right, but since then two posts have come without bringing anything more.

Moreover, for more than six months I have been waiting for flower seeds, paints, canvas, sizing glue, and absorbent Japanese paper. Soon I shall have nothing left to work with.

I had about fifteen pictures and a dozen drawings to send you, but as the steamer arrived five days ahead of schedule, I had no time to get them ready; they must go by the next boat. In any event I have heard nothing about my last consignment or about the carvings!!!

Answer this letter.

Yours truly
Paul Gauguin

As if he had not found it sufficiently difficult merely to live and work, Gauguin now began to suffer the consequences of his violent controversies with the colonial authorities and the police. He had thrown himself into this fray partly to defend the rights of the natives, partly because of his

overpowering need for activity and his uncontrollable tendency to 'boil over.' But the police were determined to stop the painter's interference and were only looking for a pretext to proceed against him. Accused, as he says, of 'inciting the natives to revolt by telling them what their rights were,' Gauguin was on the point of being deported for resisting a gendarme. Yet even more serious was the fact that the letter he had written to the governor had been turned over to the police, who filed suit for libel. As had to be expected, Gauguin was found guilty. In April 1903 he wrote to his friend Charles Morice: 'I have just been caught in a police trap, and I have been convicted without a hearing. It means ruin for me, and perhaps on appeal the result will be the same. If I lose the appeal here I shall take the case to the Appellate Court in Paris. . . . If we win, it will have been a glorious fight and I will have rendered a great service to the Marquesas. Many abuses will be abolished, and that is worth suffering for. I am stricken to earth but not yet vanquished.'

The letter Gauguin wrote to Vollard at the same time sounded more optimistic.

PAUL GAUGUIN TO AMBROISE VOLLARD

[La Dominique] April 1903

Dear Monsieur Vollard:

I am sending you a rather good assortment (I think) of fourteen pictures and drawings. I have heard nothing from you about the last shipment; you must have received it or you would have informed me. I also asked you to figure up my account.

Your last letter, dated December, enclosed 500 francs in bank notes and advised the belated remittance of 550 francs through Scharf, so adding these sums and the usual monthly remittances of 350 francs to what I expect will be due me when you settle my account, I have drawn what I needed from the Société Commerciale on credit. So now I owe them 1,350 francs.

Moreover, I shall have to go to Tahiti to defend myself in court, on appeal from a judgment rendered against me (three months in prison and 500 francs fine). I am sure to win the case, but all the same the expenses of the trip and lawyers' fees will increase my debts. So I beg you to send me, as soon as you receive this letter, all the money you owe me and even, if you can, a small additional sum as an advance on the pictures I am sending you, for when these pictures arrive there should be a balance in my favor of about 3,000 francs.

The post has come. Nothing yet from you and neither letter nor notification from the Scharf office. This is a terrible blow—at this time.

Paul Gauguin

I am sending Vilmorin an order for seeds. Please pay the bill and deduct it from my monthly account.

In a letter to Monfreid Gauguin complained: 'All my life it will be that I am fated to fall down, to pick myself up, to fall again, and so on. . . . My old energy

is growing weaker every day. Vollard has not written me for three posts nor sent me any money.'

PAUL GAUGUIN TO AMBROISE VOLLARD

[La Dominique] April 1903

Dear Monsieur Vollard:

It is now more than eight months since you advised me of the shipment of canvases, paper, Tautin glue, etc., and flower seeds.

At the present moment my health would permit me to work hard, and I have nothing to work with.

Yours truly
Paul Gauguin

Here comes the post.

Vollard carried his negligence so far that he did not even take the trouble to reply to Vilmorin regarding the flower seeds that Gauguin had so urgently requested. At the beginning of July, Vollard received this letter:

Paris, July 1, 1903

Sir:

We are surprised not to have received an answer to our letter of June 12. We should be greatly obliged if you would advise us whether or not you are willing to pay for the articles ordered by M. Paul Gauguin, so that, if you reply in the affirmative, we may ship them without further delay.

Hoping to hear from you by return of post, we remain

Very truly yours
Vilmorin-Andrieux

The shipment promised for so long, which should have included these seeds and Daniel's portrait, never left France. On May 8, 1903, a neighbor had discovered Gauguin alone in his cabin, dead, with one swollen leg hanging over the edge of the bed.

While Vilmorin awaited Vollard's reply about the seeds for Gauguin's garden, the painter's cabin at Atuana was being emptied, and his clothes, household gear, notebooks, the few colors he had left, and some half-finished pictures were being sold at public auction. It was not until the end of August that Gauguin's death was officially announced in France. In accordance with the artist's expressed wish, confirmed by his widow in Denmark, the settlement of his affairs was entrusted to Daniel de Monfreid. As executor Daniel was obliged to audit Vollard's accounts and remittances. The result of this audit is not known, but there is no reason to doubt that Vollard fulfilled his obligations, if not completely during Gauguin's life, at least through a settlement with the painter's estate. Nevertheless, before he showed his account books to Monfreid, Vollard notified him that he intended to pay less than usual for the pictures that constituted Gauguin's last shipment.

'I shall treat your transactions as those of a friend of Gauguin's,' Monfreid replied on October 8, 1903, 'for I realize that Gauguin found in you not only a picture dealer, useful from a commercial standpoint, but also an admirer who encouraged and helped him in his time of great need. But to tell the truth, I was very much astonished when you wrote me that you had reconsidered your decision to pay Gauguin 250 francs for each picture. However!'

NOTE

The letters of Paul Gauguin to Ambroise Vollard were translated from the unpublished originals. Found among Vollard's papers after his death in 1939, they were sold by his brother to an autograph dealer from whom the Grabhorn Press, San Francisco, acquired the copyright. With the exception of the letter of Apr. 1897, this text was published by the Press in 1943 in an edition of 250 copies.

Gauguin's four letters to André Fontainas were published in France in 1921 in a small booklet, of which only a few copies were printed. Fontainas decided to issue the letters after he had seen an announcement, by a German publisher, of a facsimile edition of the manuscript Gauguin had sent him. In a short introduction Fontainas explained that, unable to find a publisher for it, he had kept the manuscript at Gauguin's request as a token of his esteem, until the artist's widow informed him that she knew a Danish publisher interested in her husband's writings. He then handed the manuscript over to Madame Gauguin. When Fontainas later asked for its return, Gauguin's family refused to send it back, having in the meantime not only sold the copyright, but the manuscript itself, with the drawings, to the German publisher.

The letters Gauguin wrote to Fontainas, as well as the latter's article in the *Mercure de France*, were translated here for the first time. The manuscript of *Avant et Après* has been published in English under the title *Paul Gauguin's Intimate Journals*, translated by Van Wyck Brooks, privately printed for subscribers only by Boni and Liveright, New York, 1921. This volume has since been issued in paperback (Indiana University Press, 1958, Bloomington). In his preface to the *Intimate Journals* the artist's son Emil does not mention Fontainas except to say that he 'did not find a publisher, and so the journals, *per fas et nefas*, came into the possession of my mother and younger brother.'

Both the German facsimile edition and the English translation bear Gauguin's dedication which says: 'To Monsieur Fontainas, all this, all that, moved by an unconscious sentiment born of solitude and savagery—idle tales of a naughty child who sometimes reflects and who is always a lover of the beautiful—the beauty that is personal—the only beauty that is human. Paul Gauguin.'

Gauguin's letters to Daniel de Monfreid, which constitute the indispensable complement to the documents included in these pages, have been printed in full only in French. The English translation of these letters published in 1922 by Dodd, Mead and Company, New York, contains only fifty-two of the eighty-three letters Gauguin wrote his friend, and many of those are considerably shortened. The translation is marred by certain defects, among them a tendency to confuse Theo van Gogh with his brother, Vincent. In both the French and the American editions Vollard's name is suppressed, and the initial R substituted.

In 1950 there appeared in Paris a new edition of Gauguin's letters to Daniel de Monfreid (Editions Georges Falaize), edited by A. Joly-Segalen, daughter of Victor Segalen to whom Daniel de Monfreid had entrusted the first edition of these documents. This new edition is much more complete than the first one of 1919; all names are given in full, some deleted passages are restored, and there are extensive notes and documents in appendix.

46 Odilon Redon *Figure in Armor* c.1885, charcoal

Some Notes and Documents on Odilon Redon

In memory of Alfred H. Barr, Jr.

Apart from the great artistic currents of the nineteenth century, Odilon Redon pursued a course that for many years kept him unnoticed by the public. He was over forty in 1881 when he had his first, and rather modest, one-man show in the office of the Paris weekly *La Vie Moderne*.[1] He exhibited only drawings—especially charcoals—and some lithographs (two years earlier he had published his first album, *Dans le rêve*). But these works did not succeed in piercing that wall of indifference by means of which the public always seems to secure itself against innovators, thus guaranteeing that it will not be disturbed from its habitual ways of thinking and seeing. The artist was naïvely surprised by this reception and later said, 'There was a coldness and a reserve that I will always remember as an enigma.'[2] The ambiguous note of about seven lines added by J.-K. Huysmans to an article on the Salon of 1881 was scarcely a consolation. This was the only response, and a minimal one, to the first manifestation of an art that was destined to play a significant role at the end of the century.

At the beginning of the following year, when Redon exhibited again, this time in the dispatch room of the newspaper *Le Gaulois*, Huysmans's appreciation progressed toward a real, though somewhat literary, enthusiasm. It is not surprising that this poet, this mystic, should have found ample inspiration in the 'blacks' of Redon, as the painter called his charcoal drawings. The lines that Huysmans devoted to them revealed little of the artist Redon, while they offered some interesting insights into the fertile imagination of the writer himself. He speaks of these charcoals and lithographs as 'microbes in vinegar which teem in the glucose tainted with soot,' or as a 'fetus of Correggio macerated in an alcohol bath,' then admits, 'It would be difficult to define the surprising art of M. Redon. Basically, if we exclude Goya, whose spectral side is less visionary and more real, if we also exclude Gustave Moreau, of whom Redon is, after all, in the healthy parts of his work, a rather distant pupil, we shall find his ancestors only among musicians, perhaps, and certainly among poets.'[3]

First published in French in the *Gazette des Beaux-Arts*, November 1956

Although he could scarcely have discovered a just interpretation of his efforts in these lines, Redon was 'singularly happy and proud.'[4] After all, the sincere but inept compliments of Huysmans (in his alluding to the 'healthy' parts of his work, was there not an implication of unhealthy ones?) were certainly better than the hostile silence to which the artist had become accustomed. In this respect Huysmans's contribution was valuable, although there could have been no doubt for Redon that the critic's sudden enthusiasm had been provoked by the appearance of an article published shortly before in the *Revue Artistique et Littéraire*, to which Huysmans occasionally contributed. It is a recognized truth that artistic appreciation by men of letters crystallizes and manifests itself only after an initiate opens their eyes. In this case, the discoverer that Huysmans was to follow was a semi-obscure but rather gifted critic by the name of Emile Hennequin.[5]

Assigned to review exhibitions for the *Revue*, Hennequin had been greatly impressed by the twenty-two charcoal drawings hung in the exhibition hall of the *Gaulois* and immediately had gone to visit the unknown artist who had signed these works. A few days later he published a short notice on Redon in the *Gaulois* itself, which was followed by a longer piece in his column, 'Beaux-Arts,' where, in addition to his own opinions, he provides a reflection of his interview with the artist:

'From now on M. Odilon Redon should be considered one of our masters, and—for those who value above all else that touch of strangeness without which, according to Francis Bacon, there is no perfect beauty—an outstanding master who, aside from Goya, has neither ancestor nor follower. Somewhere on the boundary between reality and fantasy he has conquered a desolate domain which he has peopled with formidable phantoms, monsters, monads, composite beings formed of all the human perversities, of all the bestial baseness, of all the terrors of inert and noxious things. Aware of the incubi and succubi that lie dormant in the depths of the human soul, he has succeeded through imperceptible refinements in creating a type of menacing horror, with a cunning and insidious profile, a forehead covered with the boils of every vice, whose vapid eyes reveal the evil subconscious of the brute. As much as Baudelaire, M. Redon deserves the superb praise of having created a new shiver. . . .

'This work is bizarre; it touches the grandiose, the delicate, the subtle, the perverse, the angelic. . . . It contains a treasure of dreams and suggestions which one should approach with caution. Add to this ideal vision an astonishing mastery of execution, which makes all these lithographs and charcoals appear more luminous and more powerful than etchings, an impeccable draftsmanship that forces the eye to admit the most bizarre deformations of real beings, and one realizes what admiration such works can cause.

'M. Odilon Redon has informed us that he intends to draw a series of illustrations for the works of Poe, Baudelaire, and—an association that would appear strange only to superficial minds—Pascal. . . .[6] To wrestle with such geniuses is an ambitious undertaking and, we say it unhesitatingly, being sure that soon we will not be alone, M. Odilon Redon seems to possess the stature to execute it. He alone among all our

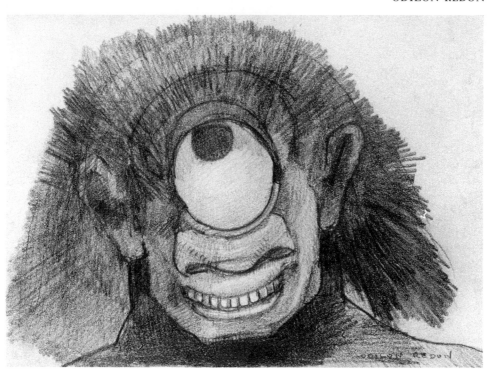

47 Odilon Redon *Cyclops c.* 1880, pencil

artists, painters, writers, and musicians appears to have reached that absolute originality which, today, in this aged world of ours, is also the supreme accomplishment. On his own he has succeeded to represent by certain symbols, by subtle synthesis, our most profound modern ideas on corruption, depravation, cunning, and, as well, on the grandiose and the beautiful. Certainly, M. Odilon Redon is a singular artist who has lost in comprehension, in universality, what he has gained in penetration and in speciality. Certainly he was not destined either to please the masses, or to paint actuality. But, certainly, too, he must be looked upon as the leader and representative of that type of mind that searches ardently in art not for scientific facts, but for unknown beauties, for strangeness, for creation, for dream, for new means of precious gripping expression. And these "decadent" minds, as they have been called, are today of such a number that the most penetrating of our critics, M. Paul Bourget, has been able to say of their ancestor, Baudelaire, that he had the ear of contemporary youth.[7]

Redon was greatly moved by these lines and the very next day wrote to their author:

Sir,
It is my turn to congratulate you and to do so eagerly. First, to express the joy I experience from reading what you think about my work; but also to compliment you ardently for the courage you have just shown. Allow me to tell you, too, that criticism is a form of creation like any other, and that in some way

you have just collaborated with me, the solitary, on my work. Thank you. The help you have so generously and so sympathetically provided dispels much of my anguish, and it is with a greater sense of dignity now that I go on working for those young minds of whom you speak.

Allow me to shake your hand firmly as a good soldier encountered in this sad battle, and please accept, Sir, the expression of my gratitude.'[8]

Contact with contemporary youth becomes one of Redon's hopes. It was perhaps the only path that might lead him out of this isolation, due much less to his taste than, so to speak, to the lack of taste in others. But since the young were slow in approaching him, he went to join them, and in 1884 he can be found beside Signac and Seurat—who could almost be his sons—among the founders of the Salon des Indépendants. At least in this way he would lay the foundations for annual exhibitions without juries where he could show in the company of those who shunned the official Salon or were not admitted. In 1885 he accepts, 'with a vivid feeling of joy and as a very sweet reward,' the invitation of Octave Maus and Edmond Picard to exhibit with the young group of Les Vingt in Brussels. He appears there in 1886 but among all the exhibitors, he is the most vilified.[9] It is especially the captions accompanying his lithographs that become the target of the most malevolent criticism, those same evocative phrases about which none other than Mallarmé will soon say to him, 'You know, Redon, I envy you your captions.'[10]

In Paris in 1886, again with Seurat and Signac, Redon participates in the last exhibition of the Impressionists, where his drawings are displayed in a corridor. They do not, of course, go well with the works of the others, and no one is surprised to see the impetuous Octave Mirbeau (another writer of good intention who needed a little guidance toward his own enthusiasms) exclaim with indignation in front of this art that contained so little that was 'naturalistic':

'After innumerable battles, all pacific by the way, and in which only ink was spattered, everybody agrees that it is necessary for art to approach nature.... Among painters there is hardly anybody except M. Odilon Redon who resists the great naturalistic current and who juxtaposes the thing dreamed to the thing experienced, the ideal to the truth. Thus M. Redon presents you with an eye that floats in an amorphous landscape at the end of a stem.[11] And the commentators assemble. Some will tell you that this eye absolutely represents the eye of Conscience, others, the eye of Incertitude; some will explain that this eye synthesizes a sun setting over hyperborean seas, others, that it symbolizes universal sorrow, a bizarre water lily about to blossom on the black waters of infernal Acherons [48]. A supreme exegete arrives and concludes, 'This eye at the end of a stem is simply a necktie pin.' The very essence of the ideal is that it evokes nothing but vague forms which might just as well be magic lakes as sacred elephants, extraterrestrial flowers as well as necktie pins, unless they are nothing at all. Yet, today we demand that whatever is represented be precise, we want the figures that emanate from an artist's brain to move and think and live.'[12]

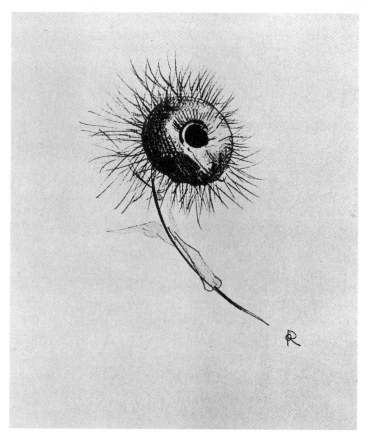

48 Odilon Redon *Cul-de-lampe* for Baudelaire's
Les Fleurs du Mal 1890, lithograph

In the notes he made later, Redon would refute the arguments of Mirbeau when he wrote (perhaps thinking particularly of him), 'All the errors the critics committed with regard to me in the early days came about because they did not see that there was no need to define anything, to understand anything, to imitate anything, to be precise about anything, because everything that is sincerely and gently new—just as beauty—carries its meaning in itself.'[13]

As the only painter of the Impressionist generation who broke from the 'great naturalistic trend' of which Mirbeau was one of the standard-bearers, Redon, who found Impressionism a little too 'low of the ceiling,' must have expected such objections. In the opposite camp, however, among the literary Symbolists who were then beginning to come together and who were proud of being 'decadents,' voices were being heard that recognized the unique genius of Redon. Charles Morice, Robert Caze, Paul Adam, Gustave Kahn, one by one they began to proclaim their admiration. The silence was broken. Yet, even among the partisans of Symbolism, there was still no unanimity regarding Redon, and Rodolphe Darzens could write in 1886: 'In spite of the enthusiasm for his drawings that is now fashionable, I cannot recognize the

219

profoundly philosophic talent that is attributed to him. All his compositions seem to me generally grotesque and childish, intentionally so, I am ready to believe.'[14]

On the other hand, Moréas, Adam, Méténier, and Fénéon, who published a witty and not always kind *Petit Bottin des Lettres et des Arts* that same year, devoted a most admiring notice, exceptionally devoid of all malice, to Redon:

> In your inimitable work, lucid allegorist,
> There is a wide-open eye of a Chaldean seer,
> There is a mournful flower, a marsh being
> Emerging from the gray water, embryonic and sad;
> At the brink of the obscure world trodden by dreams,
> There is suddenly, in the air screened by light,
> With her hard chin and her stubborn profile,
> The goddess of the Intelligible.[15]

The adversaries, however, were not at all convinced, although their nasty comments often lost their mark by their very foolishness. 'It suffices,' wrote a Belgian critic in characterizing the work of Redon, 'to juxtapose, without preconceived idea, a horse, an eye, a head, some white, some black, much more black than white, or much more white than black, or better yet to mix the whole thing and to serve it warm to the stunned young public.'[16]

Doubtless, these insults were not what was the most painful—they are the badge of honor of every creator—but it was the tenacity of the incomprehension, the refusal to make the least effort to penetrate the spirit of his art, which was so humiliating. By continuing to exhibit in Paris and in Brussels, by publishing several volumes of lithographs in rapid succession, Redon slowly earned the esteem of a few collectors, of a few critics (Mellerio after Hennequin), of a few writers (Mallarmé[17] after Huysmans), and even, especially satisfying to the painter who so loved music, of a composer (Vincent d'Indy).[18] In Belgium, where youthful energies were then stirring a great deal more than in France, Jules Destrée even undertook a catalogue of Redon's lithographs; but there were no painters in his entourage, and, in any case, it was their friendship that he wanted most.

It seems that the first artist among the young to render homage to Redon was Emile Bernard. Toward 1889, when he was just twenty-one years old, Bernard asked Schuffenecker to introduce him to Redon at the Concert Colonne. He was well received by the master whose works he had admired for a long time and for whom he showed 'the enthusiastic respect that one has for genius.'[19] Already in 1887, Bernard had tried to communicate his admiration for Redon to Vincent van Gogh, but the latter did not share 'very much . . . the enthusiasm that he has for those things.' Moreover, van Gogh thought he discerned Redon's influence in some of the drawings that Bernard made during that period.

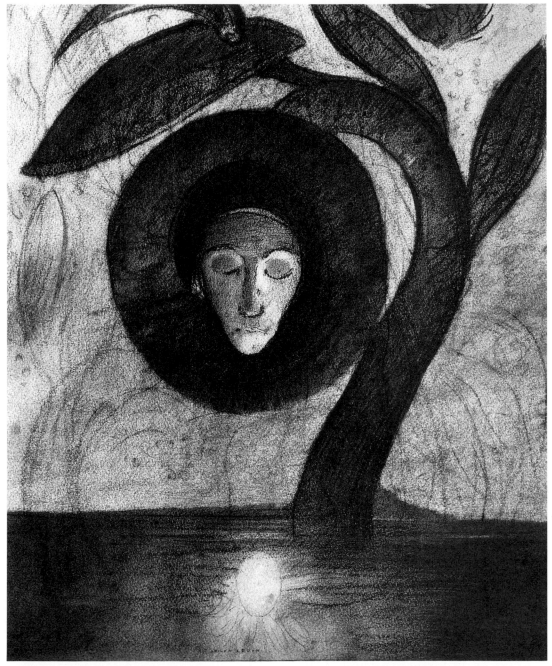

49 Odilon Redon *Marsh Flower* c. 1885, charcoal

In spite of his extreme youth, Bernard had already accumulated an astonishing treasury of experience and acquaintances; his conversation, even his work, was enlivened by all that he had seen, felt, and read. Curious about everything, ready for any adventure, he had been the friend of Lautrec before becoming the friend of Gauguin—who was much his elder—then, finally, the friend of van Gogh. In his friendships he had learned to give as much as he received, and among his most remarkable qualities were a perpetual need for discovery, a natural tendency for enthusiasm, and a fine inclination, not to say penchant, for proselytizing. It is not surprising, therefore, that in his enthusiasm he had recourse to his pen, which he handled very well, in order to communicate better to others what he was one of the first to perceive. Just as he had known early on to discern Redon's importance, he had discovered inexhaustible riches in the almost-unknown work of Cézanne. In 1890 he published the first small monograph ever written on the solitary figure from Aix, whom he himself had never met. (Almost at the same time, in the same series of *Les Hommes d'aujourd'hui*, there was a similar pamphlet on Redon, with a text by Charles Morice and a portrait by Schuffenecker.)

When in December 1891 the *Echo de Paris* asked several young painters, among other questions, 'Who is the master you admire the most?' Lautrec named Degas and Forain; Anquetin mentioned Cézanne and Renoir; Denis and Bonnard avoided any answer; but Bernard declared without hesitation, 'I admire among contemporaries only Cézanne and Odilon Redon.'[20] This spontaneous homage elicited a letter from Redon:

> My dear Bernard,
> Yesterday Schuffenecker handed me the *Echo de Paris* where you had been interviewed and where I read with great joy the words you devoted to me. It is the first time that a young person has given me attention publicly and I do appreciate it. I am anxious to tell you so. Some day you will doubtless see how much a little admiration from those who are up-and-coming eases one's recollection of the past and activates one's last energies.[21] But I hope that there will not be too many delays in the growth of the new branch of art of which you are a part. . . .[22]

This new branch, was it Bernard who directed it toward Redon? The fact is that the latter soon saw himself surrounded by a group of young artists, all of whom, like Bernard himself, belonged either strictly or loosely to the circle of Gauguin, such as Maurice Denis *(52)*, Bonnard *(50)*, and Vuillard, and later also Maillol. But it is certain that it was Gauguin himself who introduced Redon to the one he considered his best pupil, Paul Sérusier *(51)*.[23] They were all open-minded, passionate searchers and, as far as Sérusier and Denis were concerned, avid theorists. Redon enjoyed their fervent company, modestly accepted their admiration, and benevolently followed their efforts toward a pictorial symbolism that contained some reflection of the literary

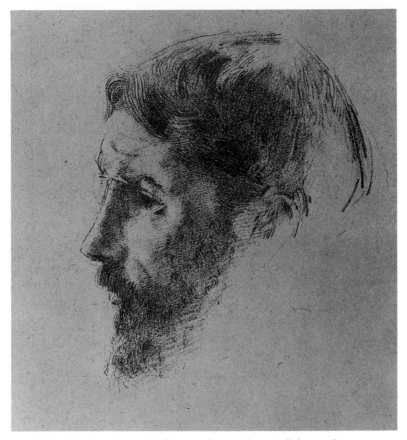

50 Odilon Redon *Portrait of Pierre Bonnard* 1902, lithograph

movement of which Mallarmé was emerging more and more each day as the uncontested head. Bonnard was to say later, 'Although he had originally anticipated it by the very nature of his mind and his art, Redon soon joined our young Symbolist group and was willing to welcome the attempts of our youth with indulgence and kindness.'[24]

Twenty years later, in 1912, Maurice Denis was to define what he and his comrades owed to Redon:

'Odilon Redon has been one of the masters and one of the friends of my youth. Highly cultivated and musical, welcoming and good, at the same time 'the honest man' of olden days and 'the art lover' of long ago, he was the ideal of the young symbolist generation—our Mallarmé. Before the influence of Cézanne, it was the thought of Redon—via Gauguin and Bernard—who, by his series of lithographs and his magnificent charcoals, determined in a spiritual sense the evolution of the art of 1890. He is at the origin of all the aesthetic innovations or renovations, of all the revolutions of taste that we have since witnessed. He foresaw them, he even loved their excesses. . . . As opposed to the weighty systems that actually mask the absence of sensitivity for most young painters, Redon's lesson is his inability to paint

51 Odilon Redon *Portrait of Paul Sérusier* 1903, lithograph

anything that does not represent a state of the soul, that does not express some deep emotion, that does not translate an interior vision.'[25]

And Bonnard was anxious to pinpoint the source of his admiration, 'What strikes me most in his work is the union of two almost opposing qualities: the very pure plastic matter and the very mysterious expression.'[26]

After so many years of isolation borne with resignation, Redon suddenly found himself not only surrounded, but deemed precursor and example by a new generation preparing new conquests, a generation opposed precisely to all the principles in the name of which Mirbeau had formerly condemned his art. As early as 1892, Albert Aurier, historian of the Symbolist movement, immediately after citing Gauguin spoke of Redon as one of the 'proclaimers with Moreau and Puvis de Chavannes of the message that the young liked to invoke.'[27] And he associates Redon with the research of that 'new breed of artist'—Sérusier, Bernard, Filiger, Denis, Roussel, Ranson, Bonnard, Vuillard—who at that time belonged to the two brotherly clans, the Nabis

52 Odilon Redon *Portrait of Maurice Denis* 1903, lithograph

and the Pont-Aven group. Gauguin himself, who had already so firmly imprinted his seal on these young intellects, would soon write: 'Odilon Redon, that extraordinary artist whom they persist in not understanding, will they someday give him his due? Yes, when all those who have imitated him will be up on the pedestal.'[28]

However, the truth is—and Gauguin was well situated to know it—nobody imitated Redon, in part because he in no way tried to impose his example (as Gauguin liked to do), and in part because his art was born from a depth of soul, of intelligence and imagination where imitators would have difficulty following. Moreover, Redon carefully avoided all those theories and formulas with which the young Symbolists liked to reinforce their efforts. While Albert Aurier explains in the *Mercure de France* why the new art must be ideological, symbolistic, synthetic, subjective, and decorative,[29] Redon, without phraseology, provides with his work the proof of what Denis postulated when he proclaimed that there exists 'for every emotion, for every human thought, a plastic decorative equivalent, a corresponding beauty.'[30]

As Redon remarked in his notes: 'They imagine too much analytical spirit in me; at least that's what emerges from the curiosity I feel among the young writers who visit me. I see their astonishment as they approach me. What have I put into my works to suggest so many subtleties? I have placed there a little door opened to the mysterious. I have made some fantasies. It is up to them to go further.'[31]

Redon himself seemed to escape through this little door and thus avoid classification into any specific category. He remained rather passive amid the discussions from which new ideas emerged, he rarely made pronouncements and—on principle—refused to give advice. That didn't mean that he was uninterested in others, quite the contrary. 'Odilon Redon never taught,' Sérusier would say later, 'but the artists who enjoyed his kind welcome and his conversation always left his place informed, encouraged, comforted.'[32] However, even in the midst of his young friends, Redon remained isolated, like a small island which only through the waves that break with more or less intensity on its shores is touched by events at large.

The year 1894 witnessed Redon's first important one-man show, no longer in an improvised gallery, but at Durand-Ruel's. The artist was then fifty-four. The collection of works that he showed to the public commanded attention. The critics finally devoted a great deal of commentary to him. No doubt, the vehemence of the young Symbolists had produced some small cracks in the wall of indifference; no doubt the efforts of Bernard, and particularly an article by him which appeared in 1893 in *Le Coeur*, directed by Antoine de la Rochefoucauld, had drawn attention to him. But the artist remains faithful to his solitude which, according to the expression of Charles Morice, he 'sets up sadly and triumphantly around his thoughts.'[33] In any case, when he decides in that same year at the request of his friend Edmond Picard, to put some of his ideas on paper, he carefully avoids the vocabulary of the young Symbolists—which is often as precious as it is obscure—their theories, and even any mention of their movement. He speaks only of what interests him, solitude.

In his notes, Redon recalls his youth, his beginnings, the war of 1870, which abruptly allowed him to become conscious of his natural gifts. He devotes some eloquent and poetic lines to the technique of charcoal, the mastery of which had enabled him to express his gifts, and he insists:

'Whatever one may say of them, my drawings are true. They are the human landscape. And a special aspect of my nature that I confide to you: I feel and have always felt the necessity of copying nature in tiny objects, particular, fortuitous, or accidental. It is only after an effort of will to represent minutely a blade of grass, a stone, a branch, a section of an old wall, that I am seized with an anguish to create the imaginary. External nature, thus received and apportioned, becomes by transformation, my source, my ferment. I owe my best work to the moments that have followed such exercises.'[34]

53 Odilon Redon
Owl c. 1890(?),
drawing

He speaks of the pastel that he was beginning to resume after having avoided all color for a long time, and he voices the hope of thus being able to give more expression to his dreams. 'The tones have a joy that is restful,' he adds. At the same time he welcomes among the young a preoccupation with arabesques thanks to which 'the line takes back its rank, its necessity, its significance.' But he avoids establishing any rapport between his art and that of the new generation; on the contrary, he opposes the critics who had tried to associate him with various artistic movements. And he concludes by saying:

'Finally on the occasion of my exhibition at Durand-Ruel's, I have had various articles, some tinged, to my regret, by magic. Oh! please understand that I am by no means a spiritualist. Others wrote very well. . . . The press was at that time rather good. But each pen wants to convert me to its belief. They are wrong to attribute to me any designs. I only make art. It is all of expansion. Here it is fashionable to discredit science in favor of pure idealism, there to exalt it. How is it connected with me? In no way. It is beside the point. However, science makes one think; art has nothing to lose from this service. After all, science will go well with the knowledge of man. Is there a better objective for personal consciousness and development? The artist, whatever he may know, will always be a special agent, isolated, alone, with an innate sense for organizing matter.'[35]

227

At a certain point his reputation for being a spiritualist attracted new visitors, and Signac, after having met a strange couple at Redon's, noted in his journal: 'Many of those who visit Redon expect to find in him a fantastic being, someone one could exploit, or a schemer with whom one could go into partnership. They disappear quickly when they realize that there is nothing but a fine and simple producer of black and whites.'[36]

In spite of this wave of curiosity, Redon continued to remain solitary and nothing better underlines his singular position than the exhibition organized in 1899 by several groups of artists in order to 'focus on the various contemporary trends,' as Mellerio explained in the preface of the catalogue. The exhibition took place in March at Durand-Ruel's and seemed to have had the purpose of reviewing the contributions of the innovative forces at the dawn of the new century. On the poster the artists were grouped by alliances; a single name appeared alone, that of Redon. He was preceded by the group of the Nabis and their friends and by that of the Neo-Impressionists; he was followed by those who were then being called the colorists, by several adherents of the Rosicrucians (among them Bernard, who had been living in Cairo for several years), and finally, by three sculptors:

BONNARD, DENIS, IBELS, HERMANN-PAUL, RANSON, RIPPL-RONAI, ROUSSEL, SÉRUSIER, VALLOTTON, VUILLARD
ANGRAND, CROSS, LUCE, PETITJEAN, SIGNAC, VAN RYSSELBERGHE
ODILON REDON
ANDRÉ, D'ESPAGNAT, DE MONFREID, ROUSSEL-MASURE, VALTAT
BERNARD, FILIGER, LA ROCHEFOUCAULD
CHARPENTIER, LACOMBE, MINNE

In this separate place, which constituted an homage to his independence, Redon was at the same time a solitary and the center around which all this youth seemed to revolve. He alone of the preceding generation found himself intertwined with the efforts of the newcomers. However, there was yet another master whom the young venerated, but an unapproachable one, whom they knew only through his work glimpsed in the shops of Tanguy and Vollard, and whose personality was so shrouded in mystery that they sometimes doubted his existence, namely, Cézanne. At the very moment when their exhibition was taking place, Denis intended to paint an *hommage* to Cézanne as a public demonstration of his admiration for the artist whose example had helped his generation react against Impressionism. Since he had never met Cézanne, Denis decided to group several friends around one of the master's still lifes propped up on an easel *(54)*; missing from the group is Cézanne's first apostle, Emile Bernard, who was still in Egypt. Depicted on this canvas are Vuillard, Sérusier, Ranson, Roussel, Bonnard, Denis and his wife, as well as Mellerio and Vollard. Denis also asked Redon to join in the homage and the latter accepted.

228

54 Maurice Denis *Homage to Cézanne* 1900–1901 (From left to right: Redon, Vuillard, Roussel, Vollard, Denis, Sérusier, Mellerio, Ranson, Bonnard, and Mme Denis)

It is certain that for about ten years at least, Redon knew the work of Cézanne, which he had been able to see principally at Vollard's, publisher of his own lithographs, and that Emile Bernard had not failed to extol the genius of the master from Aix. In 1896, Redon himself had copied a Cézanne still life, but he had done it as the result of various circumstances that had made this canvas available to him (and because he liked to copy), rather than by deliberate choice.[37]

Nevertheless, Redon continued to express certain reservations and even some objections with regard to Cézanne, which, however, were not strong enough to prevent him from satisfying Denis's request. Redon stands at the extreme left in the *Hommage à Cézanne*, turned toward the still life on the easel, but Denis's composition is arranged in such a way that Redon assumes an importance at least equal to that of Cézanne's canvas:·his young friends seem to be turned in his direction and look at him rather than at the Cézanne painting, the alleged pretext of their gathering. And Paul Sérusier, the central

229

figure, extends both hands toward Redon in a friendly and respectful gesture, as if to emphasize still more his role of dean. Thus this *Hommage à Cézanne* is at the same time an 'Hommage à Redon,' and it is very likely that a good number of the visitors who saw this large painting at the Salon of 1901 thought that they recognized the master from Aix in the features of Redon, who, by age, stance, and position in the composition becomes the psychological center of attention.[38]

By so uniting Redon and Cézanne, Denis seemed to want to affirm what would later be expressed by another young friend of Redon, the American painter Walter Pach, who wrote that they were 'the poles between which the modern movement has since oscillated.' Did they not seem to be dividing the heritage of Delacroix, Cézanne by developing his qualities of form and color, and Redon by pursuing his research toward new conclusions in the visionary world?[39] But the living connection between Cézanne and Redon was still Emile Bernard *(56)*, who continued to think about his two masters while working in Egypt. In March 1902 he sent Redon an article on Symbolism in which he spoke of him, and in December 1903 he finished a long study devoted exclusively to Redon, which he brought with him when he returned to France at the beginning of 1904 after an absence of ten years. Upon landing at Marseilles in February, he decided to pay his first visit to Cézanne, at Aix-en-Provence, and remained near him for several weeks.

Since his beginnings, when all his efforts had been directed toward the invention of a new pictorial language, Bernard had 'wised up' and had turned toward technical problems in his attempt to achieve a classical draftsmanship and composition, as well as a method inspired by the Renaissance masters. In Bernard's conversation, his enthusiasms, his knowledge of Italian museums and of life in the Orient, Cézanne at first found a contact with the world from which he had withdrawn, but he soon tired of the interminable theories of his young admirer. During his long stay in Cairo where books had often been his sole companions, Bernard had greatly expanded his literary and, particularly, his philosophical knowledge, and his conversation was liberally filled with references that were not always familiar to Cézanne. Intending to welcome a young colleague, Cézanne soon found himself drawn into discussions that extended beyond the focus of his own interests and that touched a little on everything: aesthetics, history, philosophy. It was not that all these questions were foreign or of no interest to him, but the dosage was a little too strong for a man used to living alone with his thoughts and his work, accustomed, as he said himself, to 'this monotony caused by the incessant pursuit of the single and unique objective, which leads in moments of physical fatigue to a kind of intellectual exhaustion. . . .'[40]

Cézanne not only tired of Bernard's 'argumentative disposition,' he particularly regretted that in his canvases Bernard thoroughly turned his back on the ideas that he expounded so eloquently. Thus Cézanne would later say

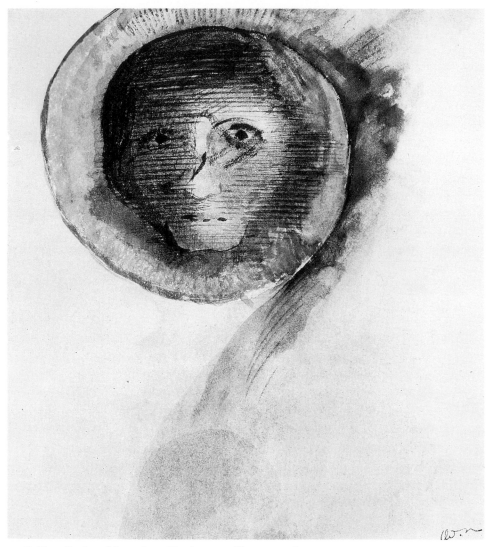

55 Odilon Redon *Mysterious Head* c. 1900(?), watercolor

of Bernard that 'his drawing is secondhand, resulting from his dreams of art which are suggested not by the emotion of nature, but by what he has been able to see in museums, and even more by a philosophical mind which comes to him from too wide a knowledge of the masters he admires.'[41]

The end of Bernard's stay in Aix was marred by several sudden outbursts of rage which barely concealed Cézanne's impatience with Bernard's interminable questions. The latter, however, wrote down everything the old man said to him and tried to induce him to give his opinion on all the problems that mattered to him. But Cézanne wound up avoiding these discussions, and when Bernard spoke to him of his own admiration for Redon, for example, Cézanne's response was as vague as possible, not to say

231

evasive: 'Redon's talent pleases me very much and I profoundly share with him his appreciation and admiration of Delacroix.'[42]

Bernard left Aix after having finished an article on Cézanne to which he would later add some extracts from letters that Cézanne would write in response to his, which were loaded with further questions. Thus Bernard arrived in Paris with, among other writings, an article on Redon and another on Cézanne. In Paris, Bernard must have seen Redon again, having continued to correspond with him throughout the years. A short time later he published the two articles devoted to the masters he had admired for more than fifteen years, in *L'Occident*, to which Denis was a regular contributor. The article on Redon appeared first, in May 1904, that on Cézanne, in July.

Bernard's long study on Redon was marked by all the devotion that had continued to develop since their first meeting, but it was based solely on his own impressions and recollections. While writing in Cairo, he naturally had no knowledge of that letter to Picard which appeared in *L'Art Moderne*, where Redon had somehow shed some of his reserve, nor was he familiar with the articles published during his absence. Quite obviously Bernard had no desire to submit his pages to the master himself, because he wished either to maintain the independence of his thought, or to add an element of surprise to this piece, which would be the first consequential study to appear on Redon for a number of years. But if, in effect, the article was to surprise Redon, it surprised him above all by the considerable number of statements and interpretations with which he was not able to agree. With a pencil that was often impatient, Redon covered the margins of this article, refuting as he went along what seemed to him erroneous *(pp. 234–35)*. These notes in Redon's hand correcting Bernard's article provide us with his own interpretation of his work and in this way add to the other statements by the artist.

In his marginal notes Redon once again affirms his love for 'the sun, the flowers, and all the splendors of the *external* world.' He emphatically denies that the supernatural is his nature and insists that his art springs 'from life itself.' He opposes those who see hallucination as an essential element of his art, since the 'keenest vision' is necessary to the gestation of his work and his will is always present at the creative moment. 'Judgment and his visual gifts' are indispensable to the artist, he says, 'even when he surrenders to the activity of the unconscious.' But having thus set the record straight, Redon shows himself ready to forget his controversy with Bernard and, despite his sixty-four years, exclaims, 'Here's to a good tennis match!'[43]

Emile Bernard never published any letter he may have received from Redon touching on this article, either because he did not want to make it public, or because Redon had made his observations orally. Nor has any such letter ever been found among the letters Bernard received from Redon that remain in his papers, which do, however, contain a letter from Redon to Emile Bernard's father, to whom he wrote on October 10, 1904:

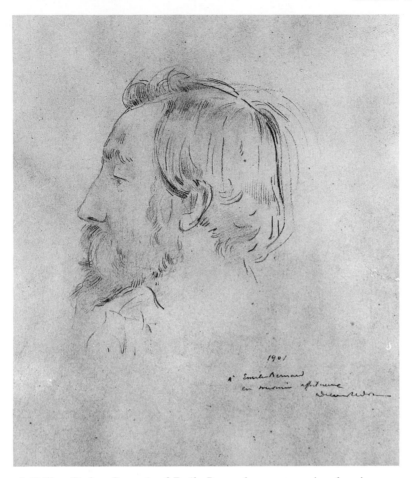

56 Odilon Redon *Portrait of Emile Bernard* 1901, sanguine drawing

'I am inquiring, immediately upon my return, about your son. . . . I should have been happy to see him again. I like him very much. He has had the generous courage to write a study about me in a journal. It was highly esteemed by some who congratulated me; then, in the eyes of certain others, it was received with reservations. It will always be that way with any sincere idea that is published. On my part, I felt it inspired by a fierce desire for justice, independent and proud, which has its own beauty. In any case, I read it as coming from an artist who has always shown me a touching, respectful, and faithful admiration, which gives me great pleasure.'[44]

These lines indicate that Redon appreciated above all the good intentions of his young friend. It is even possible that out of respect for the rights of criticism, Redon decided not to let Bernard know his reaction, although he thought of Bernard more as colleague than author and must have tried in their conversations to correct his errors. However that may be, thanks to Redon's annotations, we are able to judge to what extent Bernard's literary mind

233

le surnaturel est sa nature ; et telle réalité qu'il se propose de scrupuleusement copier se transforme, à son insu, sous sa main, pour signifier plus qu'il ne l'avait prévu lui-même.

Parmi les études qu'élève encore il peignait, cette étrange faculté transpirait déjà, et telle nature-morte ou tel paysage en dit beaucoup plus que l'objet représenté, lequel apparaît comme la partie d'une force oppressante nous cernant de toutes parts, à tous instants, et dont nous devons à jamais frémir. Devant les plus simples choses de l'usage, une angoisse assaille déjà le peintre sans qu'il en soit conscient, effaçant l'apparence, trahissant la destinée irrévocable du *fini* qui les engendre et les réclame. L'ombre, *l'ombre qui finalement fera sa proie de tout,* règne là, pesante, lourde, affligeante impérieusement.

La *Puissance des ténèbres* n'avait été traduite encore avec une si pascalienne éloquence.

Plus tard Redon trouva sa voie : à son dire ce fut après la guerre de 1870-1871, dont la vision d'horreur jeta dans son esprit de décevantes pensées. Dès lors la méchanceté de l'homme lui était dévoilée, et aussi l'effroyable gouffre où tout sombre : la *mort.*

Ceci nous amène à l'art actuel du maître, à sa technique. Il est le magicien évident du clair-obscur, cette chose crue usée et d'une si persuasive éloquence ; il est le plus savant distributeur de noir de tous les temps.

Après l'expérience des brosses et des couleurs, Redon reconnut qu'un seul outil lui suffisait : le fusain.

L'absurdité à laquelle fut en butte ce mode de dessin l'avait jeté parmi les artistes dans un discrédit profond, et certes les platitudes habiles d'un Allongé ou d'un Lalanne ne pouvaient faire prévoir jusqu'à quelle hauteur un procédé déshonoré allait être porté par un véritable maître. Qui décida Odilon Redon à ce choix ? La simplicité du matériel, le bon marché ou son instinct ? Je penche pour cette dernière raison.

Dès l'atelier le fusain était aux doigts de l'étudiant, il l'y conserva peut-être par habitude prise ; les motifs d'ailleurs importent peu, puisque les résultats supérieurs nous requièrent. Au moyen de ce rudimentaire procédé, Odilon Redon fit des chefs-d'œuvre.

Ici se place une autre rénovation du maître : Par la bonne volonté de satisfaire quelques amateurs, Redon s'adonna à la

[marginalia manuscrite haut de page :] le surnaturel n'est pas ma nature ; j'aime trop la nature externe.

[marginalia manuscrite gauche :] quand une réalité se transforme sous ma main, trouvant le travail mauvais, je le déchire.

tout ceci est faux.

La guerre est saine. on y boit et mange bien. Et le jour d'une bataille fut pour moi l'occasion de ma plus vive curiosité très-lucide. Je n'ai pas attendu 1870 pour savoir que parmi les hommes il y en avait de méchants.

[marginalia manuscrite droite centre :] non, la guerre, n'est pas ce tableau.

[marginalia manuscrite droite :] non, Je ne reconnais pas que le fusain soit mon seul outil.

[marginalia manuscrite bas de page :] X Le choix du fusain est indiqué pour la rapidité de l'exécution.

lithographie. Cet art comme le fusain était alors désuet et
languissant ; là encore il triompha, ayant à sa disposition des
octaves noires prolongées. C'est ainsi que naquirent des
pièces rares aujourd'hui qui ont établi sa suprématie en cette
matière. D'abord l'*Hommage à Goya* et à *Poë*, puis une série
plus inspirée qu'illustrative sur la *Tentation de Saint Antoine*
et les *Fleurs du mal*, enfin les frontispices des poésies de
Verhaeren. Ce fut un essor neuf, une révélation inattendue,
qui posa Redon d'un coup et sans appel à la tête des litho-
graphes du siècle.

Pourquoi décrirai-je le sujet de ces planches devenues
rares après avoir été méconnues longuement ? il vaut mieux,
sans doute citer les phrases lapidaires et suggestives comme
les dessins mêmes dont l'artiste se plût à les aggraver. En
voici quelques-unes de l'*Hommage à Goya* :

Dans mon rêve, je vis au ciel un visage de mystère.

C'est un fou, dans un morne paysage.

Il y eut aussi des êtres embryonnaires.

Au réveil, je vis la déesse de la certitude au profil sévère
et dur. *j'aperçus la Déesse de l'Intelligible*

Phrases qui semblent des vers du Dante et qui gardent
sous leur aspect simple, une multitude de tragiques effrois.
L'art de Redon ne se peut décrire, l'auteur l'a trop spé-
cialisé, trop borné à ce qu'il veut être, à son insu.
Le meilleur commentaire n'en saurait être que ces phrases
brèves qui se bornent plus à faire deviner qu'à expliquer.
L'intuition joue ici un rôle trop prépondérant pour que les
investigations de l'analyse soient un recours. Redon lui-
même, d'ailleurs, renonce à se divulguer sur ce point. En
vérité il ignore, quand il prend un crayon, où l'Inconnu le
conduira, et son mode de travail demeure un mystère.
Il me racontait un jour qu'ayant commencé le portrait de
Joris-Karl Huysmans, son ami et son seul bon critique, il
termina par une tête d'empereur romain, sans se rendre
compte sur le coup de cette bizarre transformation. Une
autre fois, Huysmans étant en Belgique, Redon fit le por-
trait de l'écrivain d'une manière satisfaisante, sans même le
vouloir.

si je me divulgue. je n'ai cherché qu'un dire in-déterminé

Je crois que le portrait est une des significations les plus hautes de l'art. Et je me suis toujours efforcé, (et j'ai réussi quelquefois) de donner d'un être humain, son caractère seul, son caractère en soi. faire un bon portrait me paraît être le dernier et plus haut effort du peintre.

Two pages from Emile Bernard's article in *L'Occident* with marginal notes by Odilon Redon

altered reality, not only when he interpreted what other artists were trying to achieve, but even when he strove to give an account of the tastes and intentions of a man he knew intimately and whom he admired. These automatic modifications he introduced into his portrait of Redon oblige us to approach his other accounts and reports with reservations, notably those concerning Cézanne. Bernard has for a long time been suspected of having prompted Cézanne to say—and even to write—certain things that he particularly wished to hear from him; this was not too difficult since, according to those who knew him, Cézanne's conversation was filled with contradictions and he did not maintain the same opinion every day. It thus seems more and more certain that Bernard projected many of his own theoretical preoccupations and his own literary taste into his relations with painters whose disciple or friend he claimed to be.[45]

This is one of the strangest aspects of the life and activity of Emile Bernard who nevertheless contributed so much to make those he admired better known. And it is perhaps no less strange that the place history conferred upon him even during his own lifetime was among the pupils of Gauguin. It would seem that history has erred twice on his account, first in considering him as the spokesman for Cézanne, and next in underestimating his role as initiator at Pont-Aven. Bernard never stopped proclaiming that from the beginning it was his own work that had provided Gauguin with certain elements of synthesis from which he was able to develop his pictorial symbolism; moreover Bernard maintained that he himself did not hold these innovations of his youth in very high esteem. An extensive study of the works and of the dates would establish Bernard's priority and render him justice. He was not the only one Gauguin used—literally or indirectly—in order to attain his end.

With regard to Cézanne, Bernard's initial enthusiasm waned in direct proportion to his attempt to assimilate the masters of the Italian Renaissance and their 'immutable methods.' It was in this cause that he would soon speak of 'the error' of Cézanne[46] and that he would write, after the master's death, 'Cézanne's imagination was poor, he had a very fine sense only for composition; he did not know how to draw without the model, which is a serious obstacle to any valid creation.' He then reproached Cézanne for not having applied himself to 'depicting the *spirit* of things' and concluded that his work boiled down to 'ten or fifteen *finished* still lifes and landscapes.'[47]

Redon shared these prejudices of his young admirer. It is indeed strange to note that Bernard never succeeded in bringing together the two painters whom he proclaimed as his masters. Cézanne had avoided expressing any specific opinion on Redon and had barely cleared himself of a debt of gratitude to the colleague who had so generously associated himself with the *Hommage à Cézanne*. Redon, on his part, spoke his piece only now that Bernard began to break away from the master from Aix.

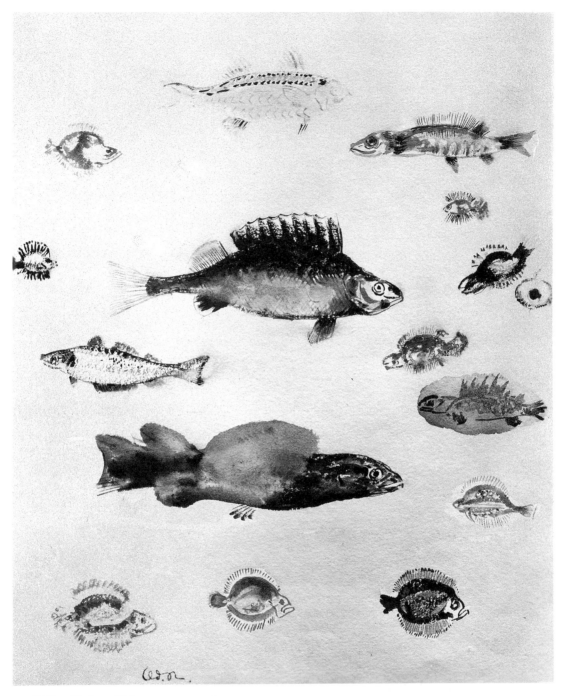

57 Odilon Redon *Fish* 1912, watercolor

'I have just read with very great interest the article you have recently finished on Cézanne,' Redon wrote to Bernard in the fall of 1907. 'It is truly good; it is one of your best writings. There is no longer the combative tone evident in certain others. . . . And how well you have done to admit your reservations concerning the work as a whole, by citing the ten to fifteen still lifes or landscapes that will provide the basis for his fame. This will help to establish his true value. And how brave it is of you to have said it!'[48]

Redon was to express his position still more clearly in a letter he wrote in 1910 to Elie Faure, after having read the latter's article on Cézanne in which he was mentioned. Indeed, Faure stated in a note that between 1890 and 1900 several painters acknowledged the influence of Cézanne, 'and among them Bonnard, Maurice Denis, X. Roussel, Vuillard, Emile Bernard, Sérusier, Odilon Redon had already been subjected to it. In 1901, Maurice Denis exhibited at the National a painting, *Hommage à Paul Cézanne*, where he assembled the disciples of the master and the propagators of his work.'[49]

Redon thereupon wrote him:

It is not in my nature to contradict writers when they are mistaken in regard to me: they have a right to express their ideas on exhibited works of art. But I am unable to resist the desire to express to you an astonishment bordering on indignation on reading in the study on Cézanne that you have published in the *Hommes d'Hier* that you cite me, in a list of certain artists much younger than I, as having recognized the influence of Cézanne and even of having 'submitted' to it. Monsieur, I protest.

My protest is not directed toward those who will read you, for that, alas, is impossible (and is what is so irritating for authors who are not publicists); but my argument is with you.

Your assertion is without proof.

Remember that I am nearly of the same generation as Cézanne[50] whom I have never known, nor seen, nor heard.

His work was brought to my attention when I was fifty years old,[51] late in the day, don't you think, to succumb to any lasting influence whatever.

I am even more astonished by what you say, since you obviously failed to use the information contained in a publication by Emile Bernard. I recall that Cézanne has written that I seemed to him to derive from Delacroix (I am not quoting him verbatim, only his meaning). He was thus far from sharing your opinion.

You also mention in support of your statement a certain painting, *Hommage à Cézanne*, in which I appear. But, Monsieur, have you seen this work?[52] I do not appear there as a disciple; believe me, that was not what the author of this painting intended.

The great dramatist in Delacroix strongly impressed my adolescence and my youth; if something of this passionate master remained in my eyes or mind, I would not try to deny it, but would be proud of it. On the contrary, the aridity of Cézanne's imagination, the impassive tranquillity of his work, from which

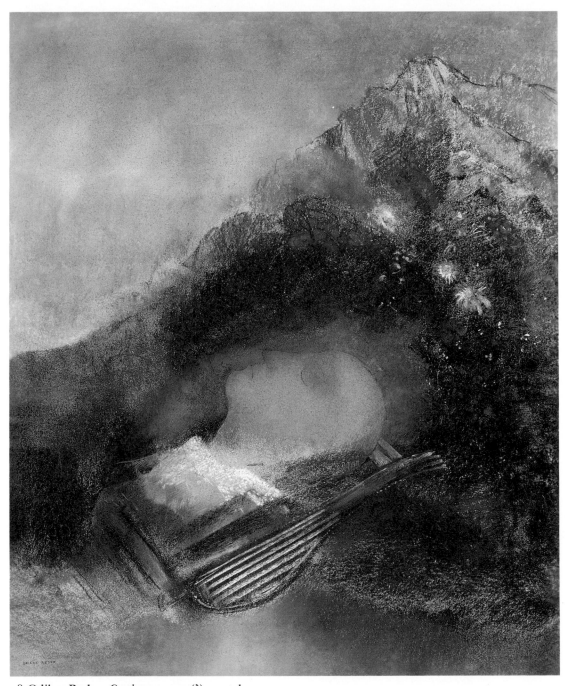

58 Odilon Redon *Orpheus* *c*. 1905(?), pastel

the soul is absent, have always left me cold. I appreciate it but do not love it.

However, out of concern for the truth I have always spoken up for him against those who blindly deny the nature and the value of this painter, undeniably a painter. . . .

It was not without a certain bitterness that Redon, who had always yearned for contact with youth, had to observe during the last ten years of his life that this youth turned more and more to Cézanne. Emile Bernard alone, like the sorcerer's apprentice frightened by the spirits he had conjured up, tried to oppose the pro-Cézanne current, but he did so with a voice that had lost all resonance, since his own work had ceased to be original. Nevertheless, in spite of the enthusiasm for Cézanne, which was the decisive influence during the first quarter of the twentieth century, the new generation did not forget Redon.

In 1912, numerous artists payed homage to Redon in the journal *La Vie* (directed by his friends Marius and Ary Leblond), among them Bonnard, Denis, Desvallières, Laprade, Sérusier, and Valtat.[53] Picasso responded to his art and Henri Matisse gave evidence of an even more concrete admiration by acquiring several works by Redon and urging his friends to do the same. It was Matisse who took the Russian collector Shchukin to see Redon, from whom he bought several important works. As Matisse himself said, he looked upon 'Redon's works with much interest—the purity and ardor of the tonalities of his palette pleased me.'[54]

Every so often tributes came to Redon from unexpected parts or from people unknown to him. So it was with Marcel Duchamp, for example, who, when asked one day if his art and that of his group did not derive from Cézanne, answered: 'I am sure that most of my friends would say so, and I know that he is a great man. Nevertheless, if I were to say what my own point of departure has been, I should say that it was the art of Odilon Redon.'[55]

The misunderstanding that persisted between Cézanne and Redon, this misunderstanding that Emile Bernard had not been able to expel, was strangely resolved by men of a younger generation. Redon was very aware of the position he occupied in the minds of these young people, and if the melancholy disappeared more and more from his subtle evocations of dreams, if a radiant lyricism and dazzling colors asserted themselves ever more in his work, perhaps it was not only because serenity came to him with age, but also because with each passing day a little more of the feeling of solitude faded away.

Along with those who, like Matisse, admired the colorist in Redon *(VI)*, it is also clear that his black and whites have influenced the painter-etchers of today, even without their knowledge. The play of contrasts in the aquatints of Rouault, the fantastic compositions in the etchings of Chagall, seem like new stages in a tradition that dates back to Goya, passed on by Odilon Redon.

240

It is true that certain elements of Redon's art blossomed only after his death, when the Surrealists began to explore the unconscious. But whereas among them the bizarre most often remains rooted in the idea, with Redon it is always seen; and whereas their art is frequently descriptive and even purely literary, that of Redon is always plastic, his imagination always subordinated to the instinct of the painter. And above all, his will never surrenders to the unconscious. Yet, if Redon had been able to witness this development of contemporary art, it is possible that he would have repeated this remark, related by Walter Pach, concerning the new young painters. 'They are a bit terrifying with some of their theories and in the lengths they are going, but no matter: when they say that I have a share in their ideas, it gives me pleasure.'[56]

NOTES

1. The exhibition was not even announced in *La Vie Moderne* itself and thus was hardly noticed. On this publication, see the essay in *Studies in Impressionism*, 'Auguste Renoir and his brother,' pp. 9–25.

2. Redon, letter to Hennequin, Aug. 25, 1882; see Auriant, 'Des lettres inédites d'Odilon Redon,' *Beaux-Arts*, June 7 and 14, 1935.

3. J.-K. Huysmans, 'Appendice,' *L'Art Moderne* (Paris, 1882). The following year, in *A Rebours* (Paris, 1883), Huysmans again speaks at great length of Redon and of his 'fantasies of illness and delirium' (p. 85).

4. See note 2.

5. Redon himself was to say, twelve years later: 'Among the earliest writers who drew attention to my art, there was first of all Emile Hennequin, at the time of the *Gaulois* exhibition in 1882. He did it with marvelous clearsightedness, in an article that appeared in the *Revue Artistique et Littéraire* [Mar. 4, 1882]. Many of the writers who followed him have enlarged upon what he had summarily indicated concerning me.' Letter to Edmond Picard, June 15, 1894; see the Belgian periodical *L'Art Moderne*, Aug. 25, 1894.

6. Later, Redon was to say on this subject: 'For Pascal's *Pensées*, I have attached a phrase of this author to only one of my pencil drawings; it seemed somewhat appropriate. I doubt that I shall pursue my idea of producing others. It is a text that is too abstract to inspire a 'black and white' which corresponds to it, even for me.' Letter to André Mellerio, July 21, 1898; see *Lettres d'Odilon Redon* (Paris and Brussels, 1923), p. 32. A. Mellerio, *Odilon Redon* (Paris, 1923), pp. 117, 118, reproduces two drawings with captions taken from Pascal.

7. E. Hennequin, 'Odilon Redon,' *Revue Artistique et Littéraire*, Mar. 4, 1882.

8. Redon to Hennequin; see Auriant, 'Des lettres inédites.'

9. See M. O. Maus, *Trente années de lutte pour l'art* (Brussels, 1926), p. 44.

10. For the letter from Mallarmé to Redon, Nov. 10, 1891, see *Maandblad voor Beldende Kunsten*, Oct. 1948.

11. Doubtless a reference to the lithograph *La Fleur du Marécage, une tête humaine et triste*, from the album *Hommage à Goya*, 1885. Mellerio, *Odilon Redon* with 'Catalogue de l'oeuvre gravé et lithographié,' Paris, 1913, No. 55.

12. Mirbeau, 'L'Art et la nature,' *Le Gaulois*, Apr. 26, 1886, quoted from the excerpt published in *Beaux-Arts*, Apr. 26, 1935.

However, ten years after this acid attack, Mirbeau was to write to Redon: 'At first I rejected you, not for your craftsmanship, which I always found to be superb, but for your philosophy. Yet today there is no artist for whom I feel the impassioned admiration I have for you, because there is none who has opened to my mind such distant, such luminous, such sorrowful vistas on the Mystery, that is, on the only true life.' And he added, 'I believe—and I can think of no higher praise—I believe that I understood and loved you from the day on which I learned to suffer.' Mirbeau to Redon [1896]; see *Lettres à Odilon Redon* (Paris, 1960), p. 249.

13. Redon, *A soi-même* (Paris, 1922), p. 28.

14. Darzens, 'Expositions des Impressionnistes,' in *La Pléiade*, May 1886.

15. Published anonymously in *Petit Bottin des Lettres et des Arts*, Paris, 1886.

16. Review published in a Belgian magazine, reprinted in *L'Art Moderne*, Oct. 25, 1891.

17. See the letter from Mallarmé to Redon concerning the *Hommage à Goya*, in H. Mondor, *Vie de Mallarmé* (Paris, 1941), pp. 452–53. Huysmans composed a 'prose poem' on the same album; see his *Croquis parisiens*, Paris, 1886.

18. See V. d'Indy's letter to Maus, Jan. 16, 1888, in Maus, *Trente années.* p. 79.

19. E. Bernard, *Recueil de lettres à Emile Bernard* (Tonnerre, 1926–27), p. 103.

20. 'Chez les jeunes peintres' [a series of interviews], *Echo de Paris*, Dec. 28, 1891.

21. Bernard himself was never to experience the 'admiration from those who are up-and-coming.' For the true story of his life, see the excellent article by Auriant, 'Souvenirs sur Emile Bernard,' *Maintenant*, no. 7 (1947).

22. Redon to Bernard, Jan. 6, 1892; see Bernard, *Recueil de lettres*, p. 107.

23. At least Sérusier himself says so in his 'Hommage à Redon,' *La Vie*, Nov. 30, 1912. Denis, on the other hand, was to write that it was Mellerio, Sérusier's friend, who introduced them to Redon; see M. Denis, *Paul Sérusier, ABC de la peinture, suivi de sa vie, son oeuvre* (Paris, 1942), p. 64.

24. Bernard, *Recueil de lettres*, p. 103.

25. M. Denis, 'Hommage à Redon,' *La Vie*, Nov. 30, 1912.

26. P. Bonnard, 'Hommage à Redon,' *La Vie*, Nov. 30, 1912.

27. A. Aurier, 'Les Symbolistes,' *Revue Encyclopédique*, Apr. 1, 1892.

28. P. Gauguin, 'Exposition de la Libre Esthétique' [Brussels], *Essais d'Art Libre*, Feb.–Apr. 1894.

29. Aurier, 'Le Symbolisme en peinture, Paul Gauguin,' *Mercure de France*, Mar. 1891.

30. Denis, Preface in *IXᵉ Exposition des peintres impressionnistes et symbolistes*, Paris, 1895; reprinted in *Théories* (Paris, 1912), p. 27.

31. Redon, *A soi-même*, p. 89 [written in 1888].

32. P. Sérusier, 'Hommage à Redon,' *La Vie*, Nov. 30, 1912.

33. C. Morice, in *Petite Tribune Républiquaine*, Apr. 2, 1885.

34. Redon, 'Confidences d'artiste,' *L'Art Moderne*, Aug. 25, 1894.

35. Ibid.

36. P. Signac, entry in his journal, Feb. 2, 1899; see 'Extraits du journal inédit de Paul Signac, 1890–99,' *Gazette des Beaux-Arts*, July–Aug. 1953, pp. 41–42.

37. The artist's son stated in a letter to the author under what circumstances this copy was made: 'One day M. Bonger [brother-in-law of Theo van Gogh and great admirer of Redon] while passing through Paris had bought a canvas by Cézanne, and since he had to go to London before returning to Amsterdam, he left the canvas at our house. In his absence, my father amused himself by copying it, and when Bonger returned to Paris, probably sooner than he had thought, he found the copy on the easel. Never thinking that it could be any canvas but his own, he exclaimed, "You are really too kind, Monsieur Redon, to have cleaned this painting that was very dirty; one now finds some colors which were completely dulled." My father laughed heartily and showed Bonger the original, which was nearby. M.

Bonger bought the copy and carried the two paintings off to Amsterdam.' The canvas copied by Redon is No. 358 of Lionello Venturi's catalogue and dates about 1880. Both pictures were at one time in the Norton Simon Inc. Museum of Art, Pasadena, California.

38. Many years later the American critic James Huneker, for instance, was to remember: 'In 1901 I saw at the Champs de Mars Salon a picture by Maurice Denis entitled *Hommage à Cézanne.* . . . The canvas depicted a still life by Cézanne on a chevalet and surrounded by Bonnard, Denis, Redon, Roussel, Sérusier, Vuillard, Mellerio, and Vollard. Himself (as they say in Irish) is shown standing and apparently unhappy, embarrassed.' James G. Huneker, *Unicorns* (New York, 1917), p. 101 (article reprinted from the *New York Sun*, Mar. 11, 1917).

39. W. Pach, *The Masters of Modern Art* (New York, 1924), p. 39.

40. Cézanne to Bernard, Oct. 23, 1905; P. Cézanne, *Correspondance* (Paris, 1978), p. 314.

41. Cézanne to his son, Sept. 13, 1906; ibid., p. 325.

42. Cézanne to Bernard, May 12, 1904; ibid., p. 301.

43. What is astonishing in these notes, is Redon's statement that 'war is healthy.' It is explained by the memory the artist had kept of his own experiences in 1870. According to Jules Destrée, 'he was then in the full flower of his youth, in good health and full of enterprise; he withstood fearlessly, even joyfully, this regular life and the physical exercises. On the march, he saw many dawns; and on the straw, he slept well. Full of curiosity and without being wounded, he witnessed a battle on the Loire; and even now, in spite of the horrors of war and the disasters of the country, he recalls those days, filled with cherished memories of keen sensations, as the best moment of his existence.' J. Destrée, *L'Oeuvre lithographiée de Odilon Redon* (Brussels [1891]), p. 64.

44. Unpublished letter communicated by M. Michel-Ange Bernard, Paris.

45. It is not without interest to note that Rainer Maria Rilke immediately felt a certain exasperation in Cézanne's letters to Bernard; on Oct. 21, 1907 he wrote to his wife: 'A painter-writer, a painter therefore who was not one, has also gotten Cézanne, through his letters, to express his responses on pictorial subjects; but when one reads these few letters of the old man, one realizes that he did not go beyond the rudiments of an awkward elocution, one which he himself infinitely abhorred. The phrases which he undertakes grow longer, become confused, bristle, form knots, and he winds up by abandoning them in a rage.' R. M. Rilke, *Briefe aus den Jahren 1906 bis 1907* (Leipzig, 1930), p. 402.

46. See Bernard, 'L'Erreur de Cézanne,' *Mercure de France*, May 1, 1926.

47. Bernard, 'Souvenirs sur Paul Cézanne et lettres inédites,' *Mercure de France*, Oct. 1 and 15, 1907 [subsequently published as a pamphlet]. The italics are Bernard's.

48. Redon to Bernard, Oct. 20, 1907; Bernard, *Recueil de lettres*, p. 122.

49. E. Faure, 'Paul Cézanne,' *Portraits d'Hier* 2, no. 28 (May 1, 1910): 123, n. 4.

50. Redon was only one year younger than Cézanne.

51. That would have been in 1890.

52. The painting then belonged to André Gide.

53. See *La Vie* of Nov. 30, 1912, as well as the following issue. Contributions by Sérusier, Denis, and Bonnard have been cited above; see notes 32, 25, and 26 respectively.

54. Matisse, letter to the author, Feb. 12, 1949.

55. W. Pach, *Queer Thing, Painting* (New York, 1938), p. 163.

56. Ibid., p. 165.

I wish to thank the late Arï Redon for all the information and unpublished documents that he willingly turned over to me. The late Walter Pach, M. Michel-Ange Bernard, and the late M. Auriant equally furnished valuable information.

The posthumous fate of
Vincent van Gogh 1890–1970

In memory of Ing. Vincent W. van Gogh

The posthumous fate of Vincent van Gogh is one of the most moving and extraordinary chapters in the history of modern art. For an artist who had sold practically nothing during his lifetime to receive the supreme consecration of being forged within twenty-five years of his death is in itself a unique occurrence. But what makes this even more exceptional is the fact that Vincent's brother Theo, who had been his sole support and confidant, died six months after the painter's suicide, so that the responsibility of propagating his work was left to Theo's widow, a young Dutchwoman who had hardly known her brother-in-law and who—not yet thirty—had to face life with huge stacks of paintings and drawings (well-meaning friends advised her to get rid of this worthless burden), a pile of mostly undated letters, and an infant son, the artist's namesake.

Shortly after Vincent's burial, Theo had told his wife that portions of his brother's letters deserved to be published; when he in turn fell ill, she would read these documents in her few idle moments. After Theo's death in January 1891, she began to peruse them systematically; yet, as she confided to a friend: 'The first evening that I spent again in our home, I turned to the bundle of letters because I knew that I would meet him in them, and night after night I found solace there from my great misery. In those days I was not looking for Vincent but only for Theo, for every word, every detail that concerned him. . . .'

Thus Johanna van Gogh–Bonger approached Vincent's letters in search of the husband to whom she had been happily married for only a year and a half. But she was soon caught up in the fascinating personality of the painter himself which illuminates every line he wrote. In this way the idea of publishing these letters took shape, after she had carefully deciphered them and tried to establish their sequence. She did not rush them into print, however, because, as she explained almost a quarter of a century later, 'It would have been unfair to the dead artist to arouse interest in his *person* before the *work*, to which he had sacrificed his life, was recognized and appreciated as it deserved to be.'

First published in *Museumjournaal*, August–September 1970

At the beginning the outlook appeared bleak. Albert Aurier, van Gogh's first apologist, succumbed to typhoid fever in 1892; Gauguin manifested no inclination to further his friend's renown (it is true that his own reputation was still not well established); her own brother, Andries Bonger, who had been Theo's best friend, showed but lukewarm interest for Vincent's work; and Emile Bernard was not only wrapped up in religious mysticism, but was preparing to leave France. Before settling in Egypt, however, Bernard did publish in the *Mercure de France* excerpts of the letters he himself had received from Vincent, followed by selections from letters to his brother, communicated by Theo's widow. These appeared between 1893 and 1895 and were subsequently translated into German. The widow also allowed thirteen letters to be reproduced in a Dutch periodical. Yet all these were small offerings compared to the hundreds of letters that had been preserved. It is of course a moot question as to how van Gogh's posthumous destiny would have fared had Theo destroyed or merely lost these precious documents. In any case, before she made available more of Vincent's correspondence, the main task for Johanna van Gogh–Bonger remained to bring his paintings to the public's attention.

In Paris, Bernard had managed to organize, with great difficulties, a small one-man show of Vincent's paintings in 1892, and *père* Tanguy proudly displayed his canvases (many on consignment from Theo's widow) to avant-garde artists and collectors. But fame was in no hurry; at the sale after Tanguy's death, held in June 1894, a painting by van Gogh brought 100 francs and a second picture, catalogued under the name of 'Vincent,' was sold for 30 francs. This last one was purchased by an unknown young man named Ambroise Vollard, who had recently established himself as a modest art dealer in Paris and who, a few years later, would travel to Provence to buy up whatever works the artist had given away, such as those he had presented to the postman Roulin and his family. Vollard eventually provided, among others, the Russian collectors Shchukin and Morosov with works by van Gogh.

In April 1894, shortly after the death of *père* Tanguy, Andries Bonger, on behalf of his sister, left ten canvases with the Durand-Ruel gallery, hoping that they might be sold there. In a letter to Theo's widow the dealer specified:

'I have the honor of informing you that Mr Bonger has left on deposit with us ten paintings of the late Theo van Gogh (one canvas of this group is rolled up and not mounted on a stretcher), as well as eleven frames.

'Since we are anxious to show these pictures to the visitors of our galleries, I herewith ask you to be kind enough to give us as soon as possible the list of prices established by you for each of these paintings among which there are some very interesting ones:

1. Nature morte, citrons
2. Peupliers

3. Vue d'Auvers
4. Orangers en fleur
5. Sous-bois à Auvers
6. Montmartre
7. Le Semeur
8. Les laveuses, réduction
9. Esquisse (panneau)
10. (Toile roulée—sujet de figure et paysage)

'As has been agreed with Mr Bonger, we shall keep these paintings on consignment for some time and shall inform you of any sales that we may be able to transact. Of the prices quoted by you, we shall charge, in case of sale, the usual commission of ten percent.'

To this letter of April 19, Theo van Gogh's widow answered on April 21, saying notably:

'I should very much like to ask you to establish the prices yourself on my behalf in accordance with the few indications I can provide. Until now the canvases that the late M. Tanguy sold for me obtained only very modest prices; not more than 400 or 500 francs, whereas in Holland I have sold a few for 800 and 1,000 francs. You know much better than I the commercial value of [these] paintings and if you will be kind enough to set a price when there is a possibility of sale, I shall be greatly obliged to you.'

Barely a week later, on May 2, 1894, a letter from Durand-Ruel notified Mrs van Gogh–Bonger:

'I have the honor to inform you that a collector has offered us for three of Mr Vinc. van Gogh's paintings (left with us by Mr Bonger),

No. 1, Les peupliers (0.72 x 0.92 m)
No. 2, Orangers en fleur (0.72 x 0.92 m)
No. 3, Les citrons (0.45 x 0.38 m)

the amount of five hundred and fifty francs (Frs. 550). These prices may appear rather low to you in comparison with those at which the works of the late Vincent van Gogh are being sold in Holland, but just the same they are those that M. Tanguy had asked for these paintings only a few months ago. In case of sale, we shall retain, as we have already informed you, a commission of 10% on this amount of 550 francs.

'Please be kind enough to inform us as soon as possible whether you accept the offer of our client.'

To this Theo's widow replied:

'I consider *three* paintings for 550 really too much. If the collector concerned wishes to take two for this amount, I accept the offer. In case of sale would you be kind enough to let me know the buyer's name?'

But the transaction fell through and there obviously was not much interest for Vincent's work in Paris. By the end of November 1894 the Durand-Ruel gallery informed Mrs Theo van Gogh–Bonger:

'We regret that until now we have not sold a single one of the paintings by M. Van Gogh which Mr Bonger left on consignment with us last April. Since our galleries are encumbered as a result of the exhibitions that we are organizing at present, I should be greatly obliged if you could tell me where these paintings are to be returned. As I do not expect to sell them, it seems useless for us to continue to keep these pictures which you may be able to place elsewhere.'

Theo's widow was reluctant, however, to take the paintings back, hoping that some other Parisian dealer might be willing to try his luck with them. At her request, Durand-Ruel got in touch with Le Barc de Bouteville, who was beginning to exhibit works by avant-garde artists, notably members of Gauguin's Pont-Aven group and Nabis. Yet, on January 17, 1895, Durand-Ruel wrote to Holland that his colleague could not accept the consignment of the paintings, adding that he would now ship them to her. 'In order to avoid unnecessary expenses,' he suggested, 'it would probably be preferable to send back the canvases only; the frames are without any value and their sizes would result in very high transportation costs.'[1]

On February 7, 1895, Durand-Ruel finally informed Mrs van Gogh–Bonger that the shipment was being sent off that very day. Thus, for the time being, Theo's widow found herself without any 'correspondent' in Paris, where Vincent's pictures could be seen only at Vollard's, possibly because he preferred to buy works outright so that he remained master of his asking price. In any case, Vollard would never have been satisfied with a 10 percent commission and would probably have found the prices established by Mrs van Gogh–Bonger too high. It is even possible that he was the client who tried to obtain the three paintings from Durand-Ruel at a 'bargain' rate.

At first, those interested in Vincent were mostly artists. Pissarro and Rodin owned canvases, and Signac had one which he had received from the painter (although he did not overly care for the Dutchman's 'unscientific' approach). In 1899, Matisse was tempted at Vollard's by one of van Gogh's Arlésiennes, as well as by a small composition of bathers by Cézanne; he finally selected the Cézanne which cost 1,300 francs, whereas the van Gogh was priced at only 900 francs. On another occasion, in 1895, a young girl from Rotterdam was prevented from acquiring a still life of sunflowers because her father would not give her the 150 florins needed for the purchase. But the most important things were that van Gogh's works could be seen in a few places and could be bought for comparatively small amounts.

While progress was slow, Johanna van Gogh–Bonger never lost faith in the ultimate destiny of her ill-starred brother-in-law, though she could not possibly have foreseen its present magnitude. For quite some time the visitors who came in increasing numbers to admire the paintings in her house presented the only reward for her devotion. Her son, looking back at his distant childhood, remembered those strangers who steadily asked to see the pictures that crowded their home. And the diary the young woman had

interrupted during her short-lived marriage but took up again after her husband's death is filled with entries concerning exhibitions—often local and of minor importance—with press reviews and other details that demanded a great deal of energy and care. Simultaneously, she took in boarders, raised her son, and continued to work on the letters.

The more significant exhibitions were held abroad, first in France and Germany. Paris became conscious of van Gogh on the occasion of a fairly large retrospective held at the Bernheim-Jeune galleries in 1901. It not only fired Derain and Vlaminck with unbounded enthusiasm, but in general contributed its decisive share to the emergence of the Fauve movement.

According to the recollections of Theo's son, the Berlin dealer Paul Cassirer would drop in each year while on the way home from some summer resort on the Channel coast and make a few purchases. In 1906 Cassirer's brother Bruno published a small volume of selected letters of van Gogh, translated into German. The first van Gogh exhibition in Germany was organized by Paul Cassirer in 1908 in Berlin. (In comparison, the first work of Seurat appeared in Germany only in 1913; but then Seurat's widow was dull-witted and in no way dedicated to his memory.) The first public institution to acquire a painting by van Gogh was the Folkwang Museum at Essen. The young German Expressionists, already indebted to the Fauves, found in van Gogh a still more vibrant and romantic example, a truly kindred soul with which they felt deep-rooted affinities.

In London, the first picture by van Gogh was shown in 1910. Two years later a fine selection of his work was included in Roger Fry's first Post-Impressionist exhibition; it contained 21 paintings by van Gogh, the same number of works by Cézanne, but even more canvases by Gauguin. In the summer of 1912 the German Sonderbund opened a truly staggering exhibition of modern art in Cologne, which presented no fewer than 108 paintings (and sixteen drawings) by van Gogh; one-third of these were owned by German collectors, while most of the balance was lent by Theo's widow. The hanging was arranged in such a way that the visitor had to cross five rooms filled with the Dutchman's work before reaching the single rooms devoted to Cézanne, Gauguin, Picasso, and others. Its impact on German painters and on the art-conscious public cannot be exaggerated.

Thus, little by little, the stage was set for the publication of Vincent's letters to his brother. In 1913 a selection was issued in the United States, curiously translated from the German edition of 1906 rather than from the mostly French originals. But the following year saw the first massive publication, three volumes edited by Johanna van Gogh–Bonger which appeared in Amsterdam and, simultaneously, in a German translation. Though the moment turned out to be ill-chosen and World War I did not exactly help the propagation of art, the impact of these letters can be judged by the fact that the German art historian Meier-Graefe, who had already

concerned himself with van Gogh in various publications, spent his years in Russian captivity preparing a two-volume biography of the painter which, slightly bordering on fiction, might be considered the forerunner of *Lust for Life*.

But the real upsurge of van Gogh's fame occurred after the First World War, when large-scale exhibitions began to be organized everywhere, usually with the full assistance of Theo's widow. An example of how they came into being is given in a volume of recollections by Oliver Brown, for many years director of the Leicester Gallery in London. He tells how an acquaintance spoke to him early in 1923 of a visit to Johanna van Gogh–Bonger and of being thrilled at seeing such a large collection of Vincent's work. When he inquired why she had never shown any of these in England, she replied, 'Nobody has ever asked me.' Brown thereupon lost no time in writing to her about an exhibition.

'She seemed pleased with the idea,' he later remembered,

'and in the summer I visited Amsterdam. Though Mme van Gogh–Bonger was then seriously ill I was able to make arrangements with her son . . . a young engineer who was most considerate and helpful. He . . . took me to his little house in a suburb of the town. The walls in every room were crowded with his famous uncle's pictures. I was astonished to find so many together. Nearly all of them were for sale, save for a few to be retained if possible for Holland. Even in the bathroom upstairs I noticed several canvases propped between the bath and the wall. It looked as if two exhibitions would be possible and I found it difficult to make a choice for the first, but I finally selected about forty pictures and drawings. They included what are now world-famous masterpieces. . . .

'This unique exhibition in December 1923 met with great success. It was the first complete showing of Vincent van Gogh in England. . . . There was one loan only from an English collector. . . . A few of the best pictures were not for sale, notably *The Chair* [*VIII*] and *The Sunflowers*, but the Trustees of the Tate Gallery were so anxious to have these two that the family were persuaded to part with them to the Tate. . . .

'Looking back, it is surprising to realise how few of the paintings were sold to our English visitors and how modest some of the prices seem now. . . . The exhibition caused such a stir in London that I considered how we could ever rival it. (However, our kind and helpful friend, V. W. van Gogh, was so pleased at the way it was presented that he and his mother promised to provide us with further examples of Vincent's genius.)'[2]

The second show took place in 1926 and met with an even greater success. In 1929, the newly founded Museum of Modern Art in New York opened with an exhibition celebrating the four 'pillars' of modern art: Cézanne, Gauguin, Seurat, and van Gogh. Six years later Alfred Barr organized an important van Gogh retrospective at the museum, accompanied by a scholarly catalogue.

Meanwhile, in 1927, Vincent's letters to Theo had begun to appear in England and the United States in a translation prepared by Johanna van

Gogh–Bonger, who did not live to see the volumes. Her death changed the situation somewhat, as Oliver Brown found out when he returned to Holland in order to prepare a third exhibition for the Leicester Gallery. Her son 'had moved from Amsterdam to Laren where the family seemed more comfortable and happy in their simple way. His country house was still full of pictures by his famous uncle. He explained to me that he had now enough money to educate his children and that he would not contemplate selling any more, but that I could have as many as I liked for an exhibition.'[3]

And things have remained thus ever since. By selling Vincent's works—though there were always paintings and drawings with which she refused to part—Theo's widow put them into circulation and allowed them to find their way around the globe; a large group eventually was assembled in Holland itself by Mrs Kröller-Müller. While Johanna van Gogh–Bonger may often have sold paintings out of financial necessity, it can be safely said that in order to spread the fame of an artist it is indispensable that his works become available not only for exhibitions, but also for acquisition, and that they be owned by people or institutions who truly care for them; their enthusiasm is an essential factor in a painter's growing reputation. Those private atelier-museums, such as that of Gustave Moreau in Paris, are sad mausoleums, and it was certainly much 'healthier' to disperse at public sales the contents of the studios of Delacroix or Degas, for instance. But by the time Theo's son inherited his mother's collection, van Gogh's reputation was already solidly established—even though prices were of course far from what they are today—so that he could stop selling Vincent's work without detracting from his fame.

This fame was shortly to receive an unwarranted boost from the uncovering of the notorious Wacker scandal in Germany and the subsequent trial of Wacker, a dealer who, it seems, was also a painter and who had put into circulation a large number of van Gogh paintings from a mysterious Russian source, all of which more or less cleverly copied or 'paraphrased' existing and well-documented works.[4]

It is rather curious that the first catalogue raisonné of any modern artist should have been that of Vincent van Gogh, assembled by J. B. de la Faille. Unfortunately, at the last minute the author could not resist the temptation to include the recently 'discovered' Wacker pictures, so that his catalogue, published in 1928, also has the unenviable distinction of featuring numerous forgeries, the authenticity of which the author did not then doubt. Within two years, however, he had to issue a volume entitled *Les Faux van Gogh*, which included many of the works he himself had previously accepted. When, in 1939, de la Faille published a new edition of his van Gogh catalogue, he again changed his opinion concerning some of the Wacker paintings which he had first considered authentic, then branded as spurious, and now once more pronounced genuine. Whether van Gogh has been forged more frequently

than any other modern master is open to debate, but there have certainly been more heated discussions and differences of opinion, more experts attacking other experts, more sworn testimony in court contradicting other sworn testimony concerning the authenticity of certain van Gogh paintings than for any other artist of that period. While Venturi's Cézanne catalogue, Lemoisne's Degas compilation, and even the Pissarro catalogue by the artist's son Ludovic-Rodo contain here or there an isolated and debatable work, none of them is so uncritical as to feature an entire group of imitations, *all* coming from the same source.

At the time of his death, de la Faille was preparing yet another edition of his catalogue. This much needed work was published posthumously by a committee of Dutch editors but does not really solve all the vexatious van Gogh problems. The new volume, which appeared in 1970, is composed of four frequently intermingled categories:

1. Paintings and drawings considered genuine by both de la Faille and the editors (these form the bulk of the publication).
2. Paintings and drawings considered to be forgeries by both de la Faille and the editors, but which had previously been accepted as genuine by the former.
3. Works rejected by de la Faille but accepted by the editors.
4. Works accepted by de la Faille but rejected—and rightly so—by the editors.

It is no surprise that such a state of affairs has not really put an end to all discussions concerning van Gogh's paintings. Vinçent's nephew wisely remained aloof from these discussions. At the Wacker trial he merely testified that he had never seen any of these paintings in his mother's home. If anything, he had a tendency to be more critical than most experts and to doubt the authenticity even of works that have not been questioned elsewhere (especially if they are not mentioned in the artist's letters). On the other hand, he was always most helpful when the family archives could clear up certain problems.

When I first met Theo's son in the thirties (all his acquaintances referred to him as 'the engineer'), I was told that he was possibly the richest man in Holland. Indeed, since inheritance taxes had been paid upon his mother's death on the basis of rather low estimates, and since there was not then in the Netherlands any capital gains tax, he *could* have sold the paintings in his collection and pocketed the full amount. Yet in the thirties he never sold anything. He lived then in his house in Laren, not far from Amsterdam (and did so until his death in 1978). There was nothing ostentatious about him nor anything that smacked of wealth. His habits, his style of life could hardly have been simpler. But all over the house there were the paintings and drawings of his uncle. As this house could not possibly accommodate all the canvases he owned, the greater part of them were at that time—and remained for many

years—on extended loan to the Stedelijk Museum of Amsterdam where they were available to the general public.

In the years after World War II, the engineer on many occasions agreed to send selections of his collection abroad, and numerous European and American museums were able to show these. He was also always generous in lending paintings by Gauguin or Monticelli, drawings by Seurat, or other works. I remember one evening at Laren when I asked to see some watercolors by Emile Bernard which the latter had sent to Vincent, who discussed them in one of his letters. The engineer went to a huge seventeenth-century Dutch cabinet which had belonged to his father and from the bottom of a drawer produced a pile of these watercolors. Beneath these lay a small panel of two figures, unsigned, which must have been buried there for more than five decades. It was a sketch by Toulouse-Lautrec, which has since been included in various exhibitions. It was in this cabinet also that Vincent's letters had been kept. After his mother had attended to their initial publication, the engineer undertook the preparation of a complete edition, containing not only some of the passages Theo's widow had left out for personal reasons or to avoid offense, but also all the letters addressed by Vincent to other members of the family (his mother and his sister Wilhelmina) and to friends, as well as the few letters from Theo to Vincent that had survived. This large collection first appeared in Holland between 1952 and 1954, presented in four volumes; all the documents were reproduced in the language in which they were written, that is, many in Dutch, a few in English, and the balance in French. They were subsequently issued in English in three volumes, in a particularly well-presented edition. This same edition was also brought out in French, though it is rather strange to think that it was not until 1958 that Vincent's correspondence was made available to the French public (until then French scholars could read his early letters only in the original Dutch, or in German or English translations).

This monumental task accomplished, his children grown and with families of their own, a widower for the second time, the engineer was faced with one remaining problem: the ultimate destiny of his collection. To leave it to his children would have meant not only splitting it up but also, in order to pay inheritance taxes, throwing on the market some of these works which he had so religiously and unselfishly kept together. Thus took shape the idea of a foundation to be established in Amsterdam. Negotiations with the Dutch government led to an agreement according to which the state (reputedly for an arbitrary amount, though sufficient to safeguard the interests of the engineer's descendants) subsidized the foundation to purchase the collection and pledged to erect a special building for it, not far from the city's two other famous institutions, the Stedelijk and the Rijksmuseum. The engineer participated in planning the structure and saw to it that the works would be shown under the best possible conditions; extensive travel has not harmed

the paintings. Although no large-scale purchases are contemplated, the foundation does have some funds and has been able to acquire a few early drawings by Vincent which have turned up in the estates of distant relatives or their heirs.[5]

Dr van Gogh's house in Laren, which he had occupied for forty years, was now bare of Vincent's works, yet he was serene and happy, as though a heavy burden had at long last been taken off his shoulders. Gone are not only the paintings and drawings by van Gogh, but also those by many others owned by the two brothers.

It seems incredible that after four score years a man should so completely change the everyday frame of his life rather than make dispositions effective only after his death. Yet this is the way the gentle, soft-spoken, shy but determined son of Theo wanted it. He looked forward to the installation of all these possessions, planned for 1972, which was to be the crowning of his efforts.

If it appears extraordinary that anybody should act in such a way, this is merely the conclusion of a long series of selfless acts which distinguished this family and which, in a certain way, compensates for the great unhappiness experienced by Vincent. It was unusual enough that the painter should have a younger brother on whom he could always count and without whom he would not have been able to live and work, but that the brother's wife should continue after her husband's death to devote her energies to the dead artist, and that the brother's son, who had not known his uncle, should in turn renounce tremendous wealth and comfort so as to further the painter's fame is a destiny which many a successful artist may well envy Vincent van Gogh.

For the eightieth birthday, on January 31, 1970, of Ing. Vincent Willem van Gogh, the painter's nephew and namesake and Theo's only child, the Dutch *Museumjournaal* wished to publish an article devoted to him, with special emphasis on the new Rijksmuseum Vincent van Gogh in Amsterdam which was then still in the planning stage and which would house the vast collection of his uncle's work that he had piously preserved. At Ing. van Gogh's request, the author, whom he had known for some thirty-five years, was asked to write this tribute.

While preparing this text for inclusion in the present collection, the author considered it advisable to carry this account beyond the Ingeneer's eightieth birthday until his death on January 28, 1978, a few days before the eighty-eighth anniversary of his birth.

NOTES

1. Unpublished correspondence between the Durand-Ruel galleries, Paris, and Mrs Theo van Gogh–Bonger, Villa Helma, Bussum, Holland. These letters were not included in the original article of 1970, having been discovered in the Durand-Ruel archives only several years later. The Ing. van Gogh was unfortunately unable to identify the paintings in question. Documents courtesy M. Charles Durand-Ruel, Paris.

2. O. Brown, *Exhibition: The Memoirs of Oliver Brown* (London, 1968), pp. 83–85.

3. Ibid., p. 98.

4. A good account of the Wacker affair can be found in L. Jeppson, 'The Battle of the van Gogh Experts,' in *The Fabulous Frauds* (New York, 1970), chap. 5.

5. On the Rijksmuseum Vincent van Gogh, see Matthias Arnold, 'Kein Mausoleum für einen Wegbereiter,' *Weltkunst*, no. 19, Oct. 1, 1979, pp. 290–93.

An Introduction to the Fauve movement

To Betsey Whitney

When, in the Autumn Salon of 1905, a group of young and mostly unknown painters banded together and showed their works in a large center gallery, the Parisian art public was startled if not shocked by the violence of their colors, the exceptional freedom of their brushwork, the willful distortions and simplifications of forms, in a word, the extreme boldness of their approach. The critic Louis Vauxcelles, pointing to a quattrocento-like sculpture in the middle of that same gallery exclaimed, 'Donatello au milieu des fauves!' (Donatello among the wild beasts) and the designation *fauves* stuck. Among those who participated in that historic exhibition were many whose names have since become famous, though not always for the work they did in their Fauve days, and others who are almost forgotten. Fauvism represents only a short phase in the evolution of almost all of them, but the importance of the Fauve movement, which heralded the art of the twentieth century, becomes ever more evident as it recedes in time.

Of those who showed at the Salon d'Automne, Matisse, Derain, Vlaminck, Rouault, van Dongen, Camoin, and Puy are still alive—as well as Dufy and Braque who joined the Fauves a little later. They all have participated actively in the preparation of the present exhibition. So have the widows of Marquet and Friesz, the daughter of Manguin. With their approval and advice the paintings and drawings here assembled have been selected as being among the most significant.

Four times during the second half of the nineteenth century painters had organized themselves in order better to put forth the ideas they held in common. First the Impressionists, then Seurat and his friends, later Gauguin and his followers, finally the Nabis. Like its predecessors, the Fauve movement was not born suddenly but went through a period of formation and gestation. Nor did it always follow a straight course. It actually emerged from the efforts of various painters who worked in more or less close communion and who can be divided into three groups: the pupils of Gustave Moreau

(Matisse, Marquet, Rouault, Manguin, Camoin); the men from Chatou (Vlaminck and Derain); and three young latecomers from Le Havre (Friesz, Braque, Dufy). Of these, Moreau's pupils were the most numerous and decisive element.

Gustave Moreau, who was named teacher of a class at the Paris Ecoles des Beaux-Arts in 1892, was a strange man, a strange artist, and an even stranger teacher. Sheltered from need as he was through inherited wealth, he lived and worked in seclusion, caring neither to exhibit nor to sell his paintings. In the isolation of his somewhat pompous ivory tower he created works in which the flowery unfolding of his imagination lost most of its sparkle under the domination of cold reason. And yet, as soon as he found himself in contact with the young and eager artists of a new generation whose first steps he was to guide, he devoted himself to his task with both extreme wisdom and heartfelt warmth. There was even daring in the unconventional way in which he endeavored to develop the individualities of his pupils. He never attempted to impose his own style upon them, as was the habit of his colleagues at the Ecole; quite to the contrary, he gave them intelligent encouragement, made no fetish of academic drawing, awakened their interest in color, urged them to study the masters in the Louvre, but also insisted that they observe the life around them.

One of his first pupils was Georges Rouault, then still coveting the Rome prize of the Ecole, whose devotion to his master has remained intense to the present day. A little later Henri Matisse joined Moreau's class. Among the new recruits of 1894 were Albert Marquet and Henri Manguin, while one of the last and youngest students was Charles Camoin from Marseilles, who entered the class in 1897, shortly before Moreau's death. Moreau left his house and collection to the state and named his favorite pupil, Rouault, as their curator. On his deathbed Moreau said to Rouault, 'I would leave my uniform of the Academy of Fine Arts to you, only you would burst all its seams.'

Alone among the teachers of the Ecole, Moreau visited the yearly, jury-free exhibitions of the Independents where such 'rebels' as Signac and Cross, Toulouse-Lautrec, and the *douanier* Rousseau showed their works. Rouault remembers that upon his return from such a visit one of Moreau's colleagues asked him, 'You saw the show of the Independents? Isn't that the end?' 'The end?' replied Rouault's teacher, 'but no, it is only a beginning.' What Moreau may not have known himself was that it was indeed a beginning to which his own pupils were to contribute a decisive share.

Next to the silent and somewhat sullen Rouault, Matisse was certainly among Moreau's pupils the one with the greatest intellectual 'appetite,' with the deepest eagerness to absorb and assimilate new experiences. When he showed for the first time a group of conventional paintings at one of the two official Salons in 1896 and was immediately nominated to membership on the

recommendation of its president, Puvis de Chavannes, this unexpected success almost made him feel uneasy.

In 1897 the Luxembourg Museum at last displayed part of the collection of Impressionist paintings bequeathed by Caillebotte (and accepted only over the protest of most teachers at the Ecole des Beaux-Arts). Matisse was profoundly stirred by these works. He himself painted a large canvas in the Impressionist vein which, when shown at the next Salon, no longer met with approval; instead it provoked a storm of protest. But Moreau defended the painting and Pissarro encouraged its author. Pissarro also advised Matisse to study Turner in London where Matisse subsequently went on a short wedding trip in 1898. At the same time, Matisse began to pay frequent visits to the small gallery of Ambroise Vollard, opened a few years previously, where he could absorb himself in the works of Cézanne, Gauguin, van Gogh, Lautrec, and the Nabis (Bonnard, Vuillard, Vallotton, Denis). Camoin, on his daily walks to the Ecole, also stopped regularly at Vollard's to admire the canvases by Cézanne on display in the narrow window. Matisse soon acquired a painting of bathers by Cézanne, though his financial situation hardly warranted such a 'folly.'

After Moreau's death his classes were taken over by the uninspiring Cormon. Rouault had already left in 1895; now Matisse determined not to return, and Marquet, with whom Matisse had struck up a close friendship, decided to leave the Ecole, too, together with his friend Camoin. Marquet and Camoin began to apply themselves more systematically to Moreau's advice of 'going down into the street' and roamed through Paris sketching passers-by or making studies of performers in various music halls, where Matisse also was frequently to be seen. While at the Ecole they had usually drawn in masses, heavy black shadows often abruptly opposing the pure white of lighted surfaces, intermediate grays barely softening the contrasts, and forms emerging with an almost brutal force from this interplay of shades. But now they adopted an entirely different technique, using mostly quill pens and catching with precise yet sparse lines the essence of their observations. There was no more modeling; instead they invented an entirely new sign language of rapid strokes, an almost stenographic style that seemed to retain on the white sheet any significant movement or gesture before it was even completed.

Since he did not wish to work under Cormon, Matisse began to attend the life class of a free academy where Carrière occasionally offered corrections to those who wished them, but where one could paint, draw, and even model from life without being disturbed. Whenever Carrière made the rounds, Matisse turned his canvas against a wall and went to smoke his pipe in a corner. It was in this academy that Matisse met Jean Puy and Derain, among others. They were all greatly attracted by his paintings, in which they sensed a new departure, as well as by the ideas he expounded. 'The audacious

transpositions which distinguish the early work of Matisse,' Puy later remembered, 'were the reason for his success because they promised to open entirely new roads to painting, an unheard-of richness of sensations. All the painters were subjected to their charm and saw in them a reason for hope. It was like a glimpse at a paradise where, through the forcefulness of equivalents, one rediscovered at last a new way of painting, a way which enabled one to retain on the canvas the tremendous splendor of life itself.' In his discussions with fellow students, Matisse clarified Cézanne's importance to them, thereby developing their feeling for structure.

A few years older than most of those around him, Matisse began to be looked upon as a leader though he still considered himself essentially a student. His early success as a conservative painter was long forgotten and the new problems with which he struggled seemed too vast and demanding to allow easy assurance. Modest and reserved though he was, he must have derived great encouragement from the leading role with which his comrades so readily entrusted him. He was conscious of his responsibilities, grave in his work and bearing. The numerous nudes which he painted at Carrière's were bold in design as well as in color, with simplified planes, decisive drawing, and an emphasis on structural elements that reveal the influence of Cézanne. But their most startling feature was the free use of color, his figures being modeled in green, violet, or blue in conjunction with complementaries. Marquet, though less bold and given to less powerful combinations—he actually preferred brighter and softer harmonies—also worked along similar lines. Together they used to go each summer afternoon to Arcueil on the outskirts of Paris (where Marquet worked in his hot corduroy suit, the only garment he owned) to paint out of doors. Intensifying local color in his landscapes, Matisse painted in broad masses with heavy accents of light and shadow, but using the same intensity of color throughout his painting so as to pull all elements together in spite of their forceful contrasts.

It was in 1901 at the first large van Gogh exhibition ever held in Paris that Derain introduced Matisse to his friend Vlaminck. Matisse thereupon went to visit them in Chatou and 'was moved to see that these very young men had certain convictions similar to my own.' Though both lived in the small community of Chatou on the banks of the Seine near Paris, Derain and Vlaminck had met only the previous year after the latter had completed three years of military service. Back in civilian life, Vlaminck, tall, muscular, and strong, had thought for a while of resuming the career of professional bicycle racer, which he had tackled before being drafted, but instead started to paint while earning his livelihood by giving music lessons, or as a violinist in various orchestras. Derain's encouragement prompted him to consider his art more seriously. Until then Vlaminck had always scrubbed his canvases bare before taking them home after working in the fields or on the banks of the river, but now he began to preserve them. He knew nothing of the perpetually searching

mind that was Derain's, had no interest in museums where Derain made copies just as Matisse, Marquet, and Manguin had done; he scorned drawing and hardly ever used a pencil; he even refused to follow any definite course. According to his own recollections he painted in a different fashion every day. He actually seems to have been almost proud of his lack of discipline, of his uncouthness, and did nothing to correct them. For a time he also showed anarchist leanings.

Shortly after they met, Derain and Vlaminck rented the large hall of an abandoned and dilapidated restaurant on a Seine island where they could work in peace. Vlaminck himself later explained that in those days 'I knew neither jealousy nor hate, but was possessed by a rage to re-create a new world, the world which my eyes perceived, a world all to myself. I was poor, but I knew that life is beautiful. And I had no other ambition than to discover with the help of new means those deep inner ties that linked me to the very soil.'

Vlaminck had received a profound shock from the work of van Gogh, which was for him an almost dolorous revelation. For in spite of all the admiration that seized him in front of van Gogh's canvases, he immediately recognized in him a formidable adversary. Here was a man who had had the same aspirations which he felt, who had translated in his work the same torments and exaltations, the same visions and impressions with which he struggled himself. And he had translated them with pure colors and brush strokes so vibrant that all his emotions seemed to lie bare on his canvases. After the pursuit of soft light effects which seemed to characterize the Impressionists, whose works Vlaminck had occasionally seen in Paris, van Gogh suddenly burst forth with an intensity of color and design unknown until then. This exhibition, which came more than ten years after the painter's suicide, left a deep impact not only on Vlaminck but on all the young artists of his generation.

Back in Chatou, Vlaminck began to assimilate van Gogh's lesson. 'I heightened all tones,' he wrote later; 'I transposed into an orchestration of pure colors all the feelings of which I was conscious. I was a barbarian, tender and full of violence. I translated by instinct, without any method, not merely an artistic truth but above all a human one. I crushed and botched the ultramarines and vermilions though they were very expensive and I had to buy them on credit.' Indeed, Vlaminck's work began to anticipate ever more strongly the Fauve explosion of 1905. Derain in the meantime had to leave their common studio to begin his military service in the fall of 1901. He was able to paint only two landscapes and a large canvas, *Dancing at Suresnes*, during his three years in the army.

While Vlaminck confined himself to the solitude of the Seine banks and the gentle slopes around Chatou, defiantly conscious of his isolation and full of contempt for Parisian art circles and their aesthetic discussions, Paris

259

continued to attract all those who wanted to devote their lives to art. Among recent newcomers were three young men from Le Havre: Othon Friesz, Raoul Dufy, and Georges Braque. Friesz had come to Paris in 1898 on a municipal fellowship, Dufy joined him in 1900 on a similar fellowship, and Braque also moved to the capital in the same year to continue his apprenticeship as a house painter (his father's profession). For those who, like Vlaminck, were not interested in the masters of the Louvre—Dufy, for instance, felt 'crushed' by them—Paris afforded a kaleidoscopic view of all the new tendencies in art. The Salon of the Independents, which had played an important role in French art life from its foundation in 1884 until the middle nineties, had seemed rather dead for several years with only such faithfuls as Signac, Cross, and the *douanier* Rousseau exhibiting there regularly. Now it began to come to life again. In 1901 all the artists of the new generation who either did not care to show at the official Salons or feared rejection by their conservative juries suddenly flocked to the Independents. Among the newcomers were Matisse, Marquet, and Puy, followed in 1902 and 1903 by Camoin, Dufy, Friesz, and many others. These same artists also began to gather in the small gallery of Berthe Weill, who in 1901 opened her little shop to all young talents. It was located at the foot of Montmartre, in the rue Victor Massé where Degas lived, and soon became a focal point for young painters, critics, and poets. But Berthe Weill had a hard time making ends meet since there were few buyers for her pictures.

While the young painters had to struggle for survival, their immediate predecessors had by no means won a wide public. Monet alone enjoyed an ever-growing reputation, but Cézanne, Seurat, and Gauguin were as yet little known. It was their works, however, which the artists of the new generation studied in small galleries, such as Vollard's, or in occasional exhibitions, that provided inspiration and food for thought. They admired the Impressionists, particularly Monet, for the freedom of his expression, the delicacy of his perceptions, though they objected to his rendering only 'fleeting impressions'; and they were interested in Guillaumin for his endeavor to reach an ever-higher key of colors although his work lacked integration. But they were more attracted by Seurat, Signac, and Cross, who seemed to have put some kind of order into the spontaneous sensations of the Impressionists, achieving a more balanced play of complementaries, a brighter palette, a more rigorous design. They were sensitive also to the subtle use of intense colors in the pastels of Redon; they found in Gauguin's work still stronger colors, richer contrasts, a willful renunciation of modeling, a powerful and decorative opposition of flat planes. Yet it was van Gogh's emotional use of pure colors, his vivid brush stroke, his rich application of pigment, it was Cézanne's conscious effort to express spatial relations through color alone that most deeply affected them. From these sources they derived whatever lessons they could or wished to assimilate, whatever elements suited their own purposes.

59 Kees van Dongen *Reclining Nude* 1904–5

But perhaps the strongest factor in the evolution of many among them came from a man in their own midst, Henri Matisse.

Both Marquet and Derain later attested that the first signs of what was soon to be called Fauvism appeared in Matisse's work as early as around 1900. In 1901, however, Matisse reverted to a darker palette and a more faithful adherence to local color. A similar evolution can be observed in the paintings of Marquet and Puy. Matisse himself today speaks of this phase as a 'period of transition between values and color.' There was also a rigidity of design that attested to his effort of overcoming the Impressionist heritage. These efforts were greatly bolstered in 1904 through Matisse's acquaintance with Cross and Signac. Matisse had already tried his hand at pointillist painting shortly before the turn of the century, but now he decided to explore more systematically the various features of Neo-Impressionism. (Marquet had done so earlier and Derain was soon to follow suit.) Matisse spent the summer of 1904 with Cross in Le Lavandou and with Signac in nearby St-Tropez on the Mediterranean. He abandoned his somewhat Cézannesque style; one of his own still lifes strongly reminiscent of Cézanne he actually translated in the pointillist technique *(60, 61)*. While he thought Signac rather dogmatic, Matisse was greatly attracted by Cross. Under their influence he found his way back to the use of pure high-keyed color, though he soon abandoned the tiresome pointillist execution. The benefits derived from his Neo-

261

60 Henri Matisse *Still Life with a Purro, I* (Saint-Tropez) 1904

Impressionist experiments were to appear in the paintings Matisse did in Collioure, where he spent the summer of 1905 with Derain, paintings which he subsequently sent to the historic exhibition of the Salon d'Automne.

The Salon d'Automne was then still a rather new venture. It had been founded in 1903 by the architect Frantz Jourdain, the critic Rambosson, and several painters, among whom were Rouault, Marquet, Vuillard, and Carrière. There already existed two official Salons, with reactionary and intolerant juries, and the Salon of the Independents, whose jury-free shows were invaded by an uncountable number of hopeless 'duds.' But there seemed room for another Salon, sponsored by more advanced artists who, in rotation, would assume jury duty, not so much to exclude what was new, as to ban what was old, slick, or simply bad. Moreover, whereas the Independents held their shows in the spring, the new organization planned its exhibitions for the fall, thus affording the artists an opportunity to send in their paintings

61 Henri Matisse *Still Life with a Purro, II* (Saint-Tropez) 1904

done during the summer when they worked out of doors. Though Signac and his friends, staunch believers in the jury-free system, refused to become members of the Salon d'Automne, most of the painters who had hitherto shown with the Independents now joined the new Salon, frequently showing at both exhibitions. Among those who supported the Salon d'Automne from the very first were Matisse, Manguin, Bonnard, Redon and, shortly afterward, Renoir (named honorary president) as well as Cézanne. Matisse actively endeavored to enlist new exhibitors and thus it developed that Derain and Vlaminck joined him and his friends in the now famous exhibition of 1905.

While the 'eccentricity' of the Fauve painters aroused the protest of most critics and the ire of the public, the painter Maurice Denis, though no friend of the new movement, seems to have best described the impressions of the perceptive visitor:

263

'When one enters the gallery devoted to their work, at the sight of these landscapes, these figure studies, these simple designs, all of them violent in color, one prepares to examine their intentions, to learn their theories; and one feels completely in the realm of abstraction. Of course, as in the most extreme departures of van Gogh, something still remains of the original feeling of nature. But here one finds, above all in the work of Matisse . . . painting outside every contingency, painting in itself, the act of pure painting. All the qualities of the picture other than the contrasts of line and color, everything which the rational mind of the painter has not controlled, everything which comes from our instinct and from nature, finally all the factors of representation and of feeling are excluded from the work of art. Here is, in fact, a search for the absolute. Yet, strange contradiction, this absolute is limited by the one thing in the world that is most relative: individual emotion. . . .'

But was Denis right when he stated that instinct and feeling were excluded from Fauve painting? Matisse himself has insisted on the great part that intuition played in his Fauve pictures, and his own canvases as well as those of the others bear him out. Whenever forms or colors or other elements excited the Fauve painter's eye, he endeavored to exaggerate them, bring out their dominant character and, while doing so, to maintain the brilliant light, the

62 André Derain *Charing Cross Bridge, London* 1905–6

63 Maurice de Vlaminck *Tugboat on the Seine, Chatou* 1906

high-keyed color throughout his entire work. Thus, instead of a single striking note, Fauve paintings present in every one of their parts the same energy, the same vivid emotion, the same audacious vision. Releasing his emotion with an energy that appeared like frenzy, frequently abandoning all adherence to local color, painting with rapid and sweeping strokes, often applying his pigment in heavy impasto, the painter had yet to control his excitement and integrate the various components of his work. In this Matisse probably succeeded better than any of his friends, because his reason and culture dominated more easily the rush of the first impression. While there are in his paintings clashes and violences, there are also incredibly subtle nuances; the forcefulness of his expression is always tempered by an almost lyrical freshness and exquisite taste. Behind all the daring of the Fauve paintings which Matisse showed at the Salon d'Automne of 1905 lay the experience and discipline of a mature mind, well versed in the traditions of the French school. Matisse was not merely a revolutionary, he remained above all a true painter.

The case of Vlaminck was somewhat different. In his own words, to him Fauvism 'was not an invention, an attitude, but a manner of being, of acting, of thinking, of breathing.' More robust, more ready to follow instinct obscured by no doubts or intellectual pursuits, he attained a violence of assertion which went beyond that of all his friends. 'To create presupposes pride,' he later explained, 'an immeasurable pride perhaps! You have to have confidence in yourself, to feel the exclusive need of expressing what you feel independently of any exterior support. It is possible also that this candid ignorance, this unconscious simplicity, preserves us from experiments in which we may lose ourselves.' In spite of the powerful urge which presided over Vlaminck's feverish output of those years, he did not always reach a complete balance of purpose and expression; where this is achieved, however, the vigorous qualities of his paintings are like the triumphant sound of trumpets.

64 Albert Marquet *Posters at Trouville* 1906

65 Raoul Dufy *Posters at Trouville* 1906

Derain was far from abandoning himself to what Vlaminck called 'candid ignorance.' He was much closer to Matisse, endeavoring to control his emotions and to cast them in a form from which neither grace nor harmony is absent, though their dominant character is one of strength. There is an equilibrium, a constant integration of all elements, a preoccupation with composition (sometimes derived from Oriental sources) which reveal in Derain, as in Matisse, a painter familiar with the achievements of the past. It was not so much a lack of audacity which set Matisse and Derain apart from Vlaminck, but rather a conscious effort not to let audacity be an end in itself. Whenever the eye roams over the sparkling canvases that Derain painted at Collioure and later at London, it discovers happy invention, solid structure, and, beneath the powerful expression, a rare sensitivity.

Marquet, while he now used bright colors like the others, remained more interested in decorative designs, in flat surfaces opposing each other, in sometimes subtle, sometimes violent contrasts. He always appears less self-consuming than Vlaminck, less eager than Derain. Instead he seems

completely relaxed; pure colors flow from his brush with a constantly happy ease.

Friesz, Manguin, Puy, Valtat, and Camoin were more subtle, less adventurous than the others, unwilling to detach themselves too much from the lesson of Cézanne. They usually avoided the loudness of tone in which their friends reveled. Actually, they were more timid, and Camoin, for instance, always maintained that he never was a real Fauve, merely a *fauvette* (warbler). But van Dongen, a comparative newcomer to the group, pulled no punches. However, whereas he occasionally resembled Vlaminck in the brutal force of his expression, he generally did show more refinement; a strange refinement though, for while it prevented him from appearing vulgar, it did not keep him from being extremely dynamic.

Rouault remained somewhat of an outsider, although he did show his works together with the others at the Salon d'Automne. His colors were dark, his moods brooding, but his sweeping brush strokes, his unconcern for slavish submission to nature, the powerful accents of his light-dark contrasts revealed his preoccupation with some of the problems that the Fauves were tackling at the same time.

Dufy and Braque did not exhibit with the others in 1905 but joined the group a year later, Dufy under the influence of Matisse, and Braque after having worked side by side with Friesz. Dufy, even in his Fauve paintings, usually showed a preference for more tender colors, sometimes even pastel tones, except when he let himself be carried away by the example of Marquet with whom he painted in Rouen. He always maintained a particular interest in linear designs that often constitute the main attraction of his Fauve canvases. Braque, who felt, as he says, that he at last came into his own when he began to adopt Fauvism, remained more conscious of solid structure and, like Dufy, seldom reached the violence of the others. Yet at L'Estaque and La Ciotat where he worked in 1907, he reached the same exaltation as Matisse and Derain, the same happy balance of force and subtlety, of perception and expression.

Unconcerned with the attacks to which they had been subjected upon their appearance at the Salon d'Automne, the Fauves continued on their road, aided by a deep conviction of being on the right track. When Berthe Weill appeared discouraged by her inability to sell their works, Dufy told her in a letter written in October 1907 from Marseilles:

'Sustain us, all of those you have had with you already, the gang; but do it with ardor, without weakness, with conviction, or don't do it at all; then, however, somebody else will take your place, and *that should not happen*. Be convinced that you have in Matisse, Vlaminck, Derain, Friesz, and several others the men of tomorrow and even of thereafter. Isn't this evident at the Salon, tell me? Compare the intensity of life, of thought in the paintings of these people with the quantity of boredom, of uselessness

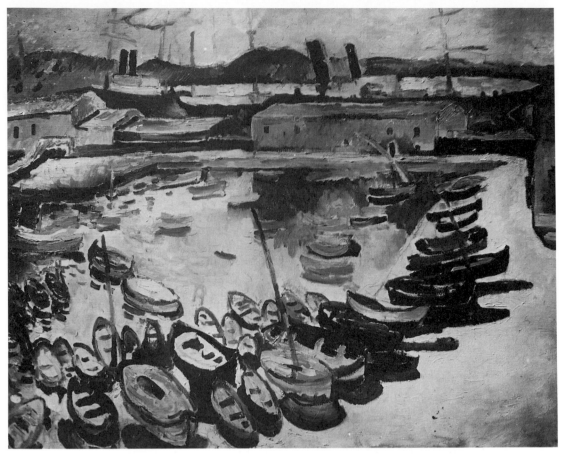

66 Georges Braque *The Harbor of La Ciotat* 1907

displayed in most of the other things; even in those of some young ones who grow old within two years! Look at Matisse and Friesz who become younger every year; they are more than ever filled with freshness and vigor.'

The intensity of life that shone in the Fauve canvases did not escape the other painters. Soon a number of Germans followed the example of the group and banded together in *Die Brücke*. In France, several young artists, such as Delaunay and Metzinger, were affected by Fauvism; Kandinsky went through a Fauve phase; and two Americans, Maurer and Hartley, submitted to Fauve influences. More tangible success came when some dealers, among them Vollard, Druet, and later Kahnweiler, began systematically to buy Fauve paintings. Yet the artists themselves felt unable to maintain for long the high pitch of expression that characterizes their Fauve production; they were even less able to go beyond it. One by one they turned toward other goals, searched for other solutions. Vlaminck reverted to a dark and dramatic

269

palette; Braque derived cubic forms from the example of Cézanne; Derain was tempted, though not quite convinced, by Cubism (he was with Picasso when the latter painted his *Demoiselles d'Avignon* in 1907); Friesz sought a closer link with the past; Dufy's evolution temporarily led him toward Cézanne; and van Dongen soon wished to please rather than to shock.

By 1908, three years after its first public appearance, Fauvism as a movement had ceased to be. Only Matisse and Marquet averted an open break with it; while they slowly developed new concepts, their Fauve experience always remained an integral part of their style. But whatever course they chose to follow, with Fauvism these men had definitely liberated painting from a too-slavish observation of nature, they had proclaimed the all-embracing power of color and paved the way for an abstract art that was to follow on their heels. Yet this had not exactly been their aim. It was Matisse who formulated what Fauvism had taught him when he wrote in 1908:

'An artist must recognize that when he uses his reason, his picture is an artifice and that when he paints, he must feel that he is copying nature—and even when he consciously departs from nature, he must do it with the conviction that it is only the better to interpret her.'

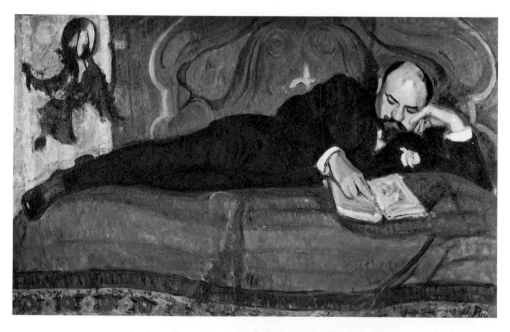

67 Jean Puy *Portrait of Ambroise Vollard* 1908

Chronology

1890 Suicide of van Gogh. 1891 Retrospective van Gogh exhibition at Independents; death of Seurat. 1892 Retrospective Seurat exhibition at Independents; Moreau named teacher at Ecole des Beaux-Arts; Rouault among his first pupils. 1893 Matisse enters Moreau's class. 1894 Vollard opens small gallery; Gauguin exhibits 40 Tahitian paintings at Durand-Ruel's. 1895 Gauguin leaves definitively for Tahiti; Vollard organizes first large Cézanne exhibition. 1896 Bing opens Art Nouveau gallery; Bonnard has first one-man show at Durand-Ruel's; Matisse exhibits at Salon. 1897 Marquet enters Moreau's class; Munch stays in Paris, shows with Independents; Caillebotte bequest of Impressionist paintings on display at Luxembourg Museum causes uproar. 1899 Signac publishes *De Delacroix au Neo-Impressionnisme*, becomes vice-president of Independents. 1900 Paris World's Fair; large Seurat show at *Revue Blanche*. 1901 Berthe Weill opens gallery exclusively for young artists; big van Gogh show at Bernheim-Jeune's; death of Toulouse-Lautrec. 1903 Death of Gauguin, Pissarro, Whistler; Salon d'Automne founded by Rouault, Marquet, Vuillard, and others; exhibition of Moslem Art in Paris; Vollard holds Gauguin retrospective. 1904 Salon d'Automne features shows of Cézanne, Redon, Renoir, and Lautrec; Druet opens gallery, begins to show interest in Fauves; Picasso settles in Paris. 1905 German Expressionist group *Die Brücke* founded in Dresden by Heckel, Schmidt-Rottluff, Nolde, Kirchner, and Pechstein; Independents organize important retrospectives of van Gogh and Seurat. 1906 Death of Cézanne; Salon d'Automne organizes very large Gauguin retrospective. 1907 Kahnweiler settles in Paris; Salon d'Automne features Cézanne retrospective and big show of Rodin drawings; Picasso paints first Cubist picture, *Les Demoiselles d'Avignon*.

1898–1908

Matisse 1898 29 years old, pupil of Moreau; short wedding trip to London to study Turner on Pissarro's advice; works with Marquet mornings in Luxembourg Gardens and afternoons in Arcueil; long sojourn in Corsica; discovers Japanese prints. 1899 Works in Carrière's Academy, meets Derain, Puy, Laprade; buys Cézanne *Bathers* from Vollard after first contemplating acquisition of van Gogh painting. 1900 For lack of money works with Marquet on ceiling decorations of Grand Palais for World's Fair; does first important sculptures. 1901–4 Years of poverty and worry. 1901 At van Gogh show meets Vlaminck through Derain, visits them in Chatou; shows with Independents, with whom he exhibits regularly until 1908. 1902 Exhibits at Berthe Weill's with Marquet (between 1902 and 1908 most of the Fauves show at *père* Soullié's and at B. Weill's); becomes member of hanging committee of Independents; retires discouraged to his home town of Bohain. 1903 Moves to 19, quai St-Michel, Paris; impressed with Moslem exhibition; shows with Salon d'Automne. 1904 Greatly impressed with Signac's work; friendship with Cross and Signac, whom he visits in St-Tropez; later goes to Collioure; becomes assistant secretary of Independents and member of Salon d'Automne, where he shows 14 works; exhibits at B. Weill's with Marquet, Manguin, Camoin, Puy; has

first one-man show at Vollard's (46 paintings), catalogue foreword by Roger Marx. **1905** Persuades Vlaminck and Derain to show with Independents and Salon d'Automne; friendship with the Steins who begin to buy his works (and Picasso's); works in Collioure with Derain; shows large pointillist composition *Luxe, Calme et Volupté* with Independents and exhibits 10 works at Salon d'Automne in same room with Vlaminck, Derain, Marquet, Manguin, Rouault, Puy, Camoin, etc.; term 'fauves' is coined by critic Vauxcelles; with Vlaminck, Derain, Manguin, Marquet also shows at B. Weill's; encourages Vollard to buy works of Derain and Puy. **1906** After completion of *Joy of Life*, shown with Independents, trip to North Africa; summer in Collioure; fall in Paris, buys Negro sculptures from Sauvage which he shows to Picasso, has one-man show at Druet's (55 paintings), shows with Libre Esthétique in Brussels and with Salon d'Automne (committee member). **1907** Acclaimed by Apollinaire; Leo Stein's enthusiasm for Matisse and Picasso wanes; shows group of drawings with Independents and *Le Luxe* with Salon d'Automne where it causes uproar; summer in Collioure. **1908** Leaves studio at quai St-Michel, moves to former Couvent des Oiseaux where he successfully opens his own academy; publishes 'Notes of a Painter'; on recommendation of Steichen, shows at Photo Secession Gallery (Stieglitz), New York; exhibits 30 paintings, drawings, and sculptures with Salon d'Automne (member of committee).

Marquet 1898 23 years old, pupil of Moreau; close friendship with Matisse, also with Camoin; on Moreau's advice copies Claude Lorrain, Poussin, Chardin, Velázquez, Veronese in the Louvre. **1899** Works mostly in Paris after leaving Ecole des Beaux-Arts, paints still lifes, nudes, landscapes. **1900** Trip to Vosges mountains; works with Matisse as before in Luxembourg Gardens and in Arcueil. **1901** Works in La Percaillerie in Normandy with Manguin, in and around Paris with Matisse, shows with Independents, with whom he exhibits regularly until 1908. **1902** Moves to quai de la Tournelle; paints views of Notre Dame; shows at B. Weill's, with whom he also exhibits in 1904 and 1905. **1903** Lives in avenue de Versailles; participates in foundation of Salon d'Automne, where he exhibits yearly until 1908. **1904** Member of hanging committee of Independents. **1905** Lives at quai des Grands-Augustins; signs contract with Druet; works on Riviera; visits Signac in St-Tropez; participates in historic Salon d'Automne show. **1906** Works in Paris, Le Havre (with Dufy does *Fourteenth of July* series), Trouville, and Ste-Adresse; shows at Druet's. **1907** Works in Paris, Le Havre, St-Jean-de-Luz; short trip to London with Camoin and Friesz; has one-man show at Druet's. **1908** Moves into Matisse's studio at quai St-Michel (Matisse keeps apartment below); enters Académie Ranson (run by Nabis group); works in Paris, Poissy, Collioure, Naples (with Manguin); becomes member of Salon d'Automne committee.

Vlaminck 1898 22 years old; military service in Vitré, Brittany, after short career as professional cyclist; strong anti-militarist feelings; attends session of Dreyfus trial, supporter of Zola and condemned captain. **1899** Continues military service in Vitré, writes first novel with friend, later to be illustrated by Derain. **1900** Released from service, has short anarchist phase, contributes articles to anarchist paper, solicits Zola for support; earns livelihood as musician (during World's Fair in 'gypsy' band,

later in theater orchestra) and paints during daytime; admires Impressionists, meets Derain, with whom he rents studio in Chatou. **1901** Deeply impressed by van Gogh show, tries but fails to buy painting by van Gogh; writes more novels illustrated by Derain. **1902** Works in Chatou; correspondence with Derain during latter's military service; frequent visits to Durand-Ruel; admiration for Cézanne. **1903** Works in Chatou. **1904** He and Derain meet Apollinaire. **1905** Shows for first time with Independents and in November at historic Salon d'Automne exhibition (urged by Matisse), also at B. Weill's, where he exhibits until 1908; meets Picasso; in Argenteuil café discovers and buys Negro sculptures, sells one mask to Derain who shows it to Matisse and Picasso. **1906** Vollard buys all of his output and continues acquisitions on monthly basis, which enables him to give up work as musician and to settle in Rueil near Chatou; avoids Paris and company of painters; prefers to work in Bougival, Marly, Villesnes, Chatou, Le Pecq, Argenteuil, Fécamp, etc.; continues to show with Independents (until 1907) and Salon d'Automne (until 1908). **1907** Works in Rueil. **1908** Joins Derain in Martigues, is fascinated by southern France but prefers to work on Seine banks; begins to paint in dark manner.

Derain 1898 18 years old; lives in Chatou; admires Louvre copies done with pure colors by friend Linaret, pupil of Moreau. **1899** Works at Carrière's, meets Matisse. **1900** Continues to work at Carrière's; meets Vlaminck, whom he encourages in his work, takes studio with him. **1901** Summer in Brittany, Belle-Isle (where Matisse and Puy had worked); in fall begins military service in Commercy (until 1904); paints only two landscapes and large canvas, *Dancing at Suresnes*, during service; correspondence with Vlaminck. **1904** Returns from military service, decides to work at Académie Julian against advice of Vlaminck; meets Apollinaire. **1905** With Matisse's help obtains parents' permission to become painter; in February Vollard, on Matisse's advice, buys all of his output, continues acquisitions on monthly basis; rents studio in rue Tourlaque (Montmartre); summer with Matisse in Collioure; urged by Matisse, shows for the first time with Independents and at historic Salon d'Automne exhibition (9 works), also at B. Weill's; toward end of year in Marseilles and L'Estaque; Vlaminck awakens his interest in Negro sculpture. **1906** Spring and fall in London (sent by Vollard), summer in L'Estaque, later Cassis; shows with Independents and Salon d'Automne (also in 1907 and 1908), and at B. Weill's. **1907** Works in Cassis, where he asks Vlaminck in vain to join him; makes woodcuts, tries his hand at sculpture; contact with Kahnweiler. **1908** Continues to live in rue Tourlaque where Vlaminck visits him frequently; in nearby rue Ravignan restaurant they gather with Picasso, van Dongen, Braque, etc.; works in Martigues with Vlaminck; is troubled and attracted by Cubism.

Friesz 1898 19 years old; obtains fellowship from Le Havre municipality to study art in Paris; in fall enters Bonnat's class at Ecole des Beaux-Arts. **1899** Works in Paris, Le Havre, Brittany. **1900** Shows for first time at official Salon. **1901** Lives in Montmartre, 12, rue Cortot (house of Suzanne Valadon, Utrillo, and many others); works in Falaise and Creuze, where he meets Guillaumin. **1902** Works in Paris and Creuze. **1903** Pissarro notices his work while he paints view of Pont-Neuf; shows with Independents, with whom he exhibits yearly until 1908. **1904** Abandons Impressionist style; has one-man show at Soullié's; begins to show with Salon

d'Automne, where he exhibits yearly until 1908. **1905** Lives at place Dauphine near Pont-Neuf (Camoin his neighbor); works in Antwerp, Honfleur, La Ciotat; shows at B. Weill's. **1906** In Antwerp with Braque whom he influences; later in Cassis. **1907** Works in La Ciotat, L'Estaque; contact with Kahnweiler, contract with Druet who gives him one-man show. **1908** Neighbor of Matisse in Couvent des Oiseaux; works in Rouen, Les Andelys, La Ciotat, L'Estaque; abandons Fauvism for more conventional composition; first purchases by Russian collector Shchukin whom he introduces to Matisse.

Dufy 1898 21 years old; released after short while from military service; close friendship with Friesz. **1899** Works in Le Havre. **1900** Comes to Paris on municipal fellowship, enters Bonnat's class at Ecole des Beaux-Arts; draws frequently for lack of colors; renews friendship with Friesz; shows at official Salon. **1901** Feels 'crushed' by Louvre masters, studies Cézanne at Vollard's and Impressionists in Caillebotte collection; influenced mainly by Pissarro. **1902** Sells for first time (pastel) to B. Weill; works in Paris, Le Havre, Ste-Adresse, Marseilles. **1903** Shows at B. Weill's, with whom he exhibits yearly until 1908, and with Independents, where he also shows regularly until 1908. **1904** Paints impressionistic views of Paris; spends summer in Ste-Adresse. **1905** Greatly impressed with Matisse show at Independents; works in Le Havre, makes many drawings, paints winter landscapes. **1906** Lives at 15, quai de Conti; works in Paris, Fécamp, Falaise, Ste-Adresse, Honfleur, and in Le Havre and Trouville with Marquet (*Fourteenth of July* series); has one-man show at B. Weill's; shows with Salon d'Automne, where he also exhibits the following year. **1907** Works mostly in Le Havre and Marseilles; has one-man show at Kahnweiler's; under Cézanne influence becomes interested in linear construction.

Braque 1898 16 years old, student in Le Havre. **1899** Leaves lycée in Le Havre, becomes apprentice house painter. **1900** Toward end of year moves to Paris; lives in Montmartre; continues apprenticeship as house painter. **1901** Military service, stationed near Le Havre. **1902** Returns from service; with parents' permission begins to study art in Paris at Académie Humbert; summer in Normandy; in fall enters Bonnat's class at Ecole des Beaux-Arts. **1903** Works at Ecole des Beaux-Arts; summer in Le Havre, Normandy; studies mostly primitive art in the Louvre, admires Poussin. **1904** Summer in Normandy and Brittany, meets Dufy in Honfleur; in fall leaves Bonnat's class, rents his own studio in Montmartre. **1905** Impressed by Seurat exhibition; works in Paris, Le Havre, Honfleur. **1906** Sees first Negro sculptures; shows for first time with Independents, sells all of his 7 paintings there (some bought by W. Uhde, 'discoverer' of the *douanier* Rousseau); proceeds enable him to join Friesz in Antwerp under whose influence he paints first Fauve pictures; spends fall in L'Estaque. **1907** With Dufy and Friesz founds Cercle de l'Art Moderne in Le Havre, first show of which includes works by Bonnard, Camoin, Cross, Derain, Manguin, Marquet, Matisse, Puy, Redon, Signac, Vallotton, Vlaminck, Vuillard, etc.; spends summer in La Ciotat; fall in L'Estaque, where change of style occurs; shows with Independents and Salon d'Automne; meets Kahnweiler. **1908** Works in L'Estaque, turns to Cubism; also in Le Havre and Honfleur; shows with Independents; at Salon d'Automne 5 of his 7 entries are

refused, withdraws them all and includes them in one-man show at Kahnweiler's with catalogue foreword by Apollinaire; begins to show at B. Weill's.

Camoin 1898 19 years old; at Ecole des Beaux-Arts since 1897 but sees little of Moreau; studies Cézanne's works in Vollard's window; friendship with Marquet with whom he makes drawings in streets and music halls. **1899–1902** Military service, first in Arles where he visits van Gogh's doctor, then Avignon, later Aix-en-Provence where he pays frequent visits to Cézanne, subsequently keeps up friendship through correspondence. **1902** Returns to Paris. **1903** Begins to show with Independents, where he exhibits regularly until 1908, and at B. Weill's, where he also shows frequently thereafter. **1904** Works in Capri; shows at Salon d'Automne where he exhibits yearly until 1908. **1905** Lives at place Dauphine (near Friesz); works in Agay (with Marquet) and Cassis; visits Signac in St-Tropez; participates in historic Salon d'Automne show. **1906** Works in his home town, Marseilles. **1907** Trip to Spain.

Puy 1898 22 years old; arrives in Paris to work at Académie Julian. **1899** After sojourn in Brittany meets Matisse at Carrière's Academy, who reveals Chardin and Poussin to him; shows with Independents, with whom he exhibits regularly afterward. **1900** Closer ties with Matisse and Derain at Carrière's; studies Cézanne's work at Vollard's. **1903** Summer in Belle-Isle; spends almost every summer in Brittany; shows for first time at B. Weill's. **1904** Lives in rue Lepic (Montmartre); begins to exhibit at Salon d'Automne, where he also shows in historic 1905 show, as well as in 1906 and 1908; summer in Brittany. **1905** Matisse visits Puy with Vollard who buys his production of last 5 years (continues acquisitions regularly until 1924); summer in Concarneau, Brittany. **1907** Summer in Talloires (Alps).

Manguin 1898 24 years old, son of well-to-do family. **1902** Shows for first time with Independents, exhibits there yearly until 1908. **1903** Shows at B. Weill's, begins to show at Salon d'Automne (becomes member the following year), where he exhibits regularly until 1908. **1904** Member of hanging committee of Independents. **1905** Introduces Matisse to Leo Stein; participates in historic Salon d'Automne show. **1906** Works in Provence, St-Tropez; member of Salon d'Automne jury. **1907** Works in St-Tropez, where he ultimately settles.

Valtat 1898 29 years old, friendship with Maillol. **1900** Lives in Anthéor (Riviera). **1902** Trip to Italy; moves to Montmartre. **1904** Contact with Vollard who begins to buy his works; shows with Independents (one painting lent by Renoir) and Salon d'Automne. **1905** Participates in historic show at Salon d'Automne. **1906** Lives in Anthéor; shows with Independents and Salon d'Automne; exhibits regularly with latter until 1908.

Van Dongen 1898 21 years old; came to Paris the previous year from Holland; feels handicapped as an alien; until 1908 earns his livelihood with all kinds of small jobs: does lettering for a printer, works as mover, wrestler in fairs, newspaper vendor in streets of Paris, stage extra, sometimes tramp, student whenever he has time; makes drawings for minor publications. **1900** Works as guide at World's Fair. **1904** Lives at

impasse Girardon (Montmartre); shows with Independents, with whom he also exhibits in 1905, 1906, and with Salon d'Automne, where he shows again in 1905, 1906, 1908. **1905** Has one-man show at Vollard's; begins to show at B. Weill's; meets Picasso. **1906** Lives in Montmartre, 14, rue Ravignan (famous Bateau-Lavoir), neighbor of Picasso; has one-man show at Druet's; paints scenes of Folies-Bergère. **1908** Works in Rotterdam; has one-man show at Bernheim-Jeune's.

Rouault **1898** 27 years old; appointed curator of Moreau collection at 2,400 francs a year; breaks with academicism; passes through spiritual crisis; shows with official Salon where he exhibits regularly until 1901. **1901** Meets J.-K. Huysmans at Abbaye de Liguge; great interest in religion. **1902** Sickness, convalescence in Alps; isolation renews his vision, inaugurates new style; does mostly watercolors. **1903** Convalescence in Alps; active in foundation of Salon d'Automne. **1904** Lives in rue Pierre Leroux; meets Léon Bloy; shows group of 44 works at Salon d'Automne, mostly drawings and watercolors of circus performers. **1905–6** Shows with Independents and Salon d'Automne (committee member), participates in historic *fauves* show. **1906** Work is laughed at in Salon d'Automne; begins to show great interest in ceramics (Vollard sends Matisse, Derain, Vlaminck, Puy, Rouault, etc., to ceramist Jean Metthey and commissions plates and vases). **1907** Shows ceramics with Independents and mostly Clowns and Lawyers with Salon d'Automne. **1908** Marries; shows with Independents and Salon d'Automne (committee member), where he again exhibits numerous ceramics.

NOTE

This introduction was written for the catalogue of the first large Fauves exhibition organized in the United States. It was held at the Museum of Modern Art, New York, October 8, 1952–January 4, 1953, and was subsequently shown in Minneapolis, San Francisco, and Toronto. The exhibition was assembled in collaboration with all the artists still alive then, who also provided information for the essay, as well as for the individual chronologies.

This text appeared without notes.

Bibliography

Writings of John Rewald arranged in chronological order by **Books**, **Exhibition Catalogues** (usually with introductions by him), **Articles**, and **Book Reviews**. Where there are several editions and/or translations of the same publication, these are listed immediately following the first edition. All publications preceded by an asterisk are reprinted in *Studies in Impressionism* or *Studies in Post-Impressionism*.

BOOKS

Cézanne et Zola. Sorbonne doctoral thesis. Paris: A. Sedrowski, 1936.
Cézanne et Zola. Translated from the French by Manjiro Mori. Tokyo: 1943 [Pirated Japanese edition].

Paul Cézanne—Correspondance. Paris: Bernard Grasset, 1937; 1949; nouvelle édition revisée et augmentée, 1978.
Paul Cézanne—Briefe. Translated by Jakob Vontobel [John Rewald]. Zurich, Leipzig: Eugen Rentsch, n.d. [1939]; new and revised edition, translated by John Rewald. Zurich: Diogenes Verlag, 1962; 1979.
Paul Cézanne—Letters. Translated by Marguerite Kay. London: Bruno Cassirer, 1941; 1944; 1946; revised and enlarged edition, 1976; simultaneous American edition, New York: Hacker Art Books, 1976. A completely revised, newly translated (by Seymour Hacker), and augmented edition is being prepared by Hacker Art Books, 1984.
Cézanne Correspondance. Translated by Masuo Iwata. Tokyo: Kusakabe, 1942 [Pirated Japanese edition].
Paul Cézanne Listy. Translated by Joanna Guze. Warsaw: Panstwowy Instytut Wydawniczy, 1968.
Paul Cézanne Levelei. Budapest: Corvina Kiado, 1971.
Paul Cézanne Kirjeenvaihto. Translated by Riita Salmi and Riita Kaipainen. Helsinki: Suomen Taiteilijaseura, 1984.

Paul Gauguin. Paris: Editions Hypérion, 1938; Paris-Limoges: 1941; New York, London: Hyperion Press, 1938; translated into German by John Rewald. Paris: Hyperion, 1938.

Cézanne, sa vie, son oeuvre, son amitié pour Zola. Completely revised and enlarged edition of the doctoral thesis. Paris: Albin Michel, 1939.
Paul Cézanne—A Biography. Slightly condensed translation by Margaret H. Liebman. New York: Simon & Schuster, 1948.
The Ordeal of Paul Cézanne. London: Theodore Brun and Phoenix House, n.d. [1950].
Paul Cézanne. London: Spring Books, 1959; 1965.
Paul Cézanne—A Biography. New York: Schocken Books, 1968 (paperback).

Camille Pissarro at the Musée du Louvre. Paris, Brussels: The Marion Press, 1939; simultaneous French edition.

Maillol. Paris: Editions Hypérion, 1939; London, New York: Hyperion Press, 1939.

**Paul Gauguin, Letters to Ambroise Vollard and André Fontainas*. San Francisco: Grabhorn Press, 1943. (Translated from the French manuscript by Gerstle Mack.)

The Woodcuts of Aristide Maillol—A Complete Catalogue. New York: Pantheon Books, 1943; 1951.

Georges Seurat. Translated from the French manuscript by Lionel Abel. New York: Wittenborn and Company, 1943; second revised edition, 1946.
Georges Seurat. Enlarged and revised edition. Paris: Albin Michel, 1948 (with an additional chapter, 'Querelles d'artistes'; for this chapter, translated by Norma Broude, see *Seurat in Perspective*, Englewood Cliffs, N.J.: Prentiss-Hall, 1978, pp. 103–7).
Georges Seurat. Translated from the French by Vera Smetanova. Abridged edition. Prague: Nakladatelstvi Ceskoslovenskych Vytvarnych Umelcu, 1963.

Camille Pissarro, Letters to His Son Lucien. Edited by John Rewald with the assistance of Lucien Pissarro. Translated from the French manuscript by Lionel Abel. New York: Pantheon Books, 1943; simultaneous English edition, London and Henley-on-Thames: Kegan Paul, 1943.
Camille Pissarro, Lettres à son fils Lucien. Paris: Albin Michel, 1950. In contrast to the editions of 1943, this edition—as well as all subsequent ones—contains a few additional letters by Camille Pissarro but, above all, a number of letters by Lucien to his father.
Camille Pissarro, Briefe an seinen Sohn Lucien. Translated from the French by Hans Kuhner. Zurich: Eugen Rentsch Verlag, 1953.
Camille Pissarro, Letters to His Son Lucien. Edited by John Rewald with the assistance of Lucien Pissarro. Revised and enlarged edition. Mamaroneck, N.Y.: Paul P. Appel, 1972; simultaneous English edition, London and Henley-on-Thames: Routledge & Kegan Paul, 1972.
Camille Pissarro, Cartas a Lucien. Translated from the French by Carina P. de Pagés Larraya. Barcelona: Muchnik Editores, 1979.
Camille Pissarro, Letters to His Son Lucien. Edited by John Rewald with the assistance of Lucien Pissarro. [Revised and enlarged.] Fourth edition. London and Henley-on-Thames: Routledge & Kegan Paul, 1980.

Camille Pissarro, Letters to His Son Lucien. Edited by John Rewald with the assistance of Lucien Pissarro. Revised and corrected edition. Santa Barbara and Salt Lake City: Peregrine Smith, Inc., 1981 (paperback).

**Degas—Works in Sculpture—A Complete Catalogue*. Translated from the French manuscript by John Coleman and Noel Moulton. New York: Pantheon Books, 1944.
Degas—L'Oeuvre sculpté. Photographs by Leonard von Matt. Zurich: Manesse (Conzett & Huber), 1956. Simultaneous German and English editions:
Degas—Das plastische Werk. Photographs by Leonard von Matt. Zurich: Manesse (Conzett & Huber), 1956.
Complete Degas Sculpture. Photographs by Leonard von Matt. London: Thames and Hudson, 1956. New York: Harry N. Abrams, 1956.

Renoir Drawings. New York: H. Bittner, 1946; 1958.

The History of Impressionism. New York: Museum of Modern Art, 1946; enlarged and revised edition, 1955; revised edition, 1961; revised edition, 1973; 1980 (also in paperback); simultaneous English edition, London: Secker & Warburg, 1980.
Storia Dell'Impressionismo. Preface by Roberto Longhi. Translated from the English by Antonio Boschetto. Florence: Sansoni, 1949.
Histoire de l'Impressionnisme. Translated by Nancy Goldet-Bouwens. Paris: Albin Michel, 1955; Paris: Club des Editeurs, 1959; Paris: Albin Michel (Livre de Poche), 1965 (2 vols., paperback, several editions).
Die Geschichte des Impressionismus. Translated by Romana Segantini. Zurich: Rascher, 1957; translated by Romana Segantini. Revised by R. Gutbrod and John Rewald. Cologne: DuMont, 1965; 1967; condensed edition, 1979, 1984.
The History of Impressionism. Russian translation by Polina Melkova. Moscow, 1959.
Historia del Impresionismo. Translated by Josep Elias. Barcelona: Seix Barral, 1972 (2 vols., paperback).

Istoria impresionismului. Translated by Irina Mavrodin. Bucharest: Editura Meridiane, 1974 (2 vols., paperback).

La Storia dell Impressionismo. New translation based on the revised edition of 1973. Milan: Arnoldo Mondadori, 1976 (paperback only).

De impressionisten. Translated from the German by O. M. Maters and E. Dabekaussen. De Bilt: Cantecleer bv, 1982 (Dutch edition, paperback only).

Edouard Manet Pastels. Oxford: Bruno Cassirer, 1947.

Cézanne—Carnets de dessins—Préface et catalogue raisonné. Paris: Quatre Chemins Editart, 1951.

Paul Cézanne Sketchbook 1875–1885. Translated by Olivier Bernier. Modified version. New York: Harcourt Brace Jovanovich, 1982, Johnson Reprint Corporation.

Paul Gauguin. New York: Harry N. Abrams, 1952; Portfolio Edition, 1954.

Post-Impressionism—From Van Gogh to Gauguin. New York: Museum of Modern Art, 1956; 1962; revised edition, 1978; 1982, reprinted 1984. Simultaneous English editions, London: Secker & Warburg, 1978; 1982.

Von van Gogh zu Gauguin—Die Meister des Nachimpressionismus. Translated by Ursula Lampe and Anni Wagner. Munich, Vienna, Basel: Kurt Desch, 1957; translation revised by Karl Gutbord and submitted to John Rewald. Cologne: DuMont Schauberg, 1967.

Le Post-Impressionnisme de van Gogh à Gauguin. Translated from the English by Alice Rewald. Paris: Albin Michel, 1961.

Post-Impressionism. Russian translation by Polina Melkova. Moscow, 1962.

Il Post-Impressionismo Da van Gogh a Gauguin. Translated by Nuccia Agazzi. Florence: Sansoni, 1967 (paperback).

Postimpresionismul de la van Gogh la Gauguin. Translated by Gabriel Gafija. Bucharest: Editura Meridiane, 1978 (2 vols., paperback).

El postimpresionismo De van Gogh a Gauguin. Translated by Ema Fondevila y Emilio Muniz. Madrid: Alianza Editorial, 1982 (paperback).

Gauguin Drawings. New York, London: Thomas Yoseloff (A Bittner Art Book), 1958.

Seurat—L'oeuvre peint, biographie et catalogue critique. With Henri Dorra. Paris: Les Beaux-Arts, 1959.

Cézanne, Geffroy et Gasquet (suivi de Souvenirs sur Cézanne de Louis Aurenche et de Lettres inédites). Paris: Quatre Chemins Editart, 1959.

Henri-Edmond Cross—Carnet de dessins. Paris: Berggruen & Cie., 1959.

Paul Gauguin—A Sketchbook. With Raymond Cogniat. New York, Paris: Hammer Galleries, 1962; simultaneous French edition: *Paul Gauguin—Carnet de Croquis.*

Meadmore, W. S. *Lucien Pissarro.* Introduction by John Rewald. London, Fakenham, and Reading: Cox & Wyman, 1962; New York: Alfred A. Knopf, 1963.

Camille Pissarro. New York: Harry N. Abrams, 1963.

Pissarro. Paris: Nouvelles Editions françaises, n.d. [1963].

Pissarro. Translated from the English by Suzanne B. Milezewsky. Cologne: DuMont Schauberg, 1963; 1968.

Pissarro. Japanese translation by Bijutsu Shuppan-sha. Tokyo, 1968.

Camille Pissarro in Venezuela. New York: Hammer Galleries, 1964.

Giacomo Manzù. Salzburg: Galerie Welz, 1966.

Giacomo Manzù. [Translated from the German by E. L. Rewald, revised by John Rewald.] London: Thames and Hudson, 1967.

Giacomo Manzù. Greenwich, Conn.: New York Graphic Society, 1967.

Giacomo Manzù. Italian translation by Luisa Franchi dell'Orto. Milan, Rome: Toninelli, 1973; simultaneous Japanese edition, Tokyo, 1973.

Salomon, Jacques. *Vuillard*. Preface by John Rewald. Paris: Gallimard, 1968.

Adhémar, Jean, and Cachin, Françoise. *Edgar Degas Gravures et Monotypes*. Introduction by John Rewald. Paris: Arts et Métiers Graphiques, 1973.

50 acquarelli di Giorgio Morandi. 'Morandi Remembered' by John Rewald. With contributions also by V. Zurlini, Renato Guttuso, and Jean Leymarie. Turin: Ilte, 1973.

Shore, Stephen. *The Gardens at Giverny*. Introduction by John Rewald. New York: Aperture, 1983; simultaneous French edition. Excerpt, *Art News* 83 (Jan. 1984): 104–8.

Paul Cézanne: The Watercolors, A Catalogue Raisonné. Boston: New York Graphic Society, 1983; London: Thames and Hudson, 1983.

Les Aquarelles de Cézanne. Translated by Jacques Chavy. Paris: Arts et Métiers Graphiques, 1983.

Aspects of Monet. Edited by John Rewald and Frances Weitzenhoffer. Foreword by John Rewald. New York: Harry N. Abrams, 1984.

Studies in Impressionism. Edited by Irene Gordon and Frances Weitzenhoffer. London: Thames and Hudson, 1985.

EXHIBITION CATALOGUES

Van Gogh (Exposition Internationale de 1937, Groupe I, Classe III). In collaboration with René Huyghe and Michel Florisoone. Catalogue: special issue of *L'Amour de l'Art*. Paris, Musée d'Art Moderne, 1937.

Hommage to Paul Cézanne. Foreword and comments on pictures. London: Wildenstein & Co., July 1939.

Modern Drawings. With Monroe Wheeler. New York: Museum of Modern Art, 1944.

The French Impressionists. Foreword. Palm Beach, Fla.: Society of the Four Arts, Feb. 15–Mar. 17, 1946.

Nineteenth Century French Drawings. 'From Ingres to Seurat.' Foreword. San Francisco: California Palace of the Legion of Honor, Mar. 8–Apr. 6, 1947.

Pierre Bonnard. Cleveland and New York: Cleveland Museum of Art and Museum of Modern Art, New York, 1948.

French Painting Since 1870, Lent by Maurice Wertheim. In collaboration with Frederick B. Deknatel, Agnes Mongan, and Frederick S. Wight. Cambridge, Mass.: Fogg Museum of Art, Harvard University, June 1–Sept. 7, 1946; Musée de la Province de Québec, July 12–Aug. 7, 1949.

Monet and the Beginnings of Impressionism (Twentieth Anniversary Exhibition). Foreword. Manchester, N.H.: The Currier Gallery of Art, Oct. 8–Nov. 6, 1949.

One Hundred Master Drawings. Edited by Agnes Mongan. Several catalogue entries. Cambridge, Mass.: Fogg Museum of Art, Harvard University, 1949.

Henri-Edmond Cross. Introduction. New York: Fine Arts Associates [Otto M. Gerson], Apr. 16–May 5, 1951.

Les Fauves. New York: Museum of Modern Art, Oct. 8, 1952–Jan. 4, 1953; The Minneapolis Institute of Arts, Jan. 21–Feb. 22, 1953; San Francisco Museum of Art, Mar. 13–Apr. 12, 1953; The Art Gallery of Toronto, May 1–May 31, 1953.

French Art Around 1900, From Van Gogh to Matisse. Introduction. New York: Fine Arts

Associates [Otto M. Gerson], Oct. 26–Nov. 21, 1953.

Seurat and his Friends. New York: Wildenstein Galleries, Nov. 18–Dec. 26, 1953.

Three Generations of Pissarros, 1830–1954. Introduction. London: O'Hana Gallery, Apr. 22–May 15, 1954.

Van Gogh. Foreword. Wildenstein Galleries, Mar. 24–Apr. 30, 1955.

Degas' Original Wax Sculptures. Foreword. New York: M. Knoedler & Co., Nov. 9–Dec. 3, 1955.

Moïse Kogan, 1879–1948. Preface. Paris: Galerie Zak, Nov. 26–Dec. 17, 1955.

Manzù. Foreword. New York: The World House Galleries, Apr. 24–May 18, 1957.

Aristide Maillol. Introduction. New York: Paul Rosenberg & Co., Mar. 3–29, 1958.

Paintings, Watercolors and Sculptures from the Collection of Mr. and Mrs. Henry Pearlman. Introduction. New York: M. Knoedler & Co., Jan. 27–Feb. 21, 1959.

The Collection of Mr. and Mrs. John Rewald. Foreword. Los Angeles: Municipal Art Gallery, Mar. 31–Apr. 19, 1959.

Twenty-six Original Copperplates engraved by Degas. Foreword. Beverly Hills, Calif.: Frank Perls Gallery, Nov. 9–Dec. 5, 1959.

The John Hay Whitney Collection. Catalogue entries. London: The Tate Gallery, Dec. 16, 1960–Jan. 29, 1961.

Redon—Moreau—Bresdin. In collaboration with D. Ashton and H. Joachim. New York: Museum of Modern Art, Dec. 4, 1961–Feb. 4, 1962; The Art Institute of Chicago, Mar. 2–Apr. 15, 1962.

Birth of Impressionism. Introduction. New York: Wildenstein Galleries, Mar. 7–Apr. 6, 1963.

Balthus Drawings. 'Thoughts on Drawings by Balthus.' New York: E. V. Thaw & Co., Nov. 26–Dec. 21, 1963; 'Thoughts on Drawings by Balthus.' Partially reprinted, Chicago: Arts Club of Chicago, Sept. 21–Oct. 28, 1964.

Etchings by Edgar Degas. Foreword. Chicago: Renaissance Society at the University of Chicago, May 4–June 12, 1964.

C. Pissarro. Foreword. New York: Wildenstein Galleries, Mar. 25–May 1, 1965.

Impressionist Treasures. Foreword. New York: M. Knoedler & Co., Jan. 12–29, 1966.

French Paintings from the Collections of Mr. and Mrs. Paul Mellon and Mrs. Mellon Bruce (Twenty-fifth Anniversary Exhibition, 1941–1966). Introduction. Washington, D.C.: National Gallery of Art, Mar. 17–May 1, 1966.

Morandi. 'Visit with Morandi.' New York: Albert Loeb & Krugier Gallery, May 1967.

100 European Paintings & Drawings from the Collection of Mr. and Mrs. Leigh B. Block. Introduction. Washington, D.C.: National Gallery of Art, May 4–June 11, 1967; Los Angeles County Museum of Art, Sept. 21–Nov. 2, 1967.

Cézanne (An Exhibition in Honor of the Fiftieth Anniversary of the Phillips Collection). Introduction. Washington, D.C.: The Phillips Collection, Feb. 27–Mar. 28, 1971; Chicago: The Art Institute, Apr. 17–May 16, 1971; Boston: Museum of Fine Arts, June 1–July 3, 1971.

Vieira da Silva Paintings 1967–71. 'A Visit with Vieira da Silva.' New York: M. Knoedler & Co., May 4–June 5, 1971; *Vieira da Silva*. 'Une visite à Vieira da Silva.' Geneva: Artel Gallery, May–June 1947; 'Et besog hos Vieira da Silva.' Aalborg, Denmark: Nordjyllands Kunstmuseum, Apr. 1–30, 1978.

Cent Ans d'Impressionnisme: Hommage à Paul Durand-Ruel, 1874–1974. Notes Biographiques. Paris: Galerie Durand-Ruel, Jan. 15–Mar. 15, 1974.

Exposition Cézanne. Essay. Tokyo: Musée National d'Art Occidental, Mar. 30–May 19, 1974; Kyoto: Musée de la Ville de Kyoto, June 1–July 17, 1974; Fukuoka: Centre Culturel de Fukuoka, July 24–Aug. 18, 1974.

Aristide Maillol: 1861–1944. 'Maillol Remembered.' New York: The Solomon R. Guggenheim Museum, 1975; *Maillol*. 'Erinnerungen an Maillol.' Baden-Baden: Staatliche Kunsthalle, June 17–Sept. 3, 1978; *Maillol au Palais des Rois de Majorque*. 'Souvenirs de Maillol.' Perpignan: Musée Hyacinthe Rigaud, Mar. 15–May 30, 1979.

*The Complete Sculpture of Degas. 'Degas's Bronzes—An Afterword.' London: The Lefevre Gallery, Nov. 18–Dec. 21, 1976.

Cézanne—The Late Work. Edited by William Rubin. 'The Last Motifs at Aix' and catalogue entries. New York: Museum of Modern Art, 1977; Paris: Grand Palais, 1978.

Small French Paintings from the Bequest of Ailsa Mellon Bruce. Introduction. Washington, D.C.: National Gallery of Art, 1978

(permanent exhibition).

Camille Pissarro 1830–1903. Introduction. London: Hayward Gallery, Oct. 30, 1980–Jan. 11, 1981; Paris: Grand Palais, Jan. 30–Apr. 27, 1981; Boston: Museum of Fine Arts, May 19–Aug. 9, 1981.

The John Hay Whitney Collection. Introduction and a number of catalogue entries. Washington, D.C.: National Gallery of Art, May–Nov. 1983.

ARTICLES

'Cézanne au Château Noir.' With Leo Marschutz. L'Amour de l'Art 16 (Jan. 1935): 15–21.

'Cézanne und der "Jas de Bouffan."' With Leo Marschutz. Forum 5 (1935): 252–53.

'Cézanne au Louvre.' L'Amour de l'Art 16 (Oct. 1935): 283–88.

'Une Copie par Cézanne d'après le Greco.' Gazette des Beaux-Arts, n.s. vol. 6, no. 15 (Feb. 1936), pp. 118–21.

'L'Oeuvre de jeunesse de Camille Pissarro.' L'Amour de l'Art 17 (Mar. 1936): 141–45.

'Sources d'Inspiration de Cézanne.' L'Amour de l'Art, special issue. 5 (May 1936): 188–95.

'Cézanne et la Provence.' With Leo Marschutz. Le Point, special issue. 4 (Aug. 1936): 2–34.

'Van Gogh en Provence.' L'Amour de l'Art 17 (Oct. 1936): 289–98.

'Paysages de Paris de Corot à Utrillo.' La Renaissance, special issue. 20 (Jan.–Feb. 1937): 5–52.

'Un Portrait de la Princesse de Metternich par Edgar Degas.' L'Amour de l'Art 18 (Mar. 1937): 89–90.

'Vincent van Gogh.' Preface by Jean Cassou. La Renaissance, special supplement. July 1937, pp. 2–8.

'L'Art français dans les écoles françaises.' Marianne, Apr. 27, 1938.

'Achille Emperaire, ami de Paul Cézanne.'

L'Amour de l'Art 19 (May 1938): 151–58.

'Camille Pissarro: His Work and Influence.' Burlington Magazine 72 (June 1938): 280–91.

'Les Ateliers de Maillol.' Le Point, special issue. (Nov. 1938): 200–240.

'Cézanne et ses logis à Aix-en-Provence.' Beaux-Arts (Jan. 20, 1939): 3.

'Réflexions autour de la Pomone d'Aristide Maillol.' La Renaissance 22 (Mar. 1939): 9–16.

'Paul Cézanne: New Documents for the Years 1870–1871.' Burlington Magazine 74 (Apr. 1939): 163–71.

'For Aristide Maillol on his Eightieth Birthday.' Art News 40 (Dec. 1, 1941): 19.

'Van Gogh vs. Nature: Did Vincent or the Camera Lie?' Art News 41 (Apr. 1, 1942): 8–11.

'Camille Pissarro in the West Indies.' Gazette des Beaux-Arts, n.s. vol. 6, no. 22 (Oct. 1942), pp. 57–60.

'For Pierre Bonnard on his Seventy-fifth Birthday.' Art News 41 (Oct. 1, 1942): 22–25.

'Corot Sources: The Camera Tells.' Art News 41 (Nov. 15, 1942): 11–13.

'Pissarro's Paris and his France.' Art News 42 (Mar. 1, 1943): 14–17.

'Ingres and the Camera: Two Precionists Look at Rome.' Art News 42 (May 1, 1943): 8–10.

'Monet, Solid Builder of Impressions.' *Art News* 42 (Oct. 1, 1943): 22–25.

'Durand-Ruel: 140 Years, One Man's Faith.' *Art News* 42 (Dec. 1, 1943): 23–25; reprinted in *The Art World—A Seventy-Five Year Treasury of Art News*. New York: Art News Books, 1977, pp. 177–79.

'As Cézanne Recreated Nature.' *Art News* 43 (Feb. 15, 1944): 9–13.

'The Camera Verifies Cézanne Watercolors.' *Art News* 43 (Sept. 1944): 16–18.

'The Cone Collection in Baltimore.' *Art in America* 32 (Oct. 1944): 200–204.

'Proof of Cézanne's Pygmalion Pencil.' *Art News* 43 (Oct. 1, 1944): 17–20.

'Degas Dancers and Horses Seen in Two and Three Dimensions.' *Art News* 43 (Oct. 15, 1944): 20–23.

'Jacques Lipchitz's Struggle.' *Museum of Modern Art Bulletin* 12 (Nov. 1944): 7–9.

*'Depressionist Days of the Impressionists; A Fortieth Anniversary of Durand-Ruel's Exhibition in London.' *Art News* 43 (Feb. 1, 1945): 12–14; reprinted in an expanded version as 'Jours sombres de l'Impressionnisme.' *L'Oeil* 223 (Feb. 1974): 14–19.

*'Auguste Renoir and his Brother.' *Gazette des Beaux-Arts*, n.s. vol. 6, no. 27 (Mar. 1945), pp. 171–88.

'Last Visit with Maillol.' *Magazine of Art* 38 (May 1945): 164–67.

'Monet Serves his Home Village.' *Art News* 44 (May 1, 1945): 20–22.

'Pissarro and his Circle.' *Art News* 44 (Oct. 15, 1945): 16–18.

*'Realism of Degas.' *Magazine of Art* 39 (Jan. 1946): 13–17.

'Future Impressionists at the Café Guerbois.' *Art News* 45 (Apr. 1946): 22–25 (chapter from *The History of Impressionism*).

'Degas's Sculpture; A Reply to "Arabesques in Bronze."' *Metropolitan Museum of Art Bulletin* 5 (July 1946): 46–48.

*'Degas and his Family in New Orleans.' *Gazette des Beaux-Arts*, n.s. vol. 6, no. 30 (Aug. 1946), pp. 105–26; reprinted in *Edgar Degas His Family and Friends in New Orleans*. With additional essays by James B. Byrnes and Jean Sutherland Boggs. New Orleans: Isaac Delgado Museum of Art, May 2–June 16, 1965.

'French Drawing: The Climax; Its West Coast Premiere in San Francisco.' *Art News* 46 (Apr. 1947): 29–32.

'Félix Fénéon.' *Gazette des Beaux-Arts*, n.s. vol. 6, no. 32 (July 1947), pp. 45–62; vol. 6, no. 34 (i.e. no. 33) (Feb. 1948), pp. 107–26.

'Thadée Natanson.' *Maandblad voor Beeldende Kunsten* 24 (Oct. 1948): 240–41.

'Cézanne's Theories about Art.' *Art News* 47 (Nov. 1948): 29–35.

'Van Gogh, the Artist and the Land.' *Art News Annual* 19 (1949): 64–73.

*'Seurat: The Meaning of the Dots.' *Art News* 48 (Apr. 1949): 24–27.

'Extraits du journal inédit de Paul Signac, 1894–1898.' Ed. *Gazette des Beaux-Arts*, n.s. vol. 6, no. 36 (July 1949), pp. 97–128; vol. 6, no. 39 (Apr. 1952), pp. 265–284; vol. 6, no. 42 (July 1953), pp. 27–57.

'Lucien Pissarro: Letters from London, 1883–1891.' *Burlington Magazine* 91 (July 1949): 188–92.

'Et Besøg Hos Raoul Dufy.' *Grønningens Medlemmer* (Copenhagen), Dec. 1949, pp. 7–9.

'Félix Fénéon, Critique d'Art.' *Maandblad voor Beeldende Kunsten* 26 (Mar. 1950): 67–71.

'Cézanne and Victor Chocquet.' *Columbus Gallery of Fine Arts Bulletin* vol. 20, nos. 3–4 (Summer 1950), pp. 3–6; reprinted in *Art Quarterly* vol. 13, no. 3 (1950), pp. 251–53.

'Cézanne Dessinateur.' *Médecine de France* 27 (Dec. 1951): 29–32.

'Gachet's Unknown Gems Emerge.' *Art News* 51 (Mar. 1952): 16–19.

'Modern Fakes of Modern Pictures.' *Art News* 52 (Mar. 1953): 16–21.

'Un article inédit sur Paul Cézanne en 1870.' *Arts*, July 21–27, 1954, p. 8.

'Collection of Carroll S. Tyson, Jr., Philadelphia, U.S.A.' *Connoisseur*, Am. ed. 134 (Sept. 1954): 62–68; reprinted *Philadelphia*

Museum of Art Bulletin 59, no. 280 (Winter 1964): 59–62.

'French Paintings in the Collection of Mr. and Mrs. John Hay Whitney.' *Connoisseur*, Am. ed. 137 (Apr. 1956): 134–40.

*'Quelques notes et documents sur Odilon Redon.' *Gazette des Beaux-Arts*, n.s. vol. 6, no. 48 (Nov. 1956), pp. 81–124.

'The Genius and the Dealer.' *Art News* 58 (May 1959): 30–31, 62–65.

'Birth of Impressionism.' *Art News* 62 (Mar. 1963): 30–31.

'Here is a Step by Step Study of Degas Etchings.' *Chicago Tribune*, May 24, 1964, p. 2.

'How New York Became the Capital of 19th Century Paris.' *Art News* 64 (Jan. 1966): 34–36.

'Une Lettre inédite de Paul Cézanne.' *Festschrift Kahnweiler*, Verlag Gerd Hatje, Stuttgart, 1966, pp. 242–48.

'Notes sur deux tableaux de Claude Monet.' *Gazette des Beaux-Arts*, n.s. vol. 6, no. 70 (Oct. 1967), pp. 245–48.

*'Chocquet and Cézanne.' *Gazette des Beaux-Arts*, n.s. vol. 6, no. 74 (July–Aug. 1969), pp. 33–96.

*'Vincent Van Gogh 1890–1970.' *Museumjournaal* 15, no. 4 (Aug.–Sept. 1970): 209–19; reprinted as 'Vincent Van Gogh, 1880–1971.' *Art News* 69 (Feb. 1971): 53–55, 62–65.

*'Cézanne and his Father.' National Gallery of Art (Washington, D.C.), *Studies in the History of Art*, 1971–72, pp. 38–62.

'Should Hoving be De-accessioned?' *Art in America* 61 (Jan. 1973): 24–30.

*'Theo van Gogh, Goupil and the Impressionists.' *Gazette des Beaux-Arts*, n.s. vol. 6, no. 81 (Jan. 1973), pp. 1–64 and (Feb. 1973), pp. 55–108. Here reprinted as 'Theo van Gogh as art dealer.'

*'The Impressionist Brush.' *Metropolitan Museum of Art Bulletin*, special issue. Vol. 32, no. 3 (1973–74), pp. 2–56.

*'Cézanne et Guillaumin.' *Etudes d'art français offertes à Charles Sterling*. Paris: Presses Universitaires de France, 1975, pp. 343–53.

'Some Entries for a New Catalogue Raisonné of Cézanne's Paintings.' *Gazette des Beaux-Arts*, n.s. vol. 6, no. 86 (Nov. 1975), pp. 158–68.

'Letter to the Editor.' *Books and Bookman* 22, no. 9 (June 1977): 4.

'William C. Seitz Collection.' *Art Journal* 37, no. 1 (Fall 1977): 49–50.

'Manzù.' *XXᵉ Siecle* 50 (June 1978): 99–105.

'Letter to the Editor' (re. Berenson). *Art in America* 69 (Jan. 1981): 5.

'The Advantage of Writing in English.' The Blashfield Foundation Address. *Proceedings of the American Academy and Institute of Arts and Letters*, 2nd ser. 32 (1981): 29–36.

'The Watercolours of Paul Cézanne.' W. A. Cargill Memorial Lecture, no. 8. University of Glasgow Press, 1982.

BOOK REVIEWS

Lionello Venturi, *Cézanne, son art, son oeuvre*. *La Renaissance* 20 (Mar.–Apr. 1937): 53–56 ('A propos du catalogue raisonné de l'oeuvre de Paul Cézanne et de la chronologie de cette oeuvre').

French Impressionists and their Contemporaries, preface by Edward Alden Jewell, photo research and biographies by Aimée Crane; Edward Allen Jewell, *Paul Cézanne; A Gallery of Great Paintings*, edited by Aimée Crane, foreword by Peyton Boswell. *Magazine of Art* 38 (Mar. 1945): 114–20.

Masterpieces of Painting from the National Gallery of Art, edited by Huntington Cairns and John Walker; *Degas, A Portfolio of 10 Reproductions*. *Magazine of Art* 38 (Apr. 1945): 156–59.

Marcel Guérin, *L'oeuvre gravé de Manet*; *Lettres de Degas*, edited by Marcel Guérin;

Duranty: La Nouvelle Peinture—1876, edited by Marcel Guérin; *Huit Sonnets de Edgar Degas*, introduction by Jean Nepveu-Degas; Denis Rouart, *Degas à la recherche de sa technique*. Magazine of Art 40 (Jan. 1947): 36–38.

R. H. Wilenski, *Modern French Painters.* Burlington Magazine 90 (Jan. 1948): 27–28 (Letter to the Editor).

Jaime Sabartés, *Picasso, An Intimate Portrait.* The Saturday Review 31 (Aug. 14, 1948): 26–27.

*Adolphe Tabarant, *Manet et ses oeuvres.* The Art Bulletin 30 (Sept. 1948): 236–41.

François-Joachim Beer, *Pierre Bonnard.* Magazine of Art 41 (Dec. 1948): 322.

Adelyn D. Breeskin, *The Graphic Work of Mary Cassatt.* Magazine of Art 42 (Jan. 1949): 35.

Kenneth Clark, *Landscape Painting.* The Saturday Review 33 (Apr. 1, 1950): 43.

Lionello Venturi, *Impressionists and Symbolists.* Translated by Francis Steegmuller. The Saturday Review 33 (Sept. 2, 1950): 41.

Claude Roger-Marx, *L'oeuvre gravé de Vuillard*; Jacques Salomon, *Vuillard: Temoignage*; André Chastel, *Vuillard*; Claude Roger-Marx, *Vuillard et son temps*; Claude Roger-Marx, *Vuillard.* Magazine of Art 43 (Oct. 1950): 234–35.

Denis Rouart, *Correspondance de Berthe Morisot, documents réunis et présentés.* Burlington Magazine 93 (May 1951): 173.

Raymond Cogniat, *French Painting at the Time of the Impressionists.* The Saturday Review 34 (July 7, 1951): 38–39.

Gerstle Mack, *Gustave Courbet.* San Francisco Chronicle, Dec. 9, 1951.

Alfred H. Barr, Jr., *Matisse, His Art and His Public.* Liturgical Arts 21 (Nov. 1952): 28.

Claude Roger-Marx, *Avant la destruction d'un monde*; Thadée Natanson, *Peints à leur tour*; Félix Fénéon, *Oeuvres*; Francis Jourdain, *L'Art officiel de Jules Grévy à Albert Lebrun*; Jean Robiquet, *L'Impressionnisme vécu*; Lionello Venturi, *Le Peinture con-*

temporaine. Gazette des Beaux-Arts 41 (Mar. 1953): 207–9.

The World of Van Gogh, text by W. Jos de Gruyter, photographs by Emmy Andriesse. The Saturday Review, Feb. 6, 1954, pp. 32–33.

Charles Estienne and C. H. Sibert, *Van Gogh*; Charles Estienne, *Gauguin*; Jacques Lassaigne, *Toulouse-Lautrec*; Frederick S. Wight, *Van Gogh*; Hans Tietze, *Toulouse-Lautrec*; Emmy Andriesse, *The World of Van Gogh*; Carl Nordenfalk, *The Life and Work of Van Gogh.* Art News 53 (Apr. 1954): 38.

Lawrence and Elisabeth Hanson, *The Tragic Life of Toulouse-Lautrec.* The Saturday Review, June 16, 1956, p. 19.

Charles Sterling, *Great French Painting in the Hermitage.* Herald Tribune Book Review, Mar. 23, 1958, p. 5.

Pierre Mornand, *Emile Bernard et ses amis.* Gazette des Beaux-Arts 52 (Sept. 1958): 192.

Ronald Alley, *Tate Gallery Catalogues: The Foreign Paintings, Drawings, and Sculpture.* Burlington Magazine 102 (May 1960): 217–18.

Paul Pétridès, *L'oeuvre complet de Maurice Utrillo.* Art News 59 (Sept. 1960): 38.

*William C. Seitz, *Monet*; *C. P. Weekes, *The Invincible Monet.* Herald Tribune Book Review, Nov. 13, 1960, p. 1.

Raymond Escholier, *Matisse: A Portrait of the Artist and the Man.* The New York Times Book Review, Feb. 12, 1961, p. 26.

Jean Renoir, *Renoir, My Father.* Translated from the French by Randolph and Dorothy Weaver. The New York Times Book Review, Nov. 18, 1962, p. 7.

Lawrence and Elizabeth Hanson, *The Seekers: Gauguin, van Gogh, Cézanne.* The New York Times Book Review, Nov. 17, 1963, p. 26.

*Charles Merrill Mount, *Monet: A Biography.* Art News 66 (Jan. 1968): 25.

Felicitas Tobien, *Paul Cézanne.* Gazette des Beaux-Arts (Dec. 1982): 19.

List of Illustrations

Index

List of Illustrations

Measurements are given in inches before centimeters within brackets

1 Claude Monet *Vétheuil* 1879. Oil on canvas. 20⅛ x 24 (51 x 61). Collection Commander C. J. Balfour, England

2 Edgar Degas *A Woman with Chrysanthemums* 1865. Oil on canvas. 29 x 36½ (74 x 92). The Metropolitan Museum of Art, New York (The H. O. Havemeyer Collection, Bequest of Mrs H. O. Havemeyer, 1929)

3 Alfred Sisley *The Seine at Suresnes* 1879. Oil on canvas. 20 x 25½ (50.8 x 64.7). Private collection, Newport, Rhode Island

4 Auguste Renoir *The Rowers' Lunch* c. 1879. Oil on canvas. 21½ x 25¾ (54.6 x 65.4). The Art Institute of Chicago (Potter Palmer Collection)

5 Paul Gauguin *Fruit Pickers, Martinique* 1887. Oil on canvas. 35¼ x 45¼ (90 x 115). Rijksmuseum Vincent van Gogh, Amsterdam

6 Paul Gauguin *By the Pond* 1887. Oil on canvas. 21¼ x 25½ (54 x 65). Rijksmuseum Vincent van Gogh, Amsterdam

7 Georges Seurat *'Eden Concert'* 1887–88. Conté crayon drawing. 11¾ x 9 (29.7 x 22.9). Rijksmuseum Vincent van Gogh, Amsterdam

8 Claude Monet *Umbrella Pines, Cap d'Antibes* 1888. Oil on canvas. 28¾ x 36¼ (73 x 92). Private collection, United States

9 Auguste Renoir *The Bay of Naples* 1881. Oil on canvas. 23½ x 32 (59.7 x 81.3). The Metropolitan Museum of Art, New York (Bequest of Julia W. Emmons, 1956)

10 Paul Gauguin *Breton Girls Dancing* 1888. Pastel. 9 x 16⅛ (24 x 41). Rijksmuseum Vincent van Gogh, Amsterdam

11 Paul Gauguin *Arlesian Women, Mistral* 1888. Oil on canvas. 28¾ x 36 (73 x 92). The Art Institute of Chicago (Mr and Mrs Lewis L. Coburn Memorial Collection)

12 Camille Pissarro *Flock of Sheep, Eragny* 1889. Oil on canvas. 24½ x 30 (62 x 76). Whereabouts unknown

13 Odilon Redon *Vierge d'Aurore* 1890. Oil on paper mounted on canvas. 19⅝ x 14⅛ (50 x 36). Formerly Collection Isidore Levin, Detroit, Michigan

14 Paul Gauguin *Be in Love, You Will Be Happy* 1889. Polychrome wood relief. 33 x 45¼ (85 x 115). Museum of Fine Arts, Boston (Arthur Tracy Cabot Fund)

15 Paul Gauguin *Eve* 1890. Glazed stoneware. Height 23⅝ (60). National Gallery of Art, Washington, D.C. (Ailsa Mellon Bruce Fund)

16 Edouard Manet *The 'Kearsarge' at Boulogne* 1864. Oil on canvas. 32 x 39¼ (81 x 99.4). Private collection, New Jersey

17 Camille Pissarro *Spring* 1872. Oil on canvas. 21⅝ x 51⅛ (55 x 130). Private collection

18 Camille Pissarro *Summer* 1872. Oil on canvas. 21⅝ x 47¼ (55 x 120). Private collection

19 Camille Pissarro *Autumn* 1872. Oil on canvas. 21⅝ x 51⅛ (55 x 130). Private collection

20 Camille Pissarro *Winter* 1872. Oil on canvas. 21⅝ x 51⅛ (55 x 130). Private collection

21 Camille Pissarro *Charing Cross Bridge, London* 1890. Oil on canvas. 23⅛ x 36 (58.8 x 91.4). Collection Mr and Mrs Paul Mellon, Upperville, Virginia

22 Claude Monet *Pheasants, Woodcock, and Partridge* 1879. Oil on canvas. 35 x 26¾ (88.9 x 67.9). Private collection, United States

23 Camille Pissarro *Path above Pontoise* c. 1871. Oil on canvas. 20½ x 32 (52 x 81.2). The Dixon Gallery and Gardens, Memphis, Tennessee

24 Paul Gauguin *Women by the River, Tahiti* 1892. Oil on canvas. 43½ x 31½ (110.4 x 80). Rijksmuseum Vincent van Gogh, Amsterdam

25 Paul Gauguin *Snow Scene, Paris* 1894. Oil on canvas. 28 x 34⅝ (72 x 88). Rijksmuseum Vincent van Gogh, Amsterdam

26 Paul Gauguin *Christ in the Garden of Olives (Christ rouge)* 1889. Oil on canvas. 28¾ x 36¼ (73 x 92). Norton Gallery, West Palm Beach, Florida

27 Edgar Degas *Ballet Dancer, Dressed* 1880 (detail). Bronze. Height 39 (99). The Metropolitan Museum of Art, New York

28 Edgar Degas *Horse at Trough* 1866–68. Bronze. Height 6 (16). The Metropolitan Museum of Art, New York (All Degas bronzes in The Metropolitan Museum of Art, New York, are part of the H. O. Havemeyer Collection bequeathed by Mrs H. O. Havemeyer, 1929)

29 Edgar Degas *Mademoiselle Fiocre in the Ballet 'La Source'* 1866–68. Oil on canvas. 51⅛ x 57⅛ (130 x 145). The Brooklyn Museum, New York (Gift of A. Augustus Healy, James H. Post, and John T. Underwood)

Color Plates

Index

Figures in italics refer to illustration numbers